Seventh edition

History and Tradition of
JAZZ

Thomas E. Larson

Kendall Hunt
publishing company

Book Team

Chairman and Chief Executive Officer Mark C. Falb
President and Chief Operating Officer Chad M. Chandlee
Vice President, Higher Education David L. Tart
Director of Publishing Partnerships Paul B. Carty
Vice President, Operations Kevin Johnson
Publishing Specialist Supervisor Lynne Rogers
Senior Publishing Specialist Michelle Bahr
Cover Designer Suzanne Millius

Cover Photo: Gilad Hekselman
Cover Photo Musician: Walter Smith III

www.kendallhunt.com
Send all inquiries to:
4050 Westmark Drive
Dubuque, IA 52004-1840

Copyright © 2002, 2005, 2008, 2011, 2016, 2018, 2022 by Kendall Hunt Publishing Company

PAK ISBN: 979-8-7657-0825-5
Text ISBN: 979-8-7657-0827-9

Printed in the United States of America

BRIEF CONTENTS

CONTENTS

CHAPTER 10

A NEW PARADIGM: JAZZ IN THE 1980S AND 1990S 183

CHAPTER 11

JAZZ IN THE NEW MILLENNIUM 205

PREFACE

The history of jazz is a fascinating story that can be interesting and enjoyable to music students and non-music students alike. It is a story of not only music and musicians but also the struggle to achieve, to create, to invent and re-invent, and to sacrifice for the sake of art. It is a look at how 20th-century Americans forged a very personal and unique art form that defined the culture they lived in.

History and Tradition of Jazz is designed for the college non-music major. It is this author's feeling that many college textbooks on jazz history do not adequately serve the needs of a student taking a one-semester course for a fine arts requirement. Some are excellent books that contain a wealth of musical analysis and technical information; however, these can be overwhelming to a student with little or no music training, and cumbersome if an instructor has to continually skip around those sections. Some books are opinionated strolls down memory lane ("back in my day...") that are too self-serving to do anyone any good. And there are other books in outline form that, while covering all the important names, dates, and recordings, are simply too incomplete and do not provide enough information. *History and Tradition of Jazz* provides a documentation of jazz history in a thorough, informative way that can be understood by all students.

One of the most important features of this edition is the use of an online music library, giving students access to millions of selections. Included within the text is a short synopsis and musical analysis of each recording, done in a way that can be understood by an interested non-music major but yet will not be beneath that of a music major.

Another important feature of *History and Tradition of Jazz* is the spiral binding. Many jazz history courses for non-music majors are lecture courses that are taught in auditoriums or recital halls where students must sit in seats instead of desks. Spiral binding allows the book to be laid flat on the lap in these situations.

Some of the features of the text *History and Tradition of Jazz* include:

1. Discussion of the characteristics of all major jazz styles of the last 100 years.
2. The stories and legends of important events and people that shaped jazz history, with stylistic analysis and biographical information about the most important figures.
3. Discussion of how jazz, American history, and popular culture are intertwined, and how they have mutually affected each other from time to time.
4. Description of how and why New Orleans, Chicago, Kansas City, New York, and Los Angeles became important cities in the development of jazz, including descriptions of important places like nightclubs and dancehalls in each, and why each (except for New York) declined in importance.
5. A thorough description of what happens in a typical jazz performance, along with musical terms and their definitions. These will allow students to attend live jazz performances in the community that can be used to enhance their classroom study. Also included are jazz performance review sheets for students to use to take notes and hand in for extra credit.

6. Discussion of how jazz has been an important lightning rod in our country's battle with the race issue. From the very beginning, jazz musicians were dealing with the problems of discrimination and segregation, well before other American institutions like higher education and professional sports.

New to This Edition

The seventh edition of *History and Tradition of Jazz* has been updated with new information that reflects the changing historical facts that have emerged since the last edition. This edition has also been updated with exciting new formatting and color schemes that will be attractive to teachers and students alike. And, for adopters, there are new ancillary items and services to provide support.

Like previous editions, the seventh edition also is packaged with a subscription to *Rhapsody*, the online music service that will give students unlimited 24/7 access to the music referenced in the book and listened to in class. There are six new music synopses, bringing the total to 61, distributed evenly throughout the book. The seventh edition of The History and Tradition of Jazz concludes with an epilog that gives a fascinating insight into the effects of the COVID-19 pandemic on the New York City jazz community. A number of prominent jazz musicians and club owners were interviewed for this piece, including the Village Vanguard's Deborah Gordon and jazz piano virtuoso Emmet Cohen.

In addition, playlists of additional music cuts mentioned in the text are available with the adoption of *History and Tradition of Jazz* so that students can easily access music that they read about and are introduced to in class.

Thomas E. Larson

ACKNOWLEDGMENTS

I would like to extend my grateful thanks to the following:

Kendall Hunt Publishing and Development Editors Lynne Rogers and Michelle Bahr.

Tad Hershorn at the Institute of Jazz Studies at Rutgers University for assistance with photo clearances; and the many photographers I have contacted whose beautiful work graces the pages of this text: Tad Hershorn, Peter Gannushkin, Dani Gurgel, Andrea Canter, Duncan Schiedt, Hans Arne Nakrem, Dragon Tasic and Dr. Steven Sussman.

Dr. Lawrence Mallett and Rusty White for the opportunity to join the faculty at the Glenn Korff School of Music at the University of Nebraska-Lincoln back in 1998, and Dr. John Richmond for fostering a continued environment of scholarship at the school. Dr. Randall Snyder for being a teacher, colleague, and provider of wisdom. Steve Doyle, Darryl White, Peter Bouffard, Danny Weiss, and Bruce Barth for valuable assistance and insights that were crucial to completing this book.

Finally, those closest to me: my wife, Kim Collier, my children Kalie, Will and Carolyn, and my parents, Roger and Shirley Larson, who fostered in me a love of music and gave me the support I needed to pursue that love.

Tom Larson

I gratefully acknowledge the constructive comments of the colleagues who provided reviews for individual chapters of this text. They include:

David Ake
 University of Nevada, Reno
Dan Aldag
 Humboldt State University
Peter Arcaro
 Lake Sumter Community College
Larry Arnold
 University of North Carolina, Pembroke
Tamar Barzel
 Wellesley College
Gene Bechen
 St. Ambrose University
David Bubsey
 East Tennessee State University
Jay Bulen
 Truman State University
Lawrence Burke
 Florida Southern College
Dave Camwell
 Simpson College
Walter Carr
 Portland Community College
Theo Cateforis
 Syracuse University
James Cauter
 Seattle Central Community College
David Chevan
 Southern Connecticut State University

John Clark
 Connecticut College
Keller Coker
 Western Oregon University
Tom Collier
 University of Washington
Ralph Converse
 Western New Mexico University
Michael Dana
 Fresno City College
Norman David
 University of the Arts
Jan DeShera
 Diablo Valley College
Scott DeVeaux
 University of Virginia
Patrick Dorian
 East Stroudsburg University, Pennsylvania
Doug Dunston
 New Mexico Tech
Larry Dwyer
 University of Notre Dame
Jeff Erickson
 University of Wisconsin—Marathon County
Bobby Ferrazza
 Oberlin Conservatory
Kenan Foley
 Carlow University

Ted Goddard
 Chandler-Gilbert Community College
Lawrence Harms
 Illinois Central College
John Hawkins
 *Potomac State College of West
 Virginia University*
Robert Hodson
 Hope College
Eric Hofbauer
 Emerson, URI
Craig Hurst
 University of Wisconsin, Waukesha
Tim Ishii
 University Texas, Arlington
Todd Kelly
 Bradley University
Sparky Koerner
 College of the Mainland
Dave Kopplin
 Cal Poly Pomona
Christopher Kozak
 University of Alabama
Stephen Kravitz
 Linfield College
Paul Kukec
 Morton College
Tracey Laird
 Agnes Scott College
David Lalama
 Hofstra University
Dana Landry
 University of Northern Colorado
Sonya Lawson
 Westfield State College
Karl Megules
 Burlington County College
Herbert Midlgey
 Stephen F. Austin State University
Steven Miller
 College of Santa Fe
Timothy Olsen
 Union College
Patricia Olsson
 Kent State University—Stark Campus
Lester Pack
 University of Arkansas, Monticello

Simeon Pillich
 Occidental College
Gene Pollart
 University of Rhode Island
Emmett Price III
 Northeastern University
Archie Rawls
 Pearl River Community College
James Romain
 Drake University
Lauren Saeger
 Illinois State University
John Salmon
 University of North Carolina at Greensboro
David Schiff
 Reed College
Ed Schupbach
 Heartland Community College
Jeff Stabley
 York College of Pennsylvania
George Starks
 Drexel University
David Stern
 Anderson University
Thomas Streeter
 Illinois Wesleyan University
Jerry Tolson
 University of Louisville
Michael Van Allen
 Roberts Wesleyan College
David Villani
 Penn State, Altoona
Roy Vogt
 Belmont University
Patrick Warfield
 Georgetown University
John West
 Western Carolina University
William White
 Three Rivers Community College
James Whitfield
 Gardner-Webb University
Curt Wilson
 Texas Christian University

MUSIC ANALYSIS CUTS

CHAPTER 2

Track 1: "West African Drum Music"
Track 2: "Holler" Charley Berry
Track 3: "Early in the Mornin'" Johnny Lee Moore
Track 4: "I'll Meet You On That Other Shore" St. James Primitive Baptist Church
Track 5: "Cross Road Blues" Robert Johnson
Track 6: "Maple Leaf Rag" Scott Joplin

CHAPTER 3

Track 7: "Just a Closer Walk with Thee (Part I)" Preservation Hall Jazz Band
Track 8: "Just a Closer Walk with Thee (Part II)" Preservation Hall Jazz Band
Track 9: "King Porter Stomp" Jelly Roll Morton
Track 10: "Wild Cat Blues" Clarence Williams' Blue Five
Track 11: "Livery Stable Blues" Original Dixieland Jass Band
Track 12: "Tiger Rag" Art Tatum

CHAPTER 4

Track 13: "Dippermouth Blues" King Oliver's Creole Jazz Band
Track 14: "Black Bottom Stomp" Red Hot Peppers
Track 15: "West End Blues" Louis Armstrong and His Hot Five
Track 16: "Weather Bird" Louis Armstrong and Earl "Fatha" Hines
Track 17: "Singin' the Blues" Frankie Trumbauer and His Orchestra
Track 18: "Gimme a Pigfoot and a Bottle of Beer" Bessie Smith

CHAPTER 5

Track 19: "Rhapsody in Blue" Paul Whiteman Orchestra
Track 20: "Hot 'n' Anxious" Fletcher Henderson Orchestra
Track 21: "Creole Love Call" Duke Ellington and His Orchestra
Track 22: "One O'clock Jump" Count Basie and His Orchestra

CHAPTER 6

Track 23: "King Porter Stomp" Benny Goodman Orchestra
Track 24: "Good Enough to Keep" Benny Goodman Sextet
Track 25: "Black, Brown, and Beige, Part I" Duke Ellington and His Orchestra
Track 26: "Take the 'A' Train" Duke Ellington Orchestra
Track 27: "Body and Soul" Coleman Hawkins and His Orchestra
Track 28: "Strange Fruit" Billie Holiday

CHAPTER 7

Track 29: "Swing to Bop" Charlie Christian
Track 30: "Koko" Charlie Parker's Reboppers
Track 31: "Manteca" Dizzy Gillespie and His Orchestra
Track 32: "Rhythm-A-Ning" Thelonious Monk
Track 33: "Four Brothers" Woody Herman Orchestra
Track 34: "Lemon Drop" Ella Fitzgerald

ABOUT THE AUTHOR

Tom Larson is Associate Professor of Composition (Emerging Media and Digital Arts) at the Glenn Korff School of Music at the University of Nebraska-Lincoln. He is the school's Director of Jazz Studies and the Music Director for the Faculty Jazz Ensemble. In addition to authoring *The History and Tradition of Jazz*, he is also the author of *Modern Sounds: The Artistry of Contemporary Jazz, The History of Rock and Roll, Film Scoring in the Digital Age,* and *Sound Recording in the 21st Century,* all published by Kendall Hunt Publishing. He has studied jazz piano with Dean Earle, Fred Hersch, Bruce Barth, and Kenny Werner, jazz arranging with Herb Pomeroy, and music composition with Robert Beadell and Randall Snyder. In addition to performing with jazz ensembles throughout the Midwest and East Coast, he has performed with The Tokyo Brass Art Orchestra in Tokyo, at the Montreux Jazz Festival, and at the International Society of Bassists Convention in Copenhagen.

Photo by Michael Farrell

Tom also writes and produces music for documentary films; among his credits are the scores for three documentaries for the PBS *American Experience* series (a production of WGBH-TV, Boston): *In the White Man's Image, Around the World in 72 Days,* and *Monkey Trial.* He also scored the documentaries *Willa Cather: The Road is All* for WNET-TV (New York), *Ashes from the Dust* for the PBS series *NOVA,* and the PBS specials *Most Honorable Son, In Search of the Oregon Trail,* and *In Standing Bear's Footsteps.* Tom has written extensively for the University of Nebraska television network, South Dakota Public Broadcasting, and the University of Illinois Asian Studies Department. His music has also been used on the CBS-TV series *The District.* His commercial credits include music written for Phoenix-based Music Oasis, LA-based Music Animals, Chicago-based Pfeifer Music Partners and General Learning Communications, and advertising agencies in Nebraska.

A Lincoln native, Tom received a Bachelor of Music in Composition from Berklee College of Music in Boston, Massachusetts in 1977, and a Master of Music in Composition from the University of Nebraska–Lincoln in 1985. He is also an avid runner, and completed the Boston Marathon in 2005, 2006 and 2007. More information on Tom Larson can be found at tomlarsonmusic.net.

UNDERSTANDING AND DEFINING JAZZ

Introduction

Jazz is America's art form. It is as much a part of our cultural heritage as baseball and our Constitution. It was created and continues to be shaped, like America itself, by risk takers and rule breakers, men and women who put everything on the line for the sake of their art. Jazz is an art form of individual expression, but unlike many other art forms, it is spontaneous; what is created now will be recreated differently later. It is an art of human interaction, and like democracy, the individual is free to pursue expression, as long as the responsibilities to the group are maintained. Jazz is a celebration of the American spirit and a reflection of our changing culture. To study jazz is to study 20th-century America.

Jazz is sometimes hard for the casual listener to grasp, so the study of jazz should take a look at how it is defined and how it is performed to develop a deeper understanding of the music. Once the essentials that go into the making of jazz are discussed in this chapter, Chapter 2 will look into the diverse elements that came together in the 19th century to make the creation of jazz possible. Future chapters will study the important musicians, styles, and changes in the music that have occurred throughout the 20th century.

Understanding Jazz

The Origins

Jazz is American music that was created out of the social conditions that were present in the southern United States, where musicians first began synthesizing the oral traditions of African music and the literal traditions of Western European music. It was in the South that the largest concentration of Americans of African ancestry lived (as a result of the institution of slavery), who around 1900 began the process of creating a new kind of music out of the resources they had available to them. These resources included the music styles they were familiar with and could play, the instruments that were readily available, and the political and cultural situations that dictated where and with whom they could play. The incubation period for the creation of jazz goes back to the very beginnings of slavery in the early 1600s. It was only after nearly 300 years of the two musical traditions—African and European—coming in contact with each other that the birth of jazz took place. It is important to remember that it was 19th-century African Americans that were motivated for various reasons (discussed in Chapter 2) to incorporate elements of European music into their own musical tradition. This is why jazz was born in New Orleans and other cities in the South and not in the northern states.

KEY TERMS

Backbeat
Bar/Measure
Beat
Changes
Call and Response
Chord
Chord Progression
Chord Symbol
Chorus
Comping
Digital Sampler
Dissonance
Doubling Instrument
Double Time
Downbeat
Dropping Bombs
Embellishment/Ornamentation
Fake Book
Form
Gig
Harmony
Head
Hot/Cool
Improvisation
Improvised Solo
Interaction
Jazz Ensemble
Jazz Interpretation
Jazz Performance Form
Jazz Standard
Lay Out
Lead Sheet
Lyrical
Melody
MIDI (musical instrument digital interface)
Phrasing
Polyrhythm
Pulse
Rhythm
Rhythm Section
Ride Rhythm

Riff	Syncopation	Trading 4s
Swing Rhythm	Tempo	Walking Bass

Jazz is America's art form.

Jazz is an art form of individual expression

The highest form of individual expression in a jazz performance is the **improvised solo**. In modern jazz, only one musician solos at a time, and the other members of the group either **"lay out"** (stop playing), or continue playing in a role supportive to the soloist.

Creating a unique musical personality is a must for a jazz musician.

Defining Jazz

Jazz, especially today, is difficult to define. Because it is performed in so many styles and its influence can be heard in so many other types of music, it is nearly impossible to come up with a set of hard and fast rules in which to define jazz. It is helpful to think of a set of loose guidelines that are followed to one degree or another during the course of a jazz performance. Five basic guidelines for defining jazz are listed in **Box 1-1**.

The Jazz Soloist

The highest form of individual expression in a jazz performance is the **improvised solo**. In modern jazz, only one musician solos at a time, and the other members of the group either **"lay out"** (stop playing), or continue playing in a role supportive to the soloist. Because the soloist is composing on the spot while performing, his or her technical skills on their instrument must be developed to a high level of proficiency. Soloists must also have "good ears"—in other words, be able to conceptualize melodies in their heads before actually playing them and be able to interact and respond to support and input from other musicians in the ensemble.

Unlike other types of music, jazz musicians are essentially free to develop their own sound that they are identified with during a solo. Creating a unique musical personality is a must for a jazz musician. One way a player can accomplish this is by the choice of which notes to play when improvising. For instance:

- Dizzy Gillespie, a trumpeter who came into prominence in the 1940s, loved to play brilliant fast-moving flourishes in the very highest register of the horn, and that is one way we can identify his style.
- Miles Davis, on the other hand, often played very low notes and far fewer of them than Dizzy.

Another way players, especially saxophonists, develop their own sound is by the tonal quality of their instruments. For example:

- Stan Getz, a tenor saxophonist who became famous in the 1960s, played with a very light and pretty tone that sounded very romantic.
- John Coltrane, another tenor sax player from the same era, had a tone that could hardly be described as pretty—harsh and penetrating are better descriptions.

BOX 1-1	Five Basic Guidelines for Defining Jazz

1. **Improvisation**. Improvisation is defined as the act of simultaneously composing and performing. It is an essential element in the performance of most, but not all, jazz. For instance, most of what you hear when you listen to a jazz big band is written down and not improvised. But generally speaking, jazz is an art form of individual expression, and most jazz contains a great deal of improvisation. When you listen to a small jazz group, it is usually easy to tell which member of the group is improvising a solo, but it is important to remember that the

other members of the group are also improvising within the framework of their responsibilities to the group sound.

2. **Rhythm**. Jazz rhythm is usually defined in terms of swing rhythm and syncopation, but these two elements, like improvisation, are sometimes used only minimally or not at all in a jazz performance (for instance, Latin, or rock-influenced jazz does not usually swing). **Swing rhythm** is best described by a loosening of the rigid adherence to the beat of the music. This is accomplished by slightly delaying the notes played between beats, creating a momentary tension that is resolved on the next beat. When this rhythmic momentum drives a piece of music, the music is said to "swing." If you can tap your foot or snap your fingers to it, there's a good chance the music is swinging. **Syncopation** is rhythmically placing or accenting notes away from the beat and in unexpected places and is almost always present in any jazz performance.

3. **Dissonance**. Jazz musicians are continually "pushing the envelope" to incorporate non-harmonious, dissonant tonalities into their music. Jazz dissonance can be subtle and barely noticeable, or sometimes very pronounced, which can make the music difficult to listen to. Like swing rhythm, dissonance creates tension for the listener, and an experienced jazz musician will use tension and its eventual resolution often in a jazz performance to give the listener a sense that the music has forward motion.

4. **Jazz Interpretation**. Jazz interpretation is best described as the unique way that jazz musicians produce sound. For instance, jazz saxophonists often slur or bend notes when playing a melody; trumpeters might put a plunger mute on their horn to create a wah-wah effect; or a pianist might "crush" two notes together to create a bent note effect. Even though these ways of changing sound production are frowned upon in much of European-influenced music (for instance, classical or church music), they are a vital part of most jazz performances.

Swing Rhythm								
Beat	1		2		3		4	
Straight								
Swing								

5. **Interaction**. Although jazz can be performed by a single musician, it is usually performed by several in an ensemble of some sort. Although it is true that any musical group requires the musicians to carefully listen to each other to stay together and to keep the music focused, it is especially important in a jazz performance. Because the musicians are usually all improvising to some degree, communication must be open and honest. A jazz quartet is no different than a panel discussion with four speakers: the conversation must be interactive, with each participant responding in turn to something another said. In a jazz performance, if one musician is soloing, he is still interacting with the other musicians in the group.

Swing rhythm is best described as a loosening of the rigid adherence to the **beat** of the music.

Syncopation is rhythmically placing or accenting notes away from the beat and in unexpected places and is almost always present in any jazz performance.

Jazz musicians can also use syncopation and rhythmic variety, as well as varying amounts of dissonance in their solos to create their own sound. Because most jazz uses established rules of melody, harmony, and rhythm, the three essential elements of music, a soloist must have a thorough understanding of those principles. And,

a soloist must know the jazz repertoire, the songs and compositions that are most often played in a jazz performance. These compositions are called jazz standards.

Jazz standards—a jazz or pop tune that is widely known by jazz musicians and is played often.

The Instruments of Jazz

The Rhythm Section

Jazz can be performed with just about any type of ensemble, from a solo clarinet to a 17-piece big band. However, most jazz ensembles generally have a rhythm section whose members usually consist of a bass player, a drummer, and either a pianist or guitarist. (Occasionally a rhythm section will use a vibraphonist instead of or in addition to the pianist or guitarist.) (See Box 1-2) Rhythm section musicians all have a specific role to play, but within the framework of those roles, they also have a tremendous amount of freedom as to exactly what they play. In general, if there are also horn players in the band, the rhythm section instruments are always playing, even as the horn players take turns soloing. If a trumpet player is soloing, the role of the rhythm section players is to provide interactive support for that solo. Although they are playing supporting roles to the soloist (as described below), the rhythm section players are also improvising, but in a different and much more limited way. Rhythm section players also can take turns soloing, so their roles will change at those times. The basic duties of each of the rhythm section instruments are outlined in Box 1-3.

Most **jazz ensembles** have a rhythm section whose members usually consist of a bass player, a drummer, and either a pianist or guitarist.

Commonly Used Wind Instruments

The most commonly used wind instruments in jazz today are the saxophone and the trumpet. There are four different saxophones used, ranging from the highest-pitched soprano to the slightly lower alto, to the even lower tenor, down to the very low baritone. (See Box 1-4 for different types of saxophones.) Rule of thumb: the bigger the saxophone, the lower its pitch. The tenor and alto are the most commonly used, with the baritone most commonly found only in a big band. The trumpet is one of a family that includes the flugelhorn, which has a larger bell and wider tubing, and the cornet, a more compact version of the instrument. The first jazz trumpeters played the cornet, which went out of style in the 1920s and is rarely used today. The flugelhorn produces a warmer and mellower tone than the trumpet, as is used most often on ballads or more intimate music. Trumpets and trombones often employ various mutes to color

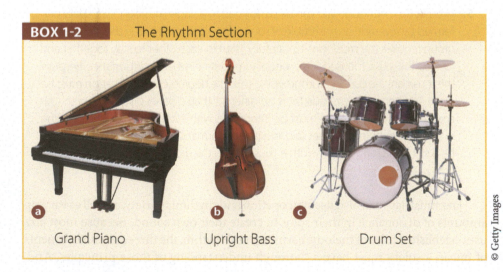

BOX 1-2 The Rhythm Section

(a) Grand Piano (b) Upright Bass (c) Drum Set

© Getty Images

BOX 1-3 Instruments of the Rhythm Section

Piano (or guitar). The pianist or guitarist plays the **chords** that accompany the melody of the song, usually in a syncopated and interactive manner that is called **comping** (short for accompanying). The pianist or guitarist often spontaneously feeds the soloist rhythmic or melodic ideas with his comping as well. How he structures those chords and the rhythm he uses is up to him. When it is the pianist's turn to solo, often he will comp with the left hand while soloing with the right hand.

Bass. The bassist might be the most important member of the rhythm section (just ask any bass player) because that player provides a foundation for the chords and keeps a steady beat. In swing rhythm, bass players usually play what is called **walking bass**—the playing of a note that outlines the chord in some way on every beat. Because the walking bass line is improvised, bassists are free to also spontaneously interact with rhythmic or harmonic ideas from the other musicians.

Drums. The modern drum set is a set of instruments put together in such a way that the performer can play with both his hands and both his feet. A typical drum set consists of a bass drum, a hi-hat cymbal, a snare drum, one or more "rack" tom-toms (mounted on a metal rack above the bass drum), a floor tom, and at least one ride cymbal and one crash cymbal. In jazz, drummers help keep the beat (or "keep time") by playing the swing rhythm on either the hi-hat or the ride cymbal with their right hand. Because drummers often use the ride cymbal to play swing rhythm, it is often called **ride rhythm**. The left hand and both feet are used to provide improvised, syncopated accents on the various drums and cymbals. When a drummer plays a spontaneous, syncopated accent on the bass drum to add energy to the performance, it is called **dropping bombs**.

BOX 1-4 The Four Different Types of Saxophones

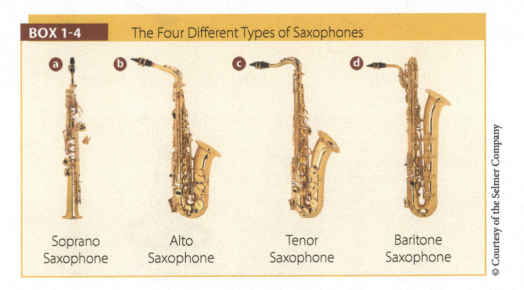

a Soprano Saxophone

b Alto Saxophone

c Tenor Saxophone

d Baritone Saxophone

the sound, giving these instruments a greater variety of tonal shadings. Among those used are the cup, straight, plunger, and the Harmon. (See **Figure 1-1**.) Another instrument related to the trumpet and a fellow member of the brass family is the trombone. Trombones use a slide and the player's embouchure (the adjustment of the lips, tongue, and mouth muscles on the mouthpiece) to vary the pitch. It is a difficult instrument on which to play jazz, but it offers a degree of flexibility in pitch that other wind instruments cannot match. (See **Box 1-5** for commonly used wind instruments.)

Flutes and clarinets are also common in jazz, although they are most often found in big bands. Flutes, clarinets, bass clarinets, and soprano saxophones are often used as **doubling instruments**, which saxophone players might be called

Doubling instruments—instruments such as flutes or soprano saxophones that are occasionally used as a second instrument by a musician.

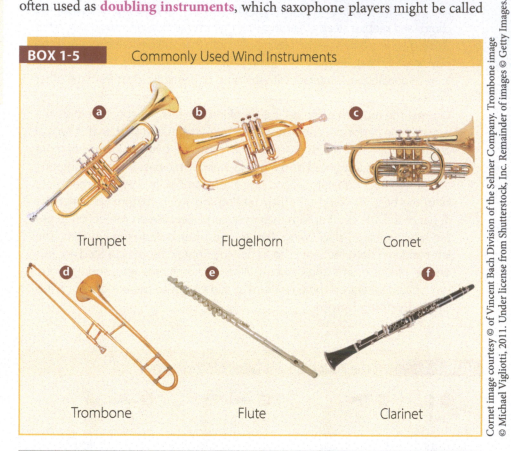

BOX 1-5 Commonly Used Wind Instruments

a. Trumpet b. Flugelhorn c. Cornet

d. Trombone e. Flute f. Clarinet

Cornet image courtesy © of Vincent Bach Division of the Selmer Company. Trombone image © Michael Vigliotti, 2011. Under license from Shutterstock, Inc. Remainder of images © Getty Images.

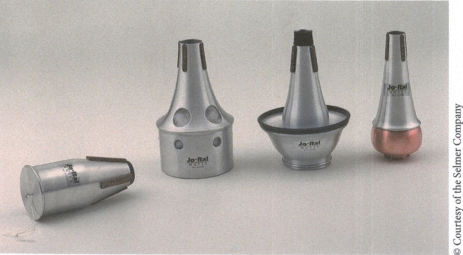

FIGURE 1-1

Brass Mutes. From left to right: straight, wispa, cup, and pixie.

© Courtesy of the Selmer Company

on to play for a specific part on a recording or an arrangement or as a secondary instrument. Other conventional acoustic instruments that are less commonly used in jazz are the violin, harmonica, banjo, and tuba.

Electronic Instruments

Since the 1930s, electronic instruments have found their way into jazz. The first was the electric guitar, followed in the 1950s by the electronic organ and the electric bass guitar. These instruments are ubiquitous in jazz today. Since the 1970s, when many jazz musicians began experimenting with rock rhythms and instruments, synthesizers have also played an increasingly large role in jazz performance. When the **MIDI (musical instrument digital interface)** protocol was agreed upon by musical instrument manufacturers in 1983, the way was cleared for the creation of keyboards, **digital samplers**, drum machines, and other digital instruments that could "talk" to each other and interconnect with computers. When a MIDI controller, such as a keyboard or drum pad is played, it sends out a digital signal containing such information as what note was played, how hard it was struck, and so on. This information can be recorded on computer sequencing software, where it can be edited in powerful ways and played back on any other MIDI instrument. Today, musicians using MIDI technology are redefining jazz with the use of laptop computers in performances and software to edit and reconstruct performances in the studio after they have been recorded. There are also MIDI controllers made for guitar players and wind players that allow them to take advantage of this technology.

> Today, **MIDI** technology (an acronym for **musical instrument digital interface**) allows musicians to create all kinds of sounds from a single keyboard and connect to computer sequencer software to create music.
>
> **Digital sampler**—a digital recording of a sound or musical phrase that is used in the performance or creation of a musical piece.

Melody, Harmony, Rhythm, and Form

Melody, Harmony, and Rhythm

To understand jazz, it helps to have a basic understanding of how music is put together. Generally, the three basic elements of music are melody, harmony, and rhythm. These are listed in **Box 1-6**.

BOX 1-6 The Three Basic Elements of Music

Melody. Most everyone knows what a melody is—simply a succession of notes that are played or sung in a specific order and rhythm. Sometimes melodies are referred to as tunes, although usually in jazz the word tune refers to the entire composition.

Harmony. Nearly every piece of music has harmony, or a set of chords (or the implication of chords) that accompany the melody. Chords are defined as three or more notes played simultaneously, and they, like melody notes, are played sequentially in a specific order called a chord progression. (**Chord progressions** are called **changes** in jazz.) Melodies are usually written with a specific chord progression in mind that will always accompany it.

Rhythm. The relationship of notes and sound with time. Rhythm is what gives music forward motion. Usually, rhythm is measured in **beats**; some notes last for one beat, whereas others may last for several beats or even fractions of beats. Beats (or **pulses**) are organized into a unit called a **measure**, or **bar**. Most music has four beats to a bar, but it is not uncommon to find music that has two or three beats to a bar (for instance, "Happy Birthday" has three beats to the bar).

Form

> **Form**—the basic structure of a musical piece.
>
> **Head**—the melody of a song.
>
> Each statement of form is called a **chorus**. The melody is almost always played in the first chorus.

Most music is organized into a basic structure or **form**. A simple form would be one time through the melody and chord progression. A good example would be to think of singing the first verse of "Silent Night." With three beats to each bar, it takes 24 bars to get through the verse, so it is said to have a 24-bar form. Some music has very complex forms, such as a Beethoven symphony or a Frank Zappa composition; however, most jazz performances are very simple in concept and easy to explain.

Usually, a jazz performance consists simply of the form (chord progression or verse) of the tune, whether it is 12, 24, or 32 bars (or whatever) in length, played over and over. Each statement of the form is called a **chorus**. Almost always, in the first chorus, the melody is played. This is called the **head**. When the head is finished the musicians start over at the beginning of the chord progression and play another chorus (think of moving on to the second verse of "Silent Night"), but this time, one of the performers creates an improvised solo using notes selected from the chords of the chord progression as it advances. The soloist is free to solo over as many choruses as he chooses; when he is done, other solos are improvised in the same fashion until the head is played one more time to finish the song. This format of head-solos-head is called the **Jazz Performance Form**. A chart of a typical jazz performance might look something like this:

Chorus 1	Chorus 2	Chorus 3	Chorus 4	Chorus 5	Chorus 6
Head	1st solo	1st solo continues	2nd solo	2nd solo continues	Head

Some Commonly Used Jazz Terms

Although there are definitions of words and phrases throughout this book, here are a few terms that are commonly used to describe jazz performance.

Melody

- **Riff**—a short melodic phrase or melody. Some jazz tunes are nothing more than simple riffs repeated several times. A riff may also describe a short phrase in an improvised solo. Also sometimes called a line, lick, phrase, or motif.
- **Phrasing**—the combining of melodies with silence, or rests. Think of human speech—when someone talks, each sentence or expression is followed by a pause of some sort. Some people talk rapidly with few pauses, others talk slowly with many pauses. Phrasing in jazz improvisation works in the same fashion.
- **Embellishment/Ornamentation**—simply the improvised decoration or "jazzing up" of a melody, whether in the head or a solo.
- **Hot/Cool**—terms used to describe an improvised solo or an individual performer's style of improvising. A hot soloist tends to add a lot of drama to his solo by playing a lot of notes, playing high in the instrument's range, or using interesting rhythmic effects, etc. A cool soloist plays in a more laid-back and relaxed style.
- **Lyrical**—a melody that is very singable or melodic. Cool soloists tend to play more lyrically than hot soloists.

Rhythm

- **Pulse**—the fundamental beat driving the music that creates the tempo.
- **Tempo**—the speed of the music. Fast music is said to have a fast tempo, slow music has a slow tempo.
- **Bar/Measure**—repeated groupings into which beats are organized. Most music in Western culture has four beats to the measure, although some have two, three, or even five, six, or seven. "Someday My Prince Will Come" for instance has three beats to each bar.
- **Downbeat**—beat one of each measure.
- **Backbeat**—beats two and four of a measure with four beats. The backbeats are usually accented in swing rhythm.
- **Syncopation**—placing notes or accents off the beat or in unexpected places.
- **Polyrhythm**—using two or more rhythms simultaneously.

Harmony

- **Chord**—the fundamental building block of harmony created when three or more notes are played simultaneously.
- **Chord Progression**—the sequential order of the chords of a tune. In the jazz world, the word **changes** refers to the chord progression of a song.
- **Chord Symbols**—notational representations of chords, or a kind of shorthand used to quickly communicate the harmonic content of a chord.
- **Lead Sheet**—a notated roadmap of a tune using only the melody and chord symbols. Lead sheets give only the most basic information to allow the performers maximum leeway in the performance of a tune. See **Figure 1-2** on page 10.
- **Fake Book**—a book made up of tunes in lead sheet form (often jazz standards).

Some Other Jazz Terms

- **Jazz Standard**—a jazz or pop tune that is widely known by jazz musicians and is played often. "Someday My Prince Will Come" is a good example of a jazz standard.
- **Gig**—a jazz performance.
- **Call and Response**—a melodic phrase played or sung by one performer that is answered by the rest of the group.
- **Trading 4s**—the technique of exchanging four-bar solos, often between a soloist and a drummer. In a performance, trading fours most often occurs (if at all) near the end of a tune, before the head is restated.
- **Double Time**—in an improvised solo, the technique of playing rhythmically twice as fast as the established tempo.

Flashback

FIGURE 1-2
Flashback

©2001 Tom Larson (ASCAP)

Name _____ Date _____

Study Questions

Understanding and Defining Jazz

1. Why is jazz hard to define? Describe some of the reasons why it is sometimes difficult to determine if a musical recording or a performance qualifies as jazz.

2. Describe the relationship between the rules rhythm section instruments must adhere to and the freedoms they have to play what they want in fulfilling their specific roles.

3. How would you describe the elements of jazz rhythm and how it differs from other types of music?

4. Describe how the roles of these three instruments change during the course of a song in a jazz performance: piano, trumpet, and bass.

5. Describe what happens during an improvised solo, both in terms of the soloist and the other members of the group.

AFRICAN MUSIC AND THE PRE-JAZZ ERA

Introduction

Before jazz existed, the European and African musical traditions were converging in slave camps, churches, and revival meetings all across the South. Because African music has an oral tradition, the work songs, shouts, and field hollers that were a part of everyday life in Africa were committed to memory and retained when slaves were brought to the New World. By the end of the 19th century, these traditional song forms had changed and adapted themselves to their new environment, and in some cases incorporated elements of European music in their performance. This cross-fertilization of musical cultures was essential to the birth of jazz, which ultimately came in the early years of the 20th century. But by this time, Black musicians and singers had already been exerting their influence on American culture and music for many years. Although minstrel shows spawned many negative stereotypes that lasted for many years after minstrelsy itself died out, they were an important and perhaps necessary beginning to the dialog between Blacks and whites on the issue of race and, in the years after the Emancipation Proclamation, important stepping stones for Black musicians into the world of entertainment.

Three musical forms that were the byproducts of the blending of African and European musical traditions came into existence in America in the 18th and 19th centuries, and each were important influences on the creation of jazz. Spirituals, the blues, and ragtime were each created to meet the specific needs of their performers and their respective audiences, and each found different ways to achieve the cross-fertilization of the African and European traditions. But one thing that all three had in common was that they were uniquely American styles, and could only have been created here.

African Music

African Musical Tradition

Africa is rich with musical traditions, but it is important that one does not make the assumption that there was one single culture that produced them. It is a huge continent—roughly four times the size of the United States—with at least 2,000 communal groups and probably at least that many languages and dialects. Africa should also not be thought of as an isolated continent, free of outside influence before the slave trade began. Instruments from ancient Greece and China have been dug up from African soil in recent years; Arabic invaders established a presence as well, as far back as the eighth century. Africa is a rich and diverse land of many cultures, traditions, and people.

KEY TERMS

12-Bar Form
AAB Lyric Form
Abolitionist Movement
Blue Notes
Blues Poetry/Lyrics
Blues Scale
Cakewalk
Call and Response
Diatonic Scale
Griot
Improvisation
Jug Bands
Minstrelsy/Minstrel Shows
Pentatonic Scale
Pianola
Second Awakening
Sheet Music
The Missouri School
Treemonisha
Vaudeville

KEY PLACES

Mississippi Delta
Sedalia, Missouri
West Africa

KEY FIGURES

Blind Lemon Jefferson
Charley Patton
James Bland
John and Alan Lomax
Leadbelly (Huddie Ledbetter)
Robert Johnson
Son House
Scott Joplin
Stephen Foster

MUSIC STYLES

Country Blues
Ethiopian Song
Field Holler

| Ragtime | Shout | The Blues |
| Ring Shout | Spiritual | Work Song |

In this chapter's discussion of African music, it is important to note that the references to the characteristics of and instruments used in African music are from historical African traditions that are in some cases hundreds of years old, rather than current African styles or trends. In the same way, references to European music point to the traditional classical music of Bach, Beethoven, and Brahms, not current European musicians. It is these traditions that were brought to the New World by Europeans as settlers and Africans as slaves that were important to the creation of jazz.

In Africa (as in Europe), each region and culture has its own indigenous musical styles and practices. However, there are a few common characteristics that have been observed throughout the continent. Possibly the most important of these is the functional role that music plays in everyday life—so much so that in many African cultures, there is no specific name given to music. Of course, there is functional music in our culture—we sing "Happy Birthday" at birthday parties and play fight songs at football games and somber music at funerals. Songs of this nature exist in African culture as well, but music's functional role goes much deeper. Among the many functional songs are those:

- To celebrate the loss of a first tooth
- To celebrate the passage into adulthood
- To shame bed wetters and thieves
- To tell of historical events
- To disseminate information, whether it is about an upcoming activity or a warning of some sort

One of the most important classes of functional songs is the work song. Work songs are as varied as the type of work that needs to be done, so there are work songs about, among other things:

- Building boats
- Cooking dinner
- Hunting
- Cleaning the home

Although these songs functioned as a way to make work go easier, work songs are celebratory—one is doing work that will make life better.

Another general characteristic of African musical tradition is the blurring of the distinct lines between the performer and audience. It is not uncommon for a person who might be singing a song as part of a story to have his or her listeners join in and participate. In parades and other celebrations, those who started as nonparticipants soon find themselves joining in. This is not to say that anyone and everyone can lead the proceedings—that role is usually left to the most highly skilled in each community, known as **griots**. In addition to serving in the role as a sort of professional musician and entertainer, griots are also in charge of maintaining the oral history of the community.

Because the African tradition is an oral one, music is passed on from one generation to the next by memorization rather than writing it down. We memorize songs and pass them on in our culture as well, but on a much more limited scale.

In addition to serving in the role as a sort of professional musician and entertainer, **griots** are also in charge of maintaining the oral history of the community.

Think about the last time that you saw the written music to the song "Happy Birthday"—few if any of us have, yet everybody knows it. Imagine having "Happy Birthday" and hundreds of other songs that have some sort of functional use committed to memory, without ever bothering to learn how to read music. Such is the nature of the African oral music tradition.

Music in African tradition also has a very close relationship to dancing, to the extent that the two are usually not thought of separately. One custom that has been widely observed throughout the continent that combines music and dance is the ring shout. The ring shout and variations of it were widely observed in America at church camp meetings and at Congo Square in New Orleans during the 19th century.

Characteristics of African Music

The most noticeable characteristic of African music is the heavy emphasis on rhythm. Many in our culture have mental images of the "savage drumming" from old movies shot in Africa, but in reality, the rhythmic content of the music is very sophisticated. Often contrasting, syncopated rhythms, each played by a different musician, are superimposed on each other, creating a polyrhythmic effect that is so complex that it cannot be written down using standard music notation (which, by the way, was invented by Europeans and is largely irrelevant to African tradition).

African harmony and melody are equally complex, although to European-trained ears, it often is characterized as simple and primitive. Once again, part of the problem rests with the urge to interpret one culture through the standards of another. One commonly observed quality of African melody is the strong reliance on a five-note pentatonic scale (on a piano, this can be approximated by playing the black keys only).

Another important aspect of African music is the importance of improvisation. Many instrumental performances are comprised of short melodic phrases that are repeated for long periods—sometimes hours—with slight variations that are introduced at the whim of the player. Improvisation is perhaps most notable in vocal performances, where a commonly used technique is call and response, with one lead singer issuing the call, and the rest of the participants responding. The very nature of call and response lends itself to much variation and improvisation.

African music is also characterized by the close relationship between instrumental music and speech. People in every culture talk using countless inflections and variations of pitch and tonality to enhance their delivery. Most African instruments are played in a way that imitates the human voice, using tonal inflections, slurred attacks, and bending of pitches. The talking drum, which when played by an experienced musician can produce an almost perfect copy of human speech, is found throughout Africa. Other instruments such as xylophones, flutes, and trumpets are also played in this way.

The **ring shout** was derived from the West African circle dance. Participants form a circle and shuffle in a counterclockwise direction in ever-increasing speed and intensity, eventually reaching a state of hysteria.

The most noticeable characteristic of African music is the heavy emphasis on rhythm.

The **pentatonic scale** is a five-note scale (usually 1-2-3-5-6, or do-re-mi-sol-la) commonly used in folk music from different cultures, including Africa. The pentatonic scale differs from the European major scale, which has seven notes (do-re-mi-fa-sol-la-ti).

Improvisation is perhaps most notable in vocal performances.

Call and response is a melodic phrase played or sung by one performer that is answered by the rest of the group.

Music Analysis

Track 1: "West African Drum Music"

A great example of the polyrhythmic and improvisational nature of West African traditional drum music.

Drums with vibrating membranes (or drumheads) are usually played by ensembles of two or more musicians, each playing one drum.

Percussion instruments without membranes include xylophones, log drums, gongs, gourds, and other instruments that are shaken or struck in some manner.

Stringed instruments are usually plucked with the fingers or struck with a stick.

Wind instruments are trumpets made of wood and ivory, wood flutes, bagpipes, and horns made from elephant tusks.

The **Abolitionist Movement** was the campaign to eliminate slavery in the United States that included the Underground Railroad, a secret network that smuggled slaves to freedom in the North. In 1851, Harriet Beecher Stowe published the best-selling book *Uncle Tom's Cabin*, which was a powerful factor in galvanizing antislavery sympathizers for the movement.

The Instruments of Africa

Although there are a countless number of musical instruments used in Africa, four general categorical lines can be drawn:

1. **Drums with vibrating membranes (or drumheads).** These are usually played by ensembles of two or more musicians, each playing one drum (as opposed to the modern jazz percussionist who usually plays two or more conga drums at a time). Two examples are the djembe, a bird bath-shaped drum, and the kalangu, or talking drum.
2. **Percussion instruments without membranes.** These include xylophones, log drums, gongs, gourds, and other instruments that are shaken or struck in some manner. Two examples are the shakere, a seed-filled gourd that is covered with a bead net, and the kalimba, or thumb piano.
3. **Stringed instruments.** These are usually plucked with the fingers or struck with a stick. Three examples are the korro, a large harp; the sanko, a zither-type instrument; and the banjar, the ancestor of the banjo.
4. **Wind instruments.** Trumpets made of wood and ivory, wood flutes, bagpipes, and horns made from elephant tusks.

Box 2-2 contains photos of some African instruments.

BOX 2-1	Characteristics of African Music

- Heavy emphasis on complex rhythm, syncopation, and polyrhythm
- Melody relies strongly on a five-note pentatonic scale
- Importance of improvisation
- Close relationship between instrumental music and speeches

The 19th Century African American

Slavery

The slave trade commenced in what is now the United States in 1619 when slaves were first brought to Jamestown, Virginia, and continued unabated throughout the 17th and 18th centuries. Many of the slaves came from what are now the **West African** countries of Senegal, Guinea, Sierra Leone, Liberia, Ghana, Benin, and Nigeria along the western coast of the continent. By 1807 when activists from the **Abolitionist Movement** finally persuaded Congress to outlaw the further importing of slaves, there were 400,000 native-born Africans in America living alongside hundreds of thousands of descendants of native-born Africans. By the beginning of the Civil War in 1861, it is estimated that there were approximately four million slaves in the United States. When Africans were brought to America to become slaves, they were stripped of their belongings, their family and community connections, their property, and their human dignity. The one thing that could not be taken from them, however, was their rich musical heritage.

Because of its oral nature, the songs and traditions of African culture were already firmly committed to the memory of the new African Americans, who not only retained them but continued their practice and performance. Slave owners generally did not encourage African instruments, particularly drums. After the Stono Rebellion in South Carolina in 1739, where drums were supposedly used to coordinate a slave uprising, many colonies banned their use by slaves. As a result, singing became the most important form of musical expression.

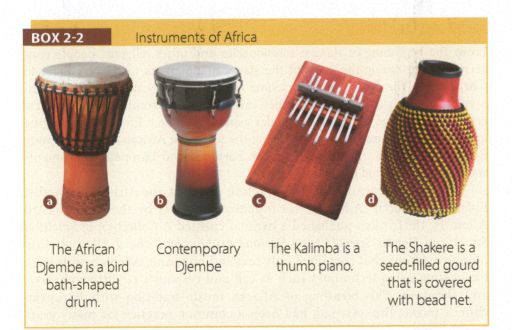

BOX 2-2 Instruments of Africa

The African Djembe is a bird bath-shaped drum.

Contemporary Djembe

The Kalimba is a thumb piano.

The Shakere is a seed-filled gourd that is covered with bead net.

Among the most important song forms that existed in slave camps during this time were the **field holler**, the **shout**, and the **work song**. These forms served essentially the same purpose—to make work easier to bear—but exhibited differences in construction and performance. The field holler is a solo song-shout without form or steady rhythm, highly spontaneous and improvisational. The shout is more defined than the field holler and contains stanzas or verses of three lines, oftentimes with the second line being a repeat of the first. The work song, as it was most commonly found in the American slave environment, was sung by a group of workers, usually incorporating call and response, with a distinct pulse. Quite often, tools that were being used in the work, such as plows, shovels, and axes accompanied the singing.

It is important to point out the fundamental difference in the way that slaves felt about working in their new surroundings. They were no longer working for themselves, nor was work improving the quality of their lives. As a result, the very nature of the field hollers, shouts, and work songs began to change to a more personal expression of one's troubles and pain, and eventually became primary sources in the creation of the blues.

> Among the most important song forms that existed in slave camps during this time were the **field holler**, the **shout**, and the **work song**.

Music Analysis

Track 2: "Holler" Charley Berry
Track 3: "Early in the Mornin'" Johnny Lee Moore

The tracks, "Holler" by Charley Berry and "Early in the Mornin'" by Johnny Lee Moore demonstrate two song forms of African origin that survived in the New World. "Holler" is a field holler, performed in the rambling and spontaneous shouting/singing fashion by a solitary worker in the field. "Early in the Mornin'" is a work song performed by a work crew, singing short, repetitive phrases in call and response fashion while accompanying themselves in a steady rhythm with their work tools. Although both songs were recorded in contemporary settings, they are believed to be accurate reproductions of the forms that were commonly sung on farms, plantations, and prisons throughout the South during the 19th century.

Slaves and Christianity

From the beginning of slavery, missionaries and other religious people concerned about saving the souls of the slaves made efforts to convert them to Christianity. The church was a welcome respite for many slaves, with its message of deliverance from their wretched existence to the Promised Land. Musical activities were one of the most popular aspects of church life, and the singing and playing of church hymns was one of the ways that African Americans were first introduced to traditional European harmony and European instruments such as the piano and organ.

The first independent Black church in America, the African Methodist Episcopal Church (A.M.E.), was organized in 1793 by the Rev. Richard Allen. In 1801, Allen published a hymnal entitled *A Collection of Spiritual Songs and Hymns Selected from Various Authors by Richard Allen, African Minister.* Although it contained only text and no music, Allen's hymns were likely sung using techniques such as call and response, repetitive phrases, and shouting. This blending of African music tradition with European church music, the **spiritual**, had been a common practice for many years by this time.

Spirituals were the first American music genre to combine elements of African and European musical traditions; many more, including jazz, would follow during the next 200 years. In the early years, it is widely believed that the performance of spirituals contained more African influences such as improvisation, shouting, and rhythmic variety than today's pre-arranged and notated variety. The popularity of spirituals grew quickly, especially during a particularly strong religious movement from 1800 to 1830 known as the **Second Awakening**. During this period, large camp meetings were held throughout the South with active participation by both Blacks and poor whites, and new songs were introduced. The ring shout was also commonly performed at these camp meetings.

Minstrelsy

Minstrelsy was the most popular form of entertainment in America in the 19th century. Through these traveling shows, people in different regions throughout the country were able to share for the first time the same songs, skits, and jokes (the "Why did the chicken cross the road?" joke has minstrel show origins). Emerging around 1820 and reaching its greatest popularity between 1850 and 1870, **minstrel shows** consisted of a series of short comedy skits, song-and-dance routines, and juggling acts. The primary feature of the minstrel show was a comical and derogatory depiction of slaves and their lives. The entertainers, all of them white men, blackened their faces with burnt cork and impersonated slaves in ways that were funny to their white audiences. The two most common characterizations were the slick, hustling ladies man, Zip Coon, and the lazy, no-good Jim Crow.

Minstrel shows included a small band that usually included:

- Banjo
- Tambourine
- Fiddle
- Bone castanets

Spiritual—music coming from the early Black Christian church that generally consisted of European hymns sung using African performance techniques.

The **Second Awakening** was the second wave of a religious revival in the United States during the years 1800–1830 that was characterized by camp meetings attended by thousands that lasted for days at a time.

Minstrel shows consisted of a series of short comedy skits, song-and-dance routines, and juggling acts.

Music Analysis

Track 4: "I'll Meet You On That Other Shore" St. James Primitive Baptist Church

A great example of what an early spiritual may have sounded like.

One of the feature presentations in each show was a dance contest called the cakewalk, patterned after the syncopated songs played by slave string bands on fiddles and banjos and accompanied by foot stomping. The cakewalk (so named because the best dance team won a cake) became extremely popular, and the music that accompanied it was influential in creating ragtime.

Minstrel shows spawned a whole genre of songs called Ethiopian songs (or sometimes called Plantation songs) that stereotyped Southern folklife and often contained references to the negative stereotypes depicted in the shows. The most prolific and famous composer of such songs was Stephen Foster, whose songs include many that are still sung today, such as "Hard Times Come Again No More," "Oh! Susanna," "Old Folks at Home," and "Beautiful Dreamer." Foster was a product of his time, and some of his song lyrics are overtly racist in tone. In others, the racial overtones were less pronounced but included lyrics in Black dialect. For instance, "Camptown Races" includes the line "De long tail filly and de big black hoss Doo-dah! Doo-dah!" in the second stanza. Other famous examples of minstrel songs include Dan Emmett's "Dixie," which to this day has racist overtones associated with it for many people.

After the war and Emancipation, Black minstrel companies began to organize and put on shows of their own. In an interesting twist of irony, Black minstrel shows, playing for Black audiences, caricaturized the white minstrel shows, which were of course caricatures of slave life. Some Black minstrels even went as far as to put on blackface. The most famous writer in the Black minstrel tradition was James Bland, who wrote approximately 700 songs, including "Oh, Dem Golden Slippers" and "Carry Me Back to Old Virginny."

As the 19th century came to an end, the popularity of minstrel shows waned as vaudeville emerged. Like minstrel shows, vaudeville shows were touring shows of short comedy skits and musical acts, but without the humor associated with slave life (although racial stereotypes persisted for many years). Although minstrel shows created and perpetuated many negative racial stereotypes, they provided one of the first avenues for Blacks to gain experience as professional musicians and entertainers. Many of the first generation jazz musicians and blues singers in the early 20th century got their start in minstrel and vaudeville shows. The popularity of minstrel shows also suggests that even in a time when racism was overt and common, white America was fascinated with African American culture.

The **cakewalk** was originally performed by slave couples who pranced proudly with high-kicking steps that imitated the pretentious behavior of white folk.

Like minstrelsy, **vaudeville** was a touring show of short comedy skits and musical acts, but without most of the humor associated with slave life.

The Blues

Like jazz and spirituals, the blues is a uniquely American phenomenon. It originated from the field hollers, shouts, and work songs sung in the fields and the prison work camps of the South in the 19th century. Over time, these song forms began to take a mournful tone as singers increasingly used them as a means

Although they share some fundamental musical elements, **the blues** and jazz developed into two very different but parallel musical universes.

12-bar form—The standard blues form, which uses 12 bars or measures for each verse.

Diatonic scale—the notes from a specific key or scale and the harmony that is derived from those notes.

of personal expressions of pain and oppression. Instead of celebrating prosperity through work, the singing of these songs became a catharsis. Eventually, the blues became an emotional release for feelings of lost love, sexual frustration, poverty, jealousy, and a whole list of other things.

The blues played a vital role in the birth of jazz, and by all accounts was born just a few years earlier than jazz and in very nearly the same place. But as these two forms evolved during the 20th century, the blues and jazz developed into two very different but parallel musical universes, although they share some fundamental musical elements. Even though most people think of the blues as an expression describing a depressed mood, musicians know the blues as a specific format of musical and lyrical rules that can be conveniently molded into an infinite variety of tempos, styles, and interpretations. The different settings in which these blues formulas have been used throughout the years is seemingly unlimited. Consider this: Glenn Miller's "In the Mood" from the 1940s, Little Richard's "Tutti Frutti" from the 1950s, and the Beatles' "Can't Buy Me Love" from the 1960s were all popular tunes of their day that utilized blues elements. Recordings by jazz musicians of songs using blues formulas are even more common, undoubtedly numbering in the thousands, and can be found among every evolutionary style of jazz from the earliest to the most contemporary. These elements of the blues certainly are, always have been, and always will be embedded into the very fabric of jazz.

There are three essential musical elements that usually determine whether a song is in fact a blues song. They are the 12-bar form, the blues scale, and the blues poetic formula. Although it is possible to have a 16-bar blues song or a blues song that does not use the standard poetic formula, these are exceptions. Each of these elements are described below.

The 12-Bar Blues Form

The blues as it is performed today is usually in a **12-bar form** with a standardized chord progression. In its simplest form, only three chords are used: the I, IV, and V chords of the **diatonic scale**. In the key of C, those chords are C (built on the first note of the C scale), F (the fourth note), and G (the fifth note). Over the course of 12 bars, the chord progression unfolds in this manner:

Bar:	1	2	3	4	5	6	7	8	9	10	11	12
Chord:	C	C	C	C	F	F	C	C	G	F	C	C
	I				IV		I		V	IV	I	

This harmonic structure found in contemporary blues comes directly from European harmonic principles commonly found in European religious music. Although hymns of this nature sometimes have complicated harmonic schemes that include reharmonizations, deceptive cadences, and passing chords, most can be distilled down to only three chords, the same three chords found in the blues: the I, IV, and V.

When you hear a jazz musician play the blues, it will probably sound different than the way a blues musician plays the blues. Jazz musicians add their own interpretations, rhythms, and dissonances that give the blues a uniquely jazz flavor. Contemporary urban blues musicians such as B. B. King and Buddy Guy tend to play the blues in a way that is closer to its original form.

Blues Notes and the Blues Scale

One prominent feature of the blues is the **blues scale**. The blues scale is a six-note scale (as opposed to the seven-note major scale) that eliminates the second and sixth scale notes and lowers, or flats, the third and seventh scale notes. In addition, a flatted fifth scale note is added beside the existing fifth note. For example, a C major scale looks like this:

1	2	3	4	5	6	7
C	D	E	F	G	A	B
(do	re	mi	fa	sol	la	ti)

The blues scale looks like this:

1	2	3	4	5	6	7
C		E♭	F	G♭ G		B♭

The lowered or flatted notes E♭, G♭, and B♭ are known as **blue notes**, and when used in blues melodies or improvised solos, they produce the dissonance that gives the blues its unique, mournful quality. Blue notes, or notes that closely resemble them, appeared in work songs, shouts, field hollers, and spirituals well before the existence of the blues, so their origins seem clearly to be African. Some scholars have speculated that the blue note came into being as slaves attempted to superimpose the five-note pentatonic scale that was common in Africa onto traditional European harmony. In the preceding example, this would be the E♭ pentatonic scale (E♭, F, G, B♭, C) superimposed onto the C major scale. In any event, the blues scale has become a ubiquitous presence in contemporary music, as it is commonly heard in the performance of the blues and jazz as well as pop music, gospel, rock, rap, hip-hop, and contemporary 20th century classical music.

Blues Poetry

Blues poetry or **lyrics** also generally follow an established guideline. Over the 12-bar form, three phrases are sung, the first two being identical, the last phrase generally responding in some way to the first two. This formula is known as the **AAB lyric form**. A similar three-line form was commonly heard in the performance of the African shout as well as sorrowful songs sung by slaves first noticed around the mid-19th century. Here is an example:

A: Since I lost my baby, my whole world has turned blue,
A: Since I lost my baby, my whole world has turned blue,
B: Since I lost that woman, don't know what I'm gonna do.

Another example:

A: My man, he don't love me, he don't treat me right,
A: My man, he don't love me, he don't treat me right,
B: Now I'm so tired and lonely, I just sit and cry all night.

These two examples also illustrate the visceral and emotional nature of most blues poetry.

The **blues scale** is a six-note scale that eliminates the second and sixth scale notes and lowers, or flats, the third and seventh scale notes.

The lowered or flatted notes E♭, G♭, and B♭ are known as **blue notes**, and when used in blues melodies or improvised solos, they produce the dissonance that gives the blues its unique, mournful quality.

Blues poetry or **lyrics** also generally follow an established guideline. Over the 12-bar form, three phrases are sung, the first two being identical, the last phrase generally responding in some way to the first two. This formula is known as the **AAB lyric form**.

The AAB form fits over the 12–bar blues progression with each of the three phrases using four bars, like this:

Bar:	1	2	3	4	5	6	7	8	9	10	11	12	
Chord:	C	C	C	C	F	F	C	C	G	F	C	C	
Phrase:	A ————————						A ————————				B ————————		

Most often, each phrase does not fill up the entire four bars allotted to it, so jazz and blues musicians have widely taken up the practice of inserting an instrumental riff at the end of each phrase, creating a call-and-response pattern something like this:

Bar:	1	2	3	4	5	6	7	8	9	10	11	12
Chord:	C	C	C	C	F	F	C	C	G	F	C	C
Phrase:	A ———				A ———			B ———				
Riff:			———				———				——	

Although some blues tunes do not use the standard AAB poetry format, generally speaking, most do. Jazz composers have also used this phrasing formula when writing instrumental jazz tunes based on the 12-bar blues. Many tunes from the swing era, such as "One O'clock Jump" and "C Jam Blues," as well as more contemporary tunes, such as Sonny Rollins' "Tenor Madness," have used riffs to substitute for the vocal lines, while still patterned on the AAB lyric form.

Country Blues

Although it took the blues several years to evolve into the form that we know today, no musicologists or recording engineers were present to witness its birth. As a result, we can only make educated guesses as to the how, why, and where. Historical evidence suggests that it happened between 1880 and 1900; these were the years immediately following Reconstruction (which ended in 1877), when the climate of racial oppression, hatred, and violence toward Southern Blacks was at its worst. The number of lynchings peaked in the 1880s and 1890s. During this time period, the free Southern Black man was faced with perhaps an even more depressing dilemma than slavery—trying to make a living with little or no job skills in this hostile environment. For many, continual moving around became the norm, not only in the constant pursuit of a job but often just to stay alive. Evidence also suggests that the blues evolved out of the field hollers, shouts, and work songs that were still being sung by sharecroppers as well as longshoremen and other laborers.

Some of these laborers chose to try to earn a living, or supplement their living by singing and playing music. Soon itinerant male singers were traveling from place to place, playing on street corners and in small, dilapidated rural restaurants and nightclubs called honky tonks or juke joints for tips and loose change. They accompanied themselves on the guitar, an instrument that was cheap, readily available, and easy to carry around. At first, they sang popular and traditional songs, but eventually new songs about bad luck and trouble that rambled on spontaneously began to emerge.

In time, as they exchanged musical ideas with others they met through their travels, certain tendencies and standardizations began to emerge. These standardizations included the above-mentioned use of the blues scale, the AAB lyric

BOX 2-3	Characteristics of Country Blues

- Solo male vocalist
- Guitar self-accompaniment
- Earliest versions loosely, but not strictly, adhere to 12-bar form

form, and the 12-bar form, as well as interpretive playing and singing styles. These men were the first blues singers, and they played what today is called country blues, the first blues style. W. C. Handy wrote of hearing one of these men play the blues for the first time in 1903, an account that provides us with a convenient mark in time as to knowing when this process was nearly complete. Handy, who today is known as the Father of the Blues, helped standardize things even further with his 1912 hit "Memphis Blues," which was notated and sold in sheet music form. It and his blockbuster 1914 hit "St. Louis Blues" provided many Americans with their first experience hearing the blues.

The Mississippi Delta

The most fertile area for the development of the country blues was the Mississippi Delta region, a 250-mile stretch of land stretching north to south from Memphis, Tennessee, down to Vicksburg, Mississippi. This region had some of the best farmland in the world, with topsoil as deep as 30 feet that had washed down from Mississippi River erosion over hundreds of years. Hard work, oppressive heat, poverty, and racial terror characterized life in the Delta in the late 19th century. It is in the Mississippi Delta that some of the most legendary figures of the blues were born or played, including Robert Johnson, Muddy Waters, and B. B. King. The Delta Blues style often features slide guitar playing with haunting vocals, often speaking of superstition, jealousy, and trouble. Today Highway 61, the legendary "Blues Highway," runs through the middle of this historic area, the holy land of the blues.

Early Delta Blues Musicians

The first Delta bluesman to achieve fame was Charley Patton (1891–1934), a regional celebrity who began recording in Chicago for Paramount Records in 1929 and soon became their biggest-selling artist. Patton was the consummate entertainer and a strong, rhythmic guitarist who employed tricks such as popping strings and beating his guitar like a drum. Patton's recordings give an insight into the early years of country blues before the 12-bar form was standardized. His recording success paved the way for two other Delta bluesmen, Willie Brown and Son House, to record.

Born in the heart of the Delta in Riverton, Mississippi, Son House (1902–1988) was one of the main influences on both Muddy Waters and Robert Johnson. A preacher by the age of 15, House picked up the guitar at age 25 and started recording sometime around 1930. After his playing partner and friend, Charley Patton, died in 1934, House went largely into retirement until 1964, when researchers found him in Rochester, New York. House became a celebrity as one of the few remaining bluesmen from the early years of the Delta until he was forced to retire in 1976 for health reasons.

Undoubtedly the most famous and legendary Delta blues musician was Robert Johnson (1911–1938). Although he only recorded 29 sides at two

Country blues is the first blues style, characterized by male singers who accompanied themselves on the guitar.

Sheet music is the music that is notated and sold in a loose, unbound sheet format. From the late 19th century on to the present, popular music has been sold in this fashion, with lyrics, melody, and piano accompaniment.

The most fertile area for the development of the country blues was the **Mississippi Delta** region, 250 miles of land stretching north to south from Memphis, Tennessee, down to Vicksburg, Mississippi.

Early Delta Blues Musicians
- Charley Patton
- Son House
- Robert Johnson

Undoubtedly the most famous and legendary Delta blues musician was Robert Johnson (1911–1938).

recording sessions in 1936 and 1937, many of his compositions have been recorded not only by other blues artists but also by rock performers such as The Rolling Stones, Led Zeppelin, and Eric Clapton. Some of Johnson's most famous songs include "Love in Vain," "Cross Road Blues," "Sweet Home Chicago," and "I Believe I'll Dust My Broom."

Johnson was born south of the Delta in Hazelhurst but by 1918 or 1920 had moved to Robinsonville, just south of Memphis with his mother and stepfather. By the late 1920s, he had taken up the guitar and was learning to play from Robinsonville-resident Willie Brown, as well as Charley Patton, a frequent visitor. Sometime around 1930, Son House arrived in town, and Johnson fell in love with House's clean yet intense slide guitar playing. Robert Johnson was still a novice at this point and was often ridiculed by Brown, Patton, and House, which may have been a factor in his decision to abruptly leave town. When he returned to the area sometime around a year later, he found House and Brown playing at a little joint in Banks, a few miles east of Robinsonville, and amazed them with a newfound technique that was brilliant, dazzling, and electrifying.

Music Analysis

Track 5: "Cross Road Blues"

(Johnson) Robert Johnson recorded at the Gunther Hotel in San Antonio, Texas, on November 27, 1936

Robert Johnson was one of the most influential of the Delta blues musicians, and his song "Cross Road Blues" is a blues classic. As was the case with many of the early country blues singers, Johnson does not strictly adhere to the 12-bar form: after each phrase, he noodles around on the guitar before singing the next phrase. However, the AAB form is intact on each of the verses. This song achieved fame among rock musicians when it was covered by Eric Clapton's band Cream in 1968. Cream renamed the song "Crossroads."

0:00	Introduction
0:07	First verse
0:42	Second verse
1:14	Third verse
1:42	Fourth verse
2:12	Fifth verse

What had happened to turn the novice into the virtuoso? Some believe the myth that Johnson sold his soul to the devil to become great. There is indeed a legend with African voodoo roots that instructs a guitarist to go to a crossroads at midnight and wait until a large man approaches. The man (supposedly the devil himself) will tune your guitar, play a song, hand it back to you, and disappear into the darkness without saying a word. The guitarist from then on could play whatever he wanted to, but the price was a life of torment and haunting nightmares.

In reality, Johnson had returned to the Hazelhurst area and began absorbing influences from phonograph records made by other blues guitarists. He also came under the tutelage of the unrecorded local guitarist Ike Zinermon, who scholars believe was the most important influence on Johnson's revolutionary modern style that stunned his contemporaries. His last years were spent traveling around the Delta from one juke joint to another, moving from woman to woman, and not setting down roots. Sometime in 1938, word of him spread to impresario John Hammond, who planned on bringing him to New York to take part in his "From Spirituals to Swing" concert at Carnegie Hall in December that would have undoubtedly made Johnson a star. Unfortunately, Robert Johnson did not live that long, poisoned at a juke joint outside of Greenwood by the jealous husband of a woman he had reportedly been having an affair with. He died on August 16.

Texas Blues

Texas was also the home to a wellspring of blues artists that emerged in the early years of the 20th century. The bluesmen of this region were known for their strong guitar playing in a more relaxed, folk-like manner than the Delta style. Two of the greatest early Texas bluesmen were **Leadbelly (Huddie Ledbetter)** (1888–1949) and **Blind Lemon Jefferson** (1893–1929). From common roots in rural Texas, the two met and performed together in Dallas around 1915 before each parting to go their separate ways. Jefferson headed off to the Delta, where a talent scout discovered him and brought him to Chicago where in 1925 he made one of the first country blues recordings. It was in Chicago that he died mysteriously in a snowstorm in December 1929.

Leadbelly's early life was considerably more troublesome. In 1917, he was arrested for shooting a man and sent to the Shaw State Prison Farm in Texas. He was pardoned in 1925 after performing one of his original songs for Governor Pat Neff. In 1930, he was arrested again in Louisiana on charges of assault to commit murder and sentenced to the Louisiana State Penitentiary at Angola. With the help of researcher John Lomax, Leadbelly was released again in 1934 and eventually moved to New York, where he became a part of the burgeoning Greenwich Village folk scene in the 1940s. In 1951, two years after his death from Lou Gehrig's disease, the folk group The Weavers had a million-selling hit with Leadbelly's tune "Goodnight Irene."

Ragtime

During the antebellum years, slaves often played syncopated music in string ensembles called **jug bands** (also called juke bands or washboard bands) consisting of fiddles and banjos, washboards, and foot stomping. Prominent in the sound of the jug band was the banjo, descendent of the African banjar that is

Texas Blues Musicians

- Blind Lemon Jefferson
- Leadbelly (Huddie Ledbetter)

John Lomax (1867–1948) and his son **Alan Lomax** (1915–2002) were important musicologists who archived American blues and folk music both by recordings and by publishing books such as *Negro Folk Songs as Sung by Leadbelly* in 1936.

Jug bands consisted of fiddles and banjos, washboards, and foot stomping.

basically a drum with strings stretched across the head. The very nature of its drum-like construction led the banjo to be played in a syncopated fashion with short, percussive melodies. When minstrel shows copied these jug bands for inclusion in their own shows, their syncopated rhythms immediately became a popular feature.

After the Civil War, more Black musicians began playing the piano, and the instrument began popping up in social halls and juke joints all across the South. As rural itinerant pianists began to get jobs playing for dancers at these places, a new style began to emerge by the 1890s that copied the syncopation of the jug bands. In **ragtime**, as it eventually became known, pianists used the left hand to substitute for the foot-stomping beat and the right hand to simulate the short, syncopated banjo melodies. The early ragtime pianists came about developing the style by traveling around and exchanging ideas in much the same way that country blues developed. As all this was happening, the piano was becoming one of the most popular instruments in America. Between 1890 and 1909, sales of pianos increased from 100,000 a year to 350,000 a year. Helping to fuel this popularity was the introduction of the **pianola**, or player piano, in 1897, which allowed the consumer to buy pre-recorded piano rolls that played when one pushed on the pianola foot pedals. It was also in 1897 that the first instrumental ragtime piece, William Krell's "Mississippi Rag," was published.

Like country blues, ragtime had its own center of development. In the Missouri cities of St. Louis, Sedalia, and Carthage, a number of talented young performers and composers gathered and began exchanging ideas in the 1890s. **The Missouri School**, as they became known, included Scott Joplin, Tom Turpin, James Scott, Scott Hayden, and Louis Chavin. Some of these men reportedly put on exhibitions of their work at the 1893 World's Columbian Exposition in Chicago and caused a sensation. By the late 1890s, rag pieces were published with increasing frequency and with so much commercial success that on January 23, 1900, the Ragtime Championship of the World Competition was held at Tammany Hall in New York to much acclaim. For the next 10 years, the ragtime craze took America by storm. The characteristics of ragtime are outlined in **Box 2-4**.

> **Ragtime** is a notated and fully composed piano style that was popular in the 1890s and early 20th century.

> **The Missouri School**
> - Scott Joplin
> - Tom Turpin
> - James Scott
> - Scott Hayden
> - Louis Chavin

© Getty Images

The introduction of the **pianola**, or player piano, helped increase the popularity of pianos.

BOX 2-4	Characteristics of Ragtime

- Fully composed instrumental (piano) music
- Notated and sold as sheet music and piano rolls for player pianos
- Short, syncopated melodies in the right hand imitating banjos
- Heavy beat in left hand imitating foot stomping
- Stiff, marchlike rhythm
- Complex form: AABBACCDD (each letter represents the statement of a theme)

Ragtime took a different course of development than the blues and jazz when its early players and composers made the conscious decision to Europeanize it. This meant, first and foremost, that ragtime would be written down, like piano music from the European classical music tradition. This left no room for improvisation or flexibility in the performance of a ragtime piece. They also began to use sophisticated forms that resembled those from classical music. One common ragtime formal structure was the AABBACCDD form, in which four distinct themes are used. Ragtime has also always been an instrumental music, which further separates it from the blues and some jazz. These rules ultimately became restrictive on ragtime's development, and it was not able to evolve past its origins like the blues and jazz eventually would.

Scott Joplin (1868–1917) Piano/Composer

The man who did more to bring ragtime to America than anyone else was **Scott Joplin**. Joplin was born in Texarkana, Texas, to a poor railroad family; interestingly, his mother played the banjo. Showing great skill at his piano studies of European classical music, Joplin was good enough to leave home while still in his teens to try to make his living traveling the juke joint circuits. In 1885, he settled in St. Louis and started to publish sentimental songs. In 1896, he moved across the state to **Sedalia, Missouri**, and got a job playing piano at the Maple Leaf Club where in 1899, publisher John Stark heard Joplin play his composition "Maple Leaf Rag." Stark published the piece; within 10 years, it had sold approximately one million copies, the first piece of sheet music in history to do so.

Joplin clearly had higher aspirations than writing rags. In 1903, he wrote a ballet, *The Rag-Time Dance,* and an opera, *A Guest of Honor, a Ragtime Opera.* Although he continued to write piano rags, a lucrative venture for him, he chafed at the way many ragtime pianists were speeding them up and adding showy embellishments. Many of his publications carry a warning at the top: "Note: Do not play this piece fast. It is never right to play ragtime fast." In 1907, he began work on his ultimate ambition, *Treemonisha*.

Treemonisha, an opera of early Black folklife in America with very little ragtime content, engulfed most of Joplin's energy for the next eight years. Unable to find a publisher for the 230-page score, he did so at his own expense in 1911. Joplin then went about the monumental task of producing the work for the orchestra and 11 voices with staging, costumes, scenery,

© MPI/Hulton Archive/Getty Images

An undated formal portrait of **Scott Joplin**, composer of "Maple Leaf Rag."

and lighting. Although *Treemonisha* did eventually premiere in Harlem in 1915, it was with only Joplin at the piano, no staging, and an under-rehearsed cast. Music critics panned it, and it closed after one performance. Crushed, Joplin went into mental and financial decline. In 1916, he was committed to Manhattan State Hospital, where he died from dementia the next year.

Scott Joplin was one of the first of many musicians who during the course of the 20th century would try to reconcile the differences between Western European music and African American music and create a new idiom. Ultimately, his efforts did not go to waste, however; in 1976, he was posthumously awarded a Pulitzer Prize for *Treemonisha* after it was resurrected and staged as he had originally intended for the first time.

Music Analysis

Track 6: "Maple Leaf Rag"

(Joplin) Scott Joplin from a Scott Joplin made Cannonized piano roll cut in 1916, recorded in stereo in 1986

This is a recording of a piano roll made by Scott Joplin himself, the composer of "Maple Leaf Rag." Joplin published the tune soon after moving to Sedalia, Missouri, a railroad town in the middle of the state, and it became a smash hit. "Maple Leaf Rag" fueled the popularity of ragtime, which in turn helped develop America's taste for the syncopated or "ragged" rhythms that would soon infuse jazz. Although "Maple Leaf Rag" employs a commonly used ragtime form with four themes (AABBACCDD), it was also innovative in its much bolder use of syncopation than earlier rags of the late 1890s. When musicians began adding syncopated rhythms similar to the ones found in "Maple Leaf Rag" to popular songs and blues tunes, they called it ragging, and it became one of the essential elements of early jazz.

0:00	First theme (A) played twice
0:44	Second theme (B) played twice
1:26	Recapitulation (repeat) of A theme
1:47	Third theme (C) played twice
2:28	Fourth theme (D) played twice, song ends

Name _____ Date _____

African Music and the Pre-Jazz Era

1. What are some important ways that the musical traditions of Africa and Europe are different?

2. In what ways was the performance of traditional African music changed when Africans were brought to the New World as slaves?

3. Describe the musical and poetic formulas of the blues.

4. Describe how ragtime evolved and some reasons why it became so popular.

5. What are the positive and negative legacies of the minstrel show?

6. Explain the differences between spirituals, the blues, and ragtime.

7. How are the blues and ragtime different in terms of their African and European influences?

8. Name and describe three common characteristics of African music.

9. What impact did the Christian church have on the music of the slaves?

10. Why did the field holler, ring shout, and the work song survive in the New World?

JAZZ TAKES ROOT

Introduction

At the turn of the 20th century, the first stirrings of the music that was eventually called jazz were coming out of the Southern and middle states. New Orleans, with its exotic mix of culture and ethnicity, was an important breeding ground where many different musical styles could be heard. Spirituals, ragtime, and the blues were especially influential to the first jazz musicians. Also influential to the creation of jazz was the climate of racial discrimination that was pervasive in the Deep South, and the enactment of so-called 'Jim Crow' laws in the years following Reconstruction that were enacted to legally enforce segregation and discrimination. During the first twenty years of the history of jazz, techniques were standardized, the first recordings were made, and the first generation of jazz musicians emerged. Other cities, particularly Harlem and Chicago, were beginning to evolve as important centers of development. By 1920, jazz was no longer confined to the South—it had spread across the country and was beginning to exert a powerful influence on American culture.

History of New Orleans

The Crescent City

New Orleans has always been an unusual city. In its heydays in the late 19th century, New Orleans was not only an important seaport but also perhaps the most unique city in America, if not the entire world. The city was founded in 1718 by a Scottish businessman who received permission to sell land to settlers in the French-owned Louisiana swamps. Despite promises of gold and riches, no one wanted to settle in *Nouvelle-Orleans*. As a result, the French government started loading up and sending prisoners and other undesirables, including a shipment of prostitutes in 1721. With these as its first residents, it is no wonder that the Crescent City has such a rich tradition of permissiveness, wildness, and corruption.

By 1800, the city had been settled by not only the French but also by German, Italian, Irish, and Spanish immigrants (Spain owned the city from 1764–1800). As New Orleans became an important port of entry into North America, it also developed a large population of slaves; some imported directly from Africa, some through the West Indies and the Caribbean. On April 30, 1803, France sold the entire Louisiana Territory to the United States as part of the agreement made between Napoleon Bonaparte and President Thomas Jefferson known as the Louisiana Purchase. During the 19th century, the US Navy established a naval base, and there was a tidal wave of American adventurers and businessmen into the city. By the late 1800s, New Orleans had become an interesting mix of culture and race, excitement and danger, food

Pete Johnson
Red Hot Peppers
Sidney Bechet

Thomas "Fats" Waller
Warren "Baby" Dodds
Willie "The Lion" Smith

MUSIC STYLES
Boogie-Woogie
New Orleans Style
Stride Piano

and music. Even though the city was becoming Americanized, it retained a distinctly European and Caribbean flavor.

By this time, however, the city was also a mess. Most streets were dirt, meaning they were muddy most of the time. There was also not much in the way of a sewage system, garbage removal, or running water. Or, city government: the police force was understaffed and corrupt, crime was out of control, as was prostitution, drug abuse, disease, and general lawlessness. It was filthy and dangerous. But despite all the city's problems, its people were intent on having a good time, and this New Orleans allowed them to do in ways unimaginable most anywhere else.

Musical Tradition in New Orleans

Music has always played a vital role in New Orleans. Each group of immigrants brought their own musical traditions with them and kept them alive, creating a rich musical gumbo that played an important role in the creation of jazz. Holidays and public events were always a cause for celebration, and quite often parades with marching bands added to the festivities. There were also many fraternal halls and dance halls that were available for parties and dances. There were all kinds of hotels, cafes, and restaurants that had music, as well as the resort areas like Milneburg along the shores of Lake Pontchartrain. The French Opera House was built in 1813 and became world-renowned for its quality. Mardi Gras was established in 1857. Starting around 1817, slaves were permitted to sing, dance, and celebrate in **Congo Square** on Sunday afternoons. This became a tourist attraction that enabled whites to get a glimpse of African American musical tradition. After the Emancipation in 1863, rural freed slaves arrived, bringing with them the sounds of work songs, field hollers, and eventually the blues. And by the 1890s, ragtime was filtering down from Missouri.

Two of the more interesting musical traditions in New Orleans were those of the brass bands and the funeral procession.

Brass Bands

After the Civil War, as brass instruments used by Confederate military bands filled pawnshops throughout the city, locals began purchasing and learning how to play them and starting their own bands. Brass bands were becoming popular all across America in the late 19th century, but the trend was especially pronounced in New Orleans. The city boasted dozens of bands that marched in parades, played at baseball games and in parks, dancehalls, and funerals, dressed smartly in matching uniforms carrying banners and flags. The musical standards of the brass bands were very high—musicians took great pride in their skills and worked hard at constantly improving them. There was a lot of competition between bands as well, and **cutting contests** were common. Among the most prominent in the city in the late 1890s were the Excelsior Brass Band, the Onward Brass Band, and the Columbia Brass Band. Typically containing around a dozen members, the standard instrumentation was three cornets, two trombones, baritone and alto horns, tuba, one or two clarinets, snare drum, and bass drum. Many of the brass bands were proudly sponsored by the numerous Black and Creole fraternal and social

Two of the most interesting musical traditions in New Orleans were those of the brass bands and funeral processions.

A **cutting contest** was an informal competitive duel (usually between two individuals) where musicians try to outplay each other by showing more creativity and originality. In New Orleans, the cutting contest was often between two bands, a practice that in later years was formally staged as a battle of the bands.

Courtesy Tom Larson

Congo Square is located just north of the French Quarter in what is now Louis Armstrong Park. It was an empty lot in 1817 when city officials allowed public performances there by slaves on Sundays as a sort of safety valve to prevent uprisings.

clubs that had proliferated throughout the city. These clubs, which have a tradition going back to the secret societies of Africa, had their own meeting halls (which are still scattered around the city's neighborhoods), collected dues that paid for funerals, sponsored dances, and gave members a sense of belonging.

Funerals

Nowhere was the African musical tradition more apparent in New Orleans than in the funeral ceremony. On the way to the cemetery, the procession is led by a brass band playing a slow **dirge**, usually a solemn hymn such as "Nearer My God to Thee" or "Just a Closer Walk with Thee." Once the body was interred, the band leads the way back to the social hall with an up-tempo song such as "Didn't He Ramble" or "When the Saints Go Marching In." This song always starts off with a drum cadence

On the way to the cemetery, the procession is led by a brass band playing a slow **dirge**, usually a solemn hymn such as "Nearer My God to Thee" or "Just a Closer Walk with Thee."

Music Analysis

Track 7: "Just a Closer Walk with Thee (Part I)"
Track 8: "Just a Closer Walk with Thee (Part II)"

(Traditional) Preservation Hall Jazz Band. Personnel: Percy Humphrey: trumpet; Frank Demond: trombone; Josiah Cie Frazier: drums; Willie Humphrey: clarinet; Allan Jaffee: tuba; Narvin Kimball: banjo; James "Sing" Miller: piano; arranged by Preservation Hall Jazz Band

Tracks 7 and 8 illustrate the music of the funeral procession in New Orleans in the two ways that the traditional hymn "Just a Closer Walk with Thee" is performed. On track 7, it is played as a slow dirge as it would be by a band leading the procession to the cemetery. In this style, the trumpet very clearly takes the lead, with the trombone and clarinet taking secondary supportive roles. The second recording starts with a drum cadence that announces the change to the second line, and the roles of the three front line instruments change dramatically. Although the trumpet is still playing the melody, it is now doing so with heavy embellishment and added syncopation, commonly known as "ragging." The clarinet is now freely improvising in the upper register while the trombone is playing the accompanying parts in the lower register in the style known as **tailgating**.

that sets the mood and tempo. As the band winds its way through the streets of New Orleans, the funeral-goers form a **second line** behind them, dancing, drinking, and partying to celebrate the life of the deceased. Throughout the years, the march-like rhythm of the New Orleans funeral procession has itself become known as a second line rhythm, and is used by jazz musicians occasionally in performance. The traditional funeral procession is still widely practiced today in the city.

New Orleans Ethnic Mix

By the 1890s, the ethnic mix in New Orleans was extremely diverse. Generally speaking, however, the city's primary racial makeup consisted of three groups:

- Whites of European descent
- Creoles of Color (those with a mixed ethnicity)
- African Americans

We will focus our attention on the Creoles of Color and African Americans.

Creoles of Color

The **Creoles of Color** occupied a unique position in New Orleans society, and their historical background is one that could only happen in New Orleans. Because of an increasing number of liaisons between French and Spanish slave owners and their female slaves, the Black Code of 1724 was passed in Louisiana, providing for the freeing of slaves (particularly wives, mistresses, and children) with the consent of their owners. By the Emancipation in 1863, there was already a large population of people in the city with varying degrees of African and European ancestry, including quadroons and octoroons (those with one-fourth and one-eighth African heritage, respectively), and those with darker skin. These Creoles of Color (sometimes called Black Creoles) had over the years achieved a social status that was nearly on par with whites. Many became artists, architects, doctors, and wealthy businessmen. To protect their social standing, Creoles of Color tended to dismiss their African heritage and discriminate against and oppress Blacks in much the same way as whites; in fact, some even owned slaves. Lighter-skinned Creoles could sometimes 'pass'—go undetected among whites as someone with colored skin. Creoles of Color celebrated their European heritage by speaking French or a French/English patois, building exquisite homes with cast-iron lace railing, and enjoying and playing European classical music. They settled in the 'downtown' or 'French city', east of Canal Street, in the *Vieux Carre* ('Old Square', now commonly known as the French Quarter), the Treme neighborhood, and Sixth and Seventh Wards.

Creole musicians typically were trained in the methods of classical music: learning scales and arpeggios to increase their technical proficiency, and reading music in order to learn the standard repertoire of European composers such as Mozart and Beethoven. As a result, their music had the soft, pure tonal refinement of the concert hall, and they were able to play at the social events of upper-crust society. Creole musicians played most often in dance orchestras, string trios, and brass bands. The most prominent Creole dance orchestra in the late 1890s was led by John Robichaux, whose members prided themselves in the ability to sight read on the job and to play any song that was requested of them.

African Americans

Being discriminated against and oppressed by both whites and Creoles of Color, Blacks in New Orleans found themselves generally segregated in the rough uptown section of town, the 'American city' west of Canal Street. They lived lives of desperation with little or no chance at a decent education or anything more than a menial

Tailgating is a style of trombone playing that makes use of dramatic slides from one note to another (known as glissandos). The term first came into use as trombonists sat on the back or tailgate when bands would perform on wagons that traveled through New Orleans.

The **second line** was a march performed during funerals. It was named after the party-goers that followed behind the bands.

The **Creoles of Color** occupied a unique position in New Orleans society, and their historical background was uniquely interesting.

Creole musicians played most often in dance orchestras, string trios, and brass bands.

low-paying job. There was also a constant fear of violence at the hands of whites. As author James Lincoln Collier states, the life of a Southern Black at the end of the 19th century, with the constant "constraints, limits, rules, authorities who at whim could hand down difficulties, suffering, death" was similar to being a private in the army. "The only difference was that the enlistment was for life."

Although they sometimes played in parks and at dances for white audiences, Black musicians for the most part played in the run-down gambling houses, cribs, and juke joints of the uptown neighborhoods. They were generally self-taught, learning to play by ear, sometimes copying an elder whom they admired, or taking an occasional informal lesson. As a result, there was no need to learn how to read music. Their musical groups played a hotter, more exciting music than one might hear played by Creoles of Color. Whereas Creole musicians prided themselves in their soft, pure tone, Black musicians played as loud as they could. Many considered the music of Black bands to be rough, crude, and disrespectable— the music of the lower class. But Black musicians in New Orleans were proud of their abilities and retained a high degree of traditional African performance techniques such as embellishing melodies, using call and response, and a wider degree of rhythmic variations. The most famous Black musician in New Orleans at the turn of the century was Buddy Bolden, who became the first legend of jazz.

Separate but Equal

In spite of being arguably the most tolerant city in the South during the 1800s, racism and bigotry were woven into the fabric of life in New Orleans. During Reconstruction, as the federal government passed new voting rights and anti-segregation laws to benefit Blacks, resentment simmered among many Southern whites. Hate groups such as the Ku Klux Klan and the New Orleans-based Knights of the White Camellia were formed in response to this Northern 'meddling'. When the federal troops that had been enforcing the laws were withdrawn in 1877 and Reconstruction ended, bottled up hatred boiled over, and resulted in the passage of a number of Jim Crow laws throughout the South that legalized common discriminatory and racist practices. One of these laws was Legislative Code No. 111, which was enacted in 1894 by the state of Louisiana. Known as the discriminatory codes, this legal document stipulated that anyone with even the slightest amount of Black ancestry would be considered Black, and therefore subject to legal discrimination.

The discriminatory codes of course had no effect on dark-skinned Blacks, who by now were well- accustomed to racism and segregation. However, the codes were devastating to the lighter-skinned Creoles, who now for the first time found themselves on the receiving end of discriminatory and segregationist practices and laws. Almost overnight, whites stopped doing business with Creoles, even those who had become lawyers, doctors, and respected businessmen. Many who had played music as a hobby were now forced to make it their profession. Creoles now had to use 'colored' facilities, shop only at certain stores and segregate themselves in certain areas. When a Creole man, Homer Plessy, was arrested for and convicted of refusing to give up his seat on a 'whites only' train car in New Orleans, he appealed his case all the way to the United States Supreme Court and lost. The 1896 *Plessy v. Ferguson* decision essentially stated that separate facilities for Blacks and whites were permissible, as long as they were equal. This 'separate but equal' doctrine set a precedent that would govern civil rights laws and practices in the United States until 1954's *Brown v. Board of Education* decision effectively struck it down.

Creole musicians were also affected by the discriminatory codes. Unable to get jobs at the high society balls and other white-sponsored functions that had been their bread and butter for years, they were forced to turn to lower-paying gigs at the cribs, whorehouses, juke joints, and honky tonks that had traditionally been held

Reconstruction was the period following the Civil War from 1865 to 1877 when the federal government-controlled social legislation in the South was introduced to grant new rights to freed Black citizens.

The **discriminatory codes** were New Orleans regulatory codes that were part of a series of Black codes (also known as Jim Crow laws) passed all across the South after Reconstruction by white supremacists in response to Reconstruction and the ending of slavery. **Legislative Code No. 111** was one of these laws.

by Black musicians. Open hostility and competition between the two groups was intense at first, as the discriminatory codes themselves could not erase institutional prejudices and attitudes that had evolved over many years. Black musicians struggled to meet the superior playing skills of the Creoles; Creoles scoffed at playing the rough, hotter Black music, which was becoming increasingly popular among dancers. In time, and as younger musicians started to enter the workforce—especially younger Creoles, who were drawn to the hotter Black music—hostilities between Blacks and Creoles began to evaporate, and they began to learn from each other. This interaction, in which Blacks increasingly began to read music and acquire technical facilities on their instruments and Creoles learned how to play the blues and embellish melodies, helped create the right environment that led to the birth of jazz.

Storyville

Prostitution has always been one of New Orleans's favorite vices, but by the late 1800s, it had gotten so out of hand that law-abiding citizens decided that something had to be done about it. In 1897 Alderman Sidney Story proposed setting aside a district where prostitution would be regulated and legal. The 38-block area, to the south and west of Vieux Carre, opened on October 1, 1897, and to his chagrin, unofficially took Alderman Story's name. At its height, **Storyville** reportedly had 200 bordellos (or sporting houses, as they were called) and 2,000 officially registered madams. A visitor to the "District" could buy the *Blue Book* for 25 cents that advertised the ladies and the various sporting houses, such as Lulu White's Mahogany Hall, Fewclothes, the Big 25, and Gypsy Schaeffer's. One saloonkeeper, Tom Anderson (owner of the Arlington Annex), was also a powerful state legislator. Although there were two large dance halls in the District that featured bands (the Tuxedo and the 101 Ranch), the sporting houses in Storyville generally were only large enough to hire piano players. These so-called "**professors**" received tips based on their skills at keeping the customers happy that generally amounted to $15 a night or more. The most famous professors in Storyville, Jelly Roll Morton, and Tony Jackson, could command much larger tips, occasionally as much as $100 on a good night.

Storyville has become legendary throughout the years as the place where jazz was born. But in fact, this is unlikely. Research has shown that there were actually two red-light districts: the white one described above and a separate, segregated Black one. Black Storyville, most commonly known as either Back o' Town or the Battlefield, was a four-square-block ghetto further south and west of white Storyville. It was one of the roughest parts of New Orleans, a dirty and dangerous place filled with cribs, gambling and sporting houses, dancehalls, and juke joints. For the thieves, whores, pimps, and gangsters who worked there, business consisted of separating customers from their money as quickly as possible, often in any way possible. Muggings, fights, robberies, and murders were common, along with the usual vices of prostitution and drug dealing. It is this area and not the more famous white District that is most likely the cradle of jazz. But how do we know this?

For one thing, written accounts of the goings-on in the Black red light district indicate that bands played there rather than the solo piano professors. It is known that the legendary Buddy Bolden's band played at Funky Butt Hall and Odd Fellows Hall in the area (and probably other halls), which means that most likely slow blues, which Bolden was known for, was being played at these halls. Nearly all the run-down wooden buildings in the area were probably used for business purposes (according to Louis Armstrong, who lived in the area as a child), which means there were a lot of places for Bolden's and other bands to play. So there were undoubtedly a lot of musicians gathering and working in the area. And with the

Professors were highly paid piano players in The District.

Music Styles That Influenced Early Jazz

- Spirituals
- The blues
- Ragtime
- European songs and classical music

District off-limits for the most part to those with dark skin, it is unlikely that any Black/Creole musical interaction was happening in white Storyville. And when surviving Black and Creole musicians who lived and worked in New Orleans during these years were interviewed later in their lives, most could not remember playing in Storyville or knowing anyone who did. They did however remember the Battlefield.

Storyville was eventually closed down on the orders of the Secretary of the Navy on November 12, 1917. With America's recent entry into the First World War, the District was thought to be a distraction to sailors stationed at the New Orleans naval base. Its closing and a general slump in the local economy helped accelerate an exodus of local musicians to Chicago in the late teens and early '20s.

The Birth of Jazz

The birth of jazz was most likely an evolutionary process that unfolded over a 10-to 20-year period, somewhere between 1895 and 1915. Because we have no recordings of any music from New Orleans or anything that even resembles jazz before 1917, it is very difficult to draw conclusions about how the music incubated, what each band and musician sounded like, or how the various instrumental techniques that are associated with early jazz came into existence. All we have to go by is newspaper articles, public notices, personal accounts, letters, and the stories and myths that have perpetuated throughout the years. Although many of the first generation of jazz musicians were interviewed later in life, their stories and accounts sometimes contradict each other. By the time the first important jazz recordings were made in Chicago in the mid-1920s, it is almost certain that some evolution of the music had already taken place. It is also fair to conclude that by this time some of the early jazz pioneers were past their prime or their playing had deteriorated due to declining health or alcoholism, as in the case of cornetist Freddie Keppard. In the end, we are left to make a number of educated guesses about the how and when of the beginnings of jazz.

As we have seen, a variety of factors were coming together in New Orleans (and to a lesser extent, other Southern locales) that made jazz music possible. The tolerant atmosphere of the city, the wide range of cultures and people and the diverse musical styles that they brought, the ethnic mix and the disruptive effects of the discriminatory codes all played roles. We also know what kinds of music the New Orleans jazz pioneers had been exposed to and were experienced at playing that would have influenced the sound of early jazz. Primarily there were four main styles:

1. **Spirituals**: as performed in Black churches throughout the South, spirituals were a staple of Black musical life since the early days of slavery and had a powerful influence on early jazzmen. Spirituals were emotionally powerful and contained elements of African culture that survived in jazz, such as improvisation and call and response. Guitarist Bud Scott wrote, "Buddy Bolden went to church, and that's where he got his idea of jazz music."

2. **The blues**: Black New Orleans musicians picked up on the blues early in its existence. Buddy Bolden and others played it in the sporting houses of Black Storyville as early as the mid-1890s. Today, the blues influence is the only early ingredient that remains in jazz with any significance.

3. **Ragtime**: with ragtime's popularity at its peak in the first years of the 20th century, many musicians were embellishing their melodies with rag-like syncopation, a practice they called '**ragging**'. In fact, many of the early jazz musicians in later years told interviewers that they were playing ragtime, not jazz. The ragged rhythms of ragtime eventually loosened up and evolved into swing rhythm as we know it today. Ragtime was also the staple of the brass bands.

Characteristics of the New Orleans Style

- Front line of cornet, clarinet, and valve or slide trombone
- Rhythm section of drums, string bass, guitar, and violin
- Collective improvisation
- Upbeat, march rhythm
- Syncopation, ragging

Ragging is the act of adding syncopated rhythms of ragtime to more traditional dance pieces.

4. **European songs and classical music**: most Black Creole musicians in the city were well versed in European songs and dance forms, such as waltzes, mazurkas, polkas, and quadrilles, and knew some of the standard repertoire of European classical literature.

The Earliest Jazz Bands and Musicians

By around 1910, there were a variety of musical groups playing in the city, including brass bands and dance orchestras. But by this time a new hybrid ensemble was also evolving that played the music destined to be called jazz in dance halls, picnics, and other venues. These bands generally consisted of seven players: a **front line** consisting of cornet, clarinet, and valve or slide trombone, and a rhythm section made up of guitar, string bass (on occasions, tuba), drums, and violin. They played a variety of blues, ragtime, popular tunes, and were beginning to compose their own songs. Over time the front line instruments developed a performance system: the cornet generally played and embellished the melody in the middle register, whereas the clarinet and trombone created new melodies in the upper and lower registers, respectively. Even though what they were doing at first was more embellishment of the melody than actual improvisation, in time this system became known as **collective improvisation** and is the distinctive sound of what was eventually called the **New Orleans Style**. Figuring out when the music these bands played could first be called jazz is, as Gunther Schuller writes in *Early Jazz*, like "trying to determine at which point rain becomes sleet and sleet becomes snow." Undoubtedly there was a period of years where it fell into the realm of "a kind of borderline music that was on the verge of becoming jazz."

There is some debate on the origin of the word jazz. Originally the music was called jass, which may have come from the word jasm (a slang word for sexual activity) because the music had become synonymous with the activities in sporting houses. Other theories abound, as do those of why 'jass' turned into 'jazz'. One legend has it that an early band, the Original Dixieland Jass Band, changed jass to jazz when they got tired of vandals scratching out the 'J' on jass (leaving only the word "ass"). In any event, the words jass and jazz started appearing in band names and song titles around 1915, and by 1917 when the first instrumental jazz recording was made, the word had become part of the national vernacular.

> **The front line** was made up of one or two cornets, one or two clarinets, and a trombone.
>
> **Collective improvisation**—the distinctive characteristic of the New Orleans Style of jazz in which the front line instruments improvise simultaneously.

BOX 3-1	Characteristics of the New Orleans Style

- Front line of cornet, clarinet, and valve or slide trombone
- Rhythm section of drums, string bass, guitar, and violin
- Collective improvisation
- Upbeat, march rhythm
- Syncopation, ragging

The Cornet Kings of New Orleans

With its power, projection, and role as melody instrument on the front line, it is only natural that the cornet was the most important instrument in the New Orleans jazz scene. The top cornet players were given royalty status and a 'king' was crowned by popular acclaim. Unfortunately, recording technology was in its infancy during the years that these men lived and worked in New Orleans, and none of them recorded until they left the city (if they recorded at all). The first three in the lineage of the cornet kings are discussed here; the fourth and last, Louis Armstrong will be discussed at length in the next chapter.

Cornet Kings of New Orleans

- Charles "Buddy" Bolden
- Freddie Keppard
- Joe "King" Oliver
- Louis Armstrong

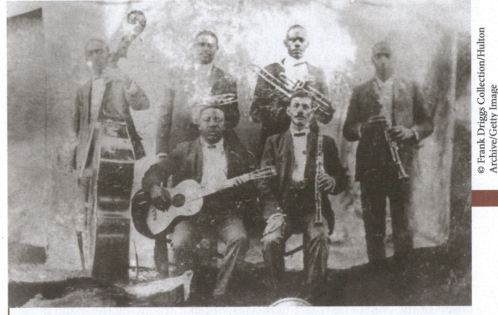

© Frank Driggs Collection/Hulton Archive/Getty Image

The only existing photo of **Charles "Buddy" Bolden**, a formal portrait made with his band, circa 1900. Left to right: bassist J. Johnson, cornetist Bolden, guitarist B. Mumford, trombonist W. Cornish, clarinetists F. Lewis and W. Warner.

Charles "Buddy" Bolden (1877–1931)

As the first legend of jazz, **Charles "Buddy" Bolden's** life is shrouded in mystery. He never recorded, there is only one photo of him in existence, and not much else about him is known. We are left to go on the authority of eyewitness accounts and newspaper stories, and because of this his life, career, and accomplishments have achieved legendary status as the years have passed. Bolden is universally regarded as the first great jazz musician; some even call him the Father of Jazz. Sometime in his late teens, he began playing the cornet and was soon entertaining at parties and dances. By the turn of the century, Bolden was acquiring a reputation for playing a bold mix of blues and syncopated music that appealed to younger Blacks in his neighborhood. One of his pieces, known alternately as "Funky Butt" and "Buddy Bolden's Blues," was considered so outrageous that when he played it police would show up and arrest people who sang it. There are stories of Bolden playing so loud that the valves of his cornet blew loose and became projectiles. There were other reports that he could be heard ten miles away. (Were the references to the "loudness" of his music merely comments on its bold and daring nature, or did he really play that loud?) In any event, it is clear that he in some way influenced the other cornet kings who followed him and who did make recordings. But Bolden's reign as cornet king would not last. By 1906, he was drinking heavily and exhibiting erratic behavior that may have been the result of an untreated case of venereal disease. He was arrested three times that year, and in 1907 declared legally insane and committed to the mental hospital in Jackson, Louisiana, where he died in obscurity 24 years later.

Freddie Keppard (1889–1933)

According to legend, **Freddie Keppard's** brilliant playing enabled him to replace Bolden as king in 1907 while still a teenager, but he relinquished the throne in 1910 when Joe Oliver outdueled him in a street showdown. Keppard was the leader of the Original Creole Orchestra, who traveled extensively throughout the country from 1911 to 1918, with stops in Chicago, New York, and Los Angeles. According to legend, the band was given the opportunity to make a record while on tour in New York in 1915 or 1916, but Keppard turned it down, fearing that other cornetists would copy his style. It would have been the first jazz recording,

a distinction that went to the Original Dixieland Jass Band a few months later. Keppard eventually settled in Chicago in 1918 and made some recordings there in the 20s. Unfortunately by this time, Keppard was drinking heavily, was in deteriorating health, and was past his prime. Of his glory days in New Orleans, however, Jelly Roll Morton later rated Keppard as the best of the cornet kings, ahead of Bolden, Oliver, *and* Louis Armstrong.

Joe "King" Oliver (1885–1938)

Mute specialist extraordinaire, and mentor to young Louis Armstrong, Joe "King" Oliver played a pivotal role in popularizing jazz beyond the confines of New Orleans. Oliver played in marching bands in his youth, and gradually made the transition to the new hybrid bands and the hotter style they played. Around 1916, Oliver took Armstrong under his tutelage and became a father figure to the aspiring cornetist. But Oliver left New Orleans in 1918 and traveled extensively with his band, King Oliver's Original Creole Jazz Band. In 1922, he landed a steady gig at the Lincoln Gardens, a huge dancehall on East 31st Street on Chicago's South Side. It was here that Oliver, leading a band consisting of the cream of the crop of early jazz musicians, began introducing the sound of New Orleans jazz to Chicago's Black community. And it gave Oliver the opportunity to send for his young protégé to come play second cornet with the band. During their year and a half tenure at the club, Oliver's band, with Louis Armstrong in tow, jelled into a tight-knit, high-energy jazz band, possibly the greatest of the era of the New Orleans style. In April 1923, the band made their first recordings at the Gennett Studio in Richmond, Indiana.

The King Oliver recordings from April 1923 are considered to be the first important jazz recordings. They are arguably the finest examples of collective improvisation in the New Orleans style and are also the first recordings made by Louis Armstrong. Oliver was the first mute master in jazz, and his use of the plunger mute "wah-wah" technique was particularly influential to later trumpet players such as Bubber Miley (chapter 5). As jazz styles evolved away from the New Orleans style, Oliver did not successfully make the transition, and his later years were spent in decline. After moving to New York City in 1927, he turned down a steady gig at the Cotton Club, the most famous club in Harlem because he wanted more money (Duke Ellington, who took the gig, became famous there). Oliver was also plagued with dental problems (he loved sugar sandwiches!), and eventually had to give up music altogether. When he died, he was a penniless janitor in Georgia. Louis Armstrong paid the train fare and funeral costs so that "Papa Joe" could be brought to New York and have a proper burial.

Other Important New Orleans Jazz Musicians

Jelly Roll Morton (1880 or 1885–1941) Piano/Composer/Arranger/Bandleader

Jelly Roll Morton was one of the first to recognize that jazz was a style that can be applied to any piece of music.

Jelly Roll Morton is sometimes called the 'Father of Jazz Piano' because he was one of the first pianists to synthesize the blues, ragtime, and European forms and styles into a new and original piano style. Because he wrote and arranged many pieces that became early jazz standards, he is also considered to be the first jazz composer and jazz arranger as well. Jelly Roll, one of the more colorful personalities in early jazz, was a Creole, born Ferdinand Lamothe. He changed his name because he did not want to be called "Frenchie." Jelly often claimed that he invented jazz in 1902, and although it is easy to dismiss this as an egotistical boast, it is true that he played a pivotal role in the early development of jazz. Morton was one of the first to recognize that jazz was a style that can be applied to any piece of music, whether the blues, popular tunes, or ragtime. This allowed

him to take a popular tune of any style, add elements of ragging and improvisation, and turn it into jazz.

According to Morton's autobiography, he began playing at the sporting houses in Storyville around 1900 and found he could make anywhere from $20—$100 a night in tips alone. At the time he was living with his deeply religious great-grandmother, as his father apparently had run off and his mother died when he was young. Lalee, as he called her, did not approve of gambling and prostitution, so Jelly told her he was a night watchman. When she discovered what he was really doing at night, she promptly kicked him out of the house. It was during this time that Jelly began to formulate his new piano style, and also to write his own compositions. Some of his compositions are constructed using simple 12-bar blues forms while others are complex, with as many as three themes. He also built introductions, breaks, key, and dynamic changes and transitions into his tunes, borrowing ideas he learned from ragtime and European composers. In 1902, Morton wrote "New Orleans Blues," a piece that includes habanera rhythms from Cuba. He called this the "Spanish tinge." "If you can't manage to put tinges of Spanish in your tunes, you will never be able to get the right seasoning, I call it, for jazz," he wrote. But in spite of the great wages and stimulating work environment, Jelly Roll was restless. In 1903, he left New Orleans and spent the next 19 years traveling around the country, with stops in New York, Chicago, Los Angeles, and the Pacific Northwest. During these years, Jelly earned his living not only playing piano but at various times as a pool hustler, gambler, hotel manager, and even a pimp.

The **Spanish tinge** was what Morton called using the rhythms of the tango and other Spanish dances in some of his compositions, the first of which is believed to be "New Orleans Bump," from 1902.

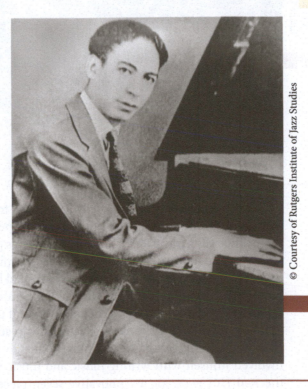

© Courtesy of Rutgers Institute of Jazz Studies

Not only was Jelly Roll Morton considered the first jazz pianist but also the first composer and jazz arranger.

Music Analysis

Track 9: "King Porter Stomp"

(Morton) Jelly Roll Morton recorded July 17, 1923, at Gennett Recording Company, Chicago, Illinois. Personnel: Jelly Roll Morton: piano

Although Jelly Roll Morton hailed from New Orleans where he was one of the architects of early jazz, he did not record until he moved to Chicago in 1923. While in the Windy City (he moved to New York in 1928), he recorded prolifically with his own groups (including the innovative Red Hot Peppers), King Oliver, the New Orleans Rhythm Kings, and a number of other orchestras. Morton also occasionally recorded solo piano pieces, including "King Porter Stomp," which he wrote in 1905. "King Porter Stomp" would go on to play an important role in jazz history when a big band arrangement recorded by Benny Goodman helped make him a star in 1935 (see chapter 6). Although Morton recorded at various studios in the Chicago area, most of his recordings from this period, including this one, were made at Chicago's Gennett Studios in Richmond, Indiana.

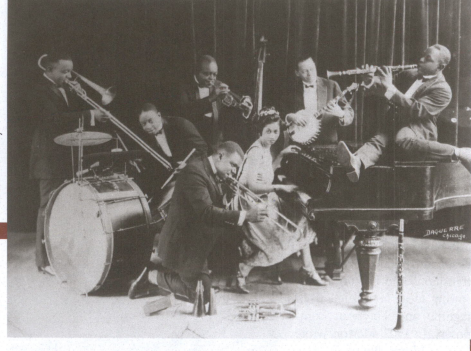

© Courtesy of the Hogan Jazz Archives, Tulane University

King Oliver's Creole Jazz Band included Honore Dutrey (trombone), Baby Dodds (drum), King Oliver (cornet in background), Louis Armstrong (cornet in front), Lil Hardin (piano), Bud Scott (banjo), and Johnny Dodds (far right clarinet).

In the course of his travels, Jelly Roll began to make written arrangements of his compositions to ensure that they would be performed exactly as he intended them. This was a novel idea at the time; up to this point, playing jazz was a spontaneous and interactive pursuit. Jelly Roll's accomplishments at this point are monumental to the early history of jazz: not only had he basically invented jazz piano, but he was also among the very first to deliberately compose and arrange music for jazz performance. By 1922, he finally got off the road and settled in Chicago, as many other New Orleans musicians had already done. But instead of working the club and jam session scene, which he considered to be beneath him, Jelly Roll involved himself with writing music and music publishing. In 1926, he formed the **Red Hot Peppers**, an innovative seven-piece group of New Orleans immigrants that was a showcase for his writing and arranging talents. The Peppers never performed in front of a live audience; instead, they focused their attention on making records, and between 1926 and 1930, they made a series of influential ones in Richmond, Indiana, and New York. Because these recordings were made by a highly polished band playing written or meticulously rehearsed material instead of just improvisations, they essentially laid out the future of jazz and the swing era of the 1930s and 1940s. However, Jelly Roll was not able to keep his creative momentum going, and soon Louis Armstrong, Duke Ellington, and others were out-innovating him. Except for some historically important recordings made for the Library of Congress in 1938, the last ten years of his life were spent in relative obscurity and he died penniless in Los Angeles.

Sidney Bechet (1897–1959) Clarinet/Soprano Sax

Sidney Bechet, a Creole of Color, was a child prodigy on the clarinet. A loner and wanderer with a belligerent and confrontational streak, he was in and out of trouble (and jail) throughout his life. After establishing his talent as a teen by playing with some of New Orleans's best ensembles, Bechet left town at seventeen to see the world. By 1919, he was touring Europe with Will Marion Cook's Southern Syncopated Orchestra, making an impression on critics, musicians, and the police: in Paris, he was arrested after a duel with a pianist over the correct chords of a

Music Analysis

Track 10: "Wild Cat Blues"

(Williams/Waller) Clarence Williams' Blue Five, recorded in New York City June 30, 1923. Personnel: Clarence Williams: piano; Sidney Bechet: soprano saxophone; Thomas Morris: cornet; John Maysfield: trombone; Buddy Christian: banjo

Like all the New Orleans architects of early jazz, Sidney Bechet did not make his recording debut until he moved out of the city. After leaving home in 1914, he traveled extensively, including a trip to Europe in 1919 where he bought and began playing the soprano saxophone. Although Bechet was a true child prodigy who played with some of the leading orchestras of the late teens and early 1920s, it was not until 1923, as a member of pianist/composer Clarence Williams' band, that he made his first recording, "Wild Cat Blues." Bechet, who was 26 at the time, dominates the session with his aggressive playing and his characteristic wide and fast vibrato.

0:00	Introduction
0:05	A theme is stated in New Orleans collective improvisation style with soprano saxophonist Sidney Bechet playing the lead
0:28	B theme
0:48	A theme restated
1:09	C theme
1:29	D section featuring a series of 2-bar solo breaks by Bechet
1:50	One chorus of collective improvisation over the C theme
2:10	D section featuring a series of 2-bar solo breaks by Bechet
2:30	Shout chorus
2:50	Tag ending featuring one more solo break for Bechet

song resulted in a wounding a bystander. Bechet also bought and began playing a soprano saxophone in London, making him the first important jazz saxophonist, and one of the few to play the soprano until John Coltrane in the 1960s. Bechet's playing on both clarinet and soprano sax is marked by a fiery virtuosity and a very wide and fast **vibrato**. A combative, feisty player, he was perhaps the only jazz soloist who could go toe to toe with Louis Armstrong in early 1920. Bechet got out of music in the 1930s, becoming a tailor, but returned in the 1940s when the music of New Orleans saw a renewed public interest.

George "Pops" Foster (1892–1969) Bass

Although he started his career playing tuba, **George "Pops" Foster** switched to string bass sometime in the late teens and became the first important bass player in jazz. Foster enjoyed a long career as a **sideman**, having played and recorded with Kid Ory, King Oliver, Louis Armstrong, Sidney Bechet, and Earl 'Fatha' Hines.

Johnny Dodds (1892–1940) Clarinet

Johnny Dodds moved to Chicago in 1921 and there played with King Oliver's Creole Jazz Band and recorded with Louis Armstrong's Hot Five and Jelly Roll Morton's Red Hot Peppers.

Warren "Baby" Dodds (1898–1959) Drums

Like his brother, Johnny, **Warren "Baby" Dodds** was an in-demand sideman, playing and recording with Freddie Keppard, Louis Armstrong's Hot Seven, and Jelly Roll Morton's Red Hot Peppers.

Vibrato is the technique of varying a pitch up and down slightly to produce a wavering sound; favored by wind and string players and vocalists.

Sideman is a musician used in a live or recording ensemble that is not the leader and is used to play a specific role or part.

Kid Ory (1886–1973) Trombone

Edward "Kid" Ory was the leader of Kid Ory's Creole Orchestra, the first Black band to make a jazz recording in 1922. Ory moved to Chicago in 1925 and recorded with Louis Armstrong and Jelly Roll Morton.

Johnny St. Cyr (1890–1966) Banjo

Johnny St. Cyr moved to Chicago in 1923 where he played and recorded with King Oliver's Creole Orchestra, Louis Armstrong's Hot Five and Seven, and Jelly Roll Morton's Red Hot Peppers.

Buddie Petit (1887–1931) Cornet

Like Buddy Bolden, **Buddy Petit** never recorded but reportedly played in a style similar to Bolden's. After briefly moving to Los Angeles in 1917 to play with Jelly Roll Morton, Petit returned to New Orleans where he led a variety of bands until his death.

The First Jazz Recording

The ODJB and the NORK

Ironically, the first jazz recording was not made by any of the innovators of the New Orleans style. Instead, the honor (although a dubious one) goes to a group of white musicians with an entrepreneurial flair. The **Original Dixieland Jass Band (ODJB)** was formed in New Orleans, and in 1916, like many of their Black and Creole counterparts, left town for Chicago where they secured a gig at the Schiller Café on the South Side. Soon after, they took off for New York and opened at Reisenweber's Café at Columbus Circle on January 15, 1917. As one of the first "jass" bands to play in

Pictorial Press Ltd/Alamy Stock Photo

A 1917 studio portrait of the **Original Dixieland Jass Band** members with their instruments. Left to right pianist Harry Ragas, clarinetist Larry Shields, trombonist Eddie Edwards, cornetist Dominic James "Nick" LaRocca, and drummer Tony Sbarbaro.

Music Analysis

Track 11: "Livery Stable Blues"

(LaRocca) Original Dixieland Jass Band recorded February 26, 1917. Personnel: Nick LaRocca: cornet; Larry Shields: clarinet; Henry Ragas: piano; Eddie Edwards: trombone; Tony Spargo: drums

The first jazz instrumental recording, written by the band's cornet player and leader, Nick LaRocca. After a short intro, the 12-bar blues melody is introduced with two choruses of 'collective improvisation', which are followed by two more choruses that include breaks of shrieking, whinnying, and belching from the clarinet, cornet, and trombone. High spirits and novelty effects like these are part of the reason that the ODJB took New York by storm in 1917. Although the recording makes extensive use of what sounds like collective improvisation in this recording, upon careful listening, it is clear that the parts are pre-conceived. It is generally believed that LaRocca and his men were playing parts that were copied after careful study of Black and Creole bands in New Orleans.

0:00	Introduction
0:08	Song begins with four choruses of collective improvisation
1:18	Two choruses with breaks that include novelty sound effects
1:54	Two choruses of collective improvisation
2:29	Break with novelty sound effects (repeating 1:18), song ends

New York, the novelty of their music took the city by storm. They also caught the attention of the major record labels. On February 26, 1917, the ODJB made the first commercially sold jazz recording with two sides, "Livery Stable Blues" and "Dixie Jass Band One Step." Over time, the record sold more than a million copies, made the band famous, and introduced jazz to much of the nation for the first time. The ODJB was also the first band to bring jazz to Europe when they toured London in 1919.

Although the success of this recording was an important stepping-stone in jazz history, it was probably not a good representation of jazz as it was being played in New Orleans at that time. It is more akin to orchestrated ragtime, rhythmically very stiff and march-like, and actually, may sound more like the very earliest jazz from around 1900 to 1905. To further complicate their historical standing, the group maintained to the New York press that they were the originators of the music they played and denied having any influence from Black or Creole bands in New Orleans. In retrospect, it is clear that the ODJB were not the innovators they presented themselves as but were instead imitators who had carefully studied and copied the early jazz masters and profited handsomely from it.

On the heels of the ODJB was another white New Orleans-based band that also moved north to seek fame and fortune. The New Orleans Rhythm Kings (NORK) were in Chicago as early as 1920, and secured a steady engagement at the Friars Inn in 1921, billing themselves for a while as the Friar's Society Orchestra. In contrast to the ODJB, the NORK acknowledged the debt they owed to the Black and Creole masters of early jazz, especially King Oliver, and their music shows it. They were a good, swinging band in the New Orleans collective improvisation style. The NORK were enormously influential to young white musicians such as the Austin High Gang that were just coming of age in the heyday of 1920s Chicago. They also made the first interracial jazz recording on July 17, 1923, when they recorded several sides with Jelly Roll Morton at Gennett Studio in Richmond, Indiana. Their association with Morton undoubtedly contributed to their musical achievements.

Stride Piano

An important development in early jazz was the emergence of new jazz piano styles. The most important of these evolved from ragtime in the 1910s and 1920s in New York City's Harlem neighborhood. Harlem was on the verge of establishing itself as a Black cultural and artistic center and was soon to become the largest Black community in the United States. There were many cabarets, juke joints, and saloons for musicians to play at. This was especially true for pianists, who could also count on getting jobs at **rent parties**. Rent parties became showcases for pianists, who had to attract and entertain partygoers with the strength and vitality of their playing. When other pianists showed up, which was often the case, a cutting contest would result. With so many opportunities for work, it was only natural that the top ragtime pianists would gravitate to Harlem. With the best came fierce competition to outplay the field, and the music evolved into a virtuosic new style called **stride piano**. Stride, named for its loping left-hand technique, is a high-energy, ostentatious, and demanding style that produced some of the greatest piano masters in jazz history. Although its roots are clearly from ragtime and the European tradition, stride incorporated improvisation and swing rhythm. Because each player, or tickler as they were called, developed his own riffs, runs, and musical tricks to show off his skills, stride, unlike ragtime, was generally not written down or sold on sheet music.

> **Rent parties** were held near the end of the month where admission of 15 to 25 cents was charged to help pay the next month's rent. The rent party was most common in Harlem during the 1920s.
>
> **Stride piano** is the loping left-hand piano playing technique full of high energy that produced some of the greatest piano masters in jazz history.

BOX 3-2	Characteristics of Stride
• Fast, energetic, technically challenging	
• Loping boom-chuck left hand found in ragtime	
• Improvisation and flashy embellishments in the right hand	
• Swing rhythm	
• Blues elements	

Important Stride Performers

James P. Johnson (1894–1955)

Known as the 'Father of Stride', **James P. Johnson** was also a fine composer as well. His "Carolina Shout" became a yardstick piece by which other pianists were judged, and his tune "The Charleston" was the accompaniment for the first great dance craze of the 1920s. He also wrote the four-movement *Harlem Symphony* in 1937, a piano concerto, and an opera. He was a great influence on Duke Ellington, and his playing and composing can be viewed as an important link between Scott Joplin and Ellington.

> **Stride Performers**
> • James P. Johnson
> • Thomas "Fats" Waller
> • Willie "The Lion" Smith
> • Art Tatum

Thomas "Fats" Waller (1904–1943) Pianist/Singer/Composer/Comedian

Thomas "Fats" Waller's gift as a pianist is sometimes overlooked because it was just one of his many gifts. He was a theatre organist who played for silent films, a producer of Broadway theatrical revues, a composer, singer, movie actor, and comedian. He was far and away the most commercially successful of the stride performers. His first influence was James P. Johnson; he in turn gave lessons to the young Count Basie. Waller's compositions include "Ain't Misbehavin'," "Honeysuckle Rose" and "Jitterbug Waltz," all jazz standards. He appeared in the 1943 film *Stormy Weather* with Lena Horne, and if he had lived, he would almost certainly have gone on to a successful movie and television career.

Willie "The Lion" Smith (1897–1973)

Known for his ever-present derby and cigar as well as his machismo at cutting contests, **Willie "The Lion" Smith** was a gladiator in a literal sense: his nickname was given him for valor on the front lines in WWI (his given name was William Henry Joseph Berthol Bonaparte Bertholoff Smith!). Smith was immortalized in Duke Ellington's "Portrait of the Lion."

Art Tatum (1909–1956)

Art Tatum is universally acknowledged as the greatest of all stride pianists, and arguably the greatest jazz pianist—ever. Tatum played faster than anyone else, and his creative ideas seemed to come from a well that never ran dry. His melodic ornamentation was dazzling, and his use of sophisticated chordal **reharmonization** was years ahead of its time and an influence on nearly every jazz musician who came after him. His records, which on first hearing can appear to have been made by two pianists, are astonishing to listen to (even today), and helped redefine the notion of virtuosity in a jazz context. Oh, and by the way—he was completely blind in his left eye and nearly so in his right. Tatum was born in Toledo, Ohio, where he learned to play by listening to and copying piano rolls. He worked his way into the local club circuit and on WSPD Radio, where he had a 15-minute program. In 1931, he moved to New York City, where he soon became a phenom playing the clubs on 52nd Street. In response, the local stride mafia—Johnson, Waller, and Smith—challenged Tatum to a cutting contest at a Harlem club. This legendary session ended with Tatum cutting the others with his rendition of "Tiger Rag." Sometime later at the Yacht Club, Tatum walked in while Waller was playing. Seeing him, Waller announced to the crowd, "I just play the piano, but God is in the house tonight." Ironically, in some ways, Tatum may have brought an end to stride's influence on jazz piano. Because his mastery of the style was so overwhelming and complete, no one could begin to match it, let alone build on it (and no one has to this day). Future jazz pianists chose instead to move away from stride and develop new styles and techniques.

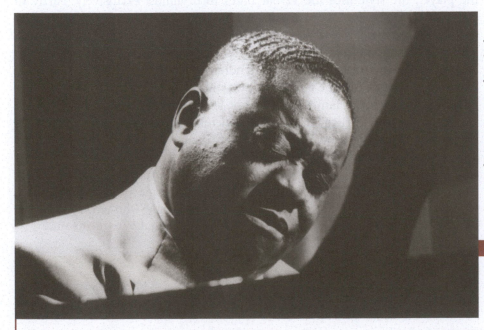

© Courtesy of Rutgers Institute of Jazz Studies

Art Tatum inspired his peers and influenced the next generation of bop musicians with his lightning-fast improvisations and harmonic inventiveness.

Music Analysis

Track 12: "Tiger Rag"

(Nick LaRocca) Art Tatum recorded March 21, 1933

Written by Nick LaRocca, the leader of the Original Dixieland Jass Band, "Tiger Rag" is a great example of Art Tatum's incredible stride piano virtuosity. One of Tatum's first recordings after moving to New York from his hometown of Toledo, "Tiger Rag" startled many listeners, some of whom thought it was actually a recording made by two pianists. Despite the incredible speed at which the piece is performed, Tatum manages to play every note with perfect accuracy while maintaining his clear bell-like tone.

0:00	Introduction, played freely
0:15	First theme
0:35	Second theme
0:51	Third theme introduced with left-hand tremolo
1:12	Improvised solo starts
1:54	Last chorus, with dramatic right-hand virtuoso runs

Boogie-Woogie

Instead of evolving out of ragtime, or a European tradition, this style was much more deeply rooted in the blues. It eventually came to be known as **boogie-woogie**.

Around the same time that stride began evolving in Harlem, another style of piano playing was emerging out of Texas that would also play a role in the development of jazz. Unlike stride, boogie-woogie was deeply rooted in the blues, and its central characteristic—the repeating left-hand pattern of eight notes to the bar—imitates the guitar riffs of the early bluesmen of Texas and the Mississippi Delta. Originally called Texas piano, boogie-woogie's popularity both among players and audiences helped it spread north, and both Kansas City and Chicago became important hotbeds of talent.

Because boogie-woogie left-hand patterns place harmonic limitations on the player, the style uses the 12-bar blues form almost exclusively. Partly in response to this, boogie-woogie pianists have during the years developed many of these patterns as a way to add variety to the genre. In the right hand, pianists play a combination of improvised blues riffs and block chords, often playing two adjacent notes to imitate the bending of notes on the guitar.

Boogie-woogie became a national craze in the late '30s and early '40s after music producer John Hammond brought several of the best players to New York to perform at Carnegie Hall and other clubs in the city in December 1938. Eventually, every big band of the swing era had at least one boogie-woogie number in its library, including the hits "Boogie Woogie" (Tommy Dorsey, 1938), "Boogie Woogie Bugle Boy" (the Andrews Sisters, 1941), and "Basie Boogie" (Count Basie, 1941). Important boogie-woogie performers include Clarence 'Pinetop' Smith, the 'Father of Boogie-Woogie' who wrote "Pinetop's Boogie Woogie," Meade Lux Lewis, Albert Ammons, and Pete Johnson.

BOX 3-3	Characteristics of Boogie-Woogie

- More rhythmic, less harmonically complex than stride
- 12-bar blues form used almost exclusively
- Left-hand plays repeated patterns, imitating blues guitar
- Right-hand plays improvised blues riffs, block chords

Name _____ Date _____

Jazz Takes Root

1. Why did New Orleans play an important role in the birth of jazz?

2. What is the difference between ragtime, stride piano, and boogie-woogie?

3. What did the earliest jazz probably sound like?

4. Describe why Jelly Roll Morton is so pivotal to the development of jazz.

5. Describe why is Joe "King" Oliver so important to early jazz, and give at least three examples.

6. Why is Art Tatum so influential to the development of jazz generally and stride piano specifically?

7. How were the ODJB and the NORK alike? How were they different?

8. Describe the performance system that the earliest jazz musicians contrived and the roles of the different instruments in the front line.

9. How did Reconstruction and the legal system influence the New Orleans music scene and the creation of jazz?

10. Describe the different influences that Black and Creoles brought to the creation of jazz.

THE JAZZ AGE

Introduction

The 1920s were a time of rapid change in America. As World War I came to an end, a new spirit of moving forward was eminent. There was new technology—talking motion pictures, radio, automobiles, and phonograph records. Our heroes were named Lindberg, Ruth, and Valentino. For the first time, America was building skyscrapers, flying across oceans, and making Trans-Atlantic phone calls. Baseball successfully rebounded from the Black Sox scandal of 1919 as college and professional football were becoming more and more popular. 1920 saw the ratification of the Nineteenth Amendment guaranteeing women the right to vote, and the beginning of **Prohibition**. And the stock market was going through the roof. Although the good times would soon come to an end, Americans were getting rich and having a good time while they were doing it.

The soundtrack to the era was the new music craze called **jazz**, which was just beginning to exert its influence on popular culture. Jazz came to symbolize the new undeniably bold spirit of America in the 1920s as well as its slang, clothing, and dance styles, prompting F. Scott Fitzgerald to label the decade as "The Jazz Age." During the 1920s, jazz was rapidly evolving from the cacophonous improvisational sound of its early years to the tightly organized sound of the swing era. It was also on the move, and as New Orleans musicians and millions of other Southerners moved north, **Chicago** became the new center of the jazz world. It was there that young, rebellious white musicians first began to make their own kind of jazz. And it was there that a young musical genius from New Orleans would make his mark as the first jazz virtuoso and in the process single-handedly modernize jazz into a music focused on individual artistic expression.

Chicago

The Great Migration

Chicago became the focal point of the jazz world in the 1920s. Jazz musicians from New Orleans actually started arriving in the city well before that: many began the exodus when Storyville closed in 1917. Jelly Roll Morton reportedly visited around 1908, and Freddie Keppard may have moved there as early as 1910. By 1925, when Pops Foster settled in Chicago, almost all of the major players on the New Orleans scene had relocated to the Windy City.

But jazz musicians were not the only ones moving to Chicago. Between 1916 and 1930, the largest inland migration in American history—the **Great Migration**—brought millions of Southern Black Americans north to cities like Chicago and New York. Many came to escape the racism and discrimination of the Jim Crow South, whereas many more came because of the promise of jobs

KEY TERMS

Acoustical Process
Black-and-Tan
Cabaret
Cadenza
C-Melody Sax
Electrical Process
Great Migration
Octave
Prohibition
Race Records
St. Valentine's Day Massacre
Scat Singing
Speakeasy
Stop Time
Theatre Owners Booking
 Agency (TOBA)
Trumpet Style

KEY PLACES

Black Belt
Chicago
Gennett Studio
Lincoln Gardens

KEY FIGURES

Al Capone
Austin High Gang
Bessie Smith
Bix Beiderbecke
Bugs Moran
Earl "Fatha" Hines
Fletcher Henderson Orchestra
Frank "Tram" Trumbauer
Hot Five/Hot Seven
Jelly Roll Morton's Red Hot
 Peppers
King Oliver's Original Creole
 Jazz Band
Louis Armstrong
Mamie Smith
W. C. Handy

Prohibition legally became known as the Volstead Act and was put into effect by the Eighteenth Amendment to the Constitution. Prohibition outlawed the manufacture, sale, and transportation of alcoholic drinks. Impossible to enforce, it was repealed in 1933 with the passage of the Twenty-First Amendment.

Jazz came to symbolize the new undeniable bold spirit of America in the 1920s.

The **Great Migration** brought two million Southern Black Americans north to cities like Chicago and New York by 1930.

The new immigrants settled on the South Side in the area just below the Loop that became known as the **Black Belt**.

Speakeasy was a gang-controlled establishment where liquor was sold illegally. Many speakeasies had entrances in alleys and other out-of-the-way places, with passwords required for entrance.

Cabarets were eating and drinking establishments.

in the mills, foundries, stockyards, and meatpacking plants. And jobs there were, as America's entry into WWII had almost completely shut down foreign immigration, the source of much of the unskilled and semiskilled labor force. The city's Black newspaper, *The Chicago Defender,* tirelessly promoted the virtues of the city to Southern readers. Chicago had been a northern symbol of freedom as far back as the 1840s as an important stop on the Underground Railroad, and now it was a hub for many railroad lines, including the Illinois Central, which led directly to New Orleans. Between 1910 and 1920, the Black population in Chicago tripled.

The Black Belt

The new immigrants settled on the South Side in the area just below the Loop that became known as the Black Belt. Nightlife flourished there—by the mid-1920s, there were literally hundreds of dance halls, theatres, speakeasies, and cabarets. Many of the cabarets were Black-and-tans, where Blacks and whites drank and danced together, a social taboo in other parts of town (and most of America). Of course, dancing required music, and jobs for musicians were plentiful. The Black Belt was a good place to be if you were a jazz musician. Chicago was also a more cosmopolitan city than New Orleans, and jazz musicians found themselves playing for larger audiences that lived life at a faster pace.

Chicago in the 1920s was also a dangerous place. During his administration from 1914 to 1931, Mayor Big Bill Thompson befriended club owners, bootleggers, pimps, and gamblers in the Black Belt by turning the other cheek to their activities, allowing vice to thrive. He also befriended gangsters, and crime syndicates took control of the city. The leaders of the Chicago mob scene were Bugs Moran, who controlled the North Side, and Al Capone, who controlled the South Side. Their infiltration was profitable: in 1927 alone, Capone's various business interests netted him more than $100 million. At the heart of the mob empire during Prohibition was the sale and distribution of illegal alcohol, and control of nightclubs and speakeasies was essential to business. Jazz musicians playing in speakeasies often witnessed police raids and gunfights as the turf wars for control of the illegal liquor business were fought.

The Chicago Club Scene

The most important clubs where musicians played were clustered in the Black Belt and on the North Side around Clark Street. The heart of the South Side nightclub scene was at 35th and Calumet Streets. Guitarist Eddie Condon recalled that there was so much music being played at that intersection in the 1920s that "around midnight you could hold an instrument in the middle of the street and the air would play it." There was the Sunset Café, "Chicago's Brightest Pleasure Spot," a large Black-and-tan where Louis Armstrong and Earl Hines played together for the first time in 1926. Across the street was the Plantation Café; next door and upstairs was the Nest (later called the Apex Club). A few blocks away was Lincoln Gardens, a dance hall big enough for 1,000 dancers at 31st and Gordon. King Oliver's Creole Jazz Band had a residency there from June 1922 until early 1924. At 3520 South State Street was the Dreamland Café, another popular Black-and-tan, and three blocks south on State was the Vendome Theatre, where Armstrong played in a pit band for silent films.

On the North Side was Kelly's Stables, a small converted horse barn. Even though it had not been used as a stable for more than 20 years, the place still smelled "horsey," according to clarinetist Johnny Dodds. At Wabash and Van Buren was Friar's Inn, a basement cabaret where the New Orleans Rhythm Kings got their first important gig in 1921, billed as the Friar's Society Orchestra. The Cellar at 222 North State Street was a dank basement club that became a hangout for Eddie Condon and other local white musicians, who often held impromptu jam sessions. The Palace Gardens was on the 600 block of North Clark Street, as was the Derby, the Liberty Inn, the 606, and several others.

Recording in Chicago

Chicago also had a burgeoning recording industry in the 1920s, and it was here that many musicians from New Orleans made their first recordings. Although Victrola phonograph players had been available since the early 1900s, it was not until the 1920s that record sales took off. Because jazz is generally an improvised art form, the recorded performance is essential in preserving its history and providing a reference point for the evolutionary process to continue. Fortunately, the evolution of the recording industry in the early part of the 20th century nearly parallels that of jazz. Except for the very earliest jazz from New Orleans, most of jazz history is preserved on record.

The industry itself underwent a huge technological advance in the 1920s. Before 1925, recordings were made with an acoustical horn that would capture the sound of the musicians huddled in front of it and transfer the vibrations to a cutting stylus that cut grooves into a wax disc. This was known as the **acoustical process**. No electricity was used. But this technology was problematic: the horns themselves were inefficient, making the music sound "tinny," and although musicians had to pack themselves closely around them to be heard, loud sounds such as drums would make the cutting stylus skip and ruin the take. Because of this, on many early recordings, drummers were reduced to playing small temple blocks that made a clopity-clop sound.

In 1925, microphones were introduced to transfer the acoustical energy to an electric signal, which was in turn fed to the cutting stylus. Although this did not solve the sensitive stylus problem, microphones were much more efficient in capturing sound realistically, and recordings made with the new **electrical process** generally sound much better than those made previously. As with the acoustical process, discs rotated at 78 revolutions per minute (rpm), limiting the length of a recorded song to slightly more than three minutes. Because commercially sold 78s could have one song on each side, recorded songs were often referred to as "sides" in those days. In the early years of electrical recordings, only one mic was used; eventually, engineers began using several mics to have more control over the mix of the instruments. Of course, throughout the years, technological advancements have dramatically improved the quality and fidelity of electrical recordings.

Although Okeh, Victor, Paramount, and other small independent recording labels had studios in Chicago, one of the most important was 250 miles away in Richmond, Indiana. The **Gennett Studio** was where

Black-and-tans were cabarets where Blacks and whites drank and danced together.

Before 1925, recordings were made with an acoustical horn that would capture the sound of the musicians huddled in front of it and transfer the vibrations to a cutting stylus that cut grooves into a wax disc. This was known as the **acoustical process**.

Electrical process involves microphones in transferring the acoustical energy to an electrical signal.

© Getty Images

Although Victrola phonograph players had been available since the early 1900s, it was not until the 1920s that record sales took off.

Music Analysis

Track 13: "Dippermouth Blues"

(Oliver) King Oliver's Creole Jazz Band recorded April 6, 1923. Personnel: Oliver, Armstrong: cornet; Johnny Dodds: clarinet; Baby Dodds: drums; Honore Dutrey: trombone; Lil Hardin: piano, Bud Scott, banjo

"Dippermouth Blues" was recorded at the Gennett Studio in Richmond, Indiana, using the acoustical process that was state of the art for its day. The sides that were recorded in the two-day session are considered to be the first important ensemble jazz recordings. The personnel in King Oliver's band had been together for almost a year by this time, and these recordings give us a glimpse of the finest New Orleans Style jazz ensemble playing at their peak. Oliver's solo, as well as the impromptu shouting of "Oh, play that thing" near the end of the song, were faithfully recreated in nearly all of the many recordings of this song that were made in the 1920s and 1930s by other bands.

0:00	Introduction
0:05	Two choruses of 12-bar blues: collective improvisation
0:36	Clarinetist Johnny Dodds plays a two-chorus clarinet solo with **stop time** accompaniment
1:07	One chorus of collective improvisation
1:23	King Oliver plays a three-chorus cornet solo using a plunger mute
2:07	Banjo player Bud Scott shouts "Oh, play that thing," followed by one more chorus of collective improvisation

Stop time is the interruption of the regular beat pattern in the rhythm section, leaving two or more beats silent per bar, usually while a musician solos.

Louis Armstrong was jazz's first virtuoso.

King Oliver's Creole Jazz Band made what are generally considered to be the first important jazz recordings on April 5 and 6, 1923. Legend has it that Louis Armstrong, playing second cornet to Oliver, played so loud that he was forced to stand at the back of the room to create the proper balance between the instruments, giving those in attendance their first inkling of his overwhelming talent. Gannett was also where the New Orleans Rhythm Kings made the first interracial jazz recording with Jelly Roll Morton in July 1923, and where Morton and Bix Beiderbecke made many of their important recordings in the 1920s.

Track 13 is an excellent contrast to Track 14. The electrically recorded "Black Bottom Stomp" by the **Jelly Roll Morton's Red Hot Peppers** is of far superior sonic quality than the acoustically recorded "Dippermouth Blues." But the nature of the music is quite different as well. "Dippermouth Blues," from the seminal 1923 Oliver sessions at Gannett, is an example of the dense polyphony of New Orleans collective improvisation, which, like acoustic recording, was soon to be a thing of the past. With "Black Bottom Stomp," Jelly Roll Morton is moving in a very different direction. Virtually every note has been carefully written down or worked out in rehearsal before the session. Morton is not only using new technology in this recording but is also creating a blueprint for the future of jazz in the 1930s and 1940s.

Louis Armstrong (1901–1971)
Cornet/Trumpet/Vocal/Bandleader

The First Virtuoso

Louis Armstrong was perhaps the most important figure in the history of jazz. He did nothing short of revolutionize the performance of the music, changing its focus from the collective improvisation of the ensemble to the artistry of the soloist. He was the music's first virtuoso. As we shall see, his innovations were numerous, especially when considering that he accomplished most of them

Music Analysis

Track 14: "Black Bottom Stomp"

(Morton) Red Hot Peppers recorded September 15, 1926. Personnel: Morton: piano; Kid Ory: trombone; Johnny St. Cyr: banjo; Omer Simeon: clarinet; John Lindsay: bass; George Mitchell: trumpet; Andrew Hillaire: drums; Jelly Roll Morton: arranger

Recorded at the Victor Studios in Chicago using the electrical process, "Black Bottom Stomp" is a great recording of Jelly Roll Morton's tight and well-rehearsed Red Hot Peppers. Morton's skill at arranging and orchestration are evident here, with fine solos by Mitchell, Simeon, Morton, and St. Cyr, as well as breaks that feature Hillaire on drums and Ory on trombone. Morton's arrangement employs breaks, stop time, collective improvisation, as well as a key change to a new theme in the ragtime tradition. By incorporating a variety of textures, solos sprinkled throughout, and a climactic shout chorus at the end of the song, Morton was predating standard swing era arranging techniques by almost a decade.

	
0:00	Introduction
0:07	First theme played twice
0:22	Trumpet solo by George Mitchell, followed by Omer Simeon's clarinet solo
0:56	Second theme in new key
1:15	Clarinet solo by Simeon in low register
1:33	Piano solo by Jelly Roll Morton (band lays out)
1:51	Plunger mute trumpet solo by Mitchell with stop time accompaniment
2:10	Banjo solo by Johnny St. Cyr
2:29	Collective improvisation with drum and trombone breaks

well before he was 30 years old. He triumphed over a broken home and abject poverty of his childhood and the social oppression of his race and his music to become wealthy, famous, a cultural icon, and an ambassador to the world, not only for jazz but for America as well.

Louis spent most of his childhood in the Battlefield district of New Orleans—Black Storyville—where crime, drugs, disease, and prostitution were an everyday part of life. Throughout his life, he gave his birth date as July 4, 1900, which had a nice, patriotic, new century ring to it; however, exhaustive research has discovered that he was actually born on August 4, 1901. His father Willie was never a presence at home; his mother Mayann worked as a prostitute off and on to feed Louis and his sister Beatrice, known to everyone as Mama Lucy. Louis occasionally lived off scraps of food found in the trash behind hotels and restaurants. He was probably getting himself in trouble often as a boy; how else can you explain that after his first recorded infraction—shooting a pistol into the air during a New Year's Eve celebration in 1912—Louis was sent to an orphanage as punishment. But his time at the Colored Waifs Home for Boys was well spent—and probably saved his life. It was there that Louis first experienced structure, regular food on the table, and where he was given a cornet to play in the school band.

Young Louis showed immediate promise on the instrument and an uncanny ability to play by ear. When he was released from the home, probably in mid-1914, he drove a coal truck for a time to make some money while going about finding a place for himself in the city's burgeoning jazz scene. Without a cornet of his own at first, he could only sit in at local juke joints and cribs. When he finally bought his own cornet for $10 in 1916, he started working nightly at Matranga's, at the corner of Perdido and Franklin, in the Battlefield. It was around this time that he befriended Joe Oliver, who would become a mentor and father figure to young Louis. When Oliver left New Orleans in 1918, he urged Kid Ory, whose band he had been playing in, to hire his young protégé. Ory took Oliver's advice.

During the next four years, Armstrong worked in Ory's and a number of other top bands in town, including a stint in the Streckfus riverboat bands that sailed up the Mississippi River. As his talent and reputation grew, Louis Armstrong climbed to the top of the New Orleans jazz world.

In 1922, Louis was summoned by Oliver to come play in his Creole Jazz Band at Chicago's **Lincoln Gardens**, and on July 8, Louis—now 20 years old—boarded a train and headed north. Oliver had just moved to Chicago in April and secured the gig at the South Side dancehall in June. He wanted Louis to play second cornet in the band. Armstrong's arrival in Chicago revved up the Oliver unit. The two cornetists would often improvise solo breaks together as if they had been planned out ahead of time. Louis, playing second cornet to "Papa Joe," seemed to intuitively know what his mentor was going to do next. They became the talk of the town. In the year and a half that the Creole Jazz Band played at Lincoln Gardens, they brought the New Orleans collective improvisational style to its apotheosis.

But Armstrong left the group in 1924. Partly at the urging of his new wife Lil (who was also Oliver's pianist), Louis accepted an offer to play with the hottest band in New York, the **Fletcher Henderson Orchestra**. Appearing at first to be an unsophisticated rube, the New York musicians soon learned that they were in the presence of a very sophisticated musical genius. As one of the featured soloists in the Henderson band, Armstrong made an indelible impression on Henderson, his fellow arrangers, and soloists. By this time, Armstrong had begun to play with a freer rhythmic feel and had abandoned the tighter, ragtime-type of syncopated rhythms that characterized much of early jazz. His solos were now fluid and flowing, and carried a sense of forward motion that was new and different. He had, in effect, created modern swing rhythm as we know it today. Like so many of Armstrong's innovations, when other musicians heard him swing, they instinctively knew that this was the way of the future. He literally taught the musicians in the Henderson Orchestra how to swing, and they in turn taught the rest of New York's musicians. Almost immediately, Henderson's became the hottest and most innovative band in New York.

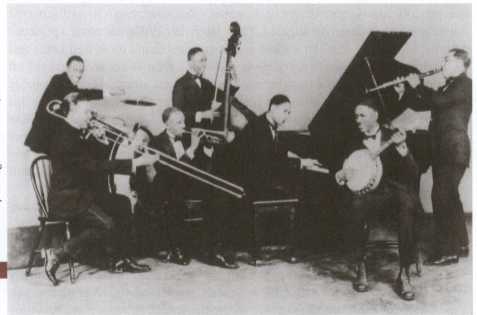

© Courtesy of Rutgers Institute of Jazz Studies

Jelly Roll Morton (at the piano) with his innovative seven-piece band, the **Red Hot Peppers**.

The Hot Five and Hot Seven

Louis Armstrong left the Henderson band in 1925 and returned to Chicago. Legend has it that he wanted to sing, which Henderson would not allow. But the apex of his career was still ahead of him. During the next four years, Louis Armstrong did nothing short of revolutionize the way jazz was created and performed. Okeh Records organized a series of recording sessions with an all-star New Orleans lineup of Johnny Dodds, Johnny St. Cyr, and Kid Ory, along with Armstrong's Memphis-born wife Lil. With this group, alternately called the **Hot Five** and **Hot Seven** (when two additional members were added), Louis recorded 65 sides between 1925 and 1928 (the group also played one promotional gig for Okeh). These records are perhaps the most important in the history of jazz. Even though the earliest Hot Five records are highly flavored by the New Orleans sound, Armstrong is the center of attention. His solos were so dramatic and attention-getting that it is clear that the music would have to eventually evolve into a vehicle for one soloist at a time to "tell his story." By the time of the last Hot Five recordings in late 1928, this evolution was complete, changing forever the way jazz was to be performed.

But this is not all Louis Armstrong did in the context of the Hot Five recordings. He also began playing his horn in the upper register, changing its sonic territory in jazz and helping to bring about the demise of the clarinet. (Clarinet players, sensing that the trumpet was crowding their space, began to increasingly turn to the lower-pitched saxophone as their main instrument.) He switched to the trumpet, which all cornetists eventually did, relegating the latter instrument to a novelty status. His superior conception of sound quality, technique, and sense of musical construction served notice that he was the first true jazz virtuoso. He brought a new vernacular of musical ideas and licks to jazz, which, as jazz musicians of every instrument began to copy, would overwhelmingly shape the sound of the music for the next 20 years, and continue to influence it even to this day. With his blues-inflected musical ideas honed in the cribs and juke joints of New Orleans, he ensured that the blues would continue to be an essential part of the

Scat singing involves an improvised solo sung by a vocalist using nonsense syllables.

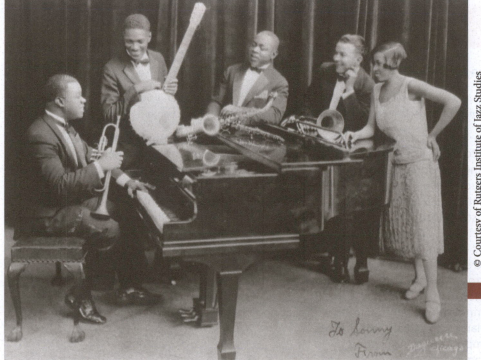

© Courtesy of Rutgers Institute of Jazz Studies

Louis Armstrong's Hot Five. (from left to right: Armstrong, Johnny St. Cyr, Johnny Dodds, Kid Ory, and Lil' Hardin Armstrong.)

jazz vocabulary. One of the early Hot Five recordings also included one of the first examples of scat singing. According to legend, halfway through the verse on "Heebie Jeebies" he dropped the lyric sheet and was forced to ad-lib in order to save the take. In later years, both Kid Ory and Lil Armstrong refuted this story, saying that Louis had planned it all along. Recorded in 1926, "Heebie Jeebies" became Louis Armstrong's first hit record.

Armstrong's Trumpet and Vocal Style

Armstrong was the very definition of a hot player. He brought excitement and drama to the improvised solo like no one else before him. He employed a variety of tricks and inventions, like ripping up to high notes, fast tonguing, slurring and bending notes, and rhythmically floating above the beat. He also had a brilliant tone that cut through in any musical context. Armstrong's singing, often overlooked in its importance, has also had a tremendous impact on not only jazz but popular music as well. He is considered to be the first important vocal interpreter of jazz and popular songs. Although not as expressive as his trumpet playing, the relaxed phrasing of his singing was copied by many. Billie Holiday, who is widely regarded as the first great jazz vocalist, as well as Bing Crosby and Frank Sinatra, the first American pop stars, have all credited Armstrong's singing as heavily influencing their own.

The most important recording of all the Hot Five sessions came on June 28, 1928. The group, which had undergone some personnel changes and now included Earl Hines on piano, recorded a King Oliver composition called "West End Blues" that began with a stunning cadenza that startled the jazz world. Utilizing the full range of the instrument and a variety of time shifts and blues inflections, Armstrong's fanfare became one of the most widely copied musical statements in the history of jazz. But that was just the beginning: Armstrong also contributed a scat solo, and his full chorus at the end of the song is just as astonishing as the opening cadenza, starting with a note at the top of his range that is held for a full 10 seconds before he descends into a furious salvo of syncopation.

> A **cadenza** is a short, unaccompanied instrumental solo, usually near the end of a performance. In jazz, cadenzas are usually performed without a regular pulse.

Music Analysis

Track 15: "West End Blues"

(Oliver/Williams) Louis Armstrong and His Hot Five recorded June 28, 1928. Personnel: Armstrong: vocal, trumpet; Earl Hines: piano; Zutty Singleton: drums; Jimmy Strong: clarinet; Fred Robinson: trombone; Mancy Cara: banjo

"West End Blues" is the most celebrated recording of the Hot Fives and Sevens, and features Armstrong's famous opening trumpet cadenza. Recordings like this helped transform jazz from the ensemble orientation of the New Orleans Style to a vehicle for the individual expression of the soloist. Also notable is Armstrong's solo during the song's fifth chorus, which includes complex syncopations and notes played in the extreme upper register of the trumpet. On "West End Blues," the Hot Five included Earl "Fatha" Hines on piano, who contributes a fine solo and closing cadenza. Armstrong also adds some light scat singing during Jimmy Strong's reflective clarinet solo.

0:00	Louis Armstrong's opening trumpet cadenza
0:13	First chorus: head stated by Armstrong
0:50	Second chorus: trombone solo by Fred Robinson; note the clopity-clop accompaniment by drummer Zutty Singleton
1:24	Third chorus: clarinet solo by Jimmy Strong with scat singing accompaniment by Armstrong
1:59	Fourth chorus: piano solo by Earl "Fatha" Hines
2:32	Fifth chorus: trumpet solo by Armstrong
2:56	Piano cadenza, tag

"West End Blues" was a clarion call to the rest of the jazz world that the rules for jazz performance had permanently changed; it was now the music of individual expression rather than an ensemble-based music. For Armstrong, it was just the latest example of his musical genius.

"Fatha"

While Armstrong was in Chicago during the years of the Hot Five and Sevens, he was also busy performing for live audiences. His first club gig after returning from New York was at the Dreamland in a band fronted by his wife, Lil. Within a month he joined the Erskine Tate Orchestra at the Vendome Theatre, playing for silent films. It was here that he began to play the trumpet for the first time, an instrument that he ultimately switched to full time. In the spring of 1926, Armstrong moved to the Sunset Café and the band of violinist Carroll Dickerson. Billed now as "Louis Armstrong, World's Greatest Trumpet Player," Armstrong was becoming a star, playing to packed audiences every night. The band, which eventually became known as Louis Armstrong's Stompers, also included a 22-year-old pianist from Pittsburgh named Earl Hines.

Earl "Fatha" Hines (1903–1983)

Earl "Fatha" Hines was an important transitional player in the evolution of jazz piano. At a time when stride piano was still very much in vogue, Hines was already developing a new, more modern style that became known as the **trumpet style**. Hines avoided the heavy-handedness of stride, replacing the plodding boom-chuck left hand with a more syncopated and rhythmically free approach. In addition, he often played brilliant right-hand runs played in **octaves** that critics compared to Armstrong's trumpet playing. Hines and Armstrong developed a competitive friendship in the two years that they worked together that brought out the best in each other's playing.

After his stint at the Sunset Café, Hines went on to lead his own big band that stayed at Chicago's Grand Terrace Ballroom from 1928 to 1938, eventually breaking up in 1948.

> At a time when stride piano was still very much in vogue, Hines was already developing a new, more modern style that became known as the **trumpet style**.
>
> An **octave** is the interval measuring eight diatonic (scale) steps; i.e., **C**-D-E-F-G-A-B-**C**.

Music Analysis

Track 16: "Weather Bird"

(Oliver) Louis Armstrong and Earl "Fatha" Hines recorded December 5, 1928

"Weather Bird" is a great example of the electricity that was created when Louis Armstrong and Earl "Fatha" Hines played together. This gem was recorded after the two had worked together for more than two years at the Sunset Café, during which time Hines had also recorded several sides with Armstrong as a member of the Hot Five. Hines's solo at 0:41 is a good example of the right-hand octave technique that was characteristic of the trumpet style.

0:00	Introduction
0:04	Head is stated by Louis Armstrong on trumpet with Hines accompanying
0:43	Hines takes a short solo that demonstrates his use of octaves in the right hand
1:01	Armstrong re-enters with an improvised solo
1:25	Hines solos
1:44	Armstrong solos
2:02	Armstrong and Hines trade two-bar solos before bringing the song to an end

Armstrong's Later Career

In 1929, Louis moved back to New York to embark on a career as a bandleader, popular entertainer, and film star. That same year, he appeared on Broadway in Fats Waller's hit show *Hot Chocolates,* and stole the show with his singing of Waller's "Ain't Misbehavin." During the 1930s and 1940s, he recorded jazz versions of Tin Pan Alley pop songs, which drew criticism from jazz purists. However, Armstrong would once again prove to be in the jazz vanguard, as the practice of recording "standards" would eventually be adopted by virtually every jazz musician and continues to this day. In 1947, he starred in the Hollywood movie *New Orleans* with Billie Holiday, one of more than 50 films in which he appeared. Even as his fame spread throughout the world and Armstrong became a millionaire, he continued to tour and perform up until his last days.

One of Armstrong's more remarkable achievements came in April 1964 when his recording of "Hello, Dolly" knocked the Beatles off the number one spot on the *Billboard* chart (at the time, they were so popular that they held the top *five* spots). And in 1988, 17 years after his death, Louis Armstrong had one more hit song when his 1967 recording of "What a Wonderful World" was included in the movie *Good Morning Vietnam.* The last of the New Orleans cornet kings turned out to be the King of kings.

White Chicago

The Austin High Gang

As the newly migrated New Orleans musicians were making their mark in Chicago playing jazz in the 1920s, they were inspiring a new crop of local musicians to begin playing the music. These new players were young; in fact, many were still teenagers. Most of them lived in the comfortable middle-class neighborhoods on the north and west edges of the city. And, they were white. Now, this was really a new development. With only a few exceptions (such as the ODJB and the NORK), up to this point playing jazz had been the province of Blacks and Creoles from New Orleans, and professional musicians at that. These were white, middle-class teens that were still in high school! For them, playing in a jazz band was something that they knew their parents or teachers would not approve of. In fact, it was nothing short of an act of rebellion. Playing jazz meant that those who were already musicians had to renounce their formal studies and the proper way to play music, and admitting to the ability to read music. Teens who were not already musicians began to learn—not by taking lessons and learning scales, but by listening to Louis Armstrong records. But no matter—they were smitten by the rhythms and hot improvisations, and they had to give it a shot. Like rock and roll would be for a future generation 30 years later, jazz became an irresistible magic potion.

Among the first was a group of schoolmates that went to Austin High School, in the west side neighborhood of suburban Oak Park. One day in 1922, hanging out after school at the ice cream parlor across the street called the Spoon and the Straw, the boys were introduced to the sound of the New Orleans Rhythm Kings on the nickelodeon. The reaction was swift, as Jimmy McPartland recalled: "Boy, when we heard that, I'll tell you, we were out of our minds. Everybody flipped . . . and we decided we would get a band and try to play like these guys."

The **Austin High Gang**, as they would soon be called, included Jimmy McPartland on cornet, his brother Dick McPartland on guitar, Frank Teschemacher on clarinet, and Bud Freeman on tenor sax. Soon Dave Tough from the Lewis Institute started to play drums, Joe Sullivan joined in on piano, and Mezz Mezzrow on clarinet and sax. Eventually, this first generation of Chicago jazz musicians

Austin High Gang

- Jimmy McPartland
- Dick McPartland
- Frank Teschemacher
- Bud Freeman
- Dave Tough
- Joe Sullivan
- Mezz Mezzrow

would include Eddie Condon on guitar and banjo, Benny Goodman and Pee Wee Russell on clarinet, Jimmy Dorsey on alto sax, Tommy Dorsey on trombone, and Gene Krupa on drums.

The Chicago Style

The jazz that the Austin High Gang and other white Chicago musicians played became known as the Chicago Style. Its roots were in the New Orleans Style, but the music was evolving and some important changes were beginning to become noticeable. Although the New Orleans front line concept was retained, the saxophone started to appear as one of the primary instruments. Collective improvisation, while not completely discarded,

© Courtesy of Duncan Scheidt

The Austin High Gang. Left to right: Frank Teschemacher, Jimmy McPartland, his brother Dick McPartland, Bud Freeman, and his brother, Arny Freeman.

was slowly de-emphasized in favor of simple ensemble passages where the front line instruments played pre-arranged, simple statements of the melody. This also meant that the new practice of one-solo-at-a-time as pioneered by Louis Armstrong became more predominant. And reflecting the new more urban setting, the Chicago Style had more drive and energy than the more relaxed New Orleans Style. **Box 4-1** lists the characteristics of the Chicago Style.

> The jazz that emerged from the Austin High Gang and other white Chicago musicians became known as the **Chicago Style**.

Bix Beiderbecke (1903–1931) Cornet/Piano/Composer

The First White Innovator

The most important of the first generation of Chicago white jazz players was not actually from Chicago, but instead from the Mississippi River town of Davenport, Iowa. Although he grew up in a strict German family, Bix Beiderbecke was drawn to jazz early on when he heard it played on the riverboats that came up the Mississippi from New Orleans. Despite the fact that Bix was never one to work hard at anything, including his studies, he showed remarkable promise first on the piano and then the cornet at a very early age. However, his parents were unhappy with his progress in school, and 1921 sent him to the Lake Forest Academy, a strict prep school northwest of Chicago, with the idea of getting him to focus on school. Unbeknownst to the elder Beiderbecke's, Chicago was by now the center of the jazz world, and its proximity to their son's new school would certainly not be conducive to his studying habits. Sure enough, Bix attended

BOX 4-1 Characteristics of the Chicago Style

- New Orleans front line, with saxophone increasingly added
- Simple ensemble passages; de-emphasized collective improvisation
- More emphasis on improvised solos in one-solo-at-a-time format
- More drive and energy in the rhythm section

Music Analysis

Track 17: "Singin' the Blues"

(Robinson/Conrad/Lewis/Young) Frankie Trumbauer and His Orchestra recorded February 4, 1927. Personnel: Trumbauer: C-Melody sax; Bix Beiderbecke: cornet; Eddie Lang: guitar; Jimmy Dorsey: clarinet; Chauncey Morehouse: drums; Bill Rank: trombone; Paul Mertz: piano

This recording of "Singin' the Blues" shows off the lyrical and melodic styles of both Frank Trumbauer and Bix Beiderbecke that were influential to future cool jazz soloists. Bix's relaxed style and bell-like tone were in sharp contrast with the fiery playing and tone of Louis Armstrong, making him one of the most important jazz innovators of his day. Trumbauer is the only important jazz saxophonist to have specialized in playing the C-Melody sax, an instrument that is nearly extinct today. Eddie Lang, one of the first great jazz guitarists, also contributes outstanding accompaniment fills throughout the piece. Also featured is future swing era bandleader Jimmy Dorsey on a short clarinet solo. As was fairly typical of Chicago Style, a short section of collective improvisation is included at the end of the song.

0:00	Introduction
0:07	Head played by Frank Trumbauer on C-Melody sax with guitar fills in background by Eddie Lang
1:02	Cornet solo by Bix Beiderbecke; Lang's fills continue
1:59	Collective improvisation "with a short" clarinet solo by Jimmy Dorsey

classes for only a few weeks before immersing himself in the local music scene and helped form a group called the Wolverines in 1923. Even though he was self-taught on the cornet, by this time he had developed a beautiful bell-like tone on the instrument. His idiosyncratic fingering patterns produced a style of playing that was lyrical and melodic. All in all, he was a striking contrast to the brilliant toned, virtuosic Louis Armstrong. But his effect on listeners was just as dramatic: when Chicago guitarist Eddie Condon first heard Bix play, he said, "The sound came out like a girl saying yes." It was not long before Bix Beiderbecke became the spiritual leader of the white Chicago scene.

Tram

Bix also began living the bohemian lifestyle to the fullest. A quiet, sensitive man by nature, alcohol helped him overcome his shyness and become more extroverted. By playing, hanging out, and making the scene in the speakeasies and cabarets in and around Chicago, Bix had a lot of opportunities to drink, and it was not long before he had a prodigious appetite for the substance. One calming influence in his life was his friend, saxophonist **Frank "Tram" Trumbauer**, whom he met in 1925. Trumbauer, or Tram as he was called, was a family man and not a partier, but looked after Bix and became a kind of big brother to him. Tram was also Bix's musical soulmate. Playing the **C-melody sax**, Tram's lyrical style matched well with Bix's, and the records they made together as the Frankie Trumbauer Orchestra are among the most enduring of the jazz age. Trumbauer also became a major influence to one of the most important tenor saxophonists of the swing era, Lester Young.

Bix and Tram both moved to New York in 1926 to play in the society dance bands of Jean Goldkette and Paul Whiteman. Whiteman had one of the most popular dance bands on the East Coast, and the exposure Bix received playing at ballrooms, and on recording sessions and radio broadcasts made him famous. Bix also wrote and recorded a few impressionistic solo piano original

The **C-melody sax** is a saxophone that was popular in the 1920s and 1930s that was similar in sound and range to the alto saxophone.

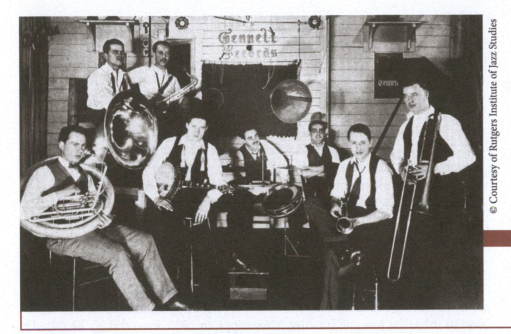

Bix Beiderbecke (second from right) with the Wolverines at their first recording session at the Gannett Studio, Richmond, Indiana, on February 18, 1924.

compositions in 1927, including the famous "In a Mist." But by this time his life-style was catching up with him. On September 15, 1929, two days after leaving a recording session early, Bix was sent home to Davenport where he was treated for alcoholism. Paul Whiteman assured him that he could return anytime and have his job back. Although Bix returned to New York in April 1930, his health remained fragile, and he was not able to return to the Whiteman Orchestra. Although he resumed playing on a limited basis, his decline continued, and on August 6, 1931, he died while suffering a delirium tremens seizure.

Bix Beiderbecke's tragic life has been romanticized and glamorized throughout the years. In many ways, he is the poster boy for the jazz age, living fast and dying young. In 1950, the movie *Young Man with a Horn*, starring Kirk Douglas, was released, based loosely on Bix's life and further enhancing his legend. It can be said, however, that during his life he was widely admired by both Black and white musicians for the beauty of his tone and the clarity of his musical mind.

The Demise of the Chicago Scene

By the late 1920s, a number of factors led to the demise of the Chicago jazz scene. Perhaps the biggest reason lay 1,000 miles to the east. New York was increasingly becoming the center of everything. Jobs for musicians were plentiful, as nightclubs, theatres, and dance halls were everywhere. The burgeoning radio and recording industries were centered there, as was the established sheet music publishing empires of Tin Pan Alley. (The New York scene will be discussed in more detail in Chapter 5).

But there were other reasons Chicago fell from grace. By the end of the 1920s, brutal gang wars that culminated in the February 14, 1929, **St. Valentine's Day Massacre** had solidified public support to force a crackdown on crime. As police raids intensified, mob violence actually increased for a while, making clubs even more unsafe for jazz musicians. In 1931, Al Capone was finally sent to prison, Mayor Big Bill Thompson was defeated in his bid for reelection, and political reformers moved in. In October 1929, the stock market went into free fall, signaling the beginning of the Great Depression. And in a final blow to the jazz age in Chicago, the Twenty-First Amendment was passed in 1933, repealing the Eighteenth Amendment and ending Prohibition. The era of speakeasies and loose morals was over.

Classic Blues

The Blues as Popular Music

On August 10, 1920, vaudeville singer and dancer Mamie Smith (1890–1937) went into the Okeh Studio in New York and recorded a song called "Crazy Blues." Smith had recorded for Okeh earlier in the year and figured "Crazy Blues" would sell a few thousand records, enough to eke out a small profit. Astonishingly, it sold 75,000 copies within a month, one million the first year, and eventually two million copies. The success of "Crazy Blues" alerted the recording industry to the existence of the Black consumer market, which up to that point they had overlooked. Suddenly, the rush was on to find the next blues singer to put out the next big hit. And so began the Classic Blues Era.

The classic blues records were not the public's first exposure to the blues. During the 1910s, the blues first became popular through songs that were sold on sheet music. The man most responsible for this was W. C. Handy (1873–1958), known as the "Father of the Blues." Handy was a college-educated bandleader from Alabama who first heard the blues performed by a musician at a train station in the Delta town of Tutwiler, Mississippi, in 1903. Even though he called it "the weirdest music I had ever heard," Handy admitted, "the tune stayed in my mind." After a number of other incidents throughout the South where he heard musicians playing similar songs, Handy began to wonder if the music had any commercial potential. Eventually, he began to notate and publish the blues tunes he heard. In 1912, his "Memphis Blues" became the first 12-bar blues hit, and its success prompted a number of other songs with the word "blues" in the title. In short order, the blues overtook ragtime in popularity. Handy's biggest hit, "St. Louis Blues" was published in 1914 and become one of the most recorded and performed songs in the first half of the 20th century. The success of "Memphis Blues," "St. Louis Blues," and others helped to standardize the 12-bar blues form, whet the public's appetite for the blues, and set the stage for the dramatic record sales of the classic blues singers in the 1920s.

Race Records

In the wake of "Crazy Blues," countless records were released throughout the 1920s that followed the same basic formula. Black female vocalists sang songs with a tragic, mournful delivery. The songs in many cases were not even 12-bar blues tunes, but usually had the word "blues" in the title. Accompanying the singer was a small band, usually with a few horn players. The classic blues singers, some of whom were pop rather than blues singers, usually had some previous experience in show business, either through recordings, minstrel shows, vaudeville acts, or tent shows, so they knew how to sell a song. The classic blues records had typical blues themes (sex, lost love, out of luck, etc.), but were now sung from a woman's rather than a man's perspective. They also helped to standardize blues singing techniques. Classic blues records sold extremely well throughout the 1920s, but the Depression of 1929 killed record sales and brought the era to a close.

Classic blues recordings fit into a broad category of records that became known as race records. These generally included any recordings made by a Black artist marketed to a Black audience. Race records were released on race labels such as Okeh, Vocalion, Black Swan, and Brunswick that targeted the Black consumer. These race distinctions were replaced in 1949 when *Billboard*

Classic Blues Performers

- Mamie Smith
- Gertrude "Ma" Rainey
- Bessie Smith
- Alberta Hunter
- Ida Cox
- Victoria Spivey
- Chippie Hill

W. C. Handy was known as the "Father of the Blues."

Classic blues records were sold on subsidiary labels set up by the major record companies, which became known as **race records**.

Theatre Owners Booking Agency (TOBA) was an agency based in New York that was responsible for booking classic blues singers on traveling tent shows.

Magazine came up with a new term to describe Black popular music: Rhythm & blues. Because the classic blues singers were often not paid much for their efforts in the studio, touring was necessary to make a living. Many were booked on traveling tent shows on circuits throughout the South by the **Theatre Owners Booking Agency (TOBA)**, based in New York. Traveling the "territories" as they were called was a difficult life, with low pay and often hundreds of miles on unpaved roads between gigs. With a grim sense of humor, TOBA came to stand for Tough on Black Artists (or Asses) by its clients.

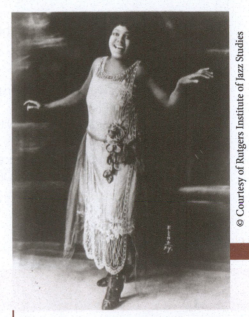

© Courtesy of Rutgers Institute of Jazz Studies

Often called the "Empress of the Blues," **Bessie Smith** was one of the most influential of the classic blues singers.

The Empress of the Blues

There were a number of classic blues singers that achieved varying degrees of success during the 1920s. They included Gertrude "Ma" Rainey (1886–1939), often called "The Mother of the Blues," Alberta Hunter (1895–1984), Ida Cox (1896–1967), Victoria Spivey (1908–1976), and Chippie Hill (1905–1950). The most influential and greatest of the classic blues singers was **Bessie Smith** (1894–1937), often called the "Empress of the Blues." Smith was the epitome of the hard-drinking, hot-tempered blues singer. She was a big, physical woman, who was known to beat up rivals and be foul-mouthed to audiences. Her sexual appetite was seemingly uncontrollable and often had violent altercations with lovers. But audiences loved her, and she was one of the top-selling artists of the 1920s.

Smith was born in Chattanooga, Tennessee, where she was discovered singing on street corners by Ma Rainey. After touring with Rainey and a number of other small-time acts throughout the rural South, Smith made her first record, "Downhearted Blues" in 1923. It sold 750,000 copies and immediately established her as a star. Within a year, her sold-out concert appearances were causing those who could not get in to riot. In 1925, she recorded "St. Louis Blues" with Louis Armstrong, and in 1929, she appeared in a film short singing the song. Smith sold well throughout the 1920s, but like the other classic blues singers, her career began to slide by the end of the decade. In November 1933, Bessie recorded four songs in a comeback attempt produced by impresario John Hammond that included "Gimme a Pigfoot and a Bottle of Beer." Unfortunately, it turned out to be her last recording session. In September 1937, she was tragically killed in an automobile accident just outside Clarksdale, Mississippi, on the way to a gig. Hammond later fabricated a story in *DownBeat* magazine that her death was the result of being refused admittance to a "whites only" hospital. Although the story was widely repeated throughout the years, it was later proved to be untrue.

Bessie Smith's powerful, growling, and mournful style of singing was influential to singers ranging from Louis Armstrong to Janis Joplin. In fact, Joplin helped purchase a headstone for Smith's unmarked grave outside Philadelphia in 1968. The characteristics of the classic blues are listed in **Box 4-2**.

BOX 4-2	Characteristics of the Classic Blues

- Black female vocalists
- Expressive, tragic vocal delivery
- Songs were sung from a woman's perspective
- Repertoire: 12-bar blues, pop songs
- Small-group accompaniment often with horns
- Experienced, professional entertainers
- Sold large quantities of records on "race" labels
- Theatre Owners Booking Agency—TOBA

Music Analysis

Track 18: "Gimme a Pigfoot and a Bottle of Beer"

(Wilson) Bessie Smith recorded November 24, 1933. Personnel: Smith: vocal; Benny Goodman: clarinet; Jack Teagarden: trombone; Frankie Newton: trumpet; Chu Berry: tenor sax; Buck Washington: piano; Bobby Johnson: guitar; Billy Taylor: bass

One quickly gets a sense of the swagger and temperament of Bessie Smith from the spoken narrative that begins "Gimme a Pigfoot and a Bottle of Beer" (a pigfoot, like hog jowls and pork rinds, was a snack food enjoyed by many poor rural Southerners). This recording comes from Smith's John Hammond produced last recording session, and included heavyweight session players Benny Goodman and Jack Teagarden. "Pigfoot" is fairly up-tempo, making it a rarity for Smith, who preferred slow grinders. The song is also fairly typical of the classic blues style in that it is not a 12-bar blues at all, but a pop tune sung in a bluesy and growling style.

0:00	Introduction with Buck Washington's piano and Bessie Smith's spoken words
0:19	Verse is sung
0:57	Refrain ("Gimme a Pigfoot . . .")
1:47	Smith repeats the refrain

Name _____ Date _____

The Jazz Age

1. Describe the changes in recording technology in the 1920s.

2. Name the ways in which Louis Armstrong's Hot Five and Hot Seven recordings had an impact on the evolution of jazz.

3. Describe how the Chicago Style is different from the New Orleans Style, not only in the music itself but also in the circumstances surrounding its creation.

4. Describe the club scene in Chicago in the 1920s.

5. Describe how the classic blues singers were different than the country blues singers, in their music and the circumstances, environments, etc.

6. Describe the differences between the styles of Louis Armstrong and Bix Beiderbecke.

7. How and why did organized crime have an impact on the jazz world in the 1920s?

8. Describe the role that W. C. Handy played in American music in the early 1920s.

9. Describe how the music of the Red Hot Peppers and King Oliver's Creole Jazz Band differed in sound and performance.

10. In what ways did Louis Armstrong influence jazz and American popular music?

NEW YORK AND KANSAS CITY

Introduction

During the late 1920s and early 1930s, a number of social and economic forces were coming together that would ultimately transform pop culture in America. During these pre-swing era years, the music business was rapidly changing and becoming more centralized, radio networks were launched that increased its already powerful influence, and public dancing was becoming more and more popular as a way for people to forget about their troubles. Jazz was rapidly changing to keep abreast with these developments, and during these years the typical jazz ensemble grew in size, smoothed out its rhythms, and standardized its instrumentation. As Chicago declined in influence, the most important centers for the development of jazz became New York and Kansas City. As the largest city in America, New York had always been an important music city and was a logical destination for musicians looking for work. Many of the top Chicago jazz musicians moved there in the late 1920s and early 1930s, and found literally thousands of nightclubs, speakeasies, cabarets, and dancehalls. Although new African American residents of the city celebrated their cultural achievements, some were not yet ready to accept jazz as one of them.

Kansas City on the other hand, with its isolated, rural setting, was an unlikely locale to support an important music scene. Nonetheless, Kansas City was the most wide-open town in America, and the music that came out of it was exciting, modern, and drenched in the blues. Like New Orleans and Chicago before them, New York and Kansas City each had a rich tradition of mixing politics and corruption that was good for jazz.

New York City

The Harlem Renaissance

As an important destination point for the Great Migration, by 1920, the northern Manhattan neighborhood of Harlem had become the largest black community in America. Between 1900 and 1920, the Black population of Harlem rose from 60,000 to 150,000; by 1930, it would be 220,000. Along with the new immigrants came optimism and a belief that the city was experiencing an awakening of the "New Negro." The **Harlem Renaissance**, as it was called, was focused on the arts: theatre, literature, art, poetry, and music. The intellectual leaders of the movement envisioned a new Black world of high culture that white America would have to accept and recognize. A Culture that was, as civil rights activist W. E. B. DuBois said, "about us, by us, for us, and near us." Other leaders of the Harlem Renaissance included authors Zora Neale Hurston, James Weldon Johnson, Langston Hughes,

Clouds of Joy	Irving Berlin	Oscar Hammerstein II
Cole Porter	Irving Mills	Paul Whiteman
Count Basie Orchestra	James "Bubber" Miley	Richard Rodgers
Don Redman	Jay McShann Orchestra	Tom "Boss" Pendergast
Duke Ellington	Jerome Kern	
Fletcher Henderson	Joe Williams	**MUSIC STYLES**
George Gershwin	Lester Young	Kansas City Style
Herschel Evans	"Little" Jimmy Rushing	Symphonic Jazz
Ira Gershwin	Lorenz Hart	Jungle Style

The **Harlem Renaissance** was focused on the arts: theatre, literature, art, poetry, and music.

Sweet bands were bands that played mild, syncopated dance music.

and Black Nationalist Marcus Garvey. During the 1910s, political and activist organizations also emerged in Harlem that were associated with the movement, including the NAACP and the Universal Negro Improvement Association.

Curiously, jazz did not fit into this scenario for some middle-class Harlemites. The music of dance halls and speakeasies was not high culture, according to many of the newest citizens of Harlem who were more than ready to disassociate themselves from jazz. Jazz for them was a reminder of the South and the lower class, two things they had hoped to escape from by moving north. However, it surely would have been hard to avoid hearing jazz, because it was all over the place in Harlem in the 1920s and the 1930s. You could hear it in dancehalls like the Savoy, Renaissance, and Roseland Ballrooms. You could hear it in nightclubs like the Cotton Club, Connie's Inn, and Small's Paradise. It was jazz that to a large degree drew white America to Harlem to get a voyeuristic taste of the exotic world of the African-American.

The New York Club Scene

Ironically, what white patrons saw when they took the fifteen-minute taxi ride up to Harlem was a world that was to a large degree manufactured for them *by* whites—specifically, white gangsters. Owney "The Killer" Madden, proprietor of the Cotton Club, was one of the white downtown gangsters that controlled much of the Harlem nightlife by bootlegging liquor to speakeasies and operating exclusive nightclubs that catered to rich and famous patrons. The high prices at these clubs essentially instilled a "whites only" policy by keeping the local middle-class Blacks out. The "Big Three" were Connie's Inn at 131st Street and Seventh Avenue, where an evening out cost an average of $15 per person in 1929; Small's Paradise, a huge club at 135th and Seventh Avenue with space for fifteen hundred customers; and the Cotton Club, the "Aristocrat of Harlem" at 142nd and Lenox Avenue. Opened in 1922 and operated by Madden with space for five to seven hundred patrons, the Cotton Club was a vestige of the Jim Crow South. The name itself was a slap in the face to Black, evoking the memory of the crop most associated with slavery and plantations. The exterior of the club had a log cabin façade, while the backdrop to the stage was a replica of a plantation house. There were murals depicting primitive African life on the wall. The band played "jungle music" while dancers performed in elaborate, risqué floorshows that had themes of darkness, danger, and Africa.

Harlem was not the only part of New York where one could hear music: there were thousands of illegal drinking establishments all around the city during Prohibition. Downtown nightclubs had names like the Moulin Rouge, Café de Paris, Trocadero, and the Hollywood Club, a dingy basement dive at West 49th and Broadway. Clubs like these were the domain of white commercial **sweet bands**, although occasionally a top Black band like Duke Ellington's was hired. Like the big Harlem clubs, these clubs were run by gangsters and featured lavish floorshows.

Uptown and downtown there were also **taxi-dance halls** and theatres like the Lafayette (with two thousand seats) and the Apollo Theatre on 125th Street in Harlem that specialized in vaudeville acts, stage shows, and musical revues.

Dancing and the Dance Halls

Harlem was also home to some of the biggest dance halls in the country in the 1920s. Dance halls became a popular place for folks to meet and socialize with their new neighbors, and admission—usually around 50 cents—was cheap and certainly affordable to most Harlemites. Although the majority of the dancers were Black, whites also attended dances at these ballrooms. The hottest Black bands in New York, led by Fletcher Henderson, Chick Webb, Cab Calloway, and others provided the music. Among the most popular halls were:

- The Renaissance Ballroom at 138th Street and Seventh Avenue
- The Alhambra Ballroom at 126th and Seventh Avenue
- The largest and most famous was the **Savoy Ballroom**, the "Home of Happy Feet." Opened in 1926, the Savoy covered an entire block between 140th and 141st Streets on Lenox Avenue and could hold 3,500 people. Its dance floor was 250' long with two stages so that two bands could alternately play non-stop music.

The Savoy was the scene of many **Battle of the Bands**, where the winner was determined by the vote of the dancers. One of the most notorious battles occurred on May 11, 1937, when the most famous big band in America, the Benny Goodman Orchestra invaded to take on the Savoy's resident band, the Chick Webb Orchestra. Goodman, the "King of Swing" was soundly defeated by the local favorites.

The Savoy was also where the biggest dance fad of the 1920s originated. In 1927, dancers started doing the **Lindy hop** as a tribute to Charles Lindbergh's famous solo "hop" across the Atlantic. The Lindy hop was an exciting, athletic dance where dancers sometimes actually threw their partners up in the air. Dances like the Lindy hop had been capturing the attention of New Yorkers throughout the 1920s with a string of musicals that appeared on Broadway. One of the first, *Shuffle Along* by stride pianist and composer Eubie Blake was a hit in 1921. Another, *Runnin' Wild* became a hit in 1923 and introduced the Charleston, the first dance craze of the 1920s. More dance fads followed: the shimmy, the black bottom, the varsity drag, the foxtrot, and the jitterbug, a watered-down version of the Lindy hop. These and other dances whetted the public appetite for dancing and helped change the very nature of popular dancing from a genteel European style to a more physical and exciting African-influenced style.

Tin Pan Alley

Since the 1890s, Midtown New York was brimming with publishing companies where composers and lyricists came to work and cranked out America's popular songs. The name **Tin Pan Alley** was originally used to describe the sound of the many pianos plinking out melodies along 28th Street between Broadway and Sixth Avenues in the early years of the 20th century that sounded like dishpans being struck. Eventually, it came to be a catchall phrase to describe the entire publishing industry based in New York (much like Hollywood describes the movie industry). Tin Pan Alley composers and lyricists wrote romantic songs with elaborate and clever rhyming schemes, and often worked within the structure known as the **standard song form**. Their songs were usually written specifically for vaudeville shows, Broadway musicals, and later for Hollywood movies.

Taxi-dance halls were dance halls where 'taxi-dancers' charged their male dance partners a small fee for one dance.

The Savoy was the scene of many **Battles of the Bands**, where the winner was determined by the vote of the dancers.

In 1927, dancers started doing the **Lindy Hop** as a tribute to Charles Lindbergh's famous solo "hop" across the Atlantic.

> **BOX 5-1** Songwriters of Tin Pan Alley
>
> **Irving Berlin** who wrote the music and lyrics to "Blue Skies" and "Puttin' On the Ritz." Berlin also wrote many songs that are not considered jazz standards but have remained popular throughout the years, like "God Bless America" and "White Christmas."
>
> **Jerome Kern** who wrote "All The Things You Are," "The Song Is You," and "The Way You Look Tonight."
>
> **George Gershwin** (music) and his brother **Ira Gershwin** (lyrics), who together wrote "Summertime," "I Got Rhythm" and "Someone to Watch Over Me." George also wrote major symphonic works, including *Rhapsody In Blue* and *An American In Paris*.
>
> **Richard Rodgers** (music) and **Lorenz Hart** (lyrics), who wrote "My Romance" and "My Funny Valentine." Richard Rodgers later entered into a successful songwriting partnership with lyricist **Oscar Hammerstein II**, and together they wrote the music for many Broadway shows, including "South Pacific," "Oklahoma" and "The Sound Of Music."
>
> **Cole Porter** another composer/lyricist who wrote "Night and Day" and "What Is This Thing Called Love." Porter also wrote many other pop songs, including "I've Got You Under My Skin" and "Let's Fall In Love."

Many of these songs have been adopted and performed by jazz musicians and singers over the years and have become jazz standards. Some of the greatest songwriters of the era are listed in **Box 5-1**.

The Music Business and the Birth of Radio

The late 1920s and early 1930s were a time of great change for those in the entertainment business. The Depression almost killed the recording industry. Sales of records went from more than 100 million in 1927 to around 5 million in 1933. The advent of talking movies caused many theatres to stop using live orchestras and music revues. Vaudeville died, and Prohibition ended. A new broadcast medium—radio—was also changing the landscape. In the new depressed economic times, people seemed more inclined to stay home and listen to the radio or go to a movie—neither of which involved going out to hear live music. The resulting—but temporary—slump in business for live music and changing tastes of consumers no doubt hurt the careers of many entertainers. Although there were other factors that sometimes contributed, the careers of Joe Oliver, Jelly Roll Morton and Bessie Smith, and many others went into decline during these years.

Radio in particular changed the entertainment business in profound ways. The burgeoning industry underwent explosive growth in its early years: between 1920 and 1924, 600 stations began broadcasting. From the beginning, radio executives realized the value of music programs, which were extremely popular and inexpensive to produce. Throughout the 1920s, it is estimated that music programming accounted for some 60 percent of all broadcast time. In 1927, three small networks were launched with headquarters in New York: NBC Red, NBC Blue, and CBS. As these networks grew and others formed, it became increasingly clear that a small number of business executives—'gatekeepers'—were deciding which orchestras would be featured on the music programs that would be heard by millions of listeners. Musicians soon realized that to earn a national reputation, which led to tours, steady engagements at large hotels,

Radio changed the entertainment business in profound ways in the late 1920s and early 1930s. It helped feed an ever-expanding music business that increasingly controlled who was going to make it, and what they were going to be playing.

and increased record sales, they would have to be based in New York and work within the guidelines of the growing music industry.

Radio, and the big money that it drew from sponsors, helped feed an ever-expanding music business that increasingly controlled who was going to make it, and what they were going to be playing. Record companies, radio networks, booking agents, music publishers, and management companies all began to exert tremendous pressure on musicians to have the right look, sound, and repertoire. As we shall see in Chapter 6, as presentation standards were put in place, jazz and popular music became increasingly homogenized. By the late 1930s, this process was more or less complete.

The Earliest New York Bands

Jazz in New York: 1920

In 1920, the jazz scene in New York was very different from Chicago or New Orleans. Although the city had gone crazy over the Original Dixieland Jass Band in 1917, jazz in New York was still a bit behind the latest developments. Ragtime was the biggest influence on the piano wizards of Harlem when they developed the stride piano style that made them famous. Ragtime was also extremely influential to the two leading Black bandleaders of the 1910s, James Reese Europe and Will Marion Cook. Both of these men had large orchestras that sounded more like a syncopated concert band than a New Orleans jazz band. Europe had founded The **Clef Club** in 1910, a nightclub and booking agency for Black bands. He had become famous for leading the orchestra that accompanied the world-famous ballroom dancers Irene and Vernon Castle on a cross-country tour in 1914, playing ragtime while they danced their famous Castle Walk dance. He also led the Hell Fighters Band on a European tour during WWI and up and down the East Coast afterward. Cook led the Southern Syncopated Orchestra that traveled to Europe in 1919, with Sidney Bechet on board as featured soloist on clarinet. Among their many performances was one at Buckingham Palace for the Prince of Wales, the future King of England. Like Europe's orchestra, the Southern Syncopated Orchestra played music that was closer to orchestrated ragtime than jazz.

Birth of the Jazz Big Band

Throughout the late 1920s and into the 1930s, jazz bandleaders were experimenting with increasing the size of their bands. Because dancehalls kept getting bigger and bigger, the amount of volume a band needed to fill them kept growing, and the only way to do it was with more players (these were the days before amplified sound reinforcement). Duke Ellington exemplified this trend: his first band in 1924 had six members. By 1927, he had 10 men, by 1930, 12, and by 1940, 15. Fletcher Henderson, who had one of the earliest big bands, increased from nine men in 1923 to fifteen in 1935. The expansion came in the brass, which evolved to five or six (3 trumpets, 2 or 3 trombones), and the saxophones, which increased to as many as five. Befriending the bandleader in the creation of the big band was the Depression, which made musical labor cheap and available.

One result of the growth of the jazz band was an increased emphasis on written **arrangements**. After a certain size, usually anything more than five to seven players, it is no longer feasible for a band to simply improvise its way through a song—musical chaos takes over. An **arranger** must write the music down in the form of a **chart** that gives each player a specific role to play in the piece. Accordingly, reading skills became more important in large ensembles,

Duke Ellington is a good example of the growth of the jazz big band; his first band in 1924 had six mem-bers. By 1927, he had 10 men, by 1930, 12, and by 1940, 15.

An **arrangement** is a notated rendition of a song or composition. Jelly Roll Morton was the first jazz **arranger**, or person who plans and notates the arrangement.

An arranger must write the music down in the form of a **chart** that gives each player a specific role to play in the piece.

A **two-beat rhythm** is the rhythmic style of ragtime and much of early jazz in which the bass plays on beats one and three, producing a boom-chuck feel.

A **4/4 rhythm** uses a walking bass line, which helps create the modern swing feel described in Chapter 1.

The sound and style of the Whiteman band became known as **symphonic jazz**.

and improvising skills became less important. During the years leading up to 1935, the bands of Duke Ellington, Fletcher Henderson, and others worked out arranging techniques that became standardized during the swing era.

As mentioned above, these years saw an increase in the use of the saxophone. During the early years of jazz, saxes were more of a novelty instrument—the clarinet was the reed instrument of choice. The saxophone provides a deeper and fuller sound than the clarinet, and by using a combination of baritone, altos, and tenor saxes in a big band, a wide range of the musical spectrum can be covered. It was during the 1920s that Coleman Hawkins became the first star of the tenor sax as a featured soloist in the Fletcher Henderson Orchestra, and an important influence to the next generation of jazz musicians. By the late 1930s, the clarinet was used primarily as a secondary or 'doubling' instrument by reed players.

More important changes were taking place in the rhythm section, as the string bass replaced the tuba and the guitar replaced the banjo. Even though both the guitar and string bass had been used to some extent since the beginning of jazz, by the early 1930s they had completely replaced the tuba and banjo. Both instruments helped to smooth out the rhythm section of the jazz band and give it more drive as the **two-beat rhythms** of the early 1920s were phased out in favor of the smoother **4/4 rhythms**.

The key bandleaders in New York during the 1920s were Paul Whiteman, Fletcher Henderson, and Duke Ellington. Each contributed to the growth of the music and the birth of the jazz big band in the years prior to the swing era.

Paul Whiteman (1890–1967) Violin/Bandleader

Key Band Leaders in New York During the 1920s
- Paul Whiteman
- Fletcher Henderson
- Duke Ellington

In 1919, a pivotal and controversial musician appeared on the New York scene from San Francisco. **Paul Whiteman** had seen the sensation the Original Dixieland Jass Band had made in New York and sensed a business opportunity in starting a jazz band of his own. He understood that jazz had an image problem, as many people still felt it was vulgar and lowbrow, and felt obligated to "make a lady out of jazz" as he called it. His plan was to expand the jazz orchestra to between 20 and 30 musicians and have some of them play orchestral instruments such as the violin and oboe. Hiring some of New York's best composers and arrangers to realize his ambition, Whiteman created what became known as **symphonic jazz**. Through his genius for self-promotion during the next few years, Whiteman soon became the most popular bandleader in New York, operated some two dozen bands on the East Coast, and sold records by the millions. He was also grossing more than a million dollars a year by 1922.

Although Whiteman's intentions were good, his music was not really jazz. His arrangements were so complex, intricate, and orchestral that they did not swing, and left very little room for improvisation. At best the music was lively dance music, kind of a polished-up cross between the syncopated orchestras that came before him and the Original Dixieland Jass Band. That is not to say that Whiteman's band was inferior; because he was paying top dollar (up to $350 per week for top players), he was able to hire some of the finest musicians of the day, including at various times, Bix Beiderbecke, Frankie Trumbauer, and both Jimmy and Tommy Dorsey. In 1927, he gave future pop superstar Bing Crosby his first job singing in Whiteman's vocal group, The Rhythm Boys.

A **concerto** is a musical composition for an ensemble (traditionally an orchestra) that features one solo instrument.

In spite of the fact that his band was not truly a jazz band, Whiteman did play an important role in jazz history. On February 12, 1924, he sponsored a concert at Aeolian Hall in New York that he called "An Experiment in Modern Music." Among the pieces on the program that evening was the premiere of a new piano **concerto** by **George Gershwin** called *Rhapsody in Blue*. Although containing

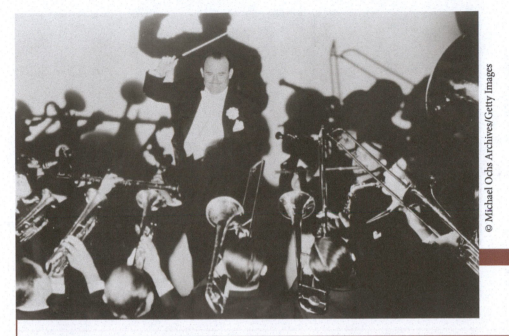

© Michael Ochs Archives/Getty Images

Paul Whiteman became one of the most popular bandleaders in New York in the 1920s, playing what became known as symphonic jazz.

Music Analysis

Track 19: "Rhapsody in Blue"

(Gershwin) Paul Whiteman Orchestra recorded April 21, 1927 at Victor Studios, Camden, New Jersey. George Gershwin: piano

"Rhapsody in Blue" is one of the most celebrated and popular concert works by an American composer. It was commissioned by Paul Whiteman to be the signature piece at his February 12, 1924 "An Experiment in Modern Music" concert in New York. At the time, George Gershwin was an up-and-coming presence on the New York music scene, with a number of musicals and hit songs to his credit. He was also becoming attuned to the nascent sounds of jazz. He spent about three weeks writing *Rhapsody in Blue*, finishing in late January. Not only was it a hit at the concert, but the piece also made Gershwin famous, and very rich. Between sales of sheet music, records, and other subsidiary rights, he made more than a quarter of a million dollars within a decade.

This is the second recording of the piece (both of which featured Gershwin himself at the piano), the first having been made on June 10, 1924, just weeks after its premiere. This recording uses a larger orchestration than that used in 1924, with more than 20 musicians. Both this and the original orchestration were done by Whiteman's regular pianist Ferde Grofé.

no improvisation, *Rhapsody in Blue* was filled with jazz-inspired harmony and melodies that included blue notes and other jazz affectations. In the audience were music critics and authorities from the world of classical music, like Russian composer and pianist Sergei Rachmaninoff. The piece, with Gershwin himself at the piano, was a sensation. For the first time, jazz was given an important place on the concert stage of the classical music world. For the next several years, Paul Whiteman was known as "The King of Jazz."

Fletcher Henderson (1897–1952) Piano/Composer/Arranger/Bandleader

At the same time that Paul Whiteman was becoming rich and famous, another bandleader was also making a contribution to jazz, but one that would not make him rich or famous. Fletcher Henderson had just graduated from Atlanta University when he moved to New York in 1920, hoping to become a chemist.

A **song plugger** was a musician who would perform a new song at music stores to encourage people to buy the sheet music. Song pluggers also tried to sell songs to vaudeville and Broadway directors to use in their shows.

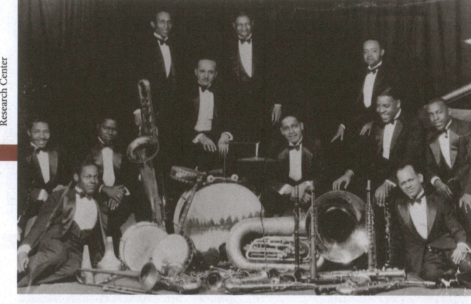

© Courtesy of Amistad Research Center

Fletcher Henderson (piano arranger, fifth from left, seated behind the drum set) together with saxophonist and fellow band member, Don Redman (far right). Don Redman was one of the many great Black jazz musicians to pass through Henderson's band. Also pictured are Coleman Hawkins (tenor sax, second from left) and Louis Armstrong (cornet, third from left).

With no opportunities available for him at the time, Henderson took a job as a **song plugger** for Pace and Handy, and soon was producing recording sessions for Black Swan Records and their classic blues singers like Ethel Waters and Bessie Smith. It was through these musical connections that Henderson was able to secure a gig for his newly formed dance orchestra at the Club Alabam in 1923, and soon after at the Roseland, the top ballroom in Harlem at the time, where they stayed off and on for nearly ten years.

Henderson pursued a different path with his band than Whiteman. He was infatuated with hot soloists and set about to acquire the best. Nearly every great Black jazz musician of the era was to pass through his band, including Coleman Hawkins, the "Father" of the tenor sax, who stayed with the band from 1924–1934, and alto saxophonist **Don Redman**, who was also an accomplished composer that began writing arrangements for the band. In 1924, with what was already regarded as the hottest band in New York, Henderson pulled off what had to be the coup of the decade when he lured Louis Armstrong to New York to be his featured trumpet soloist.

Armstrong's one-year stay changed everything for the Henderson band, and ultimately for the New York jazz scene (Louie supposedly left because Henderson would not let him sing). After hearing Armstrong's modern swing conception, phrasing, and superior soloing skills, Redman began to incorporate these ideas into his arrangements. During the next four years, Redman created the mold for the big band arrangements of the swing era. His innovations are listed in **Box 5-3**.

When Redman left in 1927 to join the rival McKinney's Cotton Pickers, the arranging duties were passed on to saxophonist **Benny Carter**, Henderson's brother Horace, and ultimately Fletcher himself. Building on the work of Redman, the Henderson Orchestra continued to be one of the elite Black bands in New York through the early 1930s.

Fletcher Henderson was never one to attend to business affairs or to possess good managerial skills. His band was undisciplined, with musicians often showing up late or underdressed for work, and Henderson would not crack the whip. He was his own booking agent and did not tend to those duties either, often leaving the band without enough work to survive on. With the onset of the Depression in 1929, missed paydays became increasingly common, and

ultimately his band deserted him en mass in late 1934. But Henderson was only beginning to make his mark on the jazz world. Down on his luck, he started selling his arrangements to and writing new ones for Benny Goodman in 1935. It was with these hot arrangements that Goodman was able to capture the mood of dancers throughout the country and become the first star of the swing era. Even though Fletcher Henderson was never as commercially successful as Paul Whiteman or Benny Goodman, his contributions as bandleader, arranger, and talent scout were critical to the popularity of jazz in the 1930s and 1940s.

BOX 5-3 "Big Band Innovations from the Fletcher Henderson Orchestra

Sectionalization: Dividing up the band into brass (trumpet and trombone) and reed (saxophone and clarinet) sections to play off each other in call and response fashion. Redman's method was for one section to play a series of melodic riffs, in between which were punctuating melodic lines by the other section.

Ensemble Swing: Writing parts for the band that were made to sound like improvisations, incorporating freer rhythms and jazz inflections, just as a soloist would do.

Block Chord Writing: Harmonizing melodies into two or three parts for each section to make them thicker and fuller.

Solos: Incorporating improvised solos throughout as an essential element of the arrangement.

Music Analysis

Track 20: "Hot 'n' Anxious"

(H. Henderson) Fletcher Henderson Orchestra recorded March 19, 1931. Personnel: Rex Stewart: cornet; Russell Smith, Bobby Stark: trumpet; Claude Jones, Benny Morton: trombone; John Kirby: tuba; Russell Procope: clarinet, alto sax; Harvey Boone: alto sax; Coleman Hawkins: tenor sax, clarinet; Horace Henderson: piano; Clarence Holiday: guitar; Walter Johnson: drums; Horace Henderson: arranger

This recording of Horace Henderson's (brother of Fletcher) 12-bar blues "Hot 'n' Anxious" shows Henderson's band utilizing big band arranging techniques that would later be widely copied during the swing era. This arrangement of "Hot 'n' Anxious" deftly incorporates call-and-response passages between horn sections, block chord and ensemble swing writing, as well as a driving 4/4 swing in the rhythm section. Also noteworthy are the plunger muted trumpet solo by Bobby Stark, the clarinet solo by Coleman Hawkins, and the guitar solo by Clarence Holiday, father of jazz vocalist Billie Holiday. Of additional interest is the riff in the second chorus, which was copied by composer Joe Garland, who made it the main theme of his composition "In the Mood." The recording of that song by the Glenn Miller Orchestra in 1938 became the biggest hit of the swing era.

0:00	Introduction: riff played by horns with the rhythm section in 4/4 time
0:16	First chorus: trumpet solo with a plunger mute by Bobby Stark, opening riff continues in the background
0:42	Second chorus: "In the Mood" riff played by reeds, answered by pops from the brass
1:05	Third chorus: brass and saxes play new riff using block chord writing and ensemble swing
1:26	Transitional section where the melody is bounced back and forth between reeds and brass
1:59	Fourth chorus: clarinet solo by Coleman Hawkins
2:21	Fifth chorus: guitar solo by Clarence Holiday
2:47	Sixth chorus: block chord ensemble writing

© Courtesy of Rutgers Institute of Jazz Studies

Duke Ellington, in a photo from the late 1920s.

Important Members of Ellington's Cotton Club Band

- Bubber Miley
- Joe "Tricky Sam" Nanton
- Barney Bigard
- Sonny Greer
- Johnny Hodges

Duke Ellington Part I: 1899–1931

The Washington Serenader

Edward Kennedy "Duke" Ellington (1899–74) is often called the greatest jazz composer, if not the greatest *American* composer. He was the first jazz composer to write extended musical works and the first to write in a variety of different styles. He was also his own arranger, and his arrangements were groundbreaking in their use of complex harmonies, instrumental voicings, and utilizing the unique talents of his musicians. He was also one of the greatest bandleaders in jazz, an often overlooked but important aspect of his career. He led an orchestra uninterrupted for more than 50 years with a remarkable record of stability among his sidemen. No jazz musician in the history of the music was as successful at combining the demands of composing, arranging, and band leading as Ellington.

Duke Ellington was born in Washington, D.C., on April 29, 1899, into the middle-class family of James and Daisy Ellington. Daisy pampered her son; James, or J. E. as friends called him, worked as a butler and a caterer (occasionally at the White House), and taught his son good manners. Together they instilled in young Edward a sense of pride in himself, his family, and his race. Very early in his life, Edward developed a strong sense of self-confidence, and an aristocratic manner of dressing, talking, and interacting with others that caused a classmate to give him his famous nickname at the age of fourteen. Both parents played the piano, and there were two grand pianos in the house. They were overprotective of their son and his sister Ruth (sixteen years younger than Edward) who later said the home was "full of love."

The turn-of-the-century Washington, D.C., that Duke Ellington grew up in was the social and cultural capital of Black America. The cornerstone of Washington's Black community was Howard University, the most prestigious Black university in the nation. Howard attracted and nurtured a large middle class of Black intellectuals who created a social structure of churches, businesses, newspapers, and civic organizations that in the years before the Harlem Renaissance made Washington unlike any other city in America. There was a thriving entertainment district along U Street in the Shaw/Uptown district near Howard, where the Howard Theatre, True Reformers Hall, and a number of other cabarets and nightclubs supported the city's musicians, dancers, and entertainers. There was also a rougher, more dangerous red-light district in the Southwest sector, where there were numerous clubs, gaming palaces, and whorehouses.

Very early in his life, Ellington developed an interest in music. As he got older he became fascinated with ragtime, and around the time he was fourteen he wrote his first piece entitled "Soda Fountain Rag." He began to take informal piano lessons. He was also an aspiring artist, and during his senior year in high school, he received a scholarship to the Pratt Art Institute in Brooklyn, which he turned down. In 1917, after dropping out of high school three months before graduating, he started his first group, the Duke's Serenaders. Through Ellington's quickly developing entrepreneurial skills, the group began to get jobs around the city playing at 'dicty' (high class) affairs as well as at clubs in the red light district. He was also establishing a network of musician friends, some of whom would stay with

him for years, including saxophonist Otto Hardwick, trumpeter Arthur Whetsol, and drummer Sonny Greer. By the time he was in his early 1920s, Ellington was firmly established in the local music scene and could have built a promising career by staying put in the city. But soon he, Greer, Whetsol, and Hardwick took off for Harlem, full of aspirations to make it in the new capital of American Black culture.

Making It in Harlem

In June 1923, Ellington and his cohorts joined a band called the Washingtonians led by banjo player and fellow Washingtonian Elmer Snowden. Although the band was more of a sweet band than a jazz band, it provided a steady, if limited, income. In June, they made their first recording, and in August appeared on a radio broadcast on station WDT. But Ellington also went about networking on his own and making his mark in the New York music scene. He met stride pianists Willie "The Lion" Smith and James P. Johnson and followed them to rent parties and cutting contests. He sought advice on long taxi rides through Central Park from orchestra leader and composer Will Marion Cook and made contacts with Tin Pan Alley publishers.

By September, the Washingtonians got their first important gig at a tiny basement tavern called the Hollywood Club at 49th & Broadway, where they would stay off and on for the next four years. They also made an important addition with the hiring of trumpeter James "Bubber" Miley, who had studied the mute techniques of Joe Oliver and was now a master himself in using a plunger mute to get a guttural, growling wah-wah effect. Miley's influence on Ellington and the Washingtonians was dramatic. For the next several years, while in the early stages of his composing career, Ellington would feature Miley's unique talent to write music that was very exotic and bluesy, and that gave his orchestra a sound that was unique and different from other New York bands.

Between 1924 and 1927, Ellington continued to take forward steps: he took over control of the band (changing the name to the Duke Ellington Orchestra), expanded it to ten members, and continued to write and make records (more than 60 sides between 1923 and 1927). In 1926, he established a business relationship with music publisher Irving Mills that was crucial to his future commercial success. Mills was a brash, fast-talking dynamo who took control of Ellington's public relations and management for a 55% share of their newly formed corporation. Working tirelessly to promote Ellington, Mills' efforts quickly paid off when in December of 1927, he secured a residency for the band at Harlem's prestigious Cotton Club.

The Cotton Club

At the Cotton Club, Ellington had to provide music for the lavish floorshows that started nightly at 12 midnight and 2:00 am. Every six months a new show would start, so Ellington was required to continually write new material. Because the shows were exotic and risqué, Ellington's growling, bluesy compositions featuring Miley fit the bill perfectly. This style of writing, Ellington's first, became known as the jungle style. With his Cotton Club orchestra, Ellington assembled a talented lineup of other unique voices besides Miley's. On trombone, Joe "Tricky Sam" Nanton was as adept as Miley with the plunger mute. Clarinetist Barney Bigard had a wailing style that was the perfect complement to Miley and Nanton. Drummer Sonny Greer used a giant set of percussion instruments that included tympani, gongs, and chimes to achieve all kinds of interesting musical sounds and effects. One of Ellington's most important soloists, alto saxophonist Johnny Hodges, joined the group in 1928. Hodges utilized a distinctive smearing technique of moving from one note to another that became his signature style. Ellington's penchant for hiring musicians with distinctive talents would be a hallmark of his career as a bandleader.

Ellington's growling bluesy compositions with Bubber Miley became known as **jungle style**.

Smearing is the technique of sliding from one note to another used by vocalists or wind instrument players. Also known as a glissando.

Music Analysis

Track 21: "Creole Love Call"

(Ellington/Miley/Jackson) Duke Ellington and His Orchestra recorded in Camden, New Jersey, on October 26, 1927. Personnel: Ellington, piano; Bubber Miley, Louis Metcalf: trumpet; Joe Nanton: trombone; Rudy Jackson: clarinet, alto sax; Otto Hardwick: clarinet, alto sax; Harry Carney: clarinet, baritone sax; Fred Guy: banjo; Wellman Braud: bass; Sonny Greer: drums; Adelaide Hall: vocal; Duke Ellington: arranger

Although "Creole Love Call" was actually recorded before Duke Ellington secured his four-year residency at Harlem's Cotton Club, it is an excellent example of the exotic "jungle style" that he became famous for playing there. As with many of the jungle style compositions from this era, trumpeter Bubber Miley is credited for at least part of the composition of "Creole Love Call," and of course, his muted muted soloing is an essential element of the song's character. Ellington also switched his three saxophonists to clarinet for this arrangement and created a wailing effect at 1:59 by scoring all three in their upper register. But the most noteworthy characteristic of "Creole Love Call" is the haunting wordless vocal by Adelaide Hall, who employs the same kind of growls and tonal shadings used by Miley in his solo. By using the human voice in this novel way, Ellington has essentially created a new instrument for his orchestra.

0:00	Clarinets play the melody in the lower register; vocalist Adelaide Hall sings the wordless vocal part; rhythm section plays slow, deliberate two-beat rhythm
0:31	Bubber Miley trumpet solo with a plunger mute
1:00	Rudy Jackson clarinet solo
1:29	Trumpets play melody; reed players switch to saxophones and play background riffs
1:58	Reed players switch back to clarinet and play the melody in upper register; brass play background riffs
2:29	Clarinets return to melody in the lower register; Hall re-enters singing wordless vocal

Wordless vocal is a written vocal line sung without words, using instead simple monosyllabic "oohs" or "aahs."

Ellington stayed at the Cotton Club until 1931. It was during his residency that he established himself as a composer, arranger, and bandleader par excellence. He also received national exposure for the first time, as the CBS Radio Network started broadcasting live from the club. In only a few months, the band itself, rather than the floorshows became the draw. Duke Ellington went in as Harlem's best-kept secret and went out as the leader of New York's premier jazz orchestra. His career after the Cotton Club and his many accomplishments will be discussed in chapter 6.

Kansas City

The Pendergast Machine

Meanwhile, 1,500 miles away another jazz scene was developing. Kansas City was a major riverboat, railroad, and slaughterhouse center, and had been a wide-open town since the 1890s. The standard vices of gambling, prostitution, and drugs were present well before Prohibition brought in the bootleggers and organized crime elements. During the early years of the 20th century, the city was slowly coming under the de facto control of Tom 'Boss' Pendergast, who as a city councilman had been skillfully building powerful coalitions from his West Bottoms base. By 1926, when he maneuvered one of his minions, Henry F. McElroy, into the post of city manager (the equivalent of mayor) and struck a deal with mob boss Johnny Lazia (the "Al Capone of Kansas City") to run the police force, Pendergast's control of Kansas City politics was complete.

The Pendergast 'administration' was one of the most remarkable and corrupt in U.S. history. He was the ultimate power broker who befriended the poor and built up a popular grassroots political base. Once in power, he managed to ramrod through deficit spending programs that included massive public construction

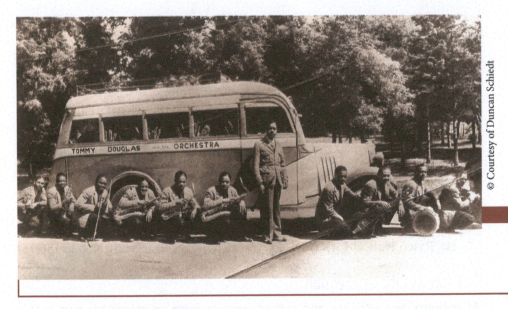

© Courtesy of Duncan Schiedt

The Tommy Douglas Orchestra, circa 1940, one of the many Kansas City-based territory bands that toured throughout the Midwest in the 1930s and 1940s.

projects similar to the New Deal programs later enacted by Franklin D. Roosevelt. While Pendergast's own Ready-Mix Cement Company was awarded every building contract, city manager McElroy's clever accounting concealed the mounting debts. But Ready-Mix was more than just a cement company—it was a front for Pendergast's vast bootlegging empire. Throughout the Prohibition years, Pendergast saw to it that the booze never stopped flowing, and with its growth as an entertainment center (similar to Las Vegas today), Kansas City became an oasis of prosperity that enabled it to remain depression-proof throughout the 1930s. It is estimated that during its heyday, the city was bringing in 100 million dollars a year in gambling; although there are no figures for the sale of alcohol, they were surely much higher. The illegal sales of narcotics were also common. And it was all unfettered by law enforcement: in fact, there was not one single alcohol violation in Kansas City during the entire Prohibition era!

The Kansas City Club Scene

With its thriving entertainment industry, the Great Depression never hit Kansas City, and it became a haven for musicians from all across the Midwest, South, and Southwest. While theatres, nightclubs, and dancehalls were closing all across the country, and bands were folding up just as quickly, the city's thriving nightclub scene became the logical destination for many jazz musicians. Although there were nightspots everywhere in town during these years (estimates run as high as 500), the major nightclub district ran from 12th Street on the north to 18th Street on the south, roughly centered around the north-south street The Paseo, east of downtown. This area included some fifty clubs that had live music during the Pendergast years, including:

- The Subway, at 18th and Vine, a basement club underneath a bar/restaurant with regular jam sessions that often attracted out-of-town musicians who were passing through.
- The Sunset Club, at 18th & Highland was where blues shouter Joe Turner tended bar and sang while boogie-woogie virtuoso Pete Johnson played the piano. A loudspeaker over the front door carried Turner's voice throughout the neighborhood.
- The Cherry Blossom, at 12th & Vine, where one of the most notorious cutting contests in jazz history took place in late 1933 (more on that later).

- The Reno Club, located closer to downtown at 12th & Cherry, catered to both Black and white customers (although they were separated by a divider that ran down the middle of the club), and had four floor shows nightly. There were also rooms upstairs where prostitutes took clients via a private stairway. It was at the Reno that John Hammond discovered the Count Basie Orchestra in 1935. It was also where a young Charlie Parker would often hang out and listen to Lester Young, Basie's main tenor soloist.
- Other notable clubs in and around the nightclub district included the Spinning Wheel at 12th & Troost, the Hey Hey, 4th & Cherry, the Boulevard Lounge at 12th & Paseo, the Hi Hat at 22nd & Vine, and the Old Kentucky Bar-B-Que, the Panama, and Lucille's Bandbox, all at 18th & Paseo.
- There were also a number of large dance halls in town, such as the Pla-Mor, the Century Room, the El Torreon, and Roseland Ballrooms, and the largest, Paseo Hall, at 15th & Paseo, which could accommodate 3,000 dancers

The Kansas City Jam Session

Jam sessions are informal, improvisational playing sessions where musicians play for fun and often without pay.

After-hours **jam sessions** and cutting contests were an important part of this club scene, where musicians were free to play whatever they wanted for as long as they wanted. Even though they were not paid for playing at jam sessions, many Kansas City musicians considered them the main attraction of the evening. For many, their paying club gig was merely a warm-up to the all-night jam session that followed. In the congenial atmosphere of the jam session, musicians could socialize among peers, work out new ideas, hear other players' new ideas, and exchange information. But most of all, it was an intensely competitive environment where a musician's mettle was tested in a trial-by-fire method, as each soloist tried to outdo or 'cut' his rivals with solos that were exciting, hot, and full of fresh and unexpected musical ideas. Those who succeeded burnished their reputations; those that did not suffered humiliating defeats.

Once a jam session really got cooking, it could last for hours; in fact, when a lot of horn players showed up to take their turn at a solo, *songs* often lasted for hours. Pianist Sam Price remembered going to the Sunset Club one night around 10:00 pm where a jam session was underway. After having a drink, he left and returned at around 1:00 am, where to his shock he found the musicians were still playing the same song! He was immediately enlisted to relieve the exhausted piano player. Lengthy songs like this took their toll on rhythm section players, who did not have the luxury of laying out between solos as horn players did. But it was for this very reason that the Kansas City pianists, bassists, and drummers developed tremendous chops and endurance that made them among the hardest swinging players of their generation.

The Kansas City jam session was particularly dangerous for tenor saxophonists, who became a sort of jazz version of the Wild West gunslinger. Not only did Kansas City develop some of the greatest tenor players of the era, including **Lester Young**, **Herschel Evans**, and **Ben Webster**, but it also drew tenor players from out of town looking to see how they stacked up. One of the most legendary jam sessions in the history of jazz took place on the night of December 18, 1933, when the Fletcher Henderson Orchestra was in town for a one-nighter. After their gig, Henderson's star tenor player Coleman Hawkins stopped into the Cherry Blossom to teach the local players a lesson in tenor supremacy. As news quickly spread that the mighty Hawkins was ready to take on all comers, tenor players from all across town started showing up. A battle ensued that lasted for hours; by dawn, only four tenor players were left standing: Hawkins, Young, Evans, and Webster. Ultimately an unofficial standoff was declared, and in the end, unable to defeat his rivals, Hawkins fled town in his brand new Cadillac in mid-day with barely enough time to get to St. Louis for

his next gig (legend has it that the engine burned out along the way). Other visiting musicians suffered similar rough treatment from locals throughout the 1930s.

The Kansas City Style

With all the musical activity and competition that were the hallmarks of the era, Kansas City jazz took on a sound all its own, unlike anywhere else in America. The backbone of the Kansas City Style was the 12 bar blues, a convenient format that could spontaneously be melded into many different styles and tempos. During performances and jam sessions, blues melodies were often constructed on the spot from simple riffs that could be embellished with other answering riffs in a call-and-response fashion. For instance, a syncopated blues riff conceived by the sax section in the first chorus of a tune might be answered in the next chorus by a contrasting one from the trumpet section. By the third chorus, when the trombones enter with yet another contrasting melodic phrase, an instant arrangement has been created. These spontaneous compositions were called head arrangements. Since head arrangements were usually not worked out in advance, they were not complex or intricate, but instead were very simple and able to be picked up quickly by a musician with good ears. This concept was a marked contrast to the elaborate arrangements that were common in New York at the time. By de-emphasizing the arrangement, improvised solos became a more important part of each tune, which in turn helped develop the city's many outstanding soloists. Because many of the bandleaders in Kansas City were pianists, boogie-woogie style piano intros and breaks were common. And the rhythm section players, veterans of long, extended jam sessions where they were required to lay down the beat for hours on end, developed a light and relaxed yet powerful swing that was crisp, modern, and irresistible to dancers.

> The backbone of the **Kansas City Style** is the 12-bar blues, a convenient format that could be melded into many different styles and tempos.
>
> **Head arrangements** use melodies constructed on the spot from riffs that can be embellished with other answering riffs in call and response fashion.

Music Analysis

Track 22: "One O'clock Jump"

(Basie) Count Basie and His Orchestra recorded July 7, 1937. Personnel: Buck Clayton, Ed Lewis, Bobby Moore: trumpet; George Hunt, Dan Minor: trombone; Earl Warren: alto sax; Herschel Evans: tenor sax, clarinet; Lester Young: tenor sax; Jack Washington: baritone and alto sax; Basie: piano; Freddie Green: guitar; Walter Page: bass; Jo Jones: drums; Eddie Durham, Buster Smith: arrangers

"One O'clock Jump," the theme song of the Count Basie Orchestra, is a great example of the incredible drive and perfect time of Basie's "All-American Rhythm Section" and the riffed-based music created in the jam session milieu of 1930s Kansas City.

0:00	Boogie-woogie piano introduction by Count Basie
0:11	Basie takes a two-chorus solo with accompaniment by the rest of the rhythm section; during this solo you can clearly hear drummer Jo Jones keeping time on the high hat cymbal and guitarist Freddie Green playing a down stroke on every beat
0:45	Lester Young plays a one chorus tenor sax solo backed by muted trumpet riffs; rhythm section keeps chugging along
1:02	One chorus trombone solo backed by saxophone riffs
1:19	One chorus tenor sax solo by Young backed by muted trumpet riffs
1:36	One chorus trumpet solo by Buck Clayton backed by saxophone riffs
1:52	Basie plays one of his famous "plink-plink" solos backed by rhythm section only
2:10	One chorus of call and response between saxes, trumpets, and trombones
2:27	Saxophones state the 'head' for the first time; brass backgrounds continue
2:43	Shout chorus

BOX 5-4	Characteristics of the Kansas City Style

- 12-bar blues format commonly used
- Head Arrangements and other simple arrangements
- Emphasis on improvised solos, especially tenor sax
- Boogie-woogie influence
- Light, crisp, powerful swing from the rhythm section

The Kansas City Bands and Musicians

Territory Bands

Many of the bands that played in Kansas City in the Pendergast years were road veterans that had spent years traveling throughout the Midwest. The "territories" as they were called, extended from Texas to Minnesota, Ohio to Colorado. Following circuits that had been established many years ago by vaudeville and minstrel acts, territory bands played ballrooms in large cities such as Dallas, San Antonio, Tulsa, Oklahoma City, Wichita, and Omaha, as well as rural dancehalls that drew dancers from miles around. Many times bands would stay at one ballroom like the Shadowland in San Antonio for weeks or even months at a time. On the last night of a long-term engagement, it was customary that the outgoing band battle the incoming band, so bands had to stay sharp in order to not be embarrassed.

Territory bands were in many ways like baseball farms teams, containing players whose talent was not quite ready for a band with a national reputation. Occasionally a player with outstanding talent would get 'called up' to a national band; sometimes a territory band would get a big break—usually by chance with a hit record—and become a national band themselves. Kansas City was 'home base' to a number of territory bands, but other Midwestern and Southwestern cities were also home to territory bands, including Omaha (the Nat Towles Orchestra), Oklahoma City (the Blue Devils), San Antonio (the Troy Floyd Orchestra) and Dallas (the Alphonso Trent Orchestra). Because their audiences were so diverse, territory bands had to know a wide variety of musical styles and popular tunes. It was not unusual for a band to have a repertoire of more than 200 songs, including everything from polkas, waltzes, country music, sweet music, as well as blues and jazz. Jitney dances were popular in the territories at this time, where a 25-cent ticket bought a young man a one-minute dance with a girl.

Life on the road was tough, to say the least. Bad roads (or no roads at all in some cases), crooked booking agents, and car problems were common. Only the most profitable bands had buses, and even then there was not much in the way of creature comforts to be found on them (as in: no air conditioning or heating). It was not uncommon for a band to hit the road immediately upon completing a one-nighter and drive all night and day to get to the next engagement the following night. Oftentimes living day to day, there was not enough money for hotels, so when musicians had extended engagements they stayed in private homes. As the Depression began to grip the territories, traveling became less and less profitable, and many bands chose to stay put in the seemingly depression-proof Kansas City.

Jitney dances were popular in the territories at this time, where a 25-cent ticket bought a young man one dance with a girl.

The Bands

The top bands in the territories and Kansas City in the 1920s and 1930s are listed in **Box 5-5**.

BOX 5-5	"Top Bands in the Territories" Kansas City (1920s–1930s)

The Clouds of Joy—started in 1925 by Terence T. Holder in Dallas, the Clouds of Joy were run by Andy Kirk from 1928 until the mid-1940s. In 1929, Mary Lou Williams (1910–1981) joined the band, and she became one of the finest pianists and arrangers in the territories. Although the Clouds of Joy were known as a sweet band, the musicianship was always of the highest caliber, and they were often known to sight-read music on the job without rehearsal.

The Blue Devils—together from 1923 until 1933, they were one of the hottest bands in the territories. Led for most of their existence by college-educated bassist/tuba player Walter Page (1900–1957), the band also included at various times Lester Young on tenor, Count Basie on piano, Buster Smith on alto sax, and Jimmy Rushing on vocals. The band's demise started in 1929 when rival bandleader Bennie Moten began raiding its best players, including Page himself in 1931.

The Bennie Moten Orchestra—led by pianist Moten (1894–1935), it was widely considered to be the top band in Kansas City from 1930 until Moten died on the operating table during a tonsillectomy in 1935. Moten consistently had the top musicians in his band (including Ben Webster on tenor and the above mentioned Basie, Young, Rushing, and Page), and possessed the great rhythmic drive and power that Count Basie's Orchestra was to be known for in the coming years. Moten's band, more than any other, developed the 'Kansas City' style.

The Count Basie Orchestra—originally called Bill Basie and the Barons of Rhythm, Basie put his first band together from the remnants of the Bennie Moten Orchestra upon Moten's tragic death in 1935. Basie immediately secured a residency for the Barons of Rhythm at the Reno Club, where experimental shortwave radio station W9XBY was broadcasting on a weekly basis. When Columbia Records producer John Hammond heard the band from his car radio in Chicago in 1936, he drove to Kansas City and set the wheels in motion for Basie to debut in New York, get a recording contract, and become the most famous of the Kansas City bands. The Count Basie Orchestra will be discussed at length in Chapter Six.

The Jay McShann Orchestra—led by pianist/vocalist McShann (1909–), this band was the last great Kansas City-era band, formed in 1938 when McShann settled in town after several years on the road. The featured soloist was 18-year-old alto saxophonist Charlie Parker, who in just a few years would become the leader of the modern jazz revolution. With a tight, red-hot band and the explosive Parker, McShann made a dramatic debut at the Savoy in January 1942 by winning a band battle with the local favorites, the Lucky Millinder Orchestra. The band fell apart in 1943 when McShann was drafted into the service.

The Shouters

Shouters were Kansas City blues singers whose robust and powerful delivery, sometimes assisted by the use of megaphones, helped project their voices over the volume of the band.

Just as the Kansas City jazz musicians were developing a unique style, so were the vocalists. Often using megaphones in the early days to project over the incredible volume of the bands, these singers became known as **shouters**, a term that aptly described their robust, powerful, and intense delivery. The shouters were male blues singers, emerging in an era that was dominated by the recordings of the female classic blues singers. The most famous of the shouters, outlined below, all sang with Count Basie at one time or another in their careers.

BOX 5-6　　　　"Kansas City Shouters"

"Little" Jimmy Rushing (1903–1972)—sang with Basie from 1935 to 1950. Known as "Mr. Five by Five" for his diminutive stature and expansive girth, Rushing was the greatest of all the blues shouters. Originally from Oklahoma City, Jimmy moved to Kansas City in the late 1920s and sang with the Blue Devils and Bennie Moten before joining Basie.

"Big" Joe Turner (1911–1985)—got his start at the Sunset Café as a bartender who occasionally belted out a song with Pete Johnson at the piano. Turner's greatest popularity came in the 1950s when he had several R&B hits, including "Shake, Rattle and Roll" in 1954. Bill Haley subsequently covered this tune, which became one of the first hits of the rock and roll era.

Joe Williams (1918–1999)—with a career that started in the late 1930s, Williams' biggest hit came in 1954 with Count Basie. "Every Day I Have The Blues" almost single-handedly revived Basie's career when hard times had fallen on big bands. Later in his life, Williams became more of a crooner in the style of Nat King Cole.

The Demise of the Kansas City Scene

Although jazz is still very much alive in Kansas City today, the glory years came to an end in the late 1930s. With Basie's discovery in 1936 came talent scouts and record executives who, like robber barons, sought out new talent to sign to management deals and record contracts. Within a short time, many of the top musicians left for New York to seek their fortune. At the same time, Tom Pendergast's reign of power was unraveling. By mid-decade, a number of high-profile gang assassinations took place, including that of Pendergast crony Johnny Lazia in 1933, and three of Pendergast's rivals at a polling place on Election Day in 1934. The increased violence seemed to be the last straw that motivated public opinion to finally do something about the municipal corruption. Pendergast himself was losing money hand over fist at the racetrack (reportedly as much as $50,000 a day), and began to dip into the public till to cover his debts. Indicted for income tax evasion in 1938, he was convicted the following year and sent to Leavenworth prison. Dealing with the huge debt that Pendergast left meant that the city faced years of rebuilding its economy. Reformers moved in and quickly shut or tore down many of the city's nightclubs. As jobs for musicians started to dry up, America's entry into WWII and the draft, gas and rubber rationing, and entertainment tax that came with it was the final blow that put an end to the glory years of Kansas City jazz.

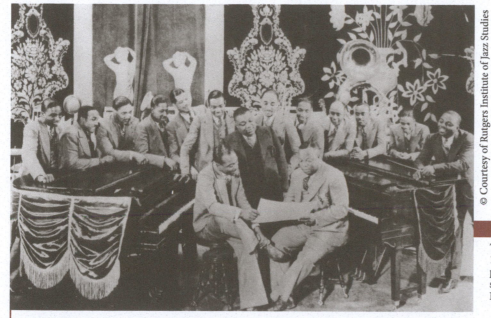

© Courtesy of Rutgers Institute of Jazz Studies

The **Bennie Moten Orchestra** around 1929. (Count Basie sitting at left piano, blues-shouter Jimmy Rushing standing between the pianos, and Bennie Moten sitting at right piano).

Name _____ Date _____

Study Questions

New York and Kansas City

1. In what ways were the gangster controlled Harlem nightclubs different than the Harlem dancehalls?

2. Why and in what ways was the Fletcher Henderson Orchestra so important to the development of the jazz big band?

3. Why was the Cotton Club important to the early career of Duke Ellington and what did he accomplish there?

4. Describe how the jazz bands in New York were different from those in Kansas City in the 1920s and early 1930s.

5. Why did Kansas City develop a vibrant music scene in the 1920s, and what were some of the reasons that it diminished in the late 1930s?

6. Why are *Rhapsody in Blue* and its premier important?

7. Describe how and why the jazz band evolved in the late 1920s and early 1930s.

8. Describe the ways in which Duke Ellington went about making his band sound unique.

9. Describe the differences in how music was composed and arranged in New York and Kansas City in the early 1930s.

10. What were some of the reasons why it was good for a jazz musician to live in New York in the 1920s and early 1930s?

THE SWING ERA

Introduction

Jazz became the cornerstone of popular culture during the period of time known as the swing era. Between 1935 and 1946, jazz, or **swing** as it came to be called, was more popular than any time in its history, and it influenced clothing styles, retail marketing, fashion, dance, and even language. Jazz helped pull America out of the Depression and get through World War II. It nursed the record industry back to health. It filled dancehalls all across the country with dancers. Bandleaders became celebrities, with fans following their every move in *DownBeat* magazine. The bands of Benny Goodman, Duke Ellington, and Count Basie were among the greatest bands of the era, and each played a unique and important role in the ongoing evolution of jazz. There were also many fine soloists who became famous and played important roles in swing's popularity, including Billie Holiday and Coleman Hawkins.

Jazz in the swing era helped define its generation, the one that broadcaster Tom Brokaw has called "The Greatest Generation." Jazz became big business, as the emphasis moved from musical innovation to commercialization. But the swing era was also the era when more than at any other time, jazz reached out and connected with its audience.

Swing and Popular Culture

Opening Night

On the evening of August 21, 1935, the Benny Goodman Orchestra pulled up to the **Palomar Ballroom** in Los Angeles, the final stop on a disastrous cross-country tour. At almost every stop they had met rejection: in Denver, they were nearly fired after one set. Another place they had to play behind chicken wire to keep from being hit by whiskey bottles. No one danced; booing was common. Band morale was, to say the least, low.

But there was a huge crowd at the Palomar. Little known to Goodman, a following had developed in Los Angeles from listening to his appearances on the *Let's Dance* radio program and his records that a local DJ had been playing. Starting off with non-offensive sweet music to avoid another likely confrontation with ballroom management, the band played for an hour with no crowd reaction. Then, Goodman made a decision. "This might be our last night together, and we might as well have a good time." He called for the Fletcher Henderson charts, the hot music the band loved to play. This was the music the crowd had come to dance to, and they came to life. "That first big roar of the crowd was one of the sweetest sounds I ever heard in my life," Goodman recalled. That big roar marked the auspicious dawning of a new day in America, as the country was about to embark on the swing era.

Django Reinhardt
Duke Ellington
Jack Teagarden
Jimmie Lunceford
Jimmy and Tommy Dorsey
John Hammond

Lester Young
Lionel Hampton
Quintette du Hot Club de France
Roy Eldridge
Stephane Grappelli
Teddy Wilson

MUSIC STYLES
Duke Ellington: Jungle, Concerto,
 Impressionistic, Popular Song
Swing

Swing should not be confused with swing rhythm as discussed in Chapter 1. Swing is the name that was given to the music played by the big band dance bands of the 1930s and 1940s.

Cultural Aspects of Swing

The swing era got its name from the musical style that Goodman's and eventually hundreds of other orchestras played; however, it marked a cultural moment in America's history that was about more than just music. Swing fans—the most ardent of which were teenagers—took on the music as their own and built an entire social phenomenon around it, much as rock and roll fans would do a generation later. As with any teen-oriented social movement, there were new clothing styles that identified you as a 'hepcat', such as bobby sox and white buck shoes with sweaters and pleated dresses for girls, zoot suits, and pork pie hats for males. Of course, a critical ingredient to the swing era was dancing, and there were a number of dance crazes that came and went, all of which were more athletic and individually spontaneous than dance fads from previous years. These included the jitterbug, the Suzie-Q, the Lindy hop, the Big Apple, and the Shag. Swing had its own lingo as well: "cutting a rug" referred to dancing, a "belly warmer" was a necktie, a "dish" or a "fine dinner," an attractive girl.

Passionate swing fans loyally followed their favorite bands like baseball fans might follow the Brooklyn Dodgers or the New York Giants. Many followed the individual stars of the bands like a favorite player, so when a star trumpeter was hired away from one band to play in another, for fans it was not unlike trading a shortstop from one team to another. Fans could follow the careers of their favorite bands and musicians in fanzines such as *DownBeat*, *Metronome,* and *Swing-Out*, and they could often see them in the more than fifty swing-themed Hollywood films released from 1936 on. In fact, many bandleaders achieved celebrity that rivaled that of movie stars; some dated or married starlets, some even starred in movies themselves.

The Sound of Changing America

As the first star of the swing era, Benny Goodman was the lightning rod—the Elvis of his generation; however, he did not create the swing era. Even though Goodman's band was one of the era's best, it should also be noted that in many ways he benefited from being at the right place at the right time. A number of factors were coming into place that were radically changing America in 1935. In the six years since the onset of the Depression, the country had been forced to reorganize itself both economically and socially. Economically, American labor industries increasingly turned to machines and new technologies to make the economy run more efficiently; socially, age-old suspicions and prejudices among different ethnicities had to be abandoned as people increasingly saw a need to come together for the common good. Teamwork was in, whether it was part of an assembly line or as a role player at a factory producing a consumer product, or simply helping out a neighbor in need. These sensibilities became increasingly intense with America's involvement in World War II. Network radio, with its music and comedy programming and the broadcasts of President Franklin D. Roosevelt's **Fireside Chats** also played an important role in bringing Americans together in these troubling times.

As Kenneth J. Bindas points out in his insightful book *Swing, That Modern Sound*, swing music was perfectly suited to this new, modern America. Swing orchestras, with their highly formalized and organized format, replaced the spontaneous individual improvisations of the New Orleans jazz ensemble. Much like the worker at a modern factory, every musician in a swing orchestra had a specific role to play as part of a team. This role, like that on an assembly line, could be repeated over and over again—in exactly the same way. In the swing band, each person's role was defined by the written arrangement, underscoring how important it was for each band to have good arrangers on hand to give it a unique and identifiable sound.

The Swing Band

During the swing era, jazz became a commercial product that had to be produced, marketed, and sold to the consumer in much the same way as a soft drink or a bar of soap. Of course, as with industry, when efficient economic principles are introduced to produce a product with a huge demand, standardization and homogenization of the product and its consumption must take place. As the commercial potential of playing swing music in an economically distressed time started to become apparent to jazz musicians, many were more than willing to adopt the basic guidelines for success that had been established by Goodman and a few others on the cutting edge of the movement. For hundreds of bands during the late 1930s, this meant generally adhering to the following standards:

- **Standard instrumentation.** Five brass (usually three trumpets and two trombones), four reeds (saxes and clarinets), and a four-man rhythm section.
- **Impeccable appearance and stage presence**. Matching suits, tuxedos, or flashy costumes were essential; coordinated movements; fronts with logos.
- **Standard repertoire**. Most bands had a mix of 'hot' tunes (up-tempo dance numbers), sentimental ballads, novelty tunes, and a few boogie-woogie tunes (after the boogie-woogie craze of 1938).
- **Vocalists**. Most bands had a 'girl' singer, whose good looks were as important as their talents; many had a 'boy' singer as well.
- **Theme songs**. Like any commercial product, a band needed a signature 'logo' that consumers could identify them with. Many theme songs were sentimental, especially during the war years.
- Emphasis on playing danceable music and entertaining the audience.

In spite of all the intentional sameness, there were in fact differences in the stylistic approaches to the music that swing bands played. Generally speaking, there were three broad categories that most bands fit into:

- **Sweet bands** were cut in the mold of the Paul Whiteman Orchestra, playing **stock arrangements** of overly commercial dance music. Some of the most popular bands of the era were sweet bands, including Guy Lombardo and his Royal Canadians and the Sammy Kaye Orchestra.
- **Commercial bands** straddled the fence and played a mix of hot and sweet music. These were the most commonly found of the swing orchestras, and because they commanded good money and played at least some jazz tunes, commercial bands often contained a few if not several excellent jazz players. Among the best commercial bands were those of Artie Shaw, Tommy Dorsey, and Harry James, who were all superior jazz soloists themselves.
- **Hot bands** were true jazz bands with the most exciting and jazz-oriented arrangements as well as the best jazz soloists. Many of the era's best hot bands were loaded with great jazz players, including the orchestras of Duke Ellington, Count Basie, Chick Webb, Jimmie Lunceford, and Benny Goodman.

Fronts were paneled cardboard structures designed to hide music stands and make the visual display of the saxophone section more attractive.

Stock arrangements are easy to play dance band arrangements of popular songs, sold by publishing companies.

It is also important to point out that Benny Goodman's orchestra was not the first band to play swing music. As has already been pointed out in chapter 5, the New York bands of Duke Ellington and Fletcher Henderson were defining the style that became known as swing throughout the 1920s; certainly, Kansas City's Benny Moten Orchestra was also playing swing before it broke up in 1935, as were the white Ben Pollack, Jean Goldkette and the Casa Loma Orchestras, all of which were formed in the mid-1920s. But it was Goodman who put it all together, with hot arrangements, good soloists, an attractive vocalist in Helen Ward, and an energetic and joyous sound, and first captured the hearts and souls of the swing generation.

BOX 6-1	Characteristics of the Swing Band

- 13 musicians in three sections:
 - 5 Brass: 3 trumpets, 2 trombones
 - 4 Reeds: usually 2 tenors, 2 altos; often doubling on clarinet
 - 4 Rhythm: drums, bass, piano, guitar
- Vocalists, often both male and female
- Theme songs
- Appearance: fronts, suits, etc.
- Arrangements/arrangers important
- Music primarily for dancing

Important Orchestras of the Swing Era: Goodman, Ellington, and Basie

Benny Goodman (1909–1986) Clarinet/Bandleader

Benjamin David Goodman was born in Chicago's Jewish ghetto, a centrally located area that ran west from Canal Street to around Damen Street. His parents David and Dora were among the thousands of immigrants from Eastern Europe who fled to the United States in the 1880s and 1890s. Benny was one of at least eight children; his father, who held various labor-intensive jobs, barely kept the family fed or housed despite 12 and 16-hour workdays. Nonetheless, David Goodman instilled in his children an intense drive to work hard and get ahead, so that one day they could enjoy a better life than the one he provided them. It was in this spirit that David signed his sons up to play in the band at the Kehelah Jacob Synagogue when Benny was ten years old. Benny was assigned the clarinet, the smallest available instrument because he was the smallest son.

Benny progressed quickly on the clarinet, and within three years had joined the musicians union. He began following Chicago clarinetists such as Johnny Dodds (playing with King Oliver at Lincoln Gardens), Leon Roppolo (playing with the New Orleans Rhythm Kings), and Frank Teschmacher (of the Austin High Gang). In 1925, while only sixteen years old, Goodman took a job with the traveling Ben Pollack Orchestra. Although Pollack's band was just forming, within two years they were well established, with a steady supply of gigs and recording sessions that enabled Benny to support the remaining family back home (a necessity, due to David Goodman's untimely death that same year after being struck by an automobile). By 1929, Benny Goodman was confident enough in his skills to leave the Pollack band and strike out on his own in New York City. He quickly broke into the music scene, becoming a sought-after sideman for recording sessions (making nearly 500 records during the next five years), dance jobs, and radio broadcasts. It was in New York in 1933 that he got his first big break when he met jazz impresario **John Hammond**.

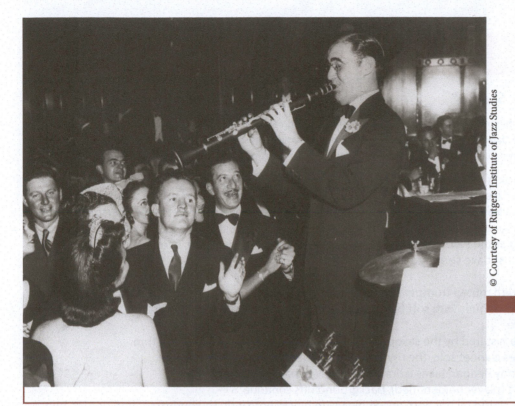

© Courtesy of Rutgers Institute of Jazz Studies

Clarinetist/bandleader
Benny Goodman, who as the
first star of the swing era expe-
rienced popularity in the 1930s
that rivaled that of Elvis Presley
20 years later.

Meeting John Hammond

Even though Hammond was a wealthy blue blood (his great-great-grandfather was Cornelius Vanderbilt), he was fiercely independent and unwilling to follow the usual private school-Ivy League-business tycoon career path that his family envisioned for him. He dropped out of Yale after one year and earnestly began to pursue his interest in jazz, even though he was not a musician himself. With the help of his large inheritance, John Hammond quickly went about making a name for himself, setting up record dates, and managing the careers of up-and-coming jazz musicians. (By the time of his death in 1987, Hammond's track record as a talent scout was legendary, having helped Goodman, Count Basie, Billie Holiday, Aretha Franklin, Bob Dylan, and Bruce Springsteen get their starts.) In 1934, after organizing Goodman's first recording sessions as a leader, Hammond helped Goodman start his own orchestra. Then, in October, Goodman got his next big break: a spot on the nationally broadcast NBC radio program *Let's Dance*.

The Saturday night show, sponsored by Nabisco to introduce their new Ritz Cracker, was to feature three bands—a sweet band, a Latin band, and a hot band—that played hour-long slots from 11 pm until 2 am. Goodman's unit, the 'hot' band, was featured during the last hour. The show not only offered the chance of fame and a decent salary in the midst of the Depression, but it also put up $250 a week for new arrangements. Although Goodman used this allowance to buy hot arrangements from a number of arrangers, the most important came from Fletcher Henderson. Purchasing charts from Henderson was mutually beneficial for both musicians, coming at a time when Goodman needed them to establish his sound, and Henderson, whose own band was falling apart, needed the money. Bringing the two musicians together was the ubiquitous John Hammond. Goodman not only played his new arrangements on *Let's Dance*, but recorded them as well, providing one more opportunity for teens, particularly those on the West Coast to hear the kind of hot music that bands in Harlem, particularly Henderson's, had been playing for years.

Music Analysis

Track 23: "King Porter Stomp"

(Morton) Benny Goodman Orchestra recorded July 1, 1935. Personnel: Goodman: clarinet; Bunny Berigan, Nate Kazebier, Ralph Muzzillo: trumpet; Red Ballard, Jack Lacey: trombone; Toots Mondello, Hymie Schertzer: alto sax; Dick Clark, Art Rollini: tenor sax; Frank Froeba: piano; George Van Eps: guitar; Harry Goodman: bass; Gene Krupa: drums; Fletcher Henderson: arranger

If there were ever a textbook big band arrangement that exemplifies the joyous dance music of the swing era, it would have to be Fletcher Henderson's "King Porter Stomp." This Jelly Roll Morton tune became the first hit of the swing era and employs all the arranging techniques that had been developed in the Henderson band by Don Redman, Benny Carter, and Fletcher and Horace Henderson. Recorded just a few weeks before Goodman's famous successful opening at the Palomar Ballroom, this superb recording gives the listener a glimpse of what the Goodman Orchestra must have sounded like that night.

0:00	Introduction with muted trumpet solo by Bunny Berigan
0:11	Trumpet solo continues with soft backgrounds of sustained notes and short riffs in horns
0:32	Short interlude
0:37	Second theme is stated by the saxophones; rhythm section plays two-beat rhythm
0:58	Goodman takes clarinet solo, the rhythm section goes back to 4/4 rhythm
1:41	Trumpeter Bunny Berigan takes a dramatic solo with background sax riffs
2:02	Trombone solo (player unidentified), background riffs continue
2:22	Third theme is stated by the horn ensemble using block chord writing; rhythm section goes to two-beat rhythm while drummer Krupa accents horn lines
2:42	Call and response between brass and saxes leads to big ending

Goodman's fortunes quickly changed, however: *Let's Dance* was cancelled in May 1935. To keep the band together, Goodman's management put together the cross-country tour that was to begin in mid-summer and conclude at the Palomar Ballroom. With the band's unexpected success there on August 21, their stay at the ballroom was extended to two months. On their return trip, a one-month booking was secured at the Urban Room of the Congress Hotel in Chicago that was so successful that it was extended to six months. It was not until May that the band finally got back to New York. But during his stay at the Congress Hotel, Goodman made history by tearing down one of the walls of racial segregation.

The Small Groups

Key Members to Goodman's Small Group

- Benny Goodman
- Teddy Wilson
- Gene Krupa
- Lionel Hampton
- Charlie Christian
- Cootie Williams

Back in July 1935, John Hammond had organized a series of trio recordings with Goodman that included a Black pianist from Austin, Texas, named Teddy Wilson. Although it was rare (and inappropriate to many) for Black and white musicians to appear together on stage, racial mixing on recordings had been going on for quite some time. Segregation was everywhere in America during the swing era—in fact, it was the law, as interpreted by the *Plessy vs. Ferguson* ruling. Black and white jazz musicians had mutual respect but understood the color barrier that barred them from playing together on stage. Nonetheless, since the Goodman trio recordings were in fact selling quite well by the end of the year, it was suggested that Goodman devote the middle part of his Congress Hotel shows to presenting the trio, including Wilson. Although reluctant at first, he eventually agreed. At a promising point in his career where he had nowhere to go but up, Benny Goodman made the potentially risky move of appearing on stage with a racially mixed group at a major hotel with the music press in attendance. The show went off without a hitch.

Music Analysis

Track 24: "Good Enough to Keep"

(Goodman/Christian/Mundy) Benny Goodman Sextet recorded June 20, 1940. Personnel: Goodman: clarinet; Lionel Hampton: vibes; Charlie Christian: guitar; Dudley Brooks: piano; Artie Bernstein: bass; Harry Jaeger: drums

The riff-based "Good Enough To Keep" (also recorded as "Airmail Special" by Billy Eckstine and other artists of the era) by this version of Goodman's Sextet features outstanding solos by Lionel Hampton, Charlie Christian, and Goodman as well as tight and precise ensemble work.

0:00	First chorus: song starts without introduction; head played in unison by guitar, vibes, and clarinet
0:35	Second chorus: vibes solo by Lionel Hampton
1:10	Third chorus: guitar solo by Charlie Christian
1:44	Fourth chorus: clarinet solo by Benny Goodman
2:18	Fifth chorus: second riff theme played in unison by guitar, vibes, and clarinet

There was no perceptible public backlash, and Goodman continued to hire more Black musicians. He eventually expanded the trio (which had become a featured part of each show) to a quartet with the addition of Black musicians Lionel Hampton on vibraphone; later additions of guitarist Charlie Christian and trumpeter Cootie Williams further expanded the group to a sextet. Despite Goodman's progressive stance, few white bandleaders followed his lead and hired Black musicians, at least right away. But it was one more stone that was rolled away in the name of civil rights for Black Americans, one that came more than a decade before major league baseball began to integrate its lineups.

The King of Swing

From the Congress Hotel, Goodman's rise to the top of the music world was unparalleled. He became known as the King of Swing. In the 1936 *DownBeat* Reader's Poll, the Goodman orchestra came in 1st, with nearly three times as many votes as the 2nd place band. In March 1937, he appeared at the Paramount Theatre in New York for a two-week run that broke all attendance records (21,000 showed up the *first day*). This event was widely covered by the media and was definitive proof that the swing era was fully a cultural phenomenon. Goodman made several return trips to Los Angeles where the band kept busy shooting Hollywood movies by day and appearing at the Palomar at night. On January 16, 1938, his orchestra headlined the first-ever jazz concert at Carnegie Hall to a standing-room-only crowd. Included on the concert were performances by Goodman's trio and quartet, as well as jam sessions with members of both the Duke Ellington and Count Basie Orchestras.

Goodman's legacy is immense. With an unpretentiousness that was perfect for the times, he became a cultural icon. Like Elvis twenty years later, he brought Black music to white America at a time when only a white performer could. He helped break the color barrier in jazz while he was in the national spotlight, the importance of which cannot be overstated. He was also the rare musician that was comfortable in both the worlds of jazz and classical music (his later career included appearances with symphony orchestras performing works composed for him by Aaron Copland and others). He headlined the first ever-jazz concert at Carnegie Hall. Through his band passed some of the greatest musicians of the era: Wilson, Krupa, Hampton, Christian, as well as trumpeters Harry James and Bunny Berigan. And, in 1985, at age 76, in an unbilled appearance at the Kool Jazz Festival, he brought a young crowd that had come to hear Stevie Ray

Vaughan to its feet, in much the same way he did at the Palomar Ballroom 50 years earlier. He died the next year of a heart attack in his Sixty-sixth Street apartment in New York, where he had been practicing Brahms.

Duke Ellington Part II: 1931–1974

Hitting the Road

In the years following his engagement at the Cotton Club, the Duke Ellington Orchestra took advantage of their growing national reputation and toured extensively. They were now able to command $6,000 per week, which put them in the upper echelons of the dance band business. The clubs and hotels they played were sold out; reporters and critics were enthusiastic. In 1933, they toured Europe, the first of nine tours there. They also toured the South and experienced the same Jim Crow indignities as other Black bands from the North. When they returned in 1934, the orchestra traveled in three Pullman railroad cars, so they would not have to worry about being hassled at gas stations and restaurants or finding the 'Black' hotel in each town they played. "We travel just like the President," Ellington said.

Ellington was also writing furiously and breaking artistic ground seemingly with each new composition. Here is a brief overview of some of his more important compositions from the 1930s:

- "Creole Rhapsody" (1931): the first recording to break the three-minute barrier of the 78-rpm disc, "Creole Rhapsody" was six and a half minutes long and filled both sides of a disc
- "It Don't Mean a Thing If It Ain't Got That Swing" (1932): the song title was apparently a favorite expression of Bubber Miley's; it is credited with putting the term *swing* into general use, three years before the start of the swing era
- "Daybreak Express" (1933): a remarkable piece that musically depicts a train starting up, cruising at top speed, and finally arriving at the station; one of Ellington's many 'train' songs
- "Symphony in Black" (1934): a four-movement, nine-minute piece depicting African-American life, it was the soundtrack to a non-dialogue film of the same name, making it in effect the first music video
- "Reminiscing in Tempo" (1935): a somber reflection on his mother's death; at thirteen minutes in length, it was his longest piece to date, and successfully integrates several themes with innovative harmonies
- "Caravan" (1937): an exotic piece written with trombonist Juan Tizol that conjures up images of the Middle East and uses Latin rhythms

The Master Composer/Arranger

By 1940, Duke Ellington had become the first important composer in jazz. In time his creative output would also make him the greatest composer in jazz, if not all American music. Throughout the course of his career, he wrote roughly 2,000 compositions that ranged from solo piano pieces to works for orchestra and chorus, humorous novelty pieces to dissonant avant-garde works, pop-oriented dance music to extended suites, gutbucket blues to highly symphonic concert music. Oftentimes, he was able to bring disparate elements together within a piece, such as the somber and joyous strains in *Black, Brown and Beige*, or the contrasting minor and major sections of "East St. Louis Toodle-Oo."

Although there are some of his works that are simply beyond category, many of Ellington's compositions can generally be categorized into four distinct styles. These are listed in **Box 6-2**.

> **BOX 6-2** Ellington's Four Writing Styles
>
> 1. **Jungle**. Written for the Cotton Club floorshows (discussed in chapter 5), this category is generally comprised of songs featuring the growling wah-wah brass of Bubber Miley and Joe "Tricky Sam" Nanton
> 2. **Concerto**. As the first jazz composer to use the European concerto format, these were written to feature the unique talents of his many fine and versatile soloists, including "Air Conditioned Jungle" for clarinetist Jimmy Hamilton, "Concerto for Cootie" for trumpeter Cootie Williams, and "Magenta Haze" for alto saxophonist Johnny Hodges.
> 3. **Impressionistic**. Extended works written mainly in his middle and later career that evoked images or memories of people, places, or history; this style can be further divided into four subcategories:
> - Musical portraits of famous personalities, including "Portrait of the Lion" (for Willie "The Lion" Smith), "Portrait of Bert Williams" (a 1920s Black comedian), and *The Queen's Suite* (for Queen Elizabeth of England)
> - Musical pictures of places, including "Harlem" (1950), *Far East Suite* (1964), and *The New Orleans Suite* (1970)
> - Historical pieces, including *Black, Brown and Beige* (1943), a 50-minute "tone parallel to the history of the Negro in America," and *Such Sweet Thunder* (1957), a 57-minute work based upon the sonnets of William Shakespeare
> - Religious: Sacred Concerts in 1965, 1968, and 1973, performed by his orchestra with full chorus in cathedrals and churches
> 4. **Popular Tunes**. A huge catalog of popular and dance tunes written throughout his career, often using the 32-bar standard song form or 12-bar blues form; they include "I Got It Bad (and That Ain't Good)," "In A Sentimental Mood," "Satin Doll," "In a Mellow Tone," and "Don't Get Around Much Anymore"

As an arranger, Ellington was a master painter. Loading his band with uniquely talented performers, he wrote to their strengths to give his orchestra a palette of sounds that rivaled that of a much larger group. His music is filled with impressionistic and dissonant harmonies that were years ahead of their time. He often gave melodies to instruments that were not typically melodic instruments, such as the baritone sax. He used **cross-sectional voicing** to achieve new tonal shadings, in direct opposition to the standard big band technique of sectionalizing the orchestra. He used a variety of mutes on brass instruments to achieve more interesting tonal effects. He was the first arranger to use a wordless vocal. He also occasionally used his rhythm section in non-conventional ways, allowing the bass and drums to break free of their traditional time-keeping roles. Although Ellington was a fine pianist, the orchestra was his "instrument."

Cross-sectional voicing is a written melody played in unison by two instruments from different sections, creating a new instrumental color; i.e., a melody written for flute and muted trumpet.

Sweet Pea

Ellington's creative output as composer and arranger was enhanced in 1939 with the addition of **Billy Strayhorn** (1915–1967) as a collaborator. Strayhorn was college-educated (unlike Ellington, who was self-taught), and immediately went about studying his mentor's scores to learn what he called the "**Ellington effect**." By learning to emulate Ellington's arranging style, he was able to take over an increasing share of those duties. Strayhorn (who was known as Sweet Pea for his diminutive size and mild manner) also began to contribute his own compositions, including some of the most memorable in

Music Analysis

Track 25: "Black, Brown, and Beige, Part I"

(Ellington) Duke Ellington and His Orchestra recorded at the Columbia Studios in Hollywood on February 5, 1958. Personnel: Duke Ellington: piano; Cat Anderson, Harold "Shorty" Baker, Clark Terry: trumpet; Ray Nance: trumpet and violin; Quentin Jackson, John Sanders, Britt Woodman: trombone; Harry Carney: baritone sax; Paul Gonsalves: tenor sax; Bill Graham: alto sax; Jimmy Hamilton: clarinet; Russell Procope: clarinet and alto sax; Jimmy Wood: bass; Sam Woodyard: drums; Duke Ellington: arranger

Black, Brown and Beige, Duke Ellington's monumental homage to African American history premiered to the general public on January 23, 1943, at Carnegie Hall in New York. It was Ellington's first performance and the first of six annual concerts at the legendary classical music venue. *B, B, & B* in its original form was a suite in three movements lasting 57 minutes, but Ellington reworked it several times, and by the time this recording was made in 1958, it had six movements and lasted less than 36 minutes, undoubtedly tailored to fit onto the two sides of a 33-1/3 rpm LP. Although Ellington had written extended works before *B, B, & B,* this piece marked a major turning point in his illustrious career, one that made some critics opine that the Maestro was going 'symphonic' and should stick to writing dance tunes. The bold and optimistic main theme of Part I of *B, B, & B* is known as "The Work Song," and is, along with "Come Sunday" one of the work's two main themes. To Ellington, work and spirituality were central to the story of early African American life.

0:00	Bass ostinato and slow tom tom beat fades in, leading into a bold statement of the melody by trombones and trumpets
0:24	Saxophones enter with melody as the tempo immediately picks up with swing rhythm on high hat cymbals by drummer Sam Woodyard; trombones, then trumpets play background riffs
0:55	Woodyard returns to tom tom beat; trombones, saxes, and then trumpets take turns restating the main melody
1:17	Saxophones play new melody with rhythm section accompaniment
1:53	Trombones and tom toms re-enter followed by loud accented ensemble writing for the entire horn section and a re-statement of the main theme
2:28	Baritone saxophonist Harry Carney plays an extended solo, backed primarily by trombones and drums, track continues

the Ellington library, including "Passion Flower," "Chelsea Bridge" and "Lush Life." "Take The 'A' Train," the tune that would become Ellington's theme song, was written by Strayhorn in 1941. Strayhorn stayed with the Ellington organization until his death in 1967.

Stability

Duke Ellington maintained a band for more than fifty years (from 1923 until his death in 1974), which is undoubtedly a record in the music business. During these years, some of the finest soloists in jazz passed through his band. One of the remarkable things about the band was the stability of the personnel, including some members who stayed for a good deal of their professional careers. This stability is impressive when considering that Ellington went out of his way to find unique personalities, and not necessarily people who could easily get along together. Ellington's abilities as a bandleader were even more impressive when taking into account the grueling grind of constant traveling by bus and train, rehearsals, recording sessions, and one-nighters that came with the job.

Music Analysis

Track 26: "Take the 'A' Train"

(Strayhorn) Duke Ellington Orchestra recorded February 15, 1941. Personnel: Wallace Jones, Ray Nance: trumpet; Rex Stewart: cornet; Joe Nanton, Lawrence Brown, Juan Tizol: trombone; Johnny Hodges, Otto Hardwick: alto sax; Ben Webster, Barney Bigard: tenor sax; Harry Carney: baritone sax; Ellington: piano; Fred Guy: guitar; Jimmie Blanton: bass; Sonny Greer: drums; Billy Strayhorn: arranger

This is the first and most famous recording of Ellington's theme song "Take The 'A' Train," composed and arranged by Billy Strayhorn. Starting off with Ellington's instantly recognizable piano intro, the arrangement includes two solos by trumpeter Ray Nance as well as the famous ascending scale secondary theme in the third chorus. Also note the modulation at 1:38 that seems to briefly change meter to three beats to the bar.

0:00	Piano introduction
0:06	First chorus: head is stated by tenor saxophones with muted trumpet and trombone background riffs
0:51	Second chorus: muted trumpet solo by Ray Nance with soft saxophone backgrounds
1:38	Modulation to new key
1:44	Third chorus: secondary theme introduced with one chorus unmuted trumpet solo by Ray Nance
2:17	Last eight bars of the chorus: theme played three times, each time softer. Tenor saxes play melody with cup-muted brass background riffs

Notable members and soloists with the Ellington Orchestra include:

- Harry Carney, baritone saxophonist for 47 years (1927–74), the first notable bari sax soloist in jazz
- Johnny Hodges, lead alto saxophonist for 38 years (1928–51, 1955–70), noted for his smearing technique
- Ray Nance, trumpet, violin, and vocal for 34 years (1940–76); Ellington called Nance "Floorshow" because of his many talents
- Lawrence Brown, trombone for 29 years (1932–51, 1960–70)
- Sonny Greer, drummer for 28 years (1923–51), who played a huge percussion set and also sang
- Paul Gonsalves, tenor sax for 24 years (1950–74)
- Cootie Williams, trumpet for 23 years (1929–40, 1962–74)
- Otto Hardwick, alto sax for 19 years (1923–28, 1932–46)
- Cat Anderson, trumpet for 12 years (1944–47, 1950–59)
- Rex Stewart, cornet for 11 years (1934–45); he used a **half-valve technique** to give his horn a novel "talking" effect
- Ben Webster, tenor sax from 1939–43, one of the powerful players from Kansas City
- Oscar Pettiford, bass from 1945–48
- Jimmie Blanton, bass from 1939–42, helped redefine bass playing before his untimely death from tuberculosis in 1942

> A **half-valve technique** involves depressing one or more trumpet valves halfway to create a novel "talking" effect.

The Famous Orchestra

From 1940 to 1943, Ellington's orchestra was hitting on all cylinders, with players who had been with him for several years that were well-rehearsed and tight. This would become known as his "**Famous Orchestra**," and is regarded as the best lineup of his career. Throughout the 1940s, Ellington continued to surge

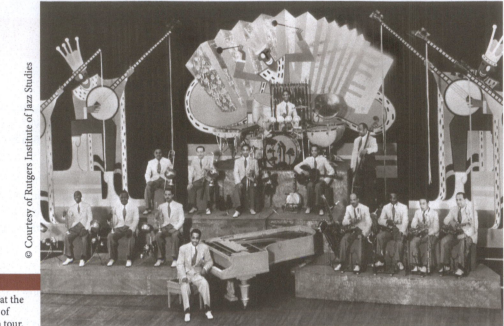

© Courtesy of Rutgers Institute of Jazz Studies

The **Duke Ellington Orchestra** at the London Palladium in 1933, one of the stops on their first European tour.

ahead with new musical projects. At a time when it would have been financially prudent of him to play hit dance tunes as other swing bands were doing, Ellington stuck to playing primarily his own music. A brief list of some of his notable compositions and achievements after 1940 include:

- *Jump for Joy* (1941), a pioneering civil rights musical
- *Cabin in the Sky* (1942), Ellington stars in the Hollywood film with singer Lena Horne
- Carnegie Hall concerts (1943–48), Ellington's Orchestra headlines six consecutive annual concerts, the first of which featured the debut performance of his suite *Black, Brown, and Beige*
- *A Drum Is a Woman* (1956), a four-movement suite, complete with narration, designed to fill both sides of a 33-1/3 rpm LP; it has been called the first-ever "concept" album
- *Anatomy of a Murder* (1959), the musical score to Otto Preminger's film

The Ellington Legacy

Ellington continued to write and tour until the end of his life. Although the years after the swing era were lean for large jazz orchestras, Ellington was one of the very few bandleaders that were able to keep his together throughout the late 1940s and early 1950s. The 60s brought tours of Europe, the Middle East, and Japan, and the "Far East Suite" in 1966. Ellington also staged three Sacred Concerts of religious music that he debuted in 1965, 1968, and 1973.

Two events stand out as memorable in his last twenty years. In 1956, at an appearance at the Newport Jazz Festival, Ellington performed "Diminuendo and Crescendo in Blue," a work that combined two pieces he had written in 1937. Urged on by the other band members and the crowd of 7,000, tenor saxophonist Paul Gonsalves played an incredible twenty-seven-chorus solo that whipped the audience into a frenzy. The resulting publicity (that included his picture on the cover of Time magazine) revived Ellington's career. On his 70th birthday, April 29, 1969, he received the Presidential Medal of Freedom from Richard Nixon in a ceremony at the White House that was attended by many of the greatest living

The **Newport Jazz Festival** was the first outdoor music festival, originated by jazz impresario George Wein and staged in Newport, Rhode Island. Now known as JVC Jazz Festival-Newport, RI, it has run annually since its inception in 1954.

jazz legends. Ellington died of cancer in 1974 at Columbia Presbyterian Hospital in New York. By his bed was an electric piano he was using to compose new music.

William "Count" Basie (1904–1984) Piano/Bandleader

On a cold January night in Chicago in 1936, John Hammond sat in his car listening to the short wave radio that he had specifically installed to scout for talent around the country. Scanning the dial to the very top, he came across experimental station W9XBY broadcasting live from the Reno Club in Kansas City. "I couldn't believe my ears", he later wrote. He was listening to the nine-piece Count Basie Orchestra. Within days, Hammond was at the Reno Club to listen to the Basie band in person, and over the next few months wrote of their virtues in *DownBeat* articles. Within three years, Basie's band was one of the most popular in the country.

William Basie was born in Red Bank, New Jersey. During his teens, he learned to play stride piano from Fats Waller and worked his way into the music business playing organ in theatres and piano with traveling vaudeville shows. One such show ran out of money in 1925, leaving him stranded in Kansas City. After deciding to stay in the city to pursue his musical career, Basie met and played with Jimmy Rushing, joined Walter Page's Blue Devils in 1928, and Bennie Moten's Orchestra in 1929. Basie by now was an accomplished stride pianist, but by playing with Walter Page, who played the most powerful walking bass of his generation, he found his piano style evolving away from the heavy-handedness of stride. His new style was streamlined, sparse, and understated, often using little if any left hand. It was a major step forward in the evolution of jazz piano.

The All-American Rhythm Section

By playing fewer notes, Basie allowed the rhythm section to "breathe," and the members were able to compliment instead of duplicate each other. When Moten died in 1935, Basie put his own band together (largely from Moten personnel), secured the gig at the Reno, and assembled the greatest rhythm section of the era. Along with Basie and Page was drummer Jo Jones, who shifted the emphasis of his playing away from the heavy bass drum on each beat (as was the custom for swing era drummers) to the hi-hat cymbal. The result was a lighter, more buoyant drumming style that was the perfect compliment for Basie's piano style.

In early 1937, Basie replaced his original guitarist Claude Williams with Freddie Green, who played a rock-solid downstroke on every beat. Because of the delegation of responsibilities, and the lighter, more fluid rhythm, Basie revolutionized the rhythm section. The All-American Rhythm Section, as they were called, was the first modern rhythm section in jazz history. With it, the Basie band built its reputation on swinging harder than anyone else, rather than with arrangements or by playing the latest pop tunes.

The rock-solid foundation provided by the rhythm section allowed Basie to showcase his superb horn soloists. Because hardly any of Basie's music in the early years was actually written

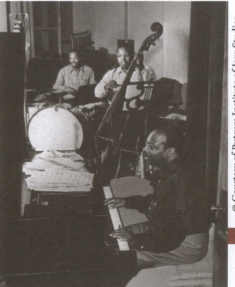
© Courtesy of Rutgers Institute of Jazz Studies

The **Count Basie Orchestra** including Jo Jones on drums, Walter Page on bass, and Count Basie on piano.

> **Count Basie's All-American Rhythm Section**
> - Count Basie—piano
> - Freddie Green—guitar
> - Walter Page—bass
> - Jo Jones—drums

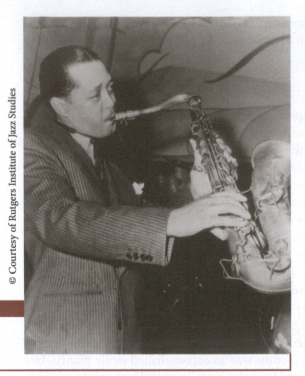

© Courtesy of Rutgers Institute of Jazz Studies

Lester "Prez" Young became the most important soloist in the Basie Band.

down on paper (head arrangements were the norm), the soloists became critically important to the sound of the band. The main attraction was the tenor players Lester Young and Herschel Evans, who had contrasting styles and often locked in competitive cutting contests with each other. Other notable soloists in the early years included trumpeters Buck Clayton and Harry "Sweets" Edison, and trombonist Dickie Wells.

Taking on the World

Within months of discovering Basie, Hammond arranged to bring the band to New York and expanded it from nine pieces to fifteen. Although New York musicians were fascinated with the band's wide-open sound, Basie struggled with integrating six new musicians into a band that had little if any written music. Their first gig at the Roseland Ballroom was met with mixed reviews. However, by the time they secured a six-month residency at the Famous Door on 52nd Street in July 1938, the problems had been ironed out, and the band was a huge success. Live network radio broadcasts and their Decca recordings helped get Basie the publicity he needed. Throughout the 1940s, the band stayed relatively intact and in time became internationally famous. More great soloists passed through the ranks, including tenor men Don Byas, Frank Foster, and Buddy Tate, and Clark Terry on trumpet.

Like many other big bands, Basie faced difficulties in the 50s and had to cut the big band down to a small group for short period. But in 1956, with a new big band backing shouter Joe Williams, his career was revived with the hit single "Everyday I Have the Blues." The Basie band in the 50s and 60s became known as a "writers" band, with the best **session musicians** and arrangers in jazz. This of course was an ironic departure from the band at the Reno Club in 1935, which relied primarily on head arrangements. The one constant through the years was the music that continued to make you, as the Count said, "Pat your foot." Basie, like Ellington, continued to tour until his death in 1984.

Session musicians are musicians used in recording sessions. They must be able to sight-read music and play fluently in a variety of styles.

Other Swing Era Bandleaders

- Chick Webb
- Jimmie Lunceford
- Cab Calloway
- Artie Shaw
- Charlie Barnet

Other Important Swing Era Bandleaders

There were literally hundreds of big bands in the swing era, and many of them became very commercially successful. Some of the more notable bandleaders and their bands are discussed briefly here.

Chick Webb (1909–1939) Drummer/Bandleader

Chick Webb led one of the hardest swinging and powerful bands of the era. He was also one of the era's most powerful drummers, despite the fact that he had congenital spinal tuberculosis that stunted his physical growth to less than five feet in height. Throughout most of the 1930s, the Webb orchestra was the house band at the Savoy Ballroom and engaged in many battles with incoming bands. The most famous battle took place on May 11, 1937, when Benny

Goodman showed up to take on Webb's band. Four thousand people showed up to witness the King of Swing go down in defeat. Webb took the confrontation so seriously that he ordered extra rehearsals for his band, and threatened to fire any musician who made a mistake. In 1934, Webb hired 17-year-old Ella Fitzgerald after she won an amateur singing contest at the Apollo Theatre. Their 1938 recording of "A-tisket, A-tasket" was the band's biggest hit. Unfortunately, Webb, who suffered constant pain throughout his life, died of complications from his spinal condition in 1939, at which time Fitzgerald took over control of the band.

Jimmie Lunceford (1902–1947) Bandleader

The **Jimmie Lunceford** Orchestra was one of the most exciting bands of the swing era. Their arrangements, many of which were written by Sy Oliver, were noted for a two-step beat that dancers loved. Lunceford was a college-educated musician who believed that a band should put on a good show, and his orchestra was the best showband in the business. To add flair, Lunceford never played but conducted with a baton. He and his men always wore smart, matching uniforms, and band members often engaged in all kinds of gimmicks to entertain audiences, including throwing their horns up in the air and twirling them on their fingers. Despite all the showmanship, the band was always disciplined, tight and precise.

Cab Calloway (1907–1994) Singer/Bandleader

Cab Calloway came to New York in 1929 from Baltimore as the leader of the Alabamians, an 11-piece territory band. After the Alabamians suffered an embarrassing defeat at a Savoy Ballroom band battle, Calloway left and took over a rival band, renaming it the Cab Calloway Orchestra. Calloway recorded his biggest hit in 1931, "Minnie the Moocher," and from the hook of that song he earned his nickname, the "hi-de-ho man." It was also in 1931 that Calloway took up residency at the Cotton Club, replacing Duke Ellington. He stayed until 1934.

Although not a jazz musician himself, Calloway was an incredible dancer who pioneered flashy moves that many entertainers have copied throughout the years. He also sang "Minnie the Moocher" in his cameo appearance in the 1980 film *The Blues Brothers*.

Artie Shaw (1910–2004) Clarinet/Bandleader

Artie Shaw put his first swing band together in 1937 and achieved national fame the next year with the hit "Begin The Beguine." Although Shaw was almost immediately drawn into a media-driven rivalry with Benny Goodman, he was never comfortable with fame and disbanded his group in 1939. The differences between the two clarinetists were striking: Goodman was the hot player with the cold personality; Shaw, the cool, lyrical player with the hot temper. Shaw hired Billie Holiday for a while to sing with his band in 1938 (one of the first white bandleaders to hire a Black vocalist), but her stay was short due to many racial incidents at clubs and hotels that forced Holiday to quit. Although Shaw remained semi-active in music for many years, his non-musical life has often drawn attention. In 1952, he published a semi-autobiographical book, *The Trouble With Cinderella*. Shaw also married often; his ex-wives include movie stars Ava Gardner and Lana Turner.

Charlie Barnet (1913–1991) Saxophones/Bandleader

With orchestral arrangements by himself and Billy May, **Charlie Barnet** was often referred to as the "White Ellington." Highly thought of in both Black and white circles, Barnet had one of the first white bands to play Harlem's Apollo Theatre in 1933.

He was also one of the first white bandleaders to hire Black musicians, including singer Lena Horne in 1941. Barnet's biggest hit was the 1939 recording of "Cherokee" which was inspirational to the young Charlie Parker. Like Artie Shaw, Charlie Barnet was a colorful personality and was married many times.

Other Important Swing Era Jazz Stars

The Tenor Titans: Coleman Hawkins and Lester Young

Swing-Era Jazz Performers

- Coleman Hawkins
- Billie Holiday
- Roy Eldridge
- Jack Teagarden
- Jimmy Dorsey
- Tommy Dorsey
- Django Reinhardt
- Stephanie Grappelli

Although many great tenor saxophone players emerged during the swing era, the two most important were the 'Bean', Coleman Hawkins, and the 'Prez', Lester Young. In many ways, they were polar opposites: Hawkins had a huge, dark sound whereas Young's was light and breathy; Hawkins' improvisations were based on his superior knowledge of harmony, Young's were rooted in the blues; and Hawkins played with a rhythmic approach that was always closely tied to the beat, whereas Young's rhythmic conception was much looser, often untied to the beat. But despite their differences, they were the most influential tenor soloists of their generation, and inspired saxophone players for years to come.

As the first major tenor soloist in jazz, **Coleman Hawkins** (1904–1969) became known as the 'Father of the Tenor Sax'. Born in St. Joseph, Missouri (just 50 miles north of Kansas City), he first toured with Mamie Smith's Jazz Hounds before joining the Fletcher Henderson Orchestra in New York in 1923. After establishing his reputation as a star soloist with Henderson, Hawkins' ambitions led him to Europe in 1934 where he spent the next five years appearing with a number of orchestras throughout the continent and energizing the burgeoning jazz scene in Paris. However, with the imminent outbreak of World War II, Hawkins returned to the United States in late 1939. He soon secured a gig at Kelly's Stables on 52nd Street and recorded "Body and Soul," the song that his name would forever be linked with.

Vertical style is an improvising style based on chord tones (which are stacked vertically in notated music) as opposed to a melodic style (which is notated horizontally).

By this time, Hawkins was experimenting with solos based on harmonic chord tones, a concept that became known as harmonic improvisation, or **vertical playing**. This of course required a thorough knowledge of harmony and music theory, and earned Hawkins his nickname (although he was also known as 'Hawk'). This improvisational concept was highly influential to the future bebop musicians who would use it as a building block for their own experimentations. Hawkins also set the standard for swing era tenor players with a huge sound that he developed in the years before microphones were used, and a tone that was dark and course.

Unlike most swing players who denounced bebop as it emerged in the mid-1940s, Hawkins embraced it and encouraged its young proponents. In early 1944, he led what is often called the first bebop recording session, recording Dizzy Gillespie's composition "Woody'n You." Later that year, he appeared at the Downbeat Club on 52nd Street with a band that included emerging bop pianist Thelonious Monk. Hawkins was one of the few musicians who understood and appreciated Monk's unorthodox playing at the time, and he was criticized for using the young pianist. Despite the fact that in time Lester Young's modern concepts would be more widely adopted by future tenor players, Hawkins continued to record and perform until the mid-60s.

Mississippi-born **Lester Young** (1909–1959) traveled the territories before settling in Kansas City where he made a name for himself playing in the hard-swinging bands of Benny Moten and Count Basie. He developed a style that was rooted in the blues and a smooth, lyrical tone that was inspired by C-Melody saxophonist Frank Trumbauer. Young also styled a loose, laid-back rhythmic

Music Analysis

Track 27: "Body and Soul"

(Green/Heyman/Sour/Eyton) Coleman Hawkins and His Orchestra recorded October 11, 1939. Personnel: Hawkins: tenor sax; Eustis Moore, Jackie Fields: alto sax; Joe Guy, Jimmy Lindsay: trumpet; Earl Handy: trombone; Gene Rogers: piano; William Oscar Smith: bass; Arthur Herbert: drums

Coleman Hawkins's rendition of "Body and Soul" sold more than 100,000 copies within six months and established him as a star on the tenor sax. The recording was done in one take at the end of an early morning session that took place after Hawkins finished a gig at New York's Kelly's Stables. Hawkins had developed a reputation for playing extended versions of the song at Kelly's, but due to the limitations of the 78-rpm record, he had to limit the recorded version to only two choruses. Hawkins stays close to the melody for only the first eight bars, after which he pretty much abandons it in favor of a new melodic improvisation. This recording is noteworthy because in it Hawkins creates a blueprint for the interpretation of ballads that has been used by many jazz soloists throughout the years: that is, start small, slowly build the energy and intensity to a high point near the end before bringing it back down again, ending with a cadenza. Hawkins's remarkable recording also made "Body and Soul" a required part of every tenor saxophonists repertoire for many, many years.

0:00	Piano introduction by Gene Rogers
0:09	Coleman Hawkins begins his solo over the first chorus with rhythm section accompaniment
1:31	Second chorus begins with horns adding accompaniment of sustained notes, dropping out on bridge; Hawkins plays with increasing fire and energy
2:47	Short tenor sax cadenza, song ends

concept that allowed him to create melodic ideas that seemed to float free of the beat. But these aspects of his playing were at odds with the conventional Hawkins-esque approach to tenor playing, and initially were not well received. In 1934 after Young left Moten to replace Hawkins in the Henderson Orchestra, he was fired after six months because he did not have the forceful sound of his predecessor. Eventually, however, Young's style became highly influential to younger bebop musicians such as Charlie Parker and made Hawkins' stricter rhythmic approach seem plodding and out of date.

After leaving Henderson's band, Young reunited with Basie, with whom he would stay until 1940. In 1937, he met Billie Holiday, with whom he had a close, but not romantic, relationship for several years. It was Holiday who gave Young his nickname (proclaiming him to be the 'president' of the tenor sax); he, in turn, gave her the sobriquet 'Lady Day'. During the next several years, the two recorded together often, demonstrating laid-back, bluesy styles that complemented each other perfectly. Although they drifted apart in their later years, they reconnected on the 1957 TV program *The Sound of Jazz* with an emotional rendition of Holiday's blues "Fine and Mellow."

Lester Young was also one of the more interesting personalities in the history of jazz. He developed an unusual idiosyncratic vocabulary that made him seem aloof to those that did not know him, but hipper than hip to those that did. Examples: cops were "Bob Crosbys," white people were "grays." In 1944, Young was drafted into the military, but his short enlistment was marred by several violent incidents that seem to have been racially motivated. It seems clear that this experience affected his emotional stability, as his later years were marked by a decline into alcoholism and mental issues.

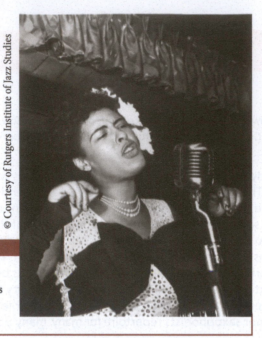

© Courtesy of Rutgers Institute of Jazz Studies

Billie Holiday singing in a nightclub setting. In spite of her tumultuous personal life, her vocal perfor mances conveyed almost unlimited emotion and expressiveness.

Billie Holiday (1915–1959) Vocal

To measure the greatness of **Billie Holiday**, a different set of standards must be used. With a limited range of about fifteen notes and a frail, delicate voice, she can hardly be called a virtuoso. But Holiday gave some of the most inspired performances by a jazz singer on record with unlimited emotion and expressiveness. With a habit of rhythmically lagging behind the beat, she was often compared to her longtime musical (but not intimate) soul mate, Lester Young. Her musical influence was Louis Armstrong; she in turn was influential to Frank Sinatra.

Holiday's short life was marred by racial and sexual discrimination and oppression, tragedy, violence, addiction to drugs and alcohol, and tempestuous relationships with managers, lovers, and husbands. Her father Clarence, who played guitar with Fletcher Henderson, deserted the family; she was sexually molested at the age of 10, and by age 12, she was working as a prostitute. Somewhere around 1932 or 1933, Billie started singing in Harlem clubs, and a mutual friend set up an audition for record executive John Hammond. Hammond, with his eye for new talent, arranged for a series of recordings to be made under the direction of pianist Teddy Wilson that also included Benny Goodman, who had just met Hammond himself. In 1935, Billie made her first recordings as a leader, followed by short stints with Count Basie in 1937 (where she met Lester Young) and Artie Shaw in 1938.

Music Analysis

Track 28: "Strange Fruit"

(Lewis Allan) Billie Holiday recorded April 20, 1939 at Brunswick Record Corporation/World Broadcasting Studio, New York City. Personnel: Billie Holiday: vocal; The Frankie Newton Orchestra under the direction of Tab Smith: Frankie Newton: trumpet; Tab Smith: alto sax; Kenneth Hollon, Stan Payne: tenor sax; Sonny White: piano; Jimmy McLin: guitar; John Williams: bass; Eddie Dougherty: drums

"Strange Fruit" has been called the first openly political song sung by an African American singer on a pop recording, and even today it has significance as a civil rights anthem. The song originated from a poem written by high school English teacher/political activist Abel Meeropol, under the pseudonym Lewis Allan. Distressed upon seeing a photograph of a lynching, Meeropol wrote a poem whose first stanza ended with a line that contained both the title and a very clear metaphor: "Strange fruit hanging from the poplar trees." Meeropol eventually set the poem to music, and it was introduced soon after to Billie Holiday. At the time, Holiday was performing at Café Society, a Greenwich Village "Black and tan" (a bar open to both Black and white customers). Legend has it that after her first performance of the song, the audience was stunned into silence for several moments before giving her a rousing ovation. Although the song was a hit at the club (and changed Holiday's life), her record company, Columbia, feared it was too controversial and refused to record it. Holiday eventually got the much small Commodore label to record the song, and it eventually sold one million copies. She also recorded the song in April 1944, again for Commodore.

0:00	Introduction with short muted trumpet solo by Frankie Newton, followed by a piano solo by Sonny White
1:10	Holiday begins vocal

In 1939, Holiday opened at a new Black and tan club in Greenwich Village called **Café Society** that was billed as "The Wrong Place for the Right People." It was at Café Society that she premiered "**Strange Fruit**," an anti-lynching song written by civil rights activist Lewis Allan. The song is a powerful and moving denunciation of the widespread racial violence in the South, and it became a highlight of her performances at Café Society. Once she recorded the song, most radio stations in the country banned it for being too controversial, but it became a hit anyway when it was inserted into jukeboxes. After its release, Holiday became more outspoken when confronted with racial discrimination. She also wrote and recorded two outstanding original tunes in 1939, "God Bless the Child" and "Fine and Mellow."

Sometime in the early 1940s, Holiday began using heroin, and her life began to spiral downward. She was arrested in 1947 for possession, served a 10-month sentence, and lost her **cabaret card** for life (barring her from performing in New York nightclubs). Her recordings from the 1950s reveal a voice that has changed dramatically from her earlier recordings: it is darker, lower, and full of pain. There have been many debates as to whether her voice improved or declined with the wear and tear of her life: it is not as flexible but portrays more emotion than her earlier recordings. There were highlights from Holiday's last years: in 1948, she broke box-office records with appearances at Carnegie Hall, and a 1954 tour of Europe was a success. But these years were also marked by constant police harassment, ugly altercations with club owners and managers, incidents of discrimination and stormy romantic relationships. Trumpeter Joe Guy, her second husband, not only introduced her to heroin but also swindled her out of $30,000. Although she appeared in the 1947 movie *New Orleans* with her idol Louis Armstrong, she was forced to play a maid. The final indignity came as Holiday lay on her deathbed in a New York hospital: she was arrested after a nurse found a packet of heroin in her room, and she was put under house arrest for the last month of her life. She died on July 17, 1959, at age 44, just four months after the death of her friend, Lester Young.

> A **cabaret card** was a card issued by the city of New York that allowed a performer to work in an establishment that sold liquor.

Other Swing-Era Musicians

- **Roy Eldridge** (1911–1989) Trumpet; an important stylistic bridge between the old and the new: growing up, he idolized Louis Armstrong; the new trailblazer, Dizzy Gillespie, grew up idolizing Eldridge. He was known as "Little Jazz," and was featured soloist in many big bands during the swing era.
- **Jack Teagarden** (1905–1964) Trombone/vocal; the greatest of the early jazz trombonists who also sang in a relaxed and easy-going manner. He worked with Louis Armstrong and Paul Whiteman and many others, and ran his own big band in the mid-1940s.
- **Jimmy Dorsey** (1904–1957) Alto sax; and **Tommy Dorsey** (1905–1956), trombone; brothers that led an early big band from 1934 until 1935, when an argument on stage prompted Tommy to walk out and start his own band. Both bands were popular throughout the swing era. They reunited in 1955 for a year until Tommy's death.
- **Django Reinhardt** (1910–1953) Guitar, and **Stephane Grappelli** (1908–1997), violin; the two leading jazz players from the burgeoning European scene in the 1930s and 1940s, and members of the **Quintette du Hot Club de France**, the house band at the **Hot Club of Paris**. Reinhardt, a gypsy from Belgium, was a masterful technician who was influential to many early jazz guitarists. Grappelli was one of the first (along with Ray Nance of the Ellington band) to play jazz on the violin.

The End of the Swing Era

The swing era seemed to collapse with a shocking suddenness. In December 1946, six major bandleaders—Jack Teagarden, Woody Herman, Tommy Dorsey, Harry James, Les Brown, and the King of Swing himself, Benny Goodman— announced that they were folding up their bands. The decade-long party was seemingly over. What happened? As it turns out, cracks in the veneer of the swing boom had been forming for years. Among the reasons the swing era died are listed in **Box 6-3**.

BOX 6-3	Factors Leading to the End of Swing

- **Changing economics.** By 1939, a steady supply of new start-up bands had actually started to outpace demand for them. Even though there was still a lot of money to be made, the cost of starting a new band aimed at the national market rose to nearly prohibitive levels. Besides uniforms, arrangements, fronts, and other intangible necessities, a start-up band had to pay salaries for rehearsals and lodging (even if there were not very many jobs at first), advertising, traveling costs, and management fees. Conventional wisdom said that an average band would lose thousands of dollars in the first year before (and if) they started to turn things around.

- **The war.** World War II only added to the economic woes of the swing band. With America's entry into the conflict in December 1941 came gas and rubber rationing and travel restrictions that made touring more costly and difficult. A 30 percent amusement tax was imposed in 1944 on venues that allowed dancing. Shellac, an essential ingredient in the production of records, became difficult to come by and was rationed. In addition, thousands of musicians were called up for duty (including Glenn Miller, who vanished in an airplane in 1944 over the English Channel), creating a labor shortage of good players. Those who stayed behind either because of age or a deferment found themselves able to command higher salaries. War-related cost increases were either passed along to dancehalls (which were increasingly having a harder time making a profit) or absorbed by the band.

- **Predictability.** The increased focus on standardized conventions and formulas in the name of making money caused the music to become homogenized, cliché ridden, and predictable. The limitations of the swing band format and its inability to produce anything new that was fresh and original had become painfully obvi- ous by the mid-1940s, except in the hands of a few innovators like Ellington. One highly successful arranger, Eddie Sauter (who wrote for Goodman and others) simply got tired of writing the same thing over and over and quit. "After a while, it got so that I couldn't hear one note going to another, it was too repetitive, too much of the same thing. I just had to stop it", he said in 1944.

- **AF of M Recording Ban.** On August 1, 1942, the American Federation of Musicians banned all recordings by its members, the result of a bitter standoff with and the recording industry. At issue was the union's demand to be reim- bursed for the increased substitution of recorded performances on phonographs, jukeboxes, and radio for live performances. The record companies did eventually give in, but not until late 1944. Although the settlement was a victory for musi- cians in the long run, the immediate impact was to turn the public's attention increasingly to other music styles, including R&B and country, whose performers typically were not union members. In any event, when the ban was over, things seemed to be different in the pop music world.

- **The changing audience.** It is often said that nothing is permanent except death and taxes, and by the mid-1940s swing had seemingly worn out its welcome. By the end of WWII (November 1944), the swing generation was in their late 20s and early 30s and ready to get on with their lives. As they got married, bought homes, and began to conceive the baby boom generation, a new era of individualism began to replace the sense of community that had been so prevalent in the 1930s. Late 1940s developments such as suburbs (the first, Levittown, New York was built in 1946), the increased use of automobiles, and the growing popularity of television contributed to this new zeitgeist. As a reflection of this shift of consciousness, the new teen audience that emerged in the mid-1940s turned away from the team-oriented sound of the swing orchestra and embraced the individuality of solo pop singers. Leading the way was Frank Sinatra, who after quitting the Tommy Dorsey Orchestra in 1943, developed his own audience of swooning, passionate fans. Sinatra and other pop singers such as Doris Day, Patti Page, Perry Como, and Eddie Fisher became the new pop stars until the advent of rock and roll in the mid-1950s.
- **Bebop.** By the early 1940s, some jazz musicians were searching for a more creative outlet than swing could provide them. As discussed in chapter 7, the emerging style of bebop forever changed the public's perception of jazz from dance music to listening music. To young fans of jazz, bebop immediately reframed swing as old-fashioned, dull, and commercial; ardent followers had new heroes named Parker and Gillespie to replace Goodman and Dorsey. Many fans that looked to jazz to provide a social atmosphere for dancing and good times began looking elsewhere. For them, bebop was listening music that they simply did not want to listen to.

Name _____ Date _____

The Swing Era

1. Describe the ways in which swing music and popular culture were interrelated during the time known as the swing era.

2. Describe John Hammond's role in the swing era and why he was important.

3. Name some of the specific innovations Duke Ellington brought to jazz in the 1930s and 1940s.

4. Describe why Count Basie's rhythm section is called the first modern rhythm section.

5. Describe why there was so much conformity in the look and sound of swing bands and how this happened.

6. Describe why Coleman Hawkins is a key figure in jazz.

7. How and why did Billie Holiday's early recordings sound different than her later ones?

8. In what ways were all swing big bands similar? What were some of the ways in which they were different?

9. Describe some of the reasons why the swing era began and why it came to an end.

10. Describe how the styles of Lester Young and Coleman Hawkins were different.

THE BEBOP REVOLUTION

Introduction

The early 1940s were a time of important changes in jazz. Just as the swing era was in full bloom, a musical revolution was brewing in Harlem. New ideas were coming together from a diverse cast of creative young musicians at after-hours jam sessions, away from the limelight of the popular big bands. In an environment of experimentation and spirited camaraderie, bebop (or simply bop), the first modern jazz style was born. It was frenetic, difficult to play, and for many jazz fans, difficult to listen to. To the music establishment, bebop was nothing less than an insurgency, with leaders that were defiant, rebellious, and disrespectful of authority. On the surface that was a fairly accurate assessment. But the roots of the bebop revolution went deeper than just a disruption caused by a few outsiders bored with swing. In many ways, the emergence of bebop was a broad reflection of some important changes that were beginning to surface in America.

Although some initially criticized bebop, it was too big a force to ignore. With its emergence, suddenly no one seemed to be quite sure what the future of jazz would hold. Bebop's influence is pervasive to this day: its melodies, rhythms, harmonies, and repertoire are still studied by jazz musicians and are intertwined in the very fabric of nearly all modern jazz.

Winds of Change

The Critical Moment

The birth of bebop marked a critical moment in the history of jazz, a seismic shift that would forever alter the way jazz was performed and perceived. **Bebop** changed jazz from popular dance music to intellectual art music. By bringing an entirely new vocabulary to jazz, it washed away the musical clichés of swing. It opened up jazz to new artistic interpretations that would lead to almost limitless stylistic approaches in the future. And from this moment on, jazz began its slide from the center of mainstream popular culture to the perimeter. In the beginning, bebop was a revolution whose repercussions brought turmoil to the jazz world: some musicians stubbornly ignored it; others embraced it; still others initiated a nostalgic backlash against it. But now that sixty years have passed since its birth, it is clear that bebop's legacy is one of evolution as well as revolution: although it quickly brought profound changes to jazz, it also set the stage for nearly every jazz style that has emerged since.

Bebop seemed to come out of nowhere. In the early 1940s times were good for the hundreds of dance band musicians who were earning a decent salary playing in a swing band. They understood the rules that governed the music industry and what their respective roles were—after all, business is business. And with a steady

The early 1940s were a time of important change in jazz. A musical revolution was brewing in Harlem.

Bebop changed jazz from popular dance music to intellectual art music.

paycheck and the undying admiration of their audience, there was little if any motivation for personal musical growth or innovation. However, with the arrival of bebop, the playing field was suddenly tilted in a disorienting way. Many musicians, like alto saxophonist Art Pepper, felt threatened. Upon hearing his first bop recording after returning from the war, Pepper said, "These guys played faster… and they really played. Not only were they fast, technically, but it all had meaning, and they swung! They were playing notes in the chords that I'd never heard before. It was more intricate, more bluesy, more swinging, more everything…and it scared me to death." To Pepper and many other musicians, it was pretty clear that bop was going to cause some fundamental—if not radical—changes to take place in jazz in the very near future. (Pepper adapted to the changes and went on to become one of the most respected musicians in jazz in the 1950s.)

What caught many musicians off guard was the complete absence of bebop recordings during the music's developmental stages. The American Federation of Musicians' ban on recordings by its members from August 1, 1942, until late 1944 neatly coincides with the new music's gestation period. (For more information on the ban, see chapter 5.) Chances are if you were not in Harlem during this time, you probably would not have heard any bebop until the first bebop recordings were made in late 1944 and early 1945. As author and historian Scott DeVeaux put it, "The recording ban falls like a curtain in the middle of the most interesting part of a play; by the time the curtain rises, the plot has taken an unexpected…turn, and the characters are speaking a new language." Of course, even if the recording ban had not happened, the music industry—major labels, radio networks, publishers, booking agents, and musicians themselves—had too much invested in the business of swing to pay much attention—at least initially—to what the nascent bop musicians were doing. That bebop was able to completely change the ethos of the jazz world in rather short order speaks to the power of the music and the artists who created it.

The New Breed of Jazz Musician

Even though it seemed that bebop suddenly came out of nowhere, in fact, the movement had been germinating for several years by the time it finally came to full bloom. The racial inequities of the music business during the swing era had allowed white dance band musicians to earn a comfortable living while denying the same economic opportunities to Black musicians. Black swing bands were routinely forced to play lesser paying gigs, had to travel farther to get to them, and, particularly in the South, had to deal with racial indignities, stereotypes, segregation, and in some cases violence. The sheer exhaustion of dealing with constant travel and racial inequalities eventually began to take its toll on many Black musicians. As the swing era headed into the 1940s, it was becoming increasingly clear to many young, creative Blacks who played in dance bands that they were playing a white man's game that was never going to recognize them for their talents. The world of swing simply was not working for them.

By virtue of being young, ambitious, and full of confidence, some Black musicians began to disengage from the swing economy. By one way or another, they ended up in Harlem around 1940, where they found an alternative music scene in the after-hours jam sessions that allowed them to play what they wanted to play, experiment with new harmonic concepts, and work on extending the technical mastery of their instruments. The informal setting of the jam session allowed them

to completely shake the notion of being entertainers, of playing for someone else's amusement; here they could play only for themselves and their peers. They embraced an increasingly militant view of themselves as artists and developed a stage presence that was cool and indifferent to the audience. The mugging Negro entertainer—as epitomized by Louis Armstrong, who suddenly went from respected elder statesman to despised Uncle Tom—was anathematized as a vestige of the minstrel show.

The Bebop Counter-Culture

Influencing the new breed of jazz musicians were the innovations of the most progressive musicians of the 1930s. These innovations included Art Tatum's reharmonizations and dazzling virtuosity; Coleman Hawkins' vertical improvisations; Lester Young's bluesy and relaxed style; and the modern swing of the Basie rhythm section. Using these concepts as inspirational springboards, they tried out their new ideas at some of Harlem's many tiny, out-of-the-way clubs, including the Rhythm Club, Pod and Jerry's and the Hoofer's Club, all on 132nd St; the Hollywood on 116th; the 101 Ranch on 139th; the Heatwave on West 145th Street; and the Nest Club on 133rd. The most important of these were Minton's Playhouse at 210 West 118th Street and Clark Monroe's Uptown House, at 198 West 134th Street. As the jam session scene coalesced in the early 1940s, a counter-culture mentality set in that was designed to keep away outside intruders. Beboppers started to dress differently, wearing goatees, sunglasses, and berets. Many became interested in Islam. They invented their own hipster language. Sadly, many began to use narcotics.

To gain entry into the bop counter-culture, one had to first hold your own in the late-night jam sessions that were beginning to swirl with experimentation and musical exploration. For an outsider, this was no easy task—bebop insiders deliberately tried to embarrass and discourage those who sat in with them by playing standard tunes at frantic tempos or in unusual keys. Another common tactic was to use 'secret' reharmonizations and chord substitutions that took unexpected twists and turns. It was the ultimate trial-by-fire initiation process designed to identify who was hip and who was square. As guitarist and jam session veteran Biddy Fleet said, "The purpose of those changes and different keys is to separate the sheep from the goats—is to get them no-players out of your way…a good way to do it is to…play it in such a way that they don't know what's going on. If and when they do know what's going on, they become one of you. A commune brother."

Minton's, Clark Monroe's, and "The Street"

The most celebrated of the Harlem jam sessions took place at **Minton's Playhouse**, opened in 1938 by Henry Minton in the Hotel Cecil. Minton's was small and unassuming but had a separate room behind the bar that was ideal for music. In 1940, Henry Minton hired ex-bandleader Teddy Hill to manage the club and set up a music schedule. Hill organized an after-hours 'Celebrity Night' jam session on Monday nights, offering free food to any musician who showed up to play. He also established a house band that included drummer Kenny Clarke and unknown pianist Thelonious Monk. Within weeks, Minton's became the "Showplace of Harlem," the place to be. Everyone in the jazz world, from the famous to the unknown, began showing up to play. Second only to Minton's was **Clark Monroe's Uptown House**, operated by onetime tap dancer Clark Monroe. Monroe was a flashy dresser and handsome—known as "Dark Gable" in reference to movie star Clark Gable—who like Teddy Hill encouraged musicians to indulge themselves in musical explorations at the club's nightly jam sessions.

But the Harlem scene was destined not to last. In the early 1940s, tensions between Black and whites began to escalate, and Harlem began to get a

The most celebrated early bebop sessions took place at **Minton's Playhouse**, opened in 1938 by Henry Minton in the Hotel Cecil at 210 West 118th Street.

Although Minton's became the place for the bebop crowd, other Harlem clubs like **Clark Monroe's Uptown House** (at 198 West 134th Street) and The Heatwave also held jam sessions on a regular basis.

Music Analysis

Track 29: "Swing to Bop"

(D.R.) Charlie Christian recorded at Minton's Playhouse May 12, 1941. Personnel: Charlie Christian: electric guitar; Joe Guy: trumpet; Nick Fenton: bass; Kenny Clarke: drums; unknown pianist

Among the regulars at the seminal Minton's Monday night jam sessions was guitarist Charlie Christian, who had come to New York from his native Oklahoma City after joining the Benny Goodman Orchestra in 1939. Because he died at age 25 from tuberculosis, few recordings of Christian exist other than the ones he made with Goodman's swing-oriented small groups. Fortunately for bebop historians, music engineer Jerry Newman took a wire recorder to Minton's in May 1941 and captured Christian and the Minton's house band at the very moment they were making the transition from swing to bebop. Newman turned on his recorder as Christian was completing the first of a six-chorus solo, after which trumpeter Joe Guy and an unknown pianist also solo. (Thelonious Monk was Minton's regular pianist but he is clearly not the pianist on this recording.) Although Newman labeled the song "Swing to Bop" when he later released it commercially, the word bebop or bop had been coined in 1941. The tune is actually a hit from the swing era entitled "Topsy," although the musicians never actually play the melody. Charlie Christian redefined the role of the guitar from a strictly rhythm instrument to one that could also function as a solo instrument. His lines (melodic riffs) also incorporated the extended chord intervals that were rapidly becoming a part of the bebop vocabulary. He died less than a year after this seminal recording was made.

reputation as a dangerous place to visit. In one incident, a deadly riot occurred on August 2, 1943, after an altercation between a white policeman and a Black soldier. Earlier that summer, the Savoy Ballroom was shut down for six months because servicemen were supposedly picking up venereal diseases there. Eventually, the jazz scene moved downtown to a one-block area on 52nd Street between Fifth and Sixth Avenues. "**The Street**," as it became known, was home to a cluster of clubs situated in the tiny, narrow basements of the brownstones that lined both sides of the street. These clubs had been speakeasies during Prohibition, and as the 1930s gave way to the 1940s, more and more of them converted to jazz venues. By the mid-1940s, 52nd Street hosted everything from Dixieland to bebop, solo pianists to swing bands. A list of some of the 52nd Streets clubs include:

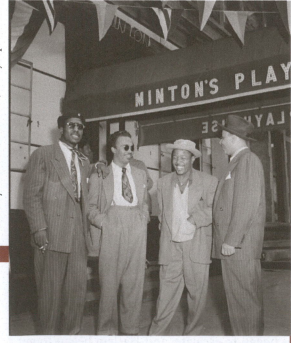

Courtesy of William P. Gottlieb, www.jazzphotos.com

Thelonious Monk, Howard McGhee, Roy Eldridge, and Teddy Hill at Minton's Playhouse, September 1947. Everyone in the jazz world it seemed, from the famous to the unknown, showed up to play at Minton's.

- The Onyx, where Dizzy Gillespie and Oscar Pettiford led the first bebop group to play outside of Harlem in November 1943
- The Downbeat, where Coleman Hawkins had a memorable stay in 1944
- The Famous Door, where Count Basie appeared in the summer of 1938
- Kelly's Stables, actually located on 51st Street, where Billie Holiday held a long residency in the mid-1940s

- Jimmy Ryan's, noted for programming Dixieland jazz
- Other 52nd Street clubs included the Yacht Club, the Spotlight, the Three Deuces, and the Flamingo Club

New Sounds

By design, bebop is dramatically different than swing:

- One of the most obvious differences is in size of the ensemble: the standard group is five-pieces with trumpet, sax (alto or tenor), piano, bass, and drums.
- Another important difference is in the arrangements: bebop charts usually are nothing more than the melody played in unison by the horns, followed by the usual succession of solos. The solos themselves become the focus of the performance in this lean setting and give the improviser maximum elbow room to experiment and show his stuff.
- Tempos were purposely undanceable: usually extremely fast, but also occasionally very slow as well.
- Despite the disaffected demeanor of the players, most bebop is generally high-spirited and joyous music. Let's look at a breakdown of the different elements of bebop.

Bebop Rhythm

Bebop is much more syncopated and rhythmically unpredictable than previous jazz styles. Bebop drummers used the bass drum for syncopated accents called dropping bombs instead of pounding out each beat as was customary in swing. Similarly, pianists played in a much freer manner, playing chords in a percussive and syncopated way (comping) that mirrored the dropping bombs of the drummer. The melodies of bebop tunes also are much more rhythmically complex, starting and stopping in unexpected places and full of unexpected accents.

Bebop Harmony

An important part of bebop involves **reharmonization** or **chord substitution** of songs and forms like the 12-bar blues. For instance, although the blues in its simplest form only utilizes three chords, a 12-bar blues as performed by a bebop group might have as many as 16 to 20 chords. Bop musicians also were fond of reharmonizing existing standards to make them more harmonically complex. A good example comes in bars 3 and 4 of the standard tune "I Can't Get Started," wherein the original form only four chords are used: Em7, Am7, Dm7, and G7. The standard bop reharmonization of bars 3 & 4 uses eight chords: Bm7, E7, Bbm7, Eb7, Am7, D7, Abm7, and Db7.

Bebop Melody

Like bop rhythm and harmony, bop melodies are more complex and challenging to play. Many bop tunes are simply outgrowths of improvisations, with unexpected and disorienting twists and turns and odd interval leaps. Even though some bop tunes are based on riffs, the riffs tend to repeat in unpredictable ways. Because bop heads are difficult to play, they are generally always played exactly the same way, as opposed to the usual custom of embellishing or "jazzing up" a Tin Pan Alley standard. Bebop musicians were also fond of the **flatted 5th** interval, and its use became a cliché in improvised solos and bop heads.

Clubs on the "Street"

- Jimmy Ryan's
- Famous Door
- Kelly's Stables
- Downbeat
- Onyx
- Yacht Club
- Spotlight
- Three Deuces
- Flamingo Club

Reharmonization, or **chord substitution** involves re-placing the existing chords of a chord progression with new ones; it was a common practice among bebop musicians and composers.

A **flatted 5th** is an interval commonly used in improvised solos and bebop melodies. From middle C, going up by a flatted 5th interval would result in a Ga.

Bebop Repertoire

The recording ban had an interesting impact on bebop repertoire. In the years immediately following the ban, there was a sharp increase in the number of small, independent record labels that put out jazz records but were unwilling to pay **artist and publishing royalties**. By creating their own publishing companies and making their artists record only original compositions, the label was able to keep all the royalties to themselves. Because of this, many bop original compositions are merely jazz standards with new melodies slapped onto the existing chords (chord progressions cannot be copyrighted). In this way "Cherokee" was the basis for "Koko," "I Got Rhythm" turned into "Anthropology," and "What Is This Thing Called Love" became "Hot House." The characteristics of bebop are listed in **Box 7-1**.

> **Publishing royalties** are payments collected from record companies by publishing companies for each record sold of a song written by one of their songwriter clients.

BOX 7-1	The Characteristics of Bebop

- Usually high spirited, positive and joyful music
- Small combo, usually five pieces: trumpet, sax, piano, bass, drums
- Simple arrangements: horns play head in unison
- Emphasis on lengthy, improvised solos
- Extreme tempos: fast or slow
- Reharmonization and chord substitution common
- Unpredictable melodies, flatted 5th common
- New repertoire created from jazz standards using new melodies

Diz, Bird, and Monk

> **Main Architects of Bebop**
> - Charlie Parker
> - Dizzy Gillespie
> - Thelonious Monk

Many musicians participated in the bebop revolution, and history has undoubtedly forgotten many who were in the trenches of the Harlem jam sessions. It is clear, however, that the most important and influential architects of bebop were Dizzy Gillespie, Charlie Parker, and Thelonious Monk. Born within three years of each other (1917–20) in North Carolina (Gillespie and Monk) and Kansas City (Parker), the three shared similarities yet were radically different in temperament, career paths, and talents. As their exploratory musical paths led them to each other, they became friends and worked together, but ultimately they went their own separate ways. In the retrospect of history, we now think of them as icons: Gillespie, the schoolmaster who hid behind the mask of a trickster; Parker, the tormented genius who exercised incredible discipline as a musician but hardly any when it came to drugs, representing everything right and wrong about bebop; and Monk, the mysterious and misunderstood high priest. In the end, their destinies took dramatically different turns: Gillespie lived to see old age as a goodwill ambassador, Parker slowly burned himself out and died 34, and

© Courtesy of Rutgers Institute of Jazz Studies

Charlie (Bird) Parker's legacy continues to shape jazz today. It is almost impossible to escape his influence.

Monk, after a brief moment of long-deserved recognition, spent his last years reclusively. These three men were at the forefront of a new revolutionary spirit of innovation and creativity that forever changed jazz from dance music into an art form. That is their ultimate legacy.

Charlie Parker (1920–1955) Alto Sax/Composer

Charlie Parker was born in Kansas City on August 29, 1920. Since his father had deserted the family and his mother worked nights, young Charlie was free to roam the Kansas City of the Pendergast era, and began to sneak into the Reno and other clubs to hear Lester Young and the other great tenor players. He started playing the alto sax as a freshman in high school and was gigging around town by the time he was fifteen. Those who played with him said he was often the worst musician in the band. One night in the spring of 1937, 17-year-old Parker went to a jam session at the Reno Club where Count Basie drummer Jo Jones was playing. As Charlie began to play, Jones was so appalled that he stopped playing and threw a cymbal across the dance floor. The deafening crash left Charlie humiliated, but determined to improve. That summer, playing with the George E. Lee band in the Ozarks, Charlie spent all his free time "woodshedding" (a jazz term for intense practice) and learning about harmony. When he returned to Kansas City that fall, he was musically a new man, showing phenomenal development and musical growth.

Bird

By this time Parker had already been married, fathered a son, and divorced. He had also been introduced to heroin, an addiction that would cause him to become a loner for much of his life. In 1938, he began working with bandleader Jay McShann, who had noticed the improvement in Charlie's playing. One day on the way to a gig at the University of Nebraska, the car Parker was in struck and killed a chicken in the road. Charlie stopped the car, retrieved the bird, and had it cooked for him when the band arrived in Lincoln. Amused fellow band members started calling him Bird (or Yardbird), a nickname that stuck for life. In late 1938, ever the wanderer, Bird quit McShann and started making his way east, first to Chicago, then to New York.

When he arrived in New York, he took a job as a dishwasher at Jimmy's Chicken Shack where Art Tatum played the piano nightly. While listening to the pianist every night for three months, Bird absorbed Tatum's astonishing harmonic restructuring, virtuoso phrasing, and breakneck tempos. Challenging himself to adopt these innovations into his own playing, Bird worked tirelessly, finally achieving a breakthrough while working on the song "Cherokee" at a Harlem jam session. He also started to attract attention sitting in at the sessions at Monroe's Uptown House. Bird returned to Kansas City in 1939 and rejoined McShann until 1942. It was during 1940 and 1941 that the jazz world outside of New York got its first glimpse of his genius, from his first recordings and national radio broadcasts with the McShann band.

In the summer of 1942, he quit McShann to stay in New York, and started to make regular appearances at the Minton's sessions with Dizzy Gillespie (by now a close friend) and Thelonious Monk. Everyone was experimenting by now, but the music seemed to crystallize when Bird showed up. He played lightning-fast runs that despite being filled with all kinds of unexpected twists and harmonic complexity made perfect sense. His tone was cutting and dry, unlike the creamy sound of the swing saxophonists. And his imagination never ran out of musical ideas.

Between the years 1942 and 1944, Bird and Gillespie both played in the Earl Hines and Billy Eckstine big bands. In 1944, they co-led a quintet that opened at

Music Analysis

Track 30: "Koko"

(Parker) Charlie Parker's Reboppers recorded November 26, 1945. Personnel: Charlie Parker: alto sax; Dizzy Gillespie: trumpet, piano; Curly Russell: bass; Max Roach: drums

Charlie Parker's recording of "Koko" is one of the most remarkable and mysterious recordings in the history of jazz. A reworking of the swing era hit "Cherokee," the song displays Parker's astonishing technique in a solo that author Ted Gioia notes "few other saxophonists of the day could have played, let alone improvise." The session at which "Koko" was recorded was somewhat chaotic, and because of the confusion over the exact details of who played and who was there, it has achieved mythic status. Apparently, pianist Bud Powell was supposed to play but did not show, and was replaced by the little-known Sadik Hakim. However, Hakim for some reason did not play on this tune. Also present was nineteen-year-old trumpeter Miles Davis, who played on the other recordings made that day but not on "Koko." "I didn't really think I was ready," he said later. "I wasn't going to get out there and embarrass myself." In the end, Dizzy Gillespie played both trumpet and piano on this legendary recording.

0:00	Introduction: pre-arranged melody is stated in unison by Charlie Parker and Dizzy Gillespie (with Harmon mute) is intertwined with improvised solos from each; drummer Max Roach accompanies using brushes on the snare drum
0:25	First chorus: improvised head is stated by Parker on alto sax while Gillespie switches to piano and Roach switches to sticks
1:16	Second chorus: Parker solos
2:07	Drummer Roach solos using primarily snare and bass drums
2:29	Head is restated

the Three Deuces on 52nd Street. The landmark recordings that this group made in November 1945 made a stunning and profound impression on the jazz world: the bop revolution was finally unveiled on vinyl for all to hear.

By late 1945, Bird's drug problem was getting worse. Although Gillespie had quit the quintet in October, they were reunited for a trip to Los Angeles in early 1946 to play at Billy Berg's. This was the first time anyone on the West Coast had heard bebop, and the reaction to the new music was mixed. Bird himself was viewed as a pathetic junkie by many that came to see him play. Depressed, he began to drink heavily (good heroin was hard to find in LA), and eventually had a total breakdown after an infamous recording session in which he could hardly play. Later that night, he set his hotel bed on fire, and was arrested. His subsequent six-month commitment to the Camarillo State Hospital cleaned him up from his heroin addiction, at least for the time being.

On Top of the World

Parker returned to New York in 1947 recovered and healthy enough to lead a quintet that included Miles Davis on trumpet and Max Roach on drums. By now he was the leading figure of the bebop movement. The jazz world became a sort of house of mirrors for Bird as alto saxophonists everywhere were trying to copy everything he played. He was also composing tunes that were to become jazz standards, including "Anthropology," "Billie's Bounce," and "Blues For Alice." Bird's influence also had taken on a much darker side, as his troubles with drugs and alcohol began to resurface. Many jazz musicians looked to him as a role model and began to experiment with heroin in the belief that under its influence they would be able to play like Bird. Sadly, an epidemic of sorts began to take its toll in the jazz world, creating a legacy of lives and careers cut short that extended well into the 1970s and 80s.

In December 1949 with great fanfare, a live radio broadcast, and Parker himself performing, **Birdland**, the "Jazz Corner of the World" opened at the corner of 53rd and Broadway. Never before had a club been named after a jazz musician, living or dead. It was an unmistakable sign of Charlie Parker's status as a living legend. With the 1950 release of *Charlie Parker with Strings*, Bird became the first jazz artist to make a recording with orchestral accompaniment. Although critics panned it and subsequent albums like it, they were a commercial success and were the recordings of which Bird was most proud.

Fall from Grace

By 1950, Charlie Parker was often so ill from drug complications that he was forced to cut back on his playing and recording. In 1951, he temporarily lost his cabaret card, prohibiting him from working in clubs in New York City. On May 15, 1953, at a concert at **Massey Hall** in Toronto that was to feature the greats of the bebop period, he had to borrow a plastic saxophone—he had pawned his own to pay off a drug debt. In 1954, he attempted suicide and was admitted to Bellevue Hospital in New York for two months. He played his last gig on March 5, 1955, at Birdland, a performance that was marred by an argument with pianist Bud Powell that caused Parker to storm out unexpectedly in the first set. On March 12, he died while watching Tommy Dorsey's TV show at the Fifth Avenue apartment of Baroness Pannonica de Koenigswarter, a wealthy jazz patron. After viewing Bird's broken-down body, the coroner estimated his age to be 55. Charlie Parker was 34 years old.

Bird's legacy continues to shape jazz today, and it is almost impossible to escape his influence. Young jazz musicians routinely learn to play bebop by learning his transcribed solos. His virtuosity and technique are still standards of achievement that are matched by few. His compositions have become the repertoire of modern jazz. Like Louis Armstrong, Parker redefined how jazz was to be played and installed a new jazz vocabulary. And like Armstrong, in the process, he exerted a tremendous influence on American music and culture.

John Birks "Dizzy" Gillespie (1917–1993) Trumpet/Composer/Bandleader

John Birks "Dizzy" Gillespie was the first of the three to make an impression on the New York scene. When he moved to Philadelphia from South Carolina in 1935, he heard trumpeter Roy Eldridge for the first time on radio broadcasts and began to emulate his style. In 1937, he actually replaced Eldridge in the Teddy Hill band, and in 1939, he became one of the featured soloists in the Cab Calloway Orchestra. During his two-year stay with Calloway, Gillespie started to break away from the Eldridge influence with his own original and explosive new style (which was also controversial and ahead of its time: Calloway called it "Chinese music"). Calloway grew tired of Gillespie's clowning and pranks (Gillespie earned his

© Courtesy of Rutgers Institute of Jazz Studies

By the early 1950s, **Dizzy Gillespie** was universally regarded as the top trumpetor in jazz.

nickname during the Calloway years), and fired the trumpeter in 1941 after the two got into a bloody fight after a spitball was thrown on stage during a performance.

The Schoolmaster

The Calloway years were formative for Gillespie: he developed his arranging and composing skills; he met his musical soul mate Charlie Parker and began to develop a life-long interest in Cuban music and Latin rhythms after meeting Cuban arranger Mario Bauza. He became a regular at Minton's where he would often share the stage with Monk and Parker. An accomplished pianist, Dizzy would often consult with Monk over the new chord substitutions and teach them to the other horn players. On many occasions, musicians ended up at Gillespie's apartment on Seventh Avenue for informal discussions on bop chord progressions, with Dizzy at the piano and his wife Lorraine in the kitchen cooking meals. In the developmental years of bebop, he was the 'professor'—in the words of saxophonist Dexter Gordon, "Diz was like the schoolmaster."

Between 1942 and 1944, both Gillespie and Parker played in the Earl Hines and Billy Eckstine big bands. In November 1943 at the Onyx Club, Dizzy and bassist Oscar Pettiford put together the first bebop combo to appear outside of Harlem. It was this group that established the two-horns-play-the-head-in-unison format that subsequent bop groups would use. In February 1944, Dizzy participated in what is often called the first bebop recording session with Coleman Hawkins, recording his composition "Woody'n You." In April 1944, Gillespie and Parker captivated the jazz world when they co-led a combo at the Three Deuces.

Breaking Out on His Own

Although the two would remain friends and still perform together, starting in 1945, Gillespie began spending less time with Parker and focusing his attention on his first love, big band music. His first big band, the "Hep-sations of 1945" was a less than successful (commercially at least) endeavor at big band bebop; but the following year, he led a more conventional big band fronted by Ella Fitzgerald that was a hit. In 1947, he introduced yet another big band, this time co-led by Cuban percussionist **Chano Pozo** that introduced a new jazz style incorporating Latin rhythms and percussion called **Afro-Cuban**. At their first gig at Carnegie Hall in September, Gillespie not only introduced Pozo to the world but also the innovative George Russell composition "Cubana Be-Cubana Bop." Although Gillespie had combined Latin music and jazz prior to this with his famous 1942 composition "A Night in Tunisia," Pozo's presence brought additional fire and energy to the band. Together with arranger Gil Fuller, Gillespie and Pozo wrote and recorded "Manteca" in December 1947, arguably the most famous Afro-Cuban composition.

> In 1947, with the help of Cuban percussionist **Chano Pozo**, Gillespie formed a big band that incorporated Latin rhythms and percussion in a new style called **Afro-Cuban**.

BOX 7-2	The Characteristics of Afro-Cuban Jazz

- Complex rhythms from Cuba, Latin America, and Africa intertwined with bebop melodies and improvisation
- Percussion instruments such as bongos, congas, timbales frequently incorporated into a jazz rhythm section
- Originally used in big band settings of Dizzy Gillespie and others, today is incorporated into many ensemble settings

By the early 1950s, Dizzy Gillespie was universally regarded as the top trumpeter in jazz. He redefined virtuosity on the instrument, especially with his extensive use of the extreme high register. He was by now a prolific composer of many tunes that became jazz standards ("A Night In Tunisia," "Groovin' High"), and an

Music Analysis

Track 31: "Manteca"

(Gillespie/Pozo/Fuller) Dizzy Gillespie and His Orchestra recorded in New York on December 30, 1947. Personnel: Gillespie, Dave Burns, Benny Bailey, Lamar Wright Jr., Elmon Wright: trumpet; Ted Kelly, Bill Shepherd: trombone; John Brown, Howard Johnson: alto sax; George 'Big Nick' Nicholas, Joe Gayles: tenor sax; Cecil Payne: baritone sax; Al McKibbon: bass; John Lewis: piano; Kenny Clark: drums; Chano Pozo: conga; Gil Fuller: arranger

"Manteca" is an example of the Afro-Cuban style that Dizzy Gillespie and Cuban percussionist Chano Pozo created in 1946 with the innovative Dizzy Gillespie Orchestra. One of the central features of this arrangement is the layering of as many as four different elements on top of each other (as in the introduction), as well as retaining bebop characteristics (as in the improvised solos in the bridges to each chorus). Much of the credit for the structure of the song goes to Gil Fuller, who pieced together themes sung to him by Pozo before writing the dramatic arrangement. One can also hear the exuberant Gillespie shouting the song title at various places within the piece.

0:00	Introduction; first entrance is by bass and bongos, then saxophones, brass, and finally Dizzy Gillespie's improvised trumpet solo
0:38	First chorus: head is stated by saxophones, answered by brass section
1:00	Bridge, with short solo by Gillespie
1:34	Short interlude based on introduction
1:48	Second chorus: tenor sax solo by George Nicholas
2:10	Bridge, with another Gillespie solo
2:44	Fade out with bass and bongos before "boom-boom" ending

accomplished scat singer. With his engaging and witty personality, he went on to become the most commercially successful of the original bebop musicians and spent much of his later years involved with jazz education. He died of cancer in 1993 with Lorraine at his side.

Thelonious Sphere Monk (1917–1982) Piano/Composer

Thelonious Monk moved with his family to New York's San Juan Hill district from North Carolina when he was around six years old. Self-taught at piano, by the time he was 16, he was playing at church and professionally at rent parties. His early influences were the Harlem stride players and especially Duke Ellington, who was himself a fine stride player. In 1940, Monk became the pianist in the house band at Minton's Playhouse. By this time, he had already developed a completely unorthodox style and was experimenting with chord substitutions and reharmonization. His influence in the formative years of bebop was powerful but is one that cannot be realistically documented because

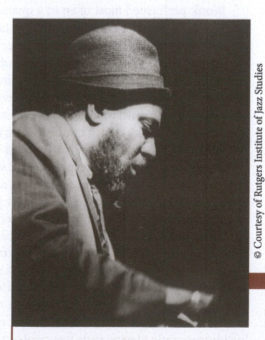

© Courtesy of Rutgers Institute of Jazz Studies

Thelonious Monk, the eccentric genius is considered to be one of the greatest composers in jazz history.

of the reclusive nature of his personality. Dizzy Gillespie was one who credited Monk with inventing many of the harmonic principles of bebop. Lacking the promotional skills of Gillespie or the electricity that Parker generated, Monk remained in the shadowy world of the Harlem nightclub scene until 1944, when Coleman Hawkins hired him to play in his quintet at the Downbeat on 52nd Street. Many who heard Monk for the first time thought him to be a hack, and Hawkins was criticized for hiring him. In retrospect, it is understandable why Monk's playing was misunderstood by so many. Jazz fans were accustomed to hearing nimble-fingered pianists such as Art Tatum and Teddy Wilson; Monk's playing was sparse, percussive, and dissonant. Instead of the cool demeanor of most bebop players, he was agitated when he played, appearing to be in a wrestling match with the piano. In spite of the criticism, Monk stubbornly did not change his playing or his stage presence, believing that the world would someday meet him on his own terms.

The High Priest

It was not until 1947 that Monk finally signed a recording contract. It was from upstart Blue Note label, whose publicity department labeled him the "High Priest of Bop." Among the recordings from the first two Blue Note albums, *Thelonious Monk— Genius of Modern Music Vols. 1 and 2* were his compositions that he had written years earlier, "Straight, No Chaser," "Epistrophy," "Off Minor," "'Round About Midnight" and others that have since become jazz standards. Monk's tunes were distinctly original in their rhythmic phrasing, offbeat sparseness, and dissonance. They were, in effect, a natural outgrowth of his piano playing. But fame would continue to elude Monk; his Blue Note albums did not sell, and the label dropped him in 1952. He lost his cabaret card in 1951 when narcotics belonging to pianist Bud Powell were found in his car (Monk took the rap to protect his friend and protégé), keeping him out of club in New York until 1957. He did sign briefly with Prestige, but they sold his contract to Riverside in 1955 for $108.27. Finally, after much legal wrangling, he was able to secure a new cabaret card in 1957. In June, he made a triumphant return at the **Five Spot**, a Greenwich Village nightspot, with a new quartet that included the young, experimental tenor saxophonist John Coltrane. Their six-month engagement, along with a new critically acclaimed album release *Brilliant Corners*, finally put Monk in a position to attain the fame and respect that had eluded him for so long.

Monk performed most often in a quartet setting with drums, bass, and tenor sax. He was known to be very animated on stage, often leaving the bandstand during sax solos and walking through the audience, waving his arms as he shuffled around. He also had a fetish for exotic hats. Monk's offbeat personality and music made him a favorite among young hip audiences in the 1960s, and he was even featured in a 1964 cover story in Time magazine. However, as his popularity diminished in the late 1960s, he returned to his reclusive lifestyle. He died in 1982. Although critics once debated Monk's contributions to jazz, it is now clear that only Ellington and perhaps Charles Mingus (chapter 8) surpass him in importance as a jazz composer. While Ellington and Mingus experimented with extended works, Monk's compositions were limited to standard song forms and 12-bar blues, but they are the very essence of jazz, and are favorites among jazz players. His melodies are so strong and distinct that musicians often begin to unconsciously play in a "Monkish" manner when playing his music. His piano style is also influential to this day, and elements of it have been incorporated into the styles of jazz musicians of all instruments.

Much has been written over the years about Monk's erratic behavior, which included a penchant for lapsing into periods of reclusiveness, laconic speech, and his taciturn manner. Monk has been described as eccentric, child-like, out of touch with the world around him, and even crazy. Attaching this narrative to his idiosyncratic playing style has created the myth of the "eccentric genius" as a

Music Analysis

Track 32: "Rhythm-A-Ning"

(Monk) Thelonious Monk from the album Criss Cross recorded November 6, 1962 in New York City. Personnel: Thelonious Monk: piano; Charlie Rouse: tenor sax; John Ore: bass; Frankie Dunlop: drums

Thelonious Monk's composition "Rhythm-A-Ning" is one of the many bop compositions that use "rhythm changes"—the chord progression from George Gershwin's 1930 song "I Got Rhythm"—for the harmonic content. The playful, almost child-like melody has made the tune a favorite among jazz musicians for many years. This recording demonstrates Monk's interesting and unorthodox piano style, both with his comping behind Charlie Rouse's tenor solo (in which he often lays out for long stretches), and during his own solo.

0:00	Introduction, first 8 bars of head is stated by Monk on piano
0:10	First chorus: head is stated in unison by Charlie Rouse on tenor sax and Monk with bass and drum accompaniment
0:47	Second chorus: tenor sax solo by Rouse starts (two choruses total)
2:02	Fourth chorus: piano solo by Monk starts with a reharmonization of the song's chord progression (two choruses total)
3:14	Head is stated twice in unison by Monk and Rouse

way to summarize Monk in a concise, convenient way. Of course, the truth about Monk's ways is much more complicated than this. In his exhaustively researched 2009 book *Thelonious Monk: The Life and Times of an American Original.* Robin D. G. Kelly discloses that in reality, Monk suffered from bipolar disorder, a fact that was not discovered until late in his life due to the general state of psychiatry and lack of information about the condition. For much of his life, Monk's episodes were misdiagnosed, resulting in long hospitalizations and wrongly prescribed medication. It is only through Kelly's unprecedented access to private family records and conversations with immediate family members, including Monk's widow Nellie just before her own death that the truth has finally emerged.

Other Important Bebop Figures

Bud Powell (1924–1966) Piano/Composer

Bud Powell influenced virtually all jazz pianists that followed him, despite a life that was marked by bouts of mental illness and alcoholism. His amazing right-hand technique produced runs that rivaled those of Gillespie and Parker. He was among the first jazz pianists to incorporate a minimal use of the left hand while concentrating on horn-like lines in the right hand. Although he was a constant companion and protégé of Monk, Powell was also heavily influenced by Art Tatum.

Powell came from a musical family in New York City, and by his late teens, he was hanging out at Minton's Playhouse. His virtuosic technique gave him recognition as an artist on par with Parker and Gillespie, and from the mid-1940s through much of the 1950s, he was considered to be one of the leading figures in the bebop movement. He recorded frequently with trios, quartets, and quintets, and became a prolific songwriter as well. However, after a racially motivated and savage head beating by police in 1945, Powell began to exhibit emotional problems and was hospitalized intermittently for the next several years. He began to use alcohol excessively as a form of self-medication, but it only ended up compounding his mental issues. Eventually, his playing suffered, as did his

Other Important Bebop Figures

- Bud Powell
- Kenny Clark
- Charlie Christian
- Max Roach
- Dexter Gordan
- Theodore "Fats" Navarro
- Todd Dameron
- Oscar Peterson
- J. J. Johnson

relationships with other musicians. In 1959, Powell moved to Paris to get away from the pressures of New York, returning to the states in 1964 until his death in 1966. Bud Powell's life was depicted in the 1986 movie *Round Midnight*.

Kenny Clarke (1914–1985) Drums

Kenny Clarke was the founder of modern jazz drumming. His innovations came about as an accident: while playing with the Teddy Hill band from 1939 to 1940, he began to rest his right foot from playing the bass drum pedal on every beat during up-tempo tunes. He also began to use his ride cymbal to keep the beat, adding syncopated "dropping bombs" on the snare drum and bass drum. His nickname "Klook" came from the sounds his bombs made. In 1940, he became the house drummer at Minton's and is widely credited with inspiring much of the rhythmic vitality that is so prevalent in bebop. After the Minton's years, Clarke was a founding member of the Modern Jazz Quartet in 1952 until 1956 when he moved to Paris.

Charlie Christian (1916–1942) Electric Guitar

Charlie Christian was born in Texas and raised in Oklahoma City where he began playing the electric guitar in 1937. In 1939, he was discovered by John Hammond, who persuaded Benny Goodman to give him an audition. Christian became a fixture in Goodman's sextet for the next two years. During this time he was also making his presence known at Minton's sessions where he was able to play more creatively than he could with Goodman. Christian was the first great electric guitarist and the first to exploit the melodic potential of single-note runs on the electric guitar which took it past its role as a purely rhythm instrument. He died at age 25 of tuberculosis.

Max Roach (1924–2007) Drums/Composer/Bandleader

Max Roach is considered to be the greatest bebop drummer. Although he inherited the style that Kenny Clarke had developed, Roach made drumming more melodic and more polyrhythmic. Around 1940, he began to hang out at Minton's Playhouse and came under the influence of Clarke. During the 1940s, his presence in the bebop milieu became ubiquitous; among the many now-famous events that he took part in were the first Parker/Gillespie gig on 52nd Street and the "Koko" session, both from 1945, the first recording sessions by Miles Davis and Bud Powell, and the Massey Hall concert in 1953. From 1953–56, Roach co-led the Clifford Brown/Max Roach quintet, one of the foremost hard bop groups of the decade that included stints by Sonny Rollins on tenor sax and Sonny Stitt on alto. Roach also recorded one of the most dramatic and overtly political albums in jazz history in 1960. *We Insist! The Freedom Now Suite* was inspired by the lunch counter sit-ins in the Deep South and includes what one writer called "the most hair-raising ninety seconds of jazz in existence," a segment in which Roach's wife Abbey Lincoln emits blood-curdling screams, accompanied by only drums. Later in his life, he became a professor of music at the University of Massachusetts at Amherst.

Dexter Gordon (1923–1990) Tenor Sax

As a regular presence on 52nd Street in the mid-1940s, Dexter Gordon "perhaps more than any of the others transferred the characteristics of bop to the tenor," according to critic Leonard Feather. Although Gordon grew up the son of a dentist in Los Angeles, when he moved to New York in 1945 he quickly became a fixture on the scene, working with Louis Armstrong, Fletcher Henderson, and the Billy Eckstine big band. Standing six feet five inches tall, he had a broad-shouldered

playing style that was an amalgam of the huskily aggressive tone of Coleman Hawkins and the laid-back rhythmic looseness of Lester Young. Although he stayed in New York only until 1947 before returning to Los Angeles, Gordon took part in some of the earliest bebop recording sessions. In 1952, he was sent to prison for two years on drug charges, and his popularity ebbed as a result. After moving to Europe in 1962, Gordon returned with a triumphant engagement at the Village Vanguard in 1976 that revitalized his career. In 1986, he received an Oscar nomination for his acting in the movie *Round Midnight*.

Theodore "Fats" Navarro (1923–1950) Trumpet

Theodore "Fats" Navarro ('Fat Girl') was the other major trumpet stylist of the bebop era, with a more lyrical style than Gillespie. He became a heroin addict, which prevented him from reaching his full potential and contributed to his early death at age 26.

Tadd Dameron (1917–1965) Piano/Composer/Arranger

A prolific composer of many bebop standards, Tadd Dameron was one of the first arrangers in the bebop style and was also a fine pianist. His life was also beset by constant drug-related problems.

Oscar Peterson (1925–2007) Piano

With incredible technique that is often compared to that of Art Tatum, Oscar Peterson has been active in jazz since his teens in his hometown of Montreal. His style is somewhat transitional, falling between stride, swing, and bebop.

J. J. Johnson (1924–2001) Trombone

J. J. Johnson was one of the first trombonists to adapt the unwieldy nature of the instrument to bebop. He led a quintet with fellow trombonist Kai Winding 1954–56.

Reaction to Bebop and Later Developments

Bebop dramatically tilted the playing field for jazz musicians in the 1940s, and the reaction to it was anything but nonchalant. Predictably, swing and older musicians were antagonized by the aloof manner of the beboppers and resented their role in messing up the good thing they had going. Swing bandleader Tommy Dorsey said "Bebop has set music back twenty years;" Charlie Barnet said, "The boppers were a bunch of fumblers who…effectively delivered the death blow to the big bands as we had known them." Even the normally effervescent Louis Armstrong called it a "modern malice" that is "really no good and you got no melody to remember and no beat to dance to." Non-musicians were equally unimpressed: impresario John Hammond stated "To me, bebop is a collection of nauseating clichés, repeated ad infinitum;" columnist Jimmy Cannon quipped that "Bebop to me sounds like a hardware store in an earthquake." Perhaps the most vitriolic war of words was carried on by jazz critics, for whom bebop rekindled an already existing old vs. new debate. To some critics, swing was already a bastardization of the 'traditional' jazz from New Orleans; bebop was nothing but a further reach into noise and chaos. The two principal archrivals in the critic feud were bebop supporter Barry Ulanov and traditionalist Rudi Blesh, who aired out their differences in a series of "Bands for Bonds" radio programs. Ulanov threw gasoline on the fire with a November 1947 article in *Metronome* called "Moldy Figs vs. Moderns," coining the term that has been used ever since to describe jazz musicians who were not keeping up with the current trends.

The New Orleans Revival

In the wake of the turf wars between the Moldy Figs and the Moderns, there was a nostalgic renewed interest in the music of New Orleans. A growing number of jazz fans felt that jazz was becoming too modern, and embraced the idea of returning to its roots. Within a relatively short time, such musicians as Bunk Johnson and Sidney Bechet began to record again. Musicians from the 1920s who had ended their music careers suddenly found they were in demand for concerts and club appearances. A club named Nick's opened in Greenwich Village that featured traditional or "trad jazz." In 1945, Eddie Condon opened his own club. Both clubs, as well as Jimmy Ryan's on 52nd Street and several others, were popular watering holes for years. Louis Armstrong in 1947 formed his All-Stars, returning to the small group jazz of his youth after years of fronting big bands. Although traditional jazz, or Dixieland as it is sometimes called, still exists to a degree all around the world, its revival faded out after a few years.

As you can imagine, the general public didn't care much for bebop either, since the melodies were not singable, the tempos were not danceable, and the musicians themselves seemed to care little if any about the audience. The general public who had embraced swing for more than ten years began to turn away. An emerging new sound, **Rhythm & Blues** began to gain in popularity as jazz slipped to the outer fringes of popular appeal.

Nonetheless, bebop has had a dramatic and long-lasting impact on jazz. Its techniques, rhythms, harmonies, and melodies remain part of the jazz DNA to this day. Its emergence signaled the moment when jazz musicians began to redefine their relationship to their music. The music was now moving out of the dance hall and into the concert hall. While it can accurately be labeled a revolution, in the end, it was also an important part of jazz evolution and the foundation from which most modern jazz is built. Here are five reasons why the bebop movement was so profoundly influential:

- **Art Music**: bebop signaled the moment when jazz was no longer thought of as entertainment or dance music. From this point on, jazz would be considered as a platform for creative expression, in essence, an art form. Although this brought new respectability to jazz and jazz musicians, it also ensured that jazz would eventually lose most of its popular appeal.
- **Innovation**: as art music, bebop brought a new zeitgeist to jazz, that musicians should now look to innovate not from within the existing norms and conventions, but from beyond them, a sensibility that would spawn a flowering of different stylistic approaches during the 1950s and inhabits the creative process in jazz to this day.
- **Individualism**: with bebop, the focus of jazz would now turn to the individual rather than the ensemble. While it is true that Louis Armstrong first articulated the shift to the soloist in the 1920s, the jazz mainstream continued to move toward a team-oriented approach to performance, culminating in the swing era. Bebop brought Armstrong's innovation to full fruition.
- **Vocabulary**: bebop brought a new vocabulary of melodic licks and phrases to jazz, making those from the swing era outdated. This vocabulary is still part of the genetic code of jazz.
- **Political Activism**: with its roots tied to the frustrations of Black musicians and the institutional racism of the swing era, bebop laid the groundwork for future political activism by Black jazz musicians throughout the 1950s and 1960s, particularly by those from the hard bop and free jazz movements.

Rhythm & Blues is a more commercial, dance-oriented version of the blues, often utilizing coordinated costumes and dance steps by performers. The phrase R&B was coined in 1949 by Jerry Wexler of Billboard Magazine as a label for charting purposes. Wexler later went on to become an executive at Atlantic Records.

Bebop's influence has also extended past the jazz world. Its explosive, spontaneous and highly improvisational nature helped unleash a new artistic license in art and literature. Among those inspired by bebop musicians were abstract expressionist artists such as Jackson Pollock and beat writers like Jack Kerouac, both of whom began to work in the same speed and immediacy present in a bebop performance. But most importantly, as the first style of modern jazz, bebop became the foundation for nearly every jazz style and practice that has evolved since the 1940s. Its impact was felt almost immediately, as we shall see in the next chapter.

Modern Big Bands from the 1940s

In the immediate wake of the bebop revolution, there were a number of developments of note in the mid to late 1940s. Although the swing era was coming to an end in 1946, the jazz big band continued to evolve. Incorporating the advancements of bebop and other progressive ideas, several bands emerged in the 1940s that were seen as modern versions of the big band. One of them, the Dizzy Gillespie big band was discussed previously in this chapter.

Modern Big Band Leaders
- Dizzy Gillespie
- Billy Eckstine
- Claude Thornhill
- Woody Herman
- Stan Kenton

Billy Eckstine (1914–1993) Singer/Bandleader, the "Sepia Sinatra"

Billy Eckstine's band was only together from 1944 to 1947, but it was years ahead of its time. The band played innovative big band bebop and included such stars as Parker and Gillespie, tenor saxophonist Dexter Gordon, trumpeters Miles Davis and Fats Navarro, and vocalist Sarah Vaughan. Few recordings exist due to the recording ban and because the band was a commercial failure, attracting little interest from record labels.

Claude Thornhill (1909–1965) Piano/Bandleader

Claude Thornhill's band was together from 1946 until his death, and utilized French horns to achieve what was called "orchestral jazz." It included musicians that were widely associated with the Cool jazz movement of the 1950s, including arrangers Gerry Mulligan and Gil Evans, and alto saxophonist Lee Konitz. It was also the inspiration for the Miles Davis Nonet (the Birth of the Cool band) in 1948.

Woody Herman (1913–1987) Clarinet/Bandleader

Starting in the late 1930s as a swing band, **Woody Herman's** bands of the 1930s, 1940s, and 1950s (known as the "Thundering Herds") played bebop-inspired modern arrangements. The Second Herd was known as the 'Four Brothers' band, referring to the saxophonists Stan Getz, Zoot Sims, Serge Chaloff, and Herbie Steward. Herman also introduced Igor Stravinsky's "Ebony Concerto" in 1946 at Carnegie Hall.

Stan Kenton (1912–1979) Piano/Composer/Bandleader

A workshop for progressive arrangers and promising young talent, Stan Kenton's band first achieved fame with the modernistic *Artistry in Rhythm* album in 1943. The band's output ranged from somewhat pretentious concert works to straightforward jazz to commercial pop. Kenton alumni include trumpeters Maynard Ferguson and Shorty Rogers, trombonist Frank Rosolino, alto saxophonists Art Pepper and Lee Konitz, and drummer Shelly Manne. Kenton also spent much time and energy conducting high school and college jazz clinics in the 1950s and 1960s.

Music Analysis

Track 33: "Four Brothers"

(Giuffre), Woody Herman Orchestra recorded December 27, 1947, in Hollywood, California. Personnel: Stan Fishelson, Bernie Glow, Marky Markowitz, Shorty Rogers, Ernie Royal: trumpet; Earl Swope, Ollie Wilson: trombone; Bob Swift: bass trombone; Woody Herman: clarinet, alto sax, vocal; Sam Marowitz: alto sax; Herbie Steward: alto sax, tenor sax; Stan Getz, Zoot Sims: tenor sax; Serge Chaloff: baritone sax; Fred Otis: piano; Gene Sargent: guitar; Walter Yoder: bass; Don Lamond: drums; Ralph Burns, Al Cohn, Jimmy Giuffre: arrangement

Of all the Thundering Herds that Woody Herman put together, the Second Herd, or "Four Brothers Band," together from 1947 to 1949, is perhaps the most noteworthy. Led by the four 'brothers' Zoot Sims, Serge Chaloff, Herbie Steward and Stan Getz, the band at times included such other jazz luminaries as Shorty Rogers (trumpet), Oscar Pettiford (bass), Gene Ammons (tenor sax), and Shelly Manne (drums). Although most fans and scholars agree that Herman's most famous hit was 1939's "Woodchopper's Ball," "Four Brothers" would have to be a close second. Written and arranged by West Coast saxophonist/composer Jimmy Giuffre, the song is a vehicle to show off the talents of the four saxophonists and helped turn each of them, especially Stan Getz, into stars. Herman's recording is emblematic of the jazz world of the late 1940s as swing was in its last throws and bebop was becoming absorbed into the mainstream, and big bands such as those led by Herman, Stan Kenton, and others were in a state of transition.

0:00	Song begins without introduction
0:34	Tenor saxophone solo by Zoot Sims
0:52	Baritone saxophone solo by Serge Chaloff
1:08	Tenor saxophone solo by Herbie Steward
1:26	Tenor saxophone solo by Stan Getz
1:43	The four saxophonists trade riffs with the rest of the horn section over the first half of the song's third chorus
2:00	Clarinet solo by Woody Herman over the bridge, followed by more saxophone/horn trading
2:17	Shout chorus begins, featuring powerful drumming by Don Lamond
2:52	Tag ending featuring short solos by Getz, Sims, Steward, and Chaloff before the song ends

Post-swing era Vocalists

- Ella Fitzgerald
- Sara Vaughan
- Eddie Jefferson
- Lambert, Hendricks & Ross

Vocalists

There were several jazz vocalists to emerge in the post-swing era years that were influenced by the innovations of the bebop musicians.

Ella Fitzgerald (1917–1996)

Ella Fitzgerald is widely regarded as the greatest scat singer in the history of jazz. Her wide vocal range, perfect elocution, and a beautifully clear, bell-like voice enabled her to spit out improvised vocal lines every bit as virtuoso as Bird or Diz. Ironically, she first became famous not for her scat singing, but for singing a nursery rhyme. In 1934, Fitzgerald was living an impoverished life in Harlem when on a whim she decided to enter an amateur singing contest at the Apollo Theatre and won. Chick Webb hired her the following year, and in 1938, they had their biggest hit with "A-tisket, A-tasket," the song that put Fitzgerald on the map. When Webb died in 1939, Fitzgerald became the rare female bandleader of the swing era when she took over the band. In 1941, she dissolved the band to concentrate on her solo career. It was not until she started to sing with the Dizzy Gillespie big band in 1946 that, on Gillespie's urging, she started to develop her scat technique. From there she went onto international fame, often touring with Norman Granz' Jazz At The Philharmonic series.

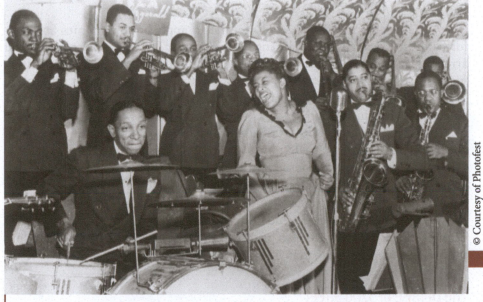

© Courtesy of Photofest

Ella Fitzgerald is widely regarded as the greatest scat singer in jazz history.

Sarah Vaughan (1924–1990)

Sarah Vaughan first came to prominence as the female vocalist in the Billy Eckstine Orchestra from 1944–45. The progressive nature of the band allowed her to display her rich and powerful voice. Combining superb scat vocals with distinct interpretations, "Sassy" was also a fine pianist and a favorite among musicians. Later on in life as her voice deepened and her respect among fans soared, she became known as "the Divine One."

Music Analysis

Track 34: "Lemon Drop"

(Wallington) Ella Fitzgerald recorded July 5, 1973. Personnel: Fitzgerald: vocal; Tommy Flanagan: piano; Joe Pass: guitar; Keeter Betts: bass; Freddie Waits: drums

An amazing display of vocal technique, "Lemon Drop" is a fine example of Ella Fitzgerald's amazing musicianship, energy and limitless creative inventiveness. Recorded live at Carnegie Hall during the 1973 Newport Jazz Festival, Ella's backup band for this performance included two of the premier session players in jazz at the time, pianist Tommy Flanagan and guitar virtuoso Joe Pass. The song is based on George Gershwin's "I Got Rhythm," whose chord changes jazz musicians commonly refer to as "**rhythm changes**," and is played at an incredibly fast tempo that only the very best improvisers can negotiate. Ella's improvisation is dazzling.

0:00	Piano introduction played by Tommy Flanagan
0:08	Head is sung with scat syllables by Ella Fitzgerald and occasionally doubled by pianist Flanagan
0:37	Fitzgerald begins her scat solo, which extends to five choruses
2:56	Fitzgerald re-sings the head
3:23	Extended ending with pedal tone in piano and bass; Fitzgerald brings song to big finish to tremendous applause

Rhythm changes refers to the chord progression of George Gershwin's 1930 song "I Got Rhythm" that was used for many bop compositions. The song uses the AABA standard song format; rhythm changes are still used today for many contemporary jazz compositions.

Vocalese is the technique of composing lyrics to fit existing recorded jazz improvised solos or instrumental arrangements (such as big band charts)

Eddie Jefferson (1918–1979) and Lambert, Hendricks & Ross (1957–1964)

Lambert, Hendricks & Ross were the first to apply bop harmonies and performance to vocal ensemble singing. Comprised of lyricist Jon Hendrix, vocal arranger Dave Lambert, and jazz soloist Annie Ross, the group grew out of informal jam sessions that eventually led to more than a dozen albums and tours, often backed with a jazz trio. The group broke up in 1964; Lambert was killed in an auto accident in 1966.

Lambert, Hendricks & Ross utilized a vocal technique called **vocalese**, which had been perfected by singer **Eddie Jefferson**. Jefferson took existing instrumental jazz solos and composed witty and inventive lyrics to them. Lambert, Hendricks & Ross took vocalese one step further by adding three-part harmony. Each of the three singers was also a versatile scat singer in their own right, and improvised solos were included in their live and recorded performances. Lambert, Hendricks & Ross also inspired other vocal jazz ensembles, including the Swingle Singers, Manhattan Transfer, and the New York Voices.

The Demise of 52nd Street

By the end of the 1940s, the good times on The Street were coming to an end. During the war, servicemen out to have a good time made up a large part of the crowd. Once the war ended, the lenient atmosphere changed. Police started to make more arrests of the hustlers and drug dealers that were always present. The racially tolerant atmosphere was starting to break down, with violent incidents between Blacks and whites becoming more common. What was probably more destructive was the opening of several large elaborate clubs on Broadway at the same time that specifically featured jazz as the main attraction. Bop City opened in 1945, the Royal Roost in 1948, and as previously mentioned, Birdland in 1949. The small, dingy basement clubs on 52nd Street could not compete with their new competitors, and many became strip joints. Today massive skyscrapers stand where some of history's most famous jazz clubs once stood.

Name _____ Date _____

Study Questions

The Bebop Revolution

1. What impact did the recording ban have on bebop?

2. Describe how rhythm, harmony, and melody are different in bebop than in swing.

3. Describe some of the reasons that motivated the first generation of bebop musicians to develop the new style.

4. What were the positive and negative legacies that Charlie Parker left behind?

5. Did most swing musicians and fans initially accept bebop? Why or why not?

6. Who do you think made the most important contribution to the development of bebop? Why?

7. Describe the differences in the career paths of Dizzy Gillespie, Charlie Parker and Thelonious Monk.

8. Describe some of the reasons why Thelonious Monk is held in such high regard today.

9. Why was there a New Orleans revival?

10. Describe the alternative music scene that developed in Harlem in the late 1930s and why it came about.

FRAGMENTATION

Introduction

In the wake of the bebop revolution, the jazz world underwent a period of great upheaval as musicians, independently and collectively, struggled to absorb its new harmonies, melodies, and rhythms. Although bebop had made its impact as a revolutionary force, it was becoming apparent that its most immediate effect was to clear the air and make way for whatever came next; its revolutionary period was over, and now we would see how powerful and long-lasting its evolutionary period would be. With no clear unified path to follow as there had been in the years before bebop emerged, a process of style fragmentation and differing schools of thought began to emerge. Fortunately for jazz as an art form, the musicians who took charge in the early 1950s were collectively some of the most talented and visionary in the history of the music.

But jazz was also dealing with a shrinking fan base. Rhythm & blues was catching on among teens in the same way that swing had done a generation earlier. **Jump bands**, R&B bands that placed more emphasis on honking saxophone solos and a heavy backbeat from the rhythm section, were particularly popular; the jump records made by Louis Jordan—a former jazz musician from the Chick Webb Orchestra—outsold all other Black bands in the 1940s. Former Benny Goodman sideman Lionel Hampton also jumped on the R&B bandwagon and had the biggest hit of 1946 with "Hey! Ba-Ba-Re-Bop." Kansas City shouter Big Joe Turner had the biggest hit of his career in 1954 with the R&B song "Shake, Rattle and Roll." When Elvis Presley burst onto the scene in 1955, rock and roll became the new revolution in popular music. But in spite of these developments, the 1950s were a time when jazz was still popular to many, and a time of great evolution of new and innovative ideas.

Cool Jazz

The Birth of the Cool

The first important post-bebop group was the **Miles Davis Nonet**, a nine-piece ensemble with three-piece rhythm section and a novel six-piece horn configuration: trumpet and trombone, alto and baritone saxes, French horn, and tuba. Rehearsing in the cramped 55th Street apartment of Canadian arranger Gil Evans, and playing new music written by Evans, baritone saxophonist Gerry Mulligan, pianist John Lewis and Davis, the group explored new musical directions away from the influence of bebop. Although the focus was on innovation, they were clearly modeled after one of the swing era's most impressionistic big bands, the Claude Thornhill Orchestra, which both Evans and Mulligan had written arrangements for. Davis envisioned the horns sounding like a choir, and to be orchestrated as a single section—a radically different concept than the

KEY TERMS

Civil Rights Movement
Counterpoint
French Impressionist
 Composers
Fugue
Harmon Mute
Jazz at the Philharmonic
Jump Band
*The Lydian Chromatic Concept
 of Tonal Organization*
Melodic Development
Odd Meter
Overdub
Time Signature

KEY PLACES

Central Avenue
The Haig
The Lighthouse
Los Angeles

KEY FIGURES

Antonio Carlos Jobim
Art Blakey/The Jazz Messengers
Bill Evans
Bill Evans Trio
Cannonball Adderley
Charles Mingus/Jazz Workshop
Chet Baker
Clifford Brown
Clifford Brown/Max Roach
 Quintet
Dave Brubeck/DB Quart
George Russell
Gerry Mulligan
Gerry Mulligan Quartet
Gunther Schuller
Horace Silver
Jimmy Smith
João and Astrud Gilberto
Lennie Tristano

	MUSIC STYLES	IMPORTANT ALBUMS
Lighthouse All-Stars	Bossa Nova	*Birth of the Cool*—Miles Davis Nonet
Miles Davis	Calypso	*Getz/Gilberto*—Stan Getz
Miles Davis First Quintet	Cool Jazz	*Jazz Samba*—Stan Getz
Miles Davis Nonet	Hard Bop	*Kind of Blue*—Miles Davis
Modern Jazz Quartet	Modal Jazz	*Mingus Ah Um*—Charles Mingus
Norman Granz	Soul Jazz	*Saxophone Colossus*—Sonny Rollins
Paul Desmond	Third Stream	*Sunday at the Village Vanguard/ Waltz*
Sonny Rollins	West Coast Jazz	*for Debby*—Evans Trio
Stan Getz		*Time Out*—Dave Brubeck Quartet
Wes Montgomery		

Jump bands were R&B ensembles that were smaller descendants of the swing big band. Jump bands usually had three to four horns, a rhythm section that included electric guitar, and a vocalist.

Cool also was sometimes known as **West Coast Jazz**, as many of the leading musicians lived in California.

Henderson/Redman mold of sections playing against each other that had been the paradigm of the large jazz ensemble for the last twenty-five years.

The group made an inauspicious debut: one two-week stay at the Royal Roost in September 1948 and three recording sessions in 1949 and 1950. Then, hardly noticed by anyone, they broke up. It was not until five years later that the rest of the jazz world caught up with them, and Capitol Records released the 12 sides under the title *Birth of the Cool*.

Davis' group defined the style that became known as "cool." Cool was the antithesis of bebop: the mood is generally low-key and tranquil, the tempos are medium. There is very little dynamic contrast—everything is played softly and with light tones. In place of the explosiveness of bop are passiveness and introspection. The emphasis is not on the improvised solo but on the arrangement. Many of the musicians, composers, and arrangers of the cool style were formally trained in European classical music and incorporated these influences, giving the music an intellectual and somewhat formal sound. Although 12-bar blues structures were sometimes used, blues tonality was largely ignored. Cool also was sometimes known as West Coast Jazz, as many of the leading musicians lived in California. Although cool embraces a wide variety of stylistic variations, generally speaking, the most commonly found characteristics are listed in **Box 8-1**.

Modern Jazz Quartet

- John Lewis—piano
- Kenny Clark/Connie Kay—drums
- Percy Heath—bass
- Milt Jackson—vibes

BOX 8-1	The Characteristics of Cool/West Coast Jazz

- General attitude of restraint, tranquility
- Medium tempos
- Little or no dynamic contrasts: soft and light tone color
- European and classical influence
- Emphasis on arrangements rather than improvised solos
- Lyrical solos
- Little or no blues influence

The Modern Jazz Quartet

Virtually all the alumni of the Miles Davis Nonet went on to make important contributions to jazz in the 1950s. The group's pianist, John Lewis was one of the founding members of the **Modern Jazz Quartet**, formed in 1952 with drummer Kenny Clarke, whom he had met in the Army, bassist Percy Heath and vibraphonist Milt Jackson. Lewis and Jackson had played together in the late 1940s in Dizzy Gillespie's big band. The college-educated Lewis brought a formality to the group that reminded some of a small chamber orchestra. He wrote extended compositions for the Modern Jazz Quartet (MJQ) that integrated European structural forms with jazz. One example of this was a tribute album to guitarist

Music Analysis

Track 35: "Boplicity"

(Henry) Miles Davis Nonet recorded April 22, 1949. Personnel: Davis: trumpet; Gerry Mulligan: baritone sax; Lee Konitz: alto sax; J. J. Johnson: trombone; Sandy Siegelstein: French horn; John Barber: tuba; John Lewis: piano; Nelson Boyd: bass; Kenny Clarke: drums; Gil Evans: arranger

The recording of "Boplicity" comes from the seminal 'Birth of the Cool' sessions by one of the most innovative bands in jazz history. The music that the Miles Davis Nonet recorded in their three sessions in 1949 and 1950 ("Boplicity" was recorded at the second) was an inventive mix of pre-arranged orchestration and improvised solos that set the tone for post-bebop jazz. Although the song was written and arranged by Gil Evans, its authorship is attributed to Cleo Henry, who in reality turned out to be the first and middle names of Miles Davis's mother. Take note of the ensemble writing for the novel six-horn section throughout the arrangement, which was remarkably different than the standard big band writing of the swing era.

0:00	Song starts with no introduction; head is played in thickly textured ensemble writing for all six horns
0:59	Baritone sax solo by Gerry Mulligan with rhythm section accompaniment
1:26	Short interlude by horns
1:36	Trumpet solo by Miles Davis with horns playing soft background parts
2:00	Trumpet solo by Davis continues
2:26	Short piano solo by John Lewis
2:40	Head is restated by horns

Django Reinhardt that contains one of the group's signature pieces, "Django." Another, "Vendome" uses a **fugue** as its unifying structure.

While Lewis' playing was sparse and restrained, Jackson was clearly a bebop player and played with drive and energy. The tension between these two stylistic approaches is one of the things that made the group interesting to listen to. The MJQ preferred playing in concert settings, away from the nightclub scene, and often performed with symphony orchestras. Clarke left the group in 1956 and was replaced by Connie Kaye who stayed with the MJQ until they split up in 1974 when Jackson decided to pursue a solo career.

Lennie Tristano (1919–1978) Piano/Composer

Lennie Tristano was a blind pianist from Chicago who, like John Lewis, consciously attempted to fuse classical music with jazz. Although he had a formal education in piano and eventually earned a master's degree in composition, Tristano developed a virtuoso and rather unorthodox style of playing that made it somewhat difficult to find work as a sideman. After moving to New York in 1946, he began a life-long working relationship with alto saxophonist Lee Konitz, guitarist Billy Bauer, and tenor player Warne Marsh. During the next few years, Tristano embarked on a series of experimental recordings, including "Digression" and "Intuition," two spontaneous improvisations that have no set form or key center, and are today considered to be the first free jazz recordings. In 1953, Tristano recorded "Descent into the Maelstrom," a harshly dissonant piece in which he **overdubbed** several piano parts. Tristano used this technique in later works such as "Turkish Mambo," and was widely criticized for it. In 1951, after finding it difficult to make a living playing jazz, he founded the New School of Music, the first-ever school dedicated to the study of jazz. His students included Charles Mingus and pianist Marian McPartland. His intensity as a teacher earned him an almost guru-like status of devoted disciples, which are still in existence today.

A **fugue** is a formal structure first used during the Baroque Era (1600–1750) that makes extensive use of counterpoint based on an opening theme or subject. See counterpoint.

Overdubbing is a feature of multi-track tape recorders that allows musicians to record additional parts independently of each other while listening to already recorded tracks with headphones. Each additional track is called an overdub.

© Courtesy of Rutgers Institute of Jazz Studies

The Modern Jazz Quartet in standard concert attire. Left to right: pianist John Lewis, drummer Connie Kaye, vibraphonist Milt Jackson, and bassist Percy Heath.

Tristano's music is hard to categorize. He was a phenomenal pianist who often played seemingly endless runs of notes. Although his tempos were often fast and the melodies very bebop-oriented, the European influence is unmistakable. It is uncompromisingly cerebral, which explains why he did not achieve greater acclaim while he was living. Because his music was so progressive for its day, Tristano's contributions to jazz are still being sorted out among musicians and writers. He was an eccentric to be sure but a genius as well. His influence can be heard in the work of such diverse musicians as pianist Bill Evans and rock musicians Frank Zappa. In his later years, he rarely recorded or performed. He died of a heart attack at age 59.

The West Coast Scene

Los Angeles and the Central Avenue Scene

Jazz had existed in Southern California since nearly its inception. Jelly Roll Morton, Freddie Keppard, and others stopped there while traveling around the country in the 1910s. It was in Los Angeles in 1923 that Kid Ory made the first recording by a Black jazz band, "Ory's Creole Trombone." By the late 1940s, jazz, blues, and R&B co-existed in southern Los Angeles in the predominantly Black South Central neighborhood. Running north and south through the heart of the area was Central Avenue, which because of its large number of jazz, blues, and R&B clubs, became a kind of West Coast 52nd Street. The premier club on Central Avenue was the Club Alabam at 42nd Street, "a huge room with beautiful drapes and silks and sparklers and colored lights turning and flashing," according to one musician who played there. "Everybody was decked out. It was a sea of opulence, big hats, and white fluffy fur." Also on Central Avenue were Lovejoy's, the Downbeat, Memo, Bird in the Basket, Last Word, and the Turban Lounge. Also in the area were The Showboat, Alex Lovejoy's, and Stuff Crouch's Backstage.

By the 1940s, there were a number of other jazz clubs scattered throughout the Los Angeles area. In 1946, the Parker/Gillespie Quintet brought bebop to the West Coast for the first time at Billie Berg's. Other clubs that sprang up were Jazz City on Hollywood and Western Ave, The Rendezvous on Pacific Boulevard, Shelly's Manne-Hole, owned by drummer Shelly Manne, and The Haig at Kenmore and Wilshire. Perhaps the most famous was The Lighthouse in Hermosa Beach, where for years bassist Howard Rumsey was the leader of the Lighthouse All-Stars that included Shorty Rogers on trumpet, Frank Rosolino on trombone, Shelly Manne on drums, and Jimmy Giuffre on tenor sax.

Clubs Located Along Central Avenue

- Elk's Hall
- Club Alabam
- Lincoln Theatre
- Jack's Basket Room

The Lighthouse All-Stars

- Howard Rumsey
- Shorty Rogers
- Frank Rosolino
- Shelly Manne
- Jimmy Guiffre

Los Angeles was also attracting jazz musicians for work in the entertainment business. For years the capital of the moviemaking industry, LA was now becoming the heart of television and record production. Work as a session musician requires formal training, the ability to sight-read and play a variety of styles. Reading music had become a necessity during the swing era, and the technicalities required to play bebop had raised the bar on general musicianship. As job opportunities in swing bands dwindled, many musicians moved to Southern California to be a part of the LA scene.

Important West Coast Cool Musicians

Gerry Mulligan (1927–1996) Baritone Sax/Composer/Arranger/Bandleader

One of the East Coast jazz musicians drawn to California was Gerry Mulligan. Mulligan had already made a name for himself as an arranger for the Claude Thornhill and Miles Davis groups, but he was broke and out of work when he decided to hitchhike to Southern California in 1952. He soon began attending jam sessions at a tiny club called the Haig where he met trumpeter Chet Baker. In July, Mulligan and Baker put together a quartet to play at the Haig on Monday nights that became famous for being "pianoless" (there was not enough room in the tiny former bungalow to move a piano on stage). Without a piano, the **Gerry Mulligan Quartet** had to rely on the **counterpoint** between the baritone sax and the trumpet to outline the harmonic movement. This kind of 'horizontal' (melodic rather than 'vertical' or harmonic) conception was the foundation of the music of the Baroque period of European classical music (early 18th century), and the design from which J. S. Bach and other composers of that era worked. Mulligan's group also occasionally used collective improvisation, another technique borrowed from the past—1900s New Orleans jazz. Led by the boyish Mulligan and the photogenic Baker and playing serene, soothing music, the group was a smash hit and helped kick-start the West Coast cool scene. For all its popularity, the Mulligan Quartet did not last long; a drug bust put Mulligan in jail in 1953 and Baker left to pursue his own career.

Mulligan went on to front many other ensembles and was active as a composer and arranger. He is also credited as being the first great soloist on the baritone saxophone, an instrument that up to this point in time had only one major player, Harry Carney of the Ellington band. Mulligan's playing was lyrical and light, making the large, unwieldy baritone sax sound almost like a tenor. As the leader of the first of the West Coast cool groups, he helped set the stage for other California jazz musicians in the 1950s.

Chet Baker (1929–1988) Trumpet/Vocals

Like Louis Armstrong before him, **Chet Baker** was influential and popular both as a trumpet player and vocalist. Born in Oklahoma, Baker moved to California as a teen and later served in the Army in the late 1940s. In the early 1950s, he became a regular at jam sessions around Los Angeles and got his first break when Charlie Parker hired him in 1952 for a short tour. That summer, he joined the front line of the "pianoless" Gerry Mulligan Quartet working at the Haig, where he was able to demonstrate his strong sense of lyricism and ability to interact spontaneously with Mulligan. Although it was Baker's inventive playing that made him popular among fellow musicians, it was his singing and movie star good looks that made him a fan favorite. His high, clear voice was dry and whispering, full of melancholy. In 1953, after leaving the Mulligan group, Baker made a vocal recording of "My Funny Valentine" and his popularity skyrocketed.

Important West Coast Musicians

- Gerry Mulligan
- Chet Baker
- Dave Brubeck
- Stan Getz
- Paul Desmond

Counterpoint is two or more melodic lines occurring simultaneously, sometimes referred to as polyphony.

By 1954 after the release of the album *Chet Baker Sings*, he began winning critics and fan polls in *DownBeat* and *Metronome*. Throughout the rest of the 1950s, Baker toured and recorded, and even began acting in films. A fictionalized film version of his own life, *All the Fine Young Cannibals* was made in 1959 starring Robert Wagner as "Chad Bixby."

Baker also became involved with heroin at some point in the late 1950s. He toured Europe extensively, but eventually, his luck and his looks started to go away: in 1966, he was beaten and had his teeth kicked in over a drug deal; by 1970, he was on welfare, had stopped playing, and was beginning to look like the Grim Reaper. Returning to Europe, Baker began playing again in the late 1970s, but in May 1988, he allegedly fell to his death from the window of his hotel room in Amsterdam. The circumstances surrounding the incident are unsolved to this day.

Dave Brubeck (1920–2012) Piano/Composer/Bandleader

The most popular and commercially successful West Coast musician was pianist **Dave Brubeck**. Born and raised on a ranch outside San Francisco, Brubeck studied classical piano as a child but began playing jazz and dance gigs in the area in his teens. Upon entering the College of the Pacific, he studied to become a veterinarian before switching to music his second year. After switching to Mills College, Brubeck studied with composer Darius Milhaud and formed an innovative octet that played original arrangements, not unlike those of the Miles Davis Nonet. One of the members of the octet was an alto saxophonist named Paul Breitenfeld, who later changed his name to **Paul Desmond**. After a stint in the Army, in 1951 Brubeck formed a quartet that included Desmond that become wildly popular playing in clubs in San Francisco and touring college campuses. By 1954, he was on the cover of *Time* magazine.

Brubeck's playing is somewhat controversial; because of his extensive classical training, some critics say his playing is stiff and does not swing. However, no one has ever criticized Desmond on that account, as he was one of the most lyrical and inventive of all the cool players. Brubeck and Desmond stayed together until 1967, an amazing 16-year run. Their biggest success came in 1959 with the release of *Time Out*, an album of seven songs, all of which are in **odd meter**. The album opens with "Blue Rondo Ala Turk," a tune influenced by Brubeck's exposure to Turkish music while in the service, and has a 9/8 **time signature**. The most famous song on the album, "Take Five," in 5/4, was written by Desmond and became a #1 hit, an amazing feat considering that it is a jazz instrumental (rock & roll had long taken over the charts by this time). Besides being a huge hit (eventually achieving platinum status of more than a million copies sold), *Time Out* was innovative, as most jazz musicians of the day had never strayed away from playing in 4/4 time. Today, odd meters are commonly used in jazz.

> A meter is the grouping of beats into bars or measures. Most music has a meter of four beats to the measure; **odd meter** refers to unusual groupings such as three, five, seven, or nine beats to the measure.
>
> A **time signature** is the way in which the meter is designated. Time signature is expressed as a fraction, with the top number being the number of beats per measure, and the bottom number being the note value of each beat, i.e., 4/4, 6/8, 3/4, etc.

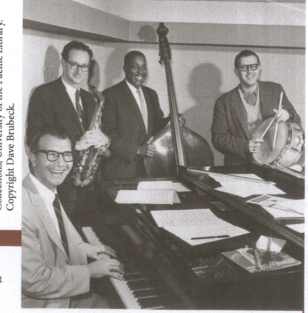

© Brubeck Collection, Holt-Atherton Special Collections, University of the Pacific Library. Copyright Dave Brubeck.

The **Dave Brubeck** Quartet, 1958. Left to right: pianist Brubeck, alto saxophonist Paul Desmond, bassist Eugene Wright, and drummer Joe Morello.

Stan Getz (1927–1991) Tenor Sax/ Bandleader

The son of Jewish Ukrainian immigrants, Stan Getz was born and raised in the lower-class neighborhoods of the East Bronx, New York. He was first given a saxophone at age 13, and he progressed quickly on the instrument: by 16, he had joined the musicians union and by 17, he was on the road, playing with the Stan Kenton Orchestra. After leaving Kenton, Getz joined Woody Herman's Second Herd and gained national attention with a short but beautiful solo on Herman's 1948 recording "Early Autumn." His light,

© Courtesy of Rutgers Institute of Jazz Studies

Tenor saxophonist **Stan Getz** started a bossa nova craze in the United States with his albums Jazz Samba and Getz/Gilberto.

graceful, pretty sound clearly showed an influence from Lester Young, but Getz also incorporated modern bop elements into his playing. Throughout the 1950s, he toured and recorded with various small combos before moving to Denmark, where he lived from 1958 to 1960. When Getz returned to the states, he was introduced to a new jazz/samba-hybrid music style from Brazil called bossa nova, and in 1962 recorded the LP *Jazz Samba* with guitarist Charlie Byrd. The album was a huge success, stayed on the charts for more than a year, and started a national bossa nova craze. Getz's follow-up was a collaboration with the creators of the bossa nova style, guitarist and vocalist João Gilberto, and composer/pianist Antonio Carlos Jobim. The resulting LP *Getz/Gilberto* was one of the most successful of the 1960s, peaking at #2 (beaten only by the Beatles' *A Hard Days Night*), won three Grammy Awards, and became Getz's only gold album. *Getz/Gilberto* also made a star out of Gilberto's wife Astrud, who sang "The Girl from Ipanema," which also won a Grammy and went to #5.

The bossa nova is a slow and romantic style that became popular among fans and musicians alike. Jobim, the co-creator of the style, characterized it as a merging of the Brazilian samba, bebop, and European classical music. He also became the most prolific bossa nova composer, and his many popular bossa nova jazz standards include "Wave," "Triste," "Desafinado," and "How Insensitive."

Bossa nova literally means "new" flair in Portuguese; containing Brazilian, jazz, and classical influences, bossa nova became popular in the early 1960s.

On July 2, 1944, music impresario **Norman Granz** sponsored the first **Jazz at the Philharmonic** concert at Philharmonic Hall in Los Angeles.

JATP

On July 2, 1944, music impresario Norman Granz sponsored the first Jazz at the Philharmonic concert at Philharmonic Hall in Los Angeles. Throughout the 1950s and 1960s, in the US and Europe, Granz' produced hundreds of more concerts and tours featuring all-star lineups that brought jazz to millions. Granz was a revolutionary. By recording the concerts and selling records of them on one of his four record labels (including Verve and Pablo), he was the first to exploit the marketing relationship between touring and recording and the first to use the concert stage as a recording studio. He was also a steadfast champion of equal pay, accommodations, and billing for Black and white artists at a time when white performers generally earned much more. He insisted on presenting integrated lineups at integrated venues and turned down many bookings in segregated concert halls that cost him hundreds of thousands of dollars throughout the years.

Music Analysis

Track 36: "Corcovado (Quiet Nights of Quiet Stars)"

(Jobim) Stan Getz and João Gilberto from the album Getz/Gilberto recorded March 18, 1963. Personnel: Getz: tenor sax; João Gilberto: guitar, vocal; Astrud Gilberto: vocal; Antonio Carlos Jobim: piano; Keeter Betts: bass; Milton Banana: drums

"Corcovado" is a great example of the Brazilian bossa nova that Stan Getz helped popularize in the early 1960s with his collaborations with João and Astrud Gilberto and Antonio Carlos Jobim. The song is one of Jobim's many compositions that have since become jazz standards, and the composer also plays piano on this album as well as a tasteful solo on this song. Getz also delivers a beautifully lyrical solo that demonstrates why he was the leading tenor player of the cool style.

0:00	Song starts with Astrud Gilberto singing one-half verse in English, accompanied by Antonio Carlos Jobim on piano
0:30	Stan Getz plays a short tenor sax solo with João Gilberto accompanying on acoustic guitar; bass and drums also enter
0:49	First chorus: João Gilberto sings verse in Portuguese
1:53	Second chorus: tenor sax solo by Getz
2:56	Third chorus: piano solo by Jobim over the first half of the chorus
3:26	João Gilberto finishes the third chorus with the last half of the verse
4:00	Getz re-enters to play a short tag ending

Hard Bop

The Black Reaction

The **Civil Rights Movement** was the political struggle for racial equality that was led by Dr. Martin Luther King, Jr. and others. The movement started with the successful effort to desegregate the city buses in Montgomery, Alabama, in 1956, and eventually led to the Civil Rights Acts of 1964 and 1968.

Not everyone in the jazz community welcomed the commercial success of cool. For Black performers, it was the same old story: white musicians getting rich playing our music. Virtually the same thing had happened in the swing era, but there was little uproar. However, things were different in postwar America. There was a new shift in Black consciousness and a greater overall expectation of change. Many Black musicians became openly resentful of their white counterparts, and Black bandleaders were criticized if they hired a white musician. As the Civil Rights Movement started to gain momentum in the 1950s, a new urban and distinctly Black music began to emerge. The new style was steeped in the music that was becoming increasingly popular in urban Black neighborhoods: rhythm and blues. R&B was more danceable than bebop but retained a strong influence from the blues and gospel music. When jazz musicians began to merge R&B and bebop, a new style emerged that became an answer for many Black musicians to the cool style. It became known as **hard bop**.

Because hard bop was patterned to some degree after R&B, it was by definition simplified somewhat from bebop. Harmony and rhythm became less complex, and melodies were often derived entirely from the blues scale. Other elements from gospel and the Black church that were absent in cool jazz were used extensively, such as call and response and gospel harmony. Hard bop musicians did retain the bebop reliance on virtuoso improvisation, however. The most consistent and predominant characteristic of hard bop is the explosive power emanating from the rhythm section. Like R&B, the "groove" must be laid down with authority and drive. (It is no coincidence that two of hard bop's greatest groups, the Jazz Messengers and the Clifford Brown/Max Roach Quintet were led or co-led by drummers.) Similarly, front line horn players—typically a trumpet and tenor sax—played with a hard edge to their sound.

BOX 8-2	The Characteristics of Hard Bop

- Return to roots: Gospel and blues influences
- Simpler harmony, rhythm, and melody than bebop
- Typical group: trumpet, tenor sax, piano, bass, drums
- Powerful, explosive, hard-driving
 - Horns: hard-edged, brassy
 - Rhythm section: emphasis on the groove
- Emphasis on virtuoso improvisation

Important Hard Bop Musicians

Art Blakey (1919–1990) Drums/Bandleader

Drummer **Art Blakey**, along with his group the Jazz Messengers, more or less defined the sound of hard bop. His roots were in bebop, but Blakey simplified the style of Max Roach and other bebop drummers in order to play with more power. His first important gig was with the Billy Eckstine Orchestra alongside Charlie Parker and Dizzy Gillespie. Upon the demise of that innovative band in 1947, Blakely traveled to Africa for a short sabbatical, converted to Islam, and changed his name to Abdullah Ibn Buhaina, or simply "Bu" as many knew him. After returning to New York, he worked his way up through the New York scene in the late 1940s and early 1950s before forming the Jazz Messengers with pianist Horace Silver in 1954. Silver wrote most of the group's material in the beginning, including their first hit "The Preacher," but left to start his own group in 1956. From the beginning, the Messengers' sound has been soulful, bluesy, and powerful, featuring original compositions from band members. The front line has been consistently great, with

Music Analysis

Track 37: "Moanin'"

(Bobby Timmons), Art Blakey and the Jazz Messengers, from the album Moanin', recorded October 30, 1958 (4:03). Personnel: Blakey, drums; Jymie Merritt, bass; Lee Morgan, trumpet; Benny Golson, tenor sax; Bobby Timmons, piano.

Bobby Timmons' "Moanin'", performed here by the Jazz Messengers, is a hard bop classic that uses call and response riffs between the horns and rhythm section. This recording features a dynamic solo by then twenty-year-old Lee Morgan, one of the leading hard bop trumpeters who was tragically shot to death by a girlfriend at a gig in New York in 1972. Blakey's power and drive is evident throughout the recording. The song is composed using the standard 32 bar AABA song formula, as its unique arrangement demonstrates.

0:00	First A section: melody is played by pianist Bobby Timmons with response by rhythm section and horns.
0:15	Second A section: melody shifts to trumpeter Lee Morgan and tenor saxophonist Benny Golson, with response by rhythm section.
0:30	B section (bridge): melody played in unison by Morgan and Golson, rhythm section goes into driving 4/4 time with drummer Blakey accenting backbeats.
0:44	Last A section: repeat of first A section.
1:00	Second chorus: trumpeter Lee Morgan plays a solo.
2:01	Third chorus: tenor sax solo by Benny Golson.
3:00	Fourth chorus: head is restated, with bridge riff repeated several times before ending with a cadenza by Timmons.

© Courtesy of Rutgers Institute of Jazz Studies

Art Blakey was the most powerful drummer of his generation.

Important Hard Bop Musicians

- Art Blakey
- Horace Silver
- Sonny Rollins
- Clifford Brown
- Charles Mingus
- Wes Montgomery

The Original Jazz Messengers

- Art Blakey—drums
- Horace Silver—piano
- Kenny Durham—trumpet
- Hank Mobley—tenor sax
- Doug Watkins—bass

some of the best horn men in jazz. Blakey's ability to drive the band using dramatic shifts in dynamics has been another important signature sound of the Messengers.

Once he took control of the group, Blakey turned it into a workshop for the musical growth and development of promising young talent. Once he felt they had matured musically, Blakey let them go to start their own groups. Throughout the years, the Jazz Messengers have turned out a who's who in jazz, including the 1958 version, which included Lee Morgan on trumpet and Benny Golson on tenor sax, the 1961 version with trumpeter Freddie Hubbard, tenor player Wayne Shorter, and trombonist Curtis Fuller, and the early 1980s version with Wynton and Branford Marsalis. All of these players, and many more, went on to make important contributions to jazz after "graduation" from the Jazz Messengers.

Horace Silver (1928–2014) Piano/Composer/Bandleader

Horace Silver was one of the most prolific hard bop composers, having contributed a tremendous number of songs to the jazz repertoire. Among his many standards are "Song For My Father," "The Preacher," "Sister Sadie" and "Nica's Dream." Although he is not considered to be a strong soloist, Silver is a major stylist, playing a simplified yet distinctive funky piano that has proven to be one of the most copied of the post-bebop era.

Silver's first important gig was with Stan Getz from 1950–51. He was a founding member of the Jazz Messengers after working with Art Blakey informally from 1953–55. In 1956, he started his own group, the Horace Silver Quintet which has stayed together continuously with shifting personnel every since. From the beginning, his lineup has been trumpet, tenor sax, piano, bass, and drums, helping to establish that instrumentation as the standard for the hard bop style. Like Blakey's group, Silver's quintet produced many promising jazz stars, including Woody Shaw (trumpet) and Joe Henderson (tenor sax).

Sonny Rollins (1930–) Tenor Sax/Composer

Sonny Rollins became the definitive tenor saxophonist of the hard bop style. His original influence was Coleman Hawkins, from whom Rollins adopted a big, heavy sound. He plays with so much fire that he once jumped off a stage to be closer to the crowd, breaking his foot in the fall (while continuing to play). Rollins is also a major composer of hard bop tunes, contributing several standards, including "Airegin" (Nigeria spelled backward), "Oleo," and "St. Thomas."

Rollins grew up and began playing jazz in the San Juan Hill section of New York City. By the early 1950s, he had successfully worked his way into the jazz scene and recorded with Thelonious Monk, The MJQ, and Art Blakey, and in 1954 joined the Miles Davis Quintet. His stay with Davis was short, however,

as he had to briefly check himself into a drug treatment facility to overcome a heroin addiction. Once released, Rollins caught fire with creative energy and released two landmark albums, *Saxophone Colossus* in 1956, which includes his **calypso** standard "St. Thomas," and *Way Out West* in 1957. With these albums, Rollins became famous for his use of **melodic development** in his solo improvisations. In 1955, Rollins also joined the Clifford Brown/Max Roach Quintet, making it for a short while one of the top hard bop groups in jazz.

Rollins withdrew from the music scene twice in his career again in 1959 for the expressed purpose of getting himself together musically (what musicians refer to as "woodshedding." During his two-year hiatus, he would often practice late at night on the Williamsburg Bridge, unconsciously creating one of jazz music's most romantic images. When he returned, one of his first releases was an album of jazz standards entitled *The Bridge*. But Rollins struggled with his direction throughout much of the 1960s when saxophonists Ornette Coleman and John Coltrane were grabbing most of the attention in jazz. In 1969, he took yet another sabbatical and traveled to India to refresh his mind. Now in his 80s, Rollins is still gigging and living a secluded life in upstate New York after having survived the September 11, 2001, terrorist attack in his apartment near the World Trade Center.

Clifford Brown (1930–1956) Trumpet/Composer

In mid-1956, **Clifford Brown** was poised to become the next great trumpet player after Dizzy Gillespie. Despite being only 25 years old, he seemed to be destined for greatness. He was the co-leader of one of the top hard bop bands in jazz, the **Clifford Brown/Max Roach Quintet**. And, unlike many jazz musicians of his generation, he was drug-free. Tragically, he was killed in an automobile accident on June 26 while traveling to a gig in Chicago.

"Brownie" was blessed with an abundance of natural talent: despite starting the trumpet at 15, he was playing with some of the top players in jazz by the time he was 18. Critics and fellow musicians alike noticed his seemingly unlimited potential. Brown was a fiery player who seemed to give each solo every ounce of energy he had. The notes seemed to crackle out of his horn. Ironically, the crash that killed him was not his first major accident: in mid-1950, another automobile accident hospitalized him for nearly a year. It seems a strange twist of fate that while many in the jazz world were dying young from their self-destructive lifestyles, Clifford Brown lived clean but still could not avoid an early death.

Charles Mingus (1922–1979) Bass/Composer/Arranger/Bandleader

Iconoclastic and eclectic, **Charles Mingus** was a huge presence in the jazz world as a bass player but most importantly as a composer. His primary writing influence was Duke Ellington, and like The Maestro, Mingus wrote in a variety of compositional formats that included 12-bar blues, standard 32-bar songs,

> A **calypso** is a syncopated type of folk song from the West Indies that is typically played by steel drum bands.
>
> **Melodic development** is an improvisational technique where the soloist repeats a short phrase or riff with constant variation and modification.

© Courtesy of Rutgers Institute of Jazz Studies

Bassist/composer/bandleader **Charles Mingus** was labeled by one critic as "jazz's most persistently apocalyptic voice."

and extended works. His music encompassed a wide variety of styles, including hard bop, Third Stream, film music, collective improvisation, and free jazz. He also wrote for everything from big band to small combo, large orchestra to solo piano. Mingus adopted one other important Ellington-ism: he encouraged and allowed his musicians to bring their unique talents to the realization of his compositions. In fact, Mingus went one step further than Ellington by often giving his musicians only sketches to work from to maximize their creative input. In all of Mingus' compositions, there is a strong mix of blues and gospel influences that give the music an unprecedented emotional power and rawness that is stirring to listen to even today.

Mingus grew up in the Watts section of Los Angeles and as a child often attended the Holiness Church, where the congregation often participated in services with shouting, moans, and trances. Being a light-skinned African American meant that he also experienced racism—from both Blacks and whites. Starting out on cello, he switched early on to bass and began working in the clubs along Central Avenue as a sideman, and also began to compose music. In 1951, he moved to New York where he quickly worked his way into the city's music scene and gained a reputation as one of the most powerful bassists in jazz. Mingus was also establishing a track record of doing things his own way, and in 1952, he formed the Dial record label so that the established labels could not dictate creative decisions to him. In 1953, he formed the Jazz Workshop, a group dedicated to performing his compositions that at one time or another included reedmen Eric Dolphy and Rahsaan Roland Kirk, trombonist Jimmy Knepper, and Mingus's longtime drummer, Dannie Richmond.

Music Analysis

Track 38: "Boogie Stop Shuffle"

(Mingus) Charles Mingus Septet from the album *Mingus Ah Um* recorded May 12, 1959. Personnel: Mingus: bass; Willie Dennis: trombone; John Handy: alto sax; Booker Ervin: tenor sax; Curtis Porter: tenor sax; Horace Parlan: piano; Dannie Richmond: drums

"Boogie Stop Shuffle" is from Charles Mingus' landmark album *Mingus Ah Um*, an album noted for creatively combining spontaneous improvisation with pre-arranged orchestration. The song is a 12-bar blues built on a sinister-sounding bass riff (an idea that he also used in his famous "Haitian Fight Song") that is doubled by pianist Horace Parlan and the horn players. "Boogie Stop Shuffle" also contains other elements that often characterize many Mingus compositions: unrelenting emotionalism and religious fervor, a reflection of his experiences attending the uninhibited services at the Holiness Church as a child; the blues, played with an apocalyptic commitment; and a willingness to take chances musically. The members of the septet that recorded *Mingus Ah Um* were part of Mingus's ongoing musical endeavor he called the Jazz Workshop (which some participants called the Jazz 'Sweatshop' after enduring Mingus's long, demanding rehearsals). The album also contains "Fables of Faubus," his biting but comical attack on Arkansas Gov. Orville Faubus and "Goodbye Pork Pie Hat," his requiem to Lester Young.

0:00	Song starts without introduction with entire band playing the riff in unison for the first chorus of 12-bar blues; Mingus adds three counter-themes in the horns over the next four choruses as the piano and bass continue the original riff
0:56	Tenor saxophonist Booker Ervin plays a four-chorus solo with background riffs played by the other horns
1:40	Pianist Horace Parlan plays a four-chorus solo
2:25	Alto saxophonist John Handy plays a four-chorus solo with background riffs
3:09	Opening riff theme is played twice
3:31	Dannie Richmond plays a short drum solo
3:53	The intro is repeated; after a brief moment of collective improvisation, the song concludes with a short drum solo

Mingus's composing and arranging skills rival those of his role model, Duke Ellington. His compositions include the 1956 extended work "Pithecanthropus Erectus," which he called "My conception of the modern counterpart of the first man to stand erect;" the four-movement *Black Saint and the Sinner Lady* from 1963, and the 19-movement two-hour long *Epitaph*, which was discovered only after his death. In 1959, Mingus recorded arguably his finest LP, *Mingus Ah Um*, which combined spontaneous improvisation with pre-arranged orchestration. Mingus also involved himself musically in political issues. In 1959, he also recorded "Fables of Faubus," a scathing attack on the segregationist Governor Orville Faubus of Arkansas; in 1960, he and Max Roach staged an "anti-festival" during the Newport Jazz Festival to protest the commercialization of the event. In the early 1950s, he was also instrumental in creating a unified, integrated musicians union in Los Angeles, which replaced the two segregated locals. He also spoke out against racism in the 1968 documentary film Mingus, and in his 1971 autobiographical book *Beneath the Underdog*. Mingus also wrote tunes that have become jazz standards, including "Nostalgia in Times Square," "Goodbye Pork Pie Hat," and the sinister "Haitian Fight Song." He died in Mexico after a two-year battle with Amyotrophic Lateral Sclerosis (Lou Gehrig's disease).

Other Jazz Styles from the 1950s

Soul Jazz

A sub-style of hard bop that drew heavily from R&B and soul music influences and artists like Ray Charles was called **soul jazz**. Soul jazz records enjoyed great commercial success in the mid-1950s and 1960s, and some single releases became big hits, including Jimmy Smith's "Walk on the Wild Side" (#21, 1962) and Ramsey Lewis' "The In Crowd" (#5, 1965). Cannonball Adderley's "Mercy, Mercy, Mercy" (#11, 1967) was a huge hit that was covered (with added lyrics) by the rock group The Buckinghams. Herbie Hancock's 1962 "Watermelon Man" and Lee Morgan's 1963 "The Sidewinder" also fit under the soul jazz heading. Soul jazz also often employs heavy use of gospel harmonies, call and response, down-home blues, and funk grooves, as well as electronic instruments such as the electric piano, bass guitar, electric guitar, and Hammond organ.

> A substyle of hard bop that drew heavily from R&B influences and artists like Ray Charles was called soul jazz.

Julian "Cannonball" Adderley (1928–1975) Alto Sax

The most soulful saxophonist in jazz in the late 1950s and 1960s was **Cannonball Adderley**. Adderley was an unknown music teacher from Florida who sat in with Oscar Pettiford's band at the Café Bohemia in Greenwich Village one night in late 1955 and was an immediate sensation. His appearance on the New York scene just months after the death of Charlie Parker prompted some to call him the 'New Bird'. Adderley went on to play with Miles Davis for a year in 1958–59 and participated in Davis' landmark *Kind of Blue* recording before starting his own quintet with his brother Nat on flugelhorn, which he maintained until his death. One of the most important members of the Adderley Quintet was Austrian-born pianist/composer Josef Zawinul, who wrote many of the group's hits, including "Mercy, Mercy, Mercy."

Jimmy Smith (1925–2005) Hammond B3 Organ

Jimmy Smith did for the organ in jazz what Coleman Hawkins did for the tenor sax—made it a bona fide jazz instrument. Since his debut at the Café Bohemia in 1956, the organ trio—organ, drums, and guitar—has become a popular format

that has been copied many times. Playing bass on the organ foot pedals, Smith's incredible dexterity with his hands and feet set the standard by which other organists are judged. His Blue Note albums recorded between 1958 and 1960, *The Sermon, Home Cookin,'* and *Back At The Chicken Shack,* are all classics.

Wes Montgomery (1925–1968) Guitar/Composer

The premier hard bop/soul jazz electric guitarist to emerge in the 1950s, **Wes Montgomery** was a hard-swinging player who often played solos with runs of notes that were doubled an octave below the melody. After bursting onto the scene from his hometown of Indianapolis in 1959, he played in a variety of small groups and was popular until his death from a heart attack. Montgomery was an important link between the style of Charlie Christian and current jazz star Pat Metheny. His gold-certified album *A Day in the Life* was the biggest selling jazz LP in 1968.

Third Stream

> Another stylistic development of the 1950s was the merging of jazz and classical music that became known as **Third Stream**, a phrase coined by composer **Gunther Schuller** in 1957.

Another stylistic development of the 1950s was the merging of jazz and classical music that became known as **Third Stream**, a phrase coined by composer **Gunther Schuller** in 1957. Fusing jazz (or African American-rooted popular music) and classical music was something that had fascinated composers for years. Scott Joplin wrote two ragtime operas. Paul Whiteman's symphonic jazz concept prompted George Gershwin to write "Rhapsody in Blue" in 1924. Many of Duke Ellington's extended works in the 1940s were using classical forms and were in effect, symphonic works (1943's *Black, Brown and Beige* for example), as were some of the late 1940s recordings of Stan Kenton (*City of Glass*). Classical composers were likewise leaning toward jazz: Russian composer Igor Stravinsky in 1946 wrote "Ebony Concerto."

In 1955, Schuller (who played French horn on the *Birth of the Cool* sessions) and pianist/composer John Lewis (of the MJQ) formed the Jazz and Classical Music Society with the intention of bringing together musicians of the jazz and classical worlds to present new works in concert. Among the new works that resulted from the society was Schuller's *Symphony For Brass And Percussion*, which uses the standard symphonic form of four contrasting movements. Other composers were experimenting as well: George Russell wrote "A Bird in Igor's Yard" (with references to both Stravinsky and Charlie Parker); Jimmy Giuffre wrote "Fugue" in 1953. Gil Evans collaborated with Miles Davis on three classic albums in the 1950s, *Miles Ahead, Porgy and Bess,* and *Sketches of Spain*. Charles Mingus as well as the above-mentioned John Lewis also wrote works in this vein.

There are several problems inherent in the concept of Third Stream. Jazz and European classical music are very different idioms that demand different disciplines: jazz players must be able to swing and improvise, whereas classical musicians must play with precise control, etc. Finding musicians that can do both convincingly can be difficult. Third Stream can also encounter difficulties being accepted by either camp, therefore limiting performance and recording opportunities as well as funding from grants and scholarships. Today, the term may evoke connotations with the 1950s, but compositions that attempt to reconcile jazz and classical music are still being written.

Modal Jazz

Throughout the 1950s, a few adventurous jazz musicians were beginning to experiment with a harmonic concept that would take them completely away from the complex chord progressions that become standard with bebop. Although modal

Music Analysis

Track 39: "All About Rosie" (1st part)

(George Russell), George Russell Orchestra, recorded June 10, 1957 (2:09). Personnel: Bill Evans, piano; John LaPorta, alto sax; Hal McKusick, tenor sax; Robert DiDomenica, flute; Manuel Zegler, bassoon; Louis Mucci, Art Farmer, trumpet; Jimmy Knepper, trombone; Jim Buffington, French horn; Teddy Charles, vibes; Barry Galbraith, guitar; Joe Benjamin, bass; Teddy Sommer, drums; Margaret Ross, harp.

Composer arranger George Russell (1923–2009) has played an important, albeit somewhat under-appreciated role in jazz history as a pioneer whose modal theories influenced Bill Evans, Miles Davis, and ultimately John Coltrane. "All About Rosie", written for the 1957 Brandeis University Jazz Festival, opens with a simple six-note call and response between trumpet and muted trombone before evolving into a piece of astounding complexity. The piece in its entirety is nearly 11 minutes long and is divided into three sections. Much of the first part (analyzed here) utilizes very intricate contrapuntal writing with several themes appearing simultaneously. The second section is slow and bluesy, reminiscent of a film noir detective movie score. The final movement is a showcase for pianist Bill Evans.

0:00	Introduction: six-note theme is stated in call and response fashion by trumpet and muted trombone.
0:09	First theme stated by muted trumpets and vibes.
0:27	Second section starts; complex contrapuntal writing.
0:56	Transitional section is introduced by trombone; bass, piano, and vibes play bass line in unison.
1:08	Third section is introduced by trumpets; more complex contrapuntal writing that dramatically builds to a screeching halt.

harmony was considered new and innovative to jazz, the concept was actually hundreds of years old, dating back to the ancient Greeks. **Modal jazz** incorporated the Greek and medieval musical practice of using modes or scales as the framework for harmony, rather than chord progressions. As a result, modal jazz compositions often contained only two, three, or even sometimes only one mode or scale, compared to a bebop tune, which might have two or three chords in *each measure*. As one might imagine, this forced composers and especially jazz soloists to be inventive in new ways to create melodies that did not rely on negotiating difficult chord progressions.

One of the first proponents of modal jazz was composer/bandleader **George Russell**, who in 1953 published *The Lydian Chromatic Concept of Tonal Organization*, which was the first book to examine the relationship between chords and scales, or modes. (The Lydian mode being one of the original Greek modes.) This chord scale relationship is today at the foundation of most jazz education throughout the world. Russell, who as previously mentioned was active in Third Stream circles, was influential in traducing modal jazz to Bill Evans and Miles Davis, who in turn, as we shall see, helped make modal jazz into an important genre in jazz in the late 1950s, 1960s, and beyond.

The Piano Trio

The piano has long been one of the primary instruments in the development of jazz. In the beginning, it was mainly used as a solo instrument, and pianists developed incredible left-hand technique to provide rhythm accompaniment for ragtime, stride, and boogie-woogie. Early piano trios had a variety of instrumental lineups: The Benny Goodman Trio of 1936 used a piano-drums-clarinet format, while the trios of Nat King Cole and Art Tatum in the 1940s and Oscar

Peterson from the 1950s on used a piano-bass-guitar format. By the mid-1940s, however, the majority of piano trios used the piano-bass-drums lineup, and it has remained the most popular to this day. Among the major piano stylists to emerge in the 1940s and 1950s leading trios were Erroll Garner, who enjoyed tremendous popularity and composed the standard tune "Misty," the impressionistic virtuoso Ahmad Jamal, and bop wizard Bud Powell. These trios were primarily vehicles for the pianist to display his "chops;" the bassist and drummer were used primarily in supporting roles, occasionally taking solos but usually staying in the background. In 1959, an innovative new group led by pianist Bill Evans redefined the sound of the jazz piano trio forever.

Bill Evans (1929–1980) Piano/Composer/Bandleader

Bill Evans brought a new sophisticated and European influence to jazz piano and is today considered one of the most influential pianists to modern jazz. Drawing influences from **French impressionist composers** Claude Debussy and Maurice Ravel as well as bebop pianist Bud Powell, his playing was lyrical, sensitive, and introspective, but still very swinging. Evans was conservatory-trained and approached the piano as if he was a musical architect. He also brought a new conception to the piano trio, one that stressed delicate interplay and equal contributions from all three members.

Evans, born in New Jersey, arrived in New York in 1955 and studied modal jazz theory from composer George Russell after obtaining a college degree in music in Louisiana. He recorded his debut album in 1956 and joined the Miles Davis Quintet in 1958. Although Davis drew criticism for hiring a white pianist, Evans was profoundly influential to the trumpeter. It was Evans's modal conceptions that were the inspiration for the landmark album *Kind of Blue*. Evans quit the Davis group soon after that recording, but not before becoming addicted to heroin.

French impressionist composers, including Claude Debussy and Maurice Ravel, attempted to infuse the ethos of impressionist art into their compositions; in the process they created atmospheric music that was inspirational to jazz musicians as far back as the 1920s.

Modal jazz is a style in which the harmonic focus is on modes, or scales, rather than chord progressions.

Music Analysis

Track 40: "Milestones"

(Davis) Bill Evans Trio from the album *Waltz for Debby* recorded June 25, 1961. Personnel: Evans: piano; Scott LaFaro: bass; Paul Motian: drums

Miles Davis's tune "Milestones" is one of his early modal compositions that he first recorded in 1958 and released on his album of the same name. The tune uses the AABA song form, with one mode used for all three A sections and another mode used for the B section. This rendition of "Milestones" by the Evans trio is a great example of the interactive playing and quiet intensity that characterized the group. Recorded live at the Village Vanguard on the final day of a week's engagement at the storied New York nightclub, this performance chronicles the culmination of the two years the trio spent playing together. Because of the tragic death of bassist Scot LaFaro just 11 days later, this recording also captures the trio at their last gig. On "Milestones," LaFaro perfectly compliments Evans' impressionistic and sophisticated playing with melodic bass lines. Notice also how Evans abstracts the simple chordal riff of the head in the first chorus of his solo.

0:00	First chorus: song starts without introduction with Bill Evans playing the theme in chord clusters
0:37	Second chorus: Evans begins solo with impressionistic chordal playing
1:13	Third chorus: Evans begins the second chorus of his solo with single-note runs in the right hand that continue throughout much of the remaining solo (four choruses total)
3:01	Bassist Scott LaFaro solos, four choruses total
5:25	Evans restates the head, after which the group vamps for a short period before ending the song

In 1959, Evans formed the first and most important of a series of trios that were to be the foundation of most of his career work. Evans, 23-year-old bassist Scott LaFaro, and drummer Paul Motian were almost telepathic in their interaction, playing with an egalitarian spirit and with tremendous yet quiet energy. Their albums *Sunday at The Village Vanguard* and *Waltz for Debby* recorded at the venerable Greenwich Village nightclub are among the greatest live jazz recordings ever made. Unfortunately, Scott LaFaro, a brilliant bassist despite being only 23 years old, was killed in a car accident only eleven days after the recording was made.

Evans was also a fine composer, and his compositions, including "Waltz For Debby" and "Very Early," reflect his intellectual approach to writing. Although the piece "Blue In Green" from *Kind of Blue* is credited to Miles Davis, nearly every scholar believes that it is Evans that composed it. In 1963, Evans recorded the highly acclaimed *Conversations with Myself*, in which he overdubbed several piano parts. It won him the first of his six Grammy Awards. Evans managed to kick his heroin habit in the 1960s, but in the process became addicted to methadone, a medically approved substitute, and never was able to escape its grasp. Although he was a scholar and an intellectual, Bill Evans in the end died like many other jazz musicians before him.

The 1959 Bill Evans Trio
• Bill Evans
• Scott LaFaro
• Paul Motian

Miles Davis Part I: 1926–1959

Chasing Bird and Diz

In September 1944, 18-year-old **Miles Dewey Davis, Jr.** (1926–1991) arrived in New York City from his hometown of East St. Louis, Illinois. His mother Cleo, a glamorous woman who played blues piano, and his father, a headstrong and wealthy dentist, were both under the assumption that their son was moving to the Big Apple to attend the prestigious Juilliard School of Music. Miles, however, had other ideas. Earlier that summer, he had filled in with the Billy Eckstine Orchestra when they played the Riviera Club in St. Louis. Playing in the same band with Charlie Parker and Dizzy Gillespie for two weeks made Miles realize

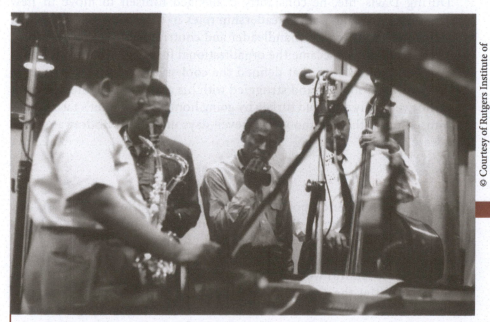

© Courtesy of Rutgers Institute of Jazz Studies

The trumpet style of **Miles Davis** was among the most influential in jazz throughout the 1950s and 1960s. Pictured from left to right: Cannonball Adderley (alto saxophone), John Coltrane (tenor saxophone), Miles Davis (trumpet), and Paul Chambers (bass).

that he had to be a part of the New York jazz scene. Although he did study at Juilliard for an entire year, the first thing he did when he got to New York was head to Minton's Playhouse to find Bird.

Although he had only just graduated from high school, Bird and Diz had been impressed with Miles when they met him in St. Louis and encouraged his move to the Big Apple. Once in New York, Miles took part in the Harlem jam session scene and, because of his association with Parker (who roomed briefly with Davis), was immediately accepted into the local scene. Miles quickly began to network in the city and establish himself further, and in April 1945, less than one year after his arrival and before his 19th birthday, he made his first recording session. In October, he joined Parker's quintet for a brief engagement at the Three Deuces on 52nd Street, replacing Gillespie. After Parker returned from his disastrous trip to California in early 1947, Davis became a regular member of his quintet for a year and a half. Playing next to the greatest musician in the world every night was an education that a young musician certainly could not get from any music school, a notion that did not escape Davis.

Miles' Style

In November 1945, Miles joined Bird and Diz in their first bebop recording sessions together. Although his solos sound tentative next to the fully developed solos of Gillespie, the foundation of his style was intact. Going against the stylistic grain of bebop, Miles was a master of understatement, playing fewer notes with more space between the phrases in his solos. Instead of playing in the upper range of the horn like Gillespie, Miles stayed close to the middle. Unlike the brassy sound that most trumpeters strove for, Miles's sound was plaintive and fragile, but full of emotional intensity. Although he occasionally missed or cracked a note, he was a very melodic soloist, and created moments of great drama. Miles also often used a **Harmon mute** that gave him a whispering buzz-like tone that was dark and brooding, and full of mystery. The Miles Davis trumpet style was among the most influential in jazz throughout the 1950s and 1960s.

During Davis' life, he constantly challenged himself to move in new musical directions and assume leadership roles in those moves. In 1947, he made his first recording as a bandleader and contributed four original compositions. By 1948, he became the organizational force behind the landmark *Birth of the Cool* sessions that defined the cool style. Around this time he also became a heroin user and struggled with his addiction for the next four years. He eventually quit cold turkey by going home to his father's farm, locking himself up in the guesthouse for seven days until the withdrawal symptoms were gone.

The Miles Davis First Quintet

- Miles Davis
- Philly Joe Jones
- Paul Chambers
- Red Garland
- John Coltrane

The First Quintet

Attracting critical and popular attention with the release of the *Birth of the Cool* album and his latest album *Walkin'* in 1954, Miles Davis was becoming a star. Now in his late twenties, he was handsome and had tremendous charisma both on and off the stage. He loved sports cars, expensive suits, and beautiful women—and they loved him. On July 17, 1955, he made his debut at the second annual Newport Jazz Festival and received

a standing ovation for his rendition of Monk's "'Round Midnight." Then later that month, he assembled a new group, today often referred to as the **Miles Davis First Quintet**, which included Philly Joe Jones on drums, Paul Chambers on bass, Red Garland on piano, and Sonny Rollins, who was soon replaced by an up and coming tenor player from Philadelphia named John Coltrane. Through a busy schedule of club engagements and recording, the quintet became one of the tightest and most elegant small groups of the 1950s, exemplified by the fact that they were able to record enough music for four albums in only two sessions in 1956. Davis undertook the marathon sessions to fulfill his contract with Prestige Records to sign with industry giant Columbia. In 1958, the band became a sextet with the addition of Cannonball Adderley on alto sax, creating one of the greatest front lines of all time. The contrasting improvisations of the soulful Adderley, the cool Davis, and the increasingly experimental Coltrane created an excitement that no other band of the era could match.

Davis was also pursuing other musical directions at this time. His friendship with Gil Evans continued to flourish, resulting in three album collaborations in the 1950s that helped to define the Third Stream style: 1957's *Miles Ahead*, 1958's *Porgy and Bess,* and 1959's *Sketches of Spain.* By 1958, he was also starting to experiment with modal jazz, and wrote one of the first pieces in that style, "Milestones." In 1958, he also hired Bill Evans to play piano in his quintet and to mine his knowledge of modal harmony. Evans' tenure with the group was brief, as he felt ostracized by Black musicians and Davis' Black fans and critics. Davis defended his choice: "Many Blacks felt that since I had the top small group in jazz and was paying the most money that I should have a Black piano player," he remarked. "Now, I don't go for that kind of shit…as long as they can play what I want, that's it." Evans left before the year was out, but Davis brought him back to collaborate on his 1959 masterpiece *Kind of Blue*.

Kind of Blue

Kind of Blue was put together in two separate sessions from sketches that Miles brought in on scraps of paper. There was no rehearsing ahead of time so that there would be a great amount of spontaneity. Most of the songs on the album are first takes. Its impressionistic tone permeates every song, and everyone plays with a kind of "quiet fire" (which is how Davis described Evans' playing). Although the album contains two 12-bar blues tunes, they are played with a strong modal spirit and affinity. One song, "Flamenco Sketches," is played with a completely elastic form whose length is determined by the soloist—a novel idea for its time. *Kind of Blue* was a landmark recording that was both highly influential to jazz musicians and an extraordinarily easy listen for casual jazz fans. It eventually became (according to the Record Industry Association of America) the largest selling acoustic jazz album in history.

In spite of its triumph, *Kind of Blue* was the only modal LP Miles Davis recorded, and the quintet that made it did not record together again. Soon after the album was released, Adderley left to start his own quintet and Evans left to form his first trio. Coltrane eventually left in early 1960. The rest of Miles Davis' career will be discussed in Chapter 9.

Music Analysis

Track 41: "So What"

(Davis) Miles Davis Sextet from the album *Kind of Blue* recorded at the Columbia 30th Street Studios, New York on March 2, 1959. Personnel: Davis: trumpet; John Coltrane: tenor sax; Cannonball Adderley: alto sax; Bill Evans: piano; Paul Chambers: bass; Jimmy Cobb: drums

As the opening piece from Miles Davis' landmark recording *Kind of Blue*, "So What" immediately sets the impressionistic mood for the rest of the album. The song uses a simple eight-note theme played by the bass and echoed in call-and-response fashion by the three horns. "So What" is an interesting variation on the 32-bar AABA song form, with one modal scale making up all three A sections, with the same scale played one half-step higher used for the B section. The recording of "So What" is a first take, as were most of the songs recorded on this landmark album.

0:00	Introduction: played by pianist Bill Evans and bassist Paul Chambers
0:33	First chorus: melody is stated by bassist Chambers with horns in call-and-response fashion
1:31	Two-chorus trumpet solo by Miles Davis
3:25	Two-chorus tenor sax solo by John Coltrane
5:15	Two-chorus alto sax solo by Cannonball Adderley
7:05	One-chorus piano solo by Evans with background horn riffs reminiscent of the head
8:01	Head is restated, after which the rhythm section vamps as the track fades

Study Questions

Fragmentation

1. Describe what the Miles Davis Nonet accomplished that made them so important to jazz history.

2. Describe the jazz scene in Los Angeles in the early 1950s.

3. What are some important musical differences between cool jazz and hard bop? What are the important cultural differences?

4. In what ways did Duke Ellington influence Charles Mingus?

5. Describe the musical and cultural circumstances leading to the development of the hard bop style.

6. Describe how the European and African influences differ in cool jazz and hard bop.

7. Describe how modal jazz differs harmonically from conventional jazz.

8. Describe some of the innovations that Lennie Tristano brought to jazz.

9. Describe the evolution of the piano trio evolve from the 1930s to 1960, and the major innovations that Bill Evans brought to it.

10. Describe some of the reasons why Gerry Mulligan is so important to jazz.

THE 1960S, 1970S AND BEYOND

Introduction

The year 1959 was a watershed year in jazz, the year that writer Darius Brubeck called "The Beginning of Beyond." There were four important, groundbreaking albums released that year, including Miles Davis' *Kind of Blue*, Dave Brubeck's *Time Out*, Charles Mingus' *Mingus Ah Um*, and John Coltrane's *Giant Steps* (discussed later in this chapter). Each brought a new innovation; each reshaped the jazz dialogue in some way. However, 1959 was also the year that, in a tiny watering hole in Greenwich Village, one of the most surreal events in the history of the music introduced a controversial musician and a revolutionary movement that would shake up the jazz world in much the same way that bebop had done 15 years earlier. This event set the tone for much of the 1960s.

The 1960s saw one of one of the most luminous stars in jazz take the music further out than anyone had ever taken it before he died of liver cancer. It was the decade that a protean trumpet player put together perhaps the most innovative group in his long career. And at the end of the decade, after encountering dwindling audiences and record sales, that same trumpet player reinvented himself yet again by tearing down the wall between jazz and rock music, and in doing so set the tone for the creation of a new style of exciting and innovative contemporary music in the 1970s. The 1960s and 1970s truly were a time of remarkable change and creativity in jazz.

Free Jazz

Rebellion

Throughout the course of jazz history, rebelling against the status quo had become an accepted part of the artistic canon. Even though the occasional musical rebellions in jazz were sometimes traumatic in nature, over and over again the changes that they brought were absorbed into the music's evolutionary process. Louis Armstrong rebelled against existing performance practices, and musicians accepted and adopted his ways. Duke Ellington rebelled against standard harmonies and instrumental usage, and his ideas in turn became standard practices. Bebop musicians rebelled against the homogenization and economic restrictions placed on them by swing, and their fresh new ideas helped bring that era to an end. And hard bop musicians rebelled against the blandness and popularity of cool jazz, and in the process created an exciting new style that broadened the jazz fan base. Change has always been good for jazz, even from its earliest years.

To be sure, much of this rebelliousness was motivated by the inequities of the cultural and economic system in which jazz operated. For years, Black musicians

had been the innovators of new techniques and styles, but it was the white musicians who copied them and profited from them. By the 1950s, many Black musicians had simply had enough, and a new militant attitude of Black cohesiveness, of 'circling the wagons', picked up steam. Unlike the 1930s and 1940s, this time it was Black musicians who resisted integration on the bandstand. Black bandleaders (including Miles Davis) were routinely criticized by their peers if they hired a white musician. With jobs for jazz musicians increasingly hard to come by, the thought was that for every white jazz musician who was working, there was a Black jazz musician who was not.

Of course, the new militant stance toward civil rights was not a uniquely jazz phenomenon. Starting in 1954, when the U. S. Supreme Court's Brown v. Board of Education ruling essentially declared that legal segregation was unconstitutional, one event after another rocked the status quo of race relations in America. Blacks became empowered, and angrily challenged the existence of segregation and discrimination all across the country. Black jazz musicians also picked up the cause, and became more politically active:

- Charles Mingus openly called Arkansas Governor Orville Faubus a "fool" in "Fables of Faubus" after Faubus tried to block Black students from entering Central High in Little Rock in 1957.
- Max Roach wrote an extended work in 1960 entitled *We Insist: The Freedom Now Suite* that was inspired by the sit-ins that were spreading around the country when Blacks were refused service at lunchroom counters.
- In 1963, John Coltrane wrote the meditative "Alabama" after four Black girls were killed in the bombing of the Sixteenth Street Baptist Church in Birmingham, Alabama.

In 1959, a new musical rebellion surfaced at a tiny club in New York's Greenwich Village that was frequented by abstract expressionist painters, beat writers, and progressive jazz musicians. The **Five Spot** was ground zero for the avant-garde arts community in lower Manhattan and had been the site of Thelonious Monk's triumphant return to performing just two years earlier. On November 17, the Ornette Coleman Quartet made their New York debut to a packed house of jazz musicians, musical intelligentsia, and avant-gardists who had come to witness one of the most talked-about and highly anticipated events in recent memory. It was an unusual band, to be sure: Coleman played a plastic alto saxophone; his front line mate Don Cherry played what looked like a toy trumpet; there was no pianist, and the music was chaotic, dissonant, and very loud. At first, people had no name for the music, or they called it **The New Thing**. But eventually, the music that Ornette Coleman unleashed in late 1959 came to be known as **free jazz**, and it would dramatically reshape the jazz landscape—forever.

Free jazz was not about creating a new set of rules but instead was about breaking them.

Breaking Rules

Free jazz was not about creating a new set of rules but instead was about breaking them. And it was not just stylistic rules that were at risk; rules of melody, harmony, and rhythm that had governed the creation of music for hundreds of years were also under attack. Everything was questioned:

- Does there have to be a key that a tune is based in?
- Does each measure have to contain an established number of beats?
- Does a tune even need to have measures?
- Do we need chords?
- Does a tune even need to have a recognizable melody?

Interestingly, the first to test the waters of freedom in jazz were white musicians. Gunther Schuller wrote a piece in 1948 entitled "Atonal Studies For Jazz", and Lennie Tristano's 1949 recordings of "Digression" and "Intuition" are generally regarded as the first recorded examples of spontaneous free jazz. But the efforts of Schuller and Tristano were one-shot experiments and were largely ignored by the mainstream. The musicians who took up the rebellion in the 1950s were committed to it and stayed the course. They were on the outside of the jazz establishment looking in, and most did not have access to higher education, recording studios, and grants as Tristano and Schuller did. Many had to work low-paying dead-end jobs to make ends meet, with no guarantee of any kind of financial reward in pursuing their music. Despite these obstacles, their vision was not compromised.

Playing Outside

Free jazz is not necessarily about blindly throwing out all the rules all the time, however. Most often, a free jazz musician makes choices about breaking some rules but not others. For instance, even the most radical of the free jazz players might follow standard practices like using the jazz performance form (head-one-solo-at-a-time-head) and playing in 4/4 time, while at the same time breaking other rules such as using no set form or chord structure. Generally speaking, the style is characterized by a spirit to willingly operate beyond the rules, whether it is one or several. Musicians refer to this as "**playing outside**."

Musicians of the free jazz movement were shocking to many simply because of their willingness to provoke and disrupt their listeners. When they burst onto the scene in the late 50s, they were easy to identify, because their approach was so radical. However, by the mid-60s, a growing number of jazz musicians who had initially rejected the idea of free jazz were embracing it in one way or another—Miles Davis and John Coltrane are two of the best examples of this. Today, nearly every jazz musician incorporates some degree of free jazz into their playing, and young musicians are comfortable with approaching creative expression in this way. The characteristics of free jazz are outlined in **Box 9-1**.

A free jazz musician makes choices about breaking some rules but not others. Generally speaking, the free jazz style is characterized by a spirit to willingly operate beyond the rules, whether it is one or several. Musicians refer to this as "**playing outside**."

BOX 9-1	Characteristics of Free Jazz

Atonal. Most jazz is tonal in nature, that is, it has one note or key that all melody and harmony revolves around. **Atonality** is the abandonment of a key center, and music created in this fashion can sound as if it has no direction or resolution.

No form. The abandonment of established musical forms such as the 12-bar blues and the AABA form used by popular songwriters. There is no cyclic nature to the music when the form is abandoned, and each composition develops unpredictably.

Dissonance. A pointed attempt to deviate from harmonious musical ideas, creating dissonant clusters of notes and intervals.

High energy and thick textures. Many musicians tend to play more notes when the rules of melody and harmony are abandoned, and many free jazz performances are thickly textured as a result.

Collective improvisation. A return to the original improvisational style of New Orleans jazz characterizes much of the free jazz style.

Unusual ensemble instrumentation. Free jazz musicians experimented with unusual combinations of instruments, such as Ornette Coleman's groundbreaking album *Free Jazz* or John Coltrane's *Ascension*.

Unorthodox playing. Oftentimes horn players will squawk or scream through their instrument, or piano players will use their fists or forearms to achieve unusual and unorthodox sounds.

Important Free Jazz Musicians

Ornette Coleman (1930–2015) Alto Sax/Trumpet/Composer/Bandleader

The most controversial musician of the free jazz movement was **Ornette Coleman**. It was his landmark debut at the Five Spot that first introduced free jazz (or the

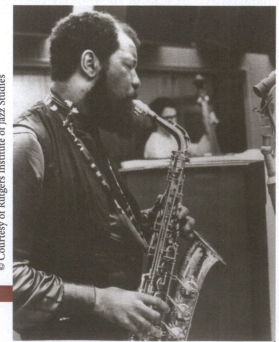

© Courtesy of Rutgers Institute of Jazz Studies

The most controversial musician of the free jazz movement was **Ornette Coleman**.

"New Thing" as they were calling it then) to the jazz community as a whole. While in retrospect we can see that Coleman's music was not earth-shatteringly different and actually adhered to many jazz conventions, it had a powerful impact on those who went to the Five Spot during his 2-1/2 month stay. Miles Davis called Coleman "all screwed up inside;" trumpeter Roy Eldridge said, "I think he's jiving, baby. He's putting everybody on." Among the other celebrities that came to hear Coleman, pocket trumpeter Don Cherry, bassist Charlie Haden, and drummer Billy Higgins were Leonard Bernstein, John Hammond, and Gunther Schuller.

Coleman grew up in Texas and played tenor sax in blues bands before switching to alto and moving to Los Angeles around 1950. At this time, he was essentially self-taught on the instrument, had received no education in music theory, and had been routinely criticized throughout his life and even beaten on one occasion for his unconventional playing. In Los Angeles, he encountered more of the same, but eventually began to work out of a garage with other musicians who were similarly committed to exploring new musical ideas. In 1958, he managed to get signed by the small Contemporary label and record his first album, *The Music of Ornette Coleman—Something Else!!!!* Although the album did not sell, it attracted the attention of the MJQ's John Lewis, who assisted Coleman in getting a contract with Atlantic and his debut in New York. In 1959, the Coleman Quartet, which by this time included his Five Spot bandmates, recorded an astounding six albums, two of which, *The Shape of Jazz to Come*, and *Change of the Century* established Coleman at the forefront of the free jazz movement.

Coleman's most daring and controversial work was recorded within months after the Five Spot gig ended. *Free Jazz: A Collective Improvisation*, recorded in December 1960, not only gave the new movement its permanent name but also established new standards for improvisational risk-taking and freedom. On it, Coleman used a double quartet—two quartets of alto, trumpet, bass, and drums, separated on the left and right sides of the stereo mix—and an expansive form that is hard to grasp on first hearing. (In a nutshell, it is divided into several improvisational sections connected by transitional passages.) The album consists of one 37-minute piece of dense, high-energy cacophonous music spread over both sides. On the album cover is a reproduction of the painting "White Light" by abstract expressionist Jackson Pollock, a perfect visual complement to the music inside.

Music Analysis

Track 42: "Lonely Woman"

(Coleman) Ornette Coleman Quartet from the album The Shape of Jazz to Come recorded in Los Angeles, May 22, 1959. Personnel: Ornette Coleman: alto sax; Don Cherry: cornet; Charlie Haden: bass; Billy Higgins: drums

1959 was not only an important year in jazz history ("The Beginning of Beyond") but also in the career of Ornette Coleman. In addition to making his New York debut at the Five Spot in November, he recorded his final album for the Los Angeles-based Contemporary Records and made his major label debut with the release of *The Shape of Jazz to Come* on Atlantic. The album begins with what is arguably Coleman's most famous and often-performed composition, "Lonely Woman," a song inspired by a painting he saw in an art gallery in 1954. Perhaps what makes the song so attractive to musicians and listeners is a timeless quality that is created by juxtaposing a free-flowing, contemplative melody over a rhythmic bed that is at once understated and urgent. The effect is powerful. The song's harmony does not come from the actual stating of chords (the conventional method) but instead is implied by the interaction of the melodic line played by the horns with Charlie Haden's creative bass playing. The song's architecture is its most conventional aspect, rising out of nothingness, hitting its high point midway through with Coleman's urgent solo, before disappearing once again like a lonely woman in the night.

0:00	Bassist Charlie Haden and drummer Billy Higgins set up a rhythm that is driving yet has no metric sense (it is impossible to establish a downbeat or sense that there are measures)
0:18	Ornette Coleman and Don Cherry (alto sax and cornet, respectively) enter with statement of head
1:47	As rhythm section continues, Coleman begins alto sax solo
2:23	Background line played by Cherry
2:56	Coleman and Cherry restate head
4:35	Haden and Higgins continue, track fades out

Throughout the early part of his career, Coleman wrote a number of tunes that have achieved near-standard status, including "Lonely Woman," "Peace," and "Una Muy Bonita." He also composed works for various types of non-jazz ensembles, including a woodwind quintet and string quartet. After winning a Guggenheim fellowship in 1972, he composed the innovative orchestral work and LP *Skies of America* and recorded it with the London Symphony Orchestra. During the 1970s, he expanded his horizon to include electronic instruments and rock influences, often working from his jazz/rock fusion group called Prime Time. Around this time, Coleman began using the word harmolodics, a contraction of the words harmony, motion, and melodic, to describe his improvisational concept. This approach focuses on melodic development unfettered by harmony or chords. He has been criticized at times for playing out of tune, but in fact, this is one more way in which Coleman chooses to "play outside." Despite the revolutionary nature of his work, he has always maintained that he was squarely in the jazz tradition. "Bird would have understood us", he said. On February 11, 2007, he received a Lifetime Achievement Award at the 49th Grammy Awards.

> Ornette Coleman calls his improvisational concept **harmolodics**, a contraction from the words harmony, motion, and melodic.

Cecil Taylor (1929–2018) Piano/Composer/Bandleader

Cecil Taylor is arguably the most explosive and aggressive pianist in the history of jazz. He is often mentioned in the same breath as Ornette Coleman, but in reality, their music is quite different. He was born and raised in New York City and studied piano and percussion as a youth. From 1951 to 1953, he studied composition at the New England Conservatory, focusing on the 20th century European avant-gardists Arnold Schoenberg, Anton Webern, Bela Bartók, and Igor Stravinsky. He also was heavily influenced by the writing of Duke Ellington and the jazz playing of Dave Brubeck and Lennie Tristano. After returning to New York, he found it troublesome to find other musicians to play with that were sympathetic to his by now eccentric style of playing. In 1956, he recorded his debut LP *Jazz Advance*, and the positive critical response to that led to an appearance at the 1957 Newport Jazz Festival. Then for some reason, he found it difficult to get any gigs at all and had to resort to washing dishes to get by. During this time, he gave "imaginary concerts" in his loft to keep his mind focused on his music.

In spite of these setbacks, Taylor persisted with his music, which got even more avant-garde throughout the 1960s. As an example, Taylor began to free

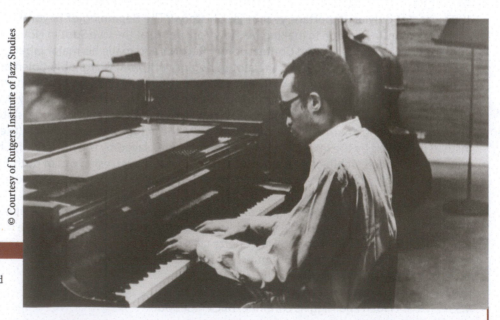

© Courtesy of Rutgers Institute of Jazz Studies

> **Cecil Taylor** often gave "imaginary concerts" in his loft to keep his mind focused during the lean years of the late 1950s.

himself from a traditional beat and play music that is free from any steady rhythmic pulse, something that even Coleman was unwilling to do. This is evident in his 1966 LP *Unit Structures*. As he moved into the 1970s, he received a number of college-teaching assignments and focused more on solo piano recitals.

Eric Dolphy (1928–1964) Alto Sax/Bass Clarinet/Flute/Composer

Free jazz maverick Eric Dolphy never achieved the fame and reputation awarded Ornette Coleman or Cecil Taylor, but he played and wrote some of the most provocative music of the early 1960s before his premature death in 1964. He was one of the first jazz reed players to master the bass clarinet, a little-used and unwieldy instrument that he often played with squawks, screams, and cries. Dolphy was a virtuoso multi-instrumentalist that could temper his playing on bass clarinet, alto sax, or flute to fit nearly any jazz context, and as a result, was in great demand as a sideman. In the late 1950s and early 1960s, some of the artists he worked with included Charles Mingus, Ornette Coleman (on *Free Jazz*), John Coltrane, and Gil Evans. His own albums became increasingly abstract, culminating with his magnum opus and final work, *Out to Lunch!* Dolphy often recorded complete albums in one day, and *Out to Lunch!* is no exception. The album is a showcase for Dolphy the player (on all three of his instruments), and Dolphy the composer, the writer of all five of the tunes on the album. Tragically, Eric Dolphy died in Berlin just five months later after falling into a diabetic coma.

Free Jazz in the 1960s

As Ornette Coleman, Cecil Taylor, and Eric Dolphy brought the free jazz movement to the attention of the jazz world, other artists emerged, including saxophonists Archie Shepp, Pharaoh Sanders, Anthony Braxton, and Albert Ayler, as well as pianist Don Pullen, drummer Sunny Murray, and bassist Gary Peacock. By the mid-1960s, free jazz movements were springing up in many inner cities in the form of musical cooperatives. New York's Jazz Composers Guild and Black Arts Repertory Theatre-School (BARTS), the St. Louis-based Black Artists Group, the Los Angeles-based Union of God's Musicians and Artists Ascension (UGMAA), and the Detroit Creative Musicians Association were a few of the organizations that appeared. The most visible was Chicago's **Association for the Advancement of Creative Musicians (AACM)**. Founded by pianist Muhal Richard Abrams, the AACM sponsored concerts, recordings, and radio programs, and supported the creation of new compositions by group members, including Henry Threadgill. In general, much of the work of the group is high-energy, full of collective improvisation, and includes African and other world influences.

Also emerging from the Chicago scene was the **Art Ensemble of Chicago**, led by trumpeter Lester Bowie. The AEC's music is characterized by an incredible variety of instruments used—as many as five hundred at times—and the celebration of their African ancestry.

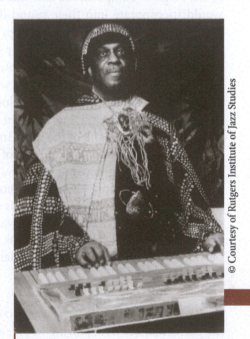

© Courtesy of Rutgers Institute of Jazz Studies

> **Other 1960s Free Jazz Musicians**
> - Archie Shepp
> - Pharaoh Sanders
> - Anthony Braxton
> - Albert Ayler
> - Don Pullen
> - Sunny Murray
> - Gary Peacock
> - Muhal Richard Abrams
> - Henry Threadgill
> - Lester Bowie
> - Sun Ra

Herman Sonny Blount is better known as **Sun Ra**.

Visual presentation of the music is another important element, with the group often performing in African costumes with painted faces and masks. Another Chicago artist who is often associated with the free jazz movement is Herman Sonny Blount, who took the name of **Sun Ra**. Born in 1914, Blount studied piano and composed music as a youth, but sometime around the age of 22 or 23, he claimed he was abducted by aliens who took him to Saturn where he was instructed to speak to humankind through music. In 1952, he legally changed his name to Le Sony'r Ra, and soon thereafter put together his first band, which he called the **Myth Science Arkestra** (and at times other names as well). The Arkestra was a musical hodgepodge of sound, including everything from swing to hard bop, world music to free jazz, and electronic music. It was also noted for the visual: performances often included dancers, elaborate costuming, theatrics, and slide shows. The references to cosmic themes were ever-present: among his many album releases are *The Nubians of Plutonia, Space Is the Place*, and *Concert for the Comet Kohoutek*. Sun Ra died in 1993.

Free and avant-garde music continues to be a presence in jazz, and the latest developments of the last 20 years will be discussed in Chapters 10 and 11.

Miles Davis Part II: 1959–1991

The Second Quintet

> **The Miles Davis Second Quintet**
>
> - Miles Davis—trumpet
> - Wayne Shorter—tenor sax
> - Ron Carter—bass
> - Herbie Hancock—piano
> - Tony Williams—drums

After the recording of *Kind of Blue* in 1959, Miles Davis went through several years of constantly changing personnel in his quintet. Finally, in 1964, he put together a stable quintet that became one of the most remarkable small jazz groups in history. Included in the new unit, today commonly referred to as the **Miles Davis Second Quintet**, was Wayne Shorter on tenor sax, a hard bop master who came by way of the Jazz Messengers; bassist Ron Carter, from Detroit; former child prodigy pianist Herbie Hancock, from Chicago; and seventeen-year-old drummer Tony Williams, from Boston. While their repertoire was initially composed of some of the same jazz standards that Davis had been playing since the 1950s, the group members immediately set out to write their own music.

The second quintet's first studio release, *ESP*, from January 1965 contains seven original compositions and was a harbinger of the changes that the group would incorporate into their sound during the next four years. Although the group's roots were clearly in hard bop, there was a noticeable influence from the avant-garde. Davis, who had initially put down Ornette Coleman and the free jazz exponents, was now moving toward it. In future releases, Shorter would emerge as an exceptionally talented writer of songs that incorporated non-traditional chord progressions and melodies that, like the compositions of Monk before him, have become ingrained in the framework of modern jazz. Shorter is recognized today as one of the most important jazz composers since 1960.

The second quintet became one of the most influential in history. The interplay between the group members was almost telepathic. Their willingness to spontaneously explore changes in tempo, mood, and form walked a fine line between hard bop and free jazz that is widely copied to this day. Davis was energized by his younger sidemen and was now playing with an explosive fire that was unlike his cool playing in the 50s. The seven albums released by this group between 1965 and 1968 are all jazz classics.

"Bitches Brew"

By 1968 however, Miles Davis was becoming restless. He was painfully aware that his performances were playing to ever-smaller crowds. He was also noticing who was now drawing the crowds: rock bands. His appearance at the 1969 Newport

Music Analysis

Track 43: "Footprints"

(Shorter) Miles Davis Quintet from the album *Miles Smiles* recorded October 24, 1966. Personnel: Davis: trumpet; Shorter: tenor sax; Herbie Hancock: piano; Ron Carter: bass; Tony Williams: drums

"Footprints" is one of the many Wayne Shorter compositions that have worked their way into the standard repertoire of modern jazz musicians. The tune is a simple 12-bar blues in 3/4 time (three beats to the bar) whose most prominent element is the **ostinato** bass line that is played by Ron Carter throughout much of the recording. Notice how Davis and Shorter paint their own abstract improvisations while Hancock, Carter, and Williams provide an ever-shifting array of rhythmic and harmonic contrasts. The overall effect is an impressionistic rendering of the blues that borders on the avant-garde yet is hauntingly beautiful.

0:00	Introduction consisting of Ron Carter playing ostinato bass figure with accompaniment by Herbie Hancock on piano and Tony Williams on drums
0:20	Head is stated twice by Davis on trumpet and Wayne Shorter on tenor sax in harmony
1:12	Davis plays extended trumpet solo
4:23	Shorter plays extended tenor sax solo
6:13	Hancock solos
7:17	Head is stated three times by Davis and Shorter; after a short vamp by the rhythm section, the head is stated one more time before the track comes to a close

An **ostinato** is a short musical phrase, either melodic or rhythmic, that is repeated.

Jazz Festival, which had included several rock groups for the first time, confirmed his own observations: attendance had more than doubled during the previous year. Although dismissing most rock music as simplistic, Davis was drawn to the music of two musicians whose music was a blend of blues, soul, and psychedelia: Sly Stone (from Sly and the Family Stone) and Jimi Hendrix. For Hendrix, as it turns out, the feeling was mutual: he loved Coltrane's playing in Miles' band, and also loved *Kind of Blue*. Although there were tentative plans to collaborate on a recording project together, Hendrix died in September 1970 before they could actually accomplish it (both musicians appeared separately at the Isle of Wight Festival in England in August of that year, one of Hendrix's last performances).

After disbanding the second quintet in late 1968, Miles went about changing musical directions—again. His new bass player, Miroslav Vitous played the electric bass guitar. He added two keyboard players, Joe Zawinul and Chick Corea, to play electric piano. He also added English guitar wizard John McLaughlin. In February 1969, the band recorded the album *In A Silent Way*, a dreamy, electric venture, and in August, the double album *Bitches Brew*. *Bitches Brew* has often been called the first jazz/rock fusion album. With rock-like grooves, layers of keyboards, and Davis' haunting trumpet soaring overhead, the music is startlingly different than anything any jazz musician had ever recorded. For three days, the group, which at times was expanded to as many as twelve players, recorded long jams from sketches of paper that Davis had brought in. There were no off-mic rehearsals—producer Teo Macero recorded everything. The takes were then meticulously spliced together, section by section to create the six songs on the album. Interestingly, *Bitches Brew* was recorded just days after the Woodstock Festival was being held 100 miles to the north in Bethel, New York.

Bitches Brew is perhaps Miles Davis' most controversial album. Packaged and marketed to attract a younger audience, many jazz musicians viewed it as a sell-out to the principles and conventions of pop music. The critics also joined in the loathing, complaining about Macero's editing and Davis' use of electronic effects. However, one can hardly call it a commercial venture, as only one of the

The **Woodstock Festival** (the Woodstock Music and Arts Fair, held from August 15–18, 1969) attracted a crowd estimated at 450,000.

The **Montreux Jazz Festival** has been held continuously since 1967 in Montreux, Switzerland.

Music Analysis

Track 44: "Bitches Brew"

(Davis) Miles Davis and His Band from the album *Bitches Brew* recorded at Columbia Studio B in New York, August 19, 1969. Personnel: Davis: trumpet; Bennie Maupin: bass clarinet; Wayne Shorter: soprano sax; Chick Corea, Josef Zawinul: electric piano; John McLaughlin: guitar; Dave Holland: bass; Harvey Brooks: electric bass; Jack DeJohnette, Lenny White: drums; Don Alias: conga; Jim Riley: shaker

"Bitches Brew" is the title cut from the landmark double album released by Miles Davis in 1969. It is usually regarded as the first successful fusion of jazz and rock, and it is the album that transitioned Miles into the final period of his career. Because *Bitches Brew* was recorded more than 35 years ago, it is sometimes easy to forget just how revolutionary it was at the time. Ralph J. Gleason's liner notes, which included the following line, are indicative: "This music is new music and it hits me like an electric shock." *Bitches Brew* was controversial among purists and critics, in part because it was too 'commercial'. However, most of the songs on the album were too long for radio play (the title track is 27 minutes long and takes up the entire side of one disc), making the argument moot. Miles was also criticized for using studio effects on his trumpet, such as the echo heard at 0:41. *Bitches Brew* was not controversial with fans, however, who made it Miles's first gold record. It also won a Grammy Award in 1970. Many of the musicians who participated in the recording of *Bitches Brew* went on to form their own jazz/rock fusion bands in the 1970s, including Josef Zawinul, Wayne Shorter, John McLaughlin, and Chick Corea.

0:00	Dramatic opening sequence played by electric pianists Chick Corea and Josef Zawinul and percussionists
0:41	Miles Davis enters on trumpet with echo effect
1:49	Overdubbed trumpet played one octave below lead part
2:51	Bassist Harvey Brooks starts bass ostinato with subtle accompaniment by bass clarinetist Bennie Maupin; Miles can be heard snapping his fingers
3:32	The rest of the rhythm section enters
3:54	Miles re-enters with an improvised solo; band gradually builds in intensity and volume; track continues

songs is under ten minutes in length. *Bitches Brew* sold 400,000 copies the first year and rejuvenated Miles' career. It is considered to be one of the most influential albums in jazz history, eventually went gold (reaching sales of 500,000 units), and won a Grammy Award. Many of the musicians who played on *Bitches Brew*, including Tony Williams, John McLaughlin, Chick Corea, Wayne Shorter, and Joe Zawinul eventually left Davis and went on to form the first generation of jazz/rock fusion groups. It was the album that "tore down the wall" between rock and jazz, and inspired an entire generation of rock and jazz musicians to concoct ways to creatively mix elements of the two styles together.

The Miles Davis Legacy

Miles Davis continued to push himself musically throughout the 1970s and 1980s, and despite lingering health problems (which forced him to retire from 1975 to 1980) he continued to record until the end of his life. Two of the most interesting albums of his later years, *Tutu* (1986) and *Doo-Bop* (1992) reflect his restless search for new musical challenges. *Tutu* was created to a large extent by producer Marcus Miller, with Miles adding his part to a scratch track of synthesizers before many of the other musicians were brought into the studio. *Doo-Bop*, released posthumously, was a collaboration with rapper Easy Mo Bee and won another Grammy for Davis. In one of the few moments of retrospection in a career full of forward motion, on July 8, 1991, Davis appeared at the Montreux Jazz Festival with a band led by producer Quincy Jones that performed arrangements Gil Evans had written for him in the 1940s and 1950s. He died less than three months later.

Miles Davis was arguably the most important jazz musician in the last half of the 20th century. He was the central figure in the creation of three distinct and important styles: cool, modal, and jazz/rock fusion; and his involvement helped shape the course of bebop and hard bop. His second quintet remains one of the most influential to today's jazz musicians, injecting mainstream jazz with the avant-garde perhaps more successfully than anyone else in history. He continually hired musicians who later went on to play important roles in the evolution of jazz. Emerging from the shadows of Gillespie, he forged an idiosyncratic trumpet style that became the most influential of his generation. His three landmark albums, *The Birth of the Cool, Kind of Blue,* and *Bitches Brew* are among the most important in the history of jazz and are still fresh and stimulating to listen to today. We are left to guess what he might have conjured up in the 1990s if he had lived. Through his music, Miles Davis epitomized the risk-taking that a jazz artist must take to contribute to the evolution of his art form.

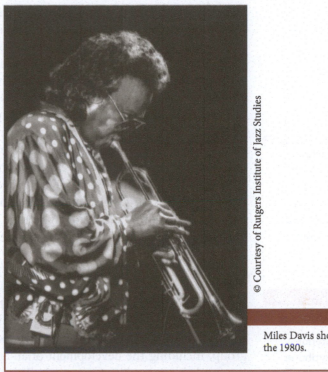

© Courtesy of Rutgers Institute of Jazz Studies

Miles Davis shown in concert in the 1980s.

John Coltrane (1926–1967)
Tenor/Soprano Saxophones/Composer

Raised in North Carolina in a family where both parents were part-time musicians and both grandparents were ministers, John Coltrane was introduced to music at an early age. His first instrument was the clarinet; later he switched to alto sax after listening to Johnny Hodges on Duke Ellington records. In the mid-1940s, he switched to the tenor sax, already aware if he was to make a path for himself in music, he would have to do it away from the shadow of Charlie Parker. In the early 1940s, his family moved to Philadelphia; soon afterward John served in the Navy. In the later 1940s, he played in a variety of R&B and jazz groups in Philadelphia and New York and developed a hard, penetrating tone on the tenor in the process. He also developed a heroin habit that cost him his job in Dizzy Gillespie's big band. After a period of struggling to make a living and support his habit, in late 1955, he was hired by Miles Davis to play in his quintet.

The Angry Young Tenor

Coltrane now had one of the most highly visible jobs in jazz, and being at this point somewhat of a diamond in the rough, critics began to weigh in. One said that Coltrane played as if he was trying to blow his horn apart, and that "his attacks almost invariably lead nowhere;" another called him an "angry young tenor," an ironic statement considering that in truth, Coltrane had a gentle, earnest personality. Other critics praised him as promising and inventive. What most listeners focused on was his raw, cut-like-glass tone and his incredible power and energy. Coltrane also seemed to be brimming with an endless supply of inventive musical ideas. But his heroin habit was beginning to take its toll in the form of missed gigs

and nodding off on stage, and eventually, Davis fired him in late 1956. For the next several months, Coltrane wallowed in despair, often too depressed to play. Finally, in the spring of 1957, he had a spiritual awakening that enabled him to overcome his habit. "I experienced, by the grace of God, a spiritual awakening which was to lead me to a richer, fuller, more productive life," he confided later. Revitalized, in June he joined the Thelonious Monk Quartet for his extended engagement at the Five Spot.

Coltrane flourished in Monk's group. Monk allowed him to play long extended solos in which he could experiment with new techniques, including using **multiphonics**. At this time, Coltrane also signed his first record contract with Prestige, allowing him to expand himself musically in other directions as a leader. By the time the Five Spot gig ended at the end of 1957, he had recorded five LPs with Prestige and signed a new contract with Blue Note that resulted in his first great album, *Blue Train*. Coltrane was back in control of his career, and when Davis asked him to rejoin his quintet in early 1958, he accepted.

Sheets of Sound

As a member of the Davis quintet during the next two years, Coltrane became a star. Inspired by a spiritual awakening after kicking his drug habit, he became even more adventurous in his solos. He expanded on his solo explorations from Monk's group, including the development of an approach to rhythmically break free of the fundamental pulse of the music. This technique, in which Coltrane used his incredible technical virtuosity to create an almost continuous wall of sound, was named "**sheets of sound**" by critic Ira Gitler in a 1958 essay in *DownBeat*. Coltrane had developed the sheets of sound technique by practicing harp music. It was not unusual for Coltrane, a practice room workaholic, to attempt to play music written for other instruments on his horn in an attempt to broaden his musical horizons.

In early 1959, two months after participating in Davis' *Kind of Blue* recording, Coltrane recorded his own landmark album, *Giant Steps*. The seven original compositions are not only a showcase for his writing talent but his highly evolved improvisational skills as well. The title track is a minefield of tricky and non-traditional

Multiphonics is a technique in which a player produces more than one note at a time on a wind instrument, often creating unusual intervals that sound dissonant.

The John Coltrane Quartet

- John Coltrane—tenor and soprano saxophone
- McCoy Tyner—piano
- Elvin Jones—drums
- Jimmy Garrison—bass

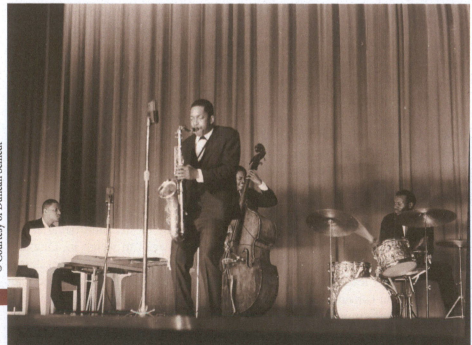

The **John Coltrane Quartet**, 1962. Left to right: McCoy Tyner, John Coltrane, Jimmy Garrison, and Elvin Jones.

© Courtesy of Duncan Schiedt

chord changes that constantly shift back and forth between three different key centers, played at breakneck tempo. Coltrane's solo is a masterpiece, easily working his way through the complex harmonies. *Giant Steps* is still a barometer by which a musician's improvising skills are judged to this day. It is also the culmination of Coltrane's late 1950s interest in complex harmonic structures and marks a transition point in his career. After leaving the Davis group in 1960 and starting his own group, the John Coltrane Quartet, and for the next several years Coltrane shifted his focus from complex harmonic structures to the pared-down harmonic principles of modal jazz that were inspired by his involvement with *Kind of Blue*.

A Love Supreme

Coltrane's new quartet included pianist McCoy Tyner, powerhouse drummer Elvin Jones, and bassist Jimmy Garrison. The title track from their first album, *My Favorite Things* (from the musical *The Sound of Music*) became a hit and a signature song for the group. The recording shows off Coltrane's extended explorations of modality on a new instrument, the soprano sax. Voiced an octave higher, the soprano was an ideal instrument that allowed Coltrane to reach beyond the range limitations of the tenor. Coltrane's new rhythm section was one of the most explosive in jazz history. Drummer Elvin Jones constantly pushed his leader with his power and explosiveness; Tyner produced his own sheets of sound from the piano and inspired by Coltrane, developed a highly individual and percussive style that is still often copied today.

John Coltrane's inspiration in the early 1960s was coming from all directions. He was among the first jazz musicians to incorporate influences from the music of India and other cultures with the utilization of repetitive drones and long improvisations on simple themes in pieces like "Africa," "India" and "Liberia." The recording of his 16-minute song "Chasin' the Trane" from 1961's *Live at the Village*

Music Analysis

Track 45: "Acknowledgement"

(Coltrane) John Coltrane Quartet from the album *A Love Supreme* recorded at the Van Gelder Studio, Englewood Cliffs, New Jersey, on December 9, 1964. Personnel: Coltrane: tenor saxophone; McCoy Tyner: piano; Elvin Jones: drums; Jimmy Garrison: bass

In 1964, four years after forming his quartet, John Coltrane had a spiritual reawakening, in which he refocused himself on the personal religious journey that he had embarked on in 1957. The result was his greatest album, *A Love Supreme*. Recorded in one night at the Van Gelder Studio, *A Love Supreme* is a four-part meditation, and his most personal album. From this point on until his death in July 1967, Coltrane's music became increasingly spiritual and more musically adventurous. The tone for the album is set immediately with Coltrane's opening fanfare-like theme and the suspended cymbal work of drummer Elvin Jones. The nearly 33 minutes long album is hypnotic and meditative, and at times seems to stretch the boundaries of physical endurance for the players—and the listeners. The excerpt presented here is the first four minutes of Part I; subsequent parts are entitled "Resolution," "Pursuance" and "Psalm."

0:00	Opening fanfare played by John Coltrane; pianist McCoy Tyner plays tremolo chords, while drummer Elvin Jones plays suspended cymbal rolls
0:31	Bassist Jimmy Garrison begins playing the hypnotic four-note ostinato on which the movement is built; Jones and Tyner make entrances
1:04	Coltrane enters; in the course of his long, exploratory improvisation he quotes the bass ostinato on several occasions, often plays in the altissimo register (above the standard range of the tenor sax), and plays multiphonics (two notes simultaneously), which he does at 3:51

Vanguard is, except for a brief intro, 80 12-bar blues choruses of furious tenor sax solo filled with screams, cries, and wails. His live performances often included solos that lasted for an hour or more. He could also play in a beautiful, melodic style as well: other early 1960s albums such as *Ballads* and *Duke Ellington and John Coltrane*, he was a master of understatement and lyricism. But outshining all of these albums and innovations was Coltrane's 1964 masterpiece *A Love Supreme*. A four-part meditation inspired by his refocus on his 1957 spiritual awakening, *A Love Supreme* is a transitional album in Coltrane's career; it built upon the modal harmonies that had been the focus of his quartet but was the beginning of a new, even more exploratory phase. The album is a musical meditation; the music is hypnotic and deeply intimate. From this point on, Coltrane's music would become increasingly spiritual, and perhaps ironically, increasingly avant-garde.

After the release of *A Love Supreme*, Coltrane became increasingly inspired by free jazz and the avant-garde movement. In 1965, he recorded one of the most controversial albums of his life, *Ascension*. The album is a single 40-minute piece performed by an 11-piece ensemble that overshadows even Ornette Coleman's earlier *Free Jazz* with its intensity and thrust Coltrane into the vanguard of the free jazz movement. In rapid succession, he recorded more intense and adventurous albums, including *Kulu Sé Mama, Om, Sun Ship, Expression* (in which he plays flute), and *Interstellar Space*, a duet with his new drummer Rashied Ali. Around this time, he contracted liver cancer and died on July 17, 1967.

The Coltrane Legacy

John Coltrane was a restless seeker of knowledge throughout his life. By jazz standards, he was a late bloomer: his 1957 spiritual awakening that revitalized his career occurred when he was 31 years old, a relatively middle age for a jazz musician to begin the productive phase of his career. His death in 1967 effectively ended this phase after just ten years. Nonetheless, he became one of the most influential musicians of the last forty years and continues to inspire musicians of all instruments, as well as poets, authors, and painters (there is even a church in San Francisco consecrated in his name). A voracious reader and innately curious seeker of knowledge, he investigated the music of the Indian, African, and Latin American cultures long before the world music movement and even the more heavily publicized trip to India by the Beatles. Coltrane expanded the possibilities of the saxophone for jazz players and influenced rock musicians. The awesome power and technique he possessed have not been surpassed since his death, and his laser-like biting tone is still widely copied. He became one of the greatest hard bop players, but just a few years later grabbed control of the free jazz movement. He revitalized interest in the soprano saxophone, which then became and continues to be a popular jazz instrument. And he was a prolific composer of music for his ensembles, writing everything from 12-bar blues to 32 bar jazz standards to extended hypnotic works. His death in 1967 at age 40 left the jazz world wondering where his soul searching would have taken him next.

Other Important Jazz Artists in the 1970s

Keith Jarrett (1945–) Piano/Soprano Sax/Composer/Bandleader

Keith Jarrett has had a profound influence on the jazz world in the last 30 years. His extraordinary piano skills encompass several styles that he freely mixes to create an idiosyncratic style that is widely copied by jazz pianists today. In addition to a large jazz discography of more than 100 albums, he has also produced

several recordings of classical music as well as solo concerts of totally spontaneous improvisations. Jarrett was born in Allentown, Pennsylvania, and was recognized early as a musical prodigy, performing a full-length piano recital at age six. In 1962, he enrolled at the Berklee College of Music in Boston, but left after a year and moved to New York. In 1964, he joined Art Blakey's Jazz Messengers for a short stint before joining the popular Charles Lloyd Quartet from 1966–69. From 1969 to 1971, he played organ and electric keyboards with Miles Davis' early fusion ventures. Since leaving Davis, Jarrett has worked almost exclusively on acoustic instruments (he is also a fine soprano saxophonist).

Much of Jarrett's recorded output has been with his various small groups. During the 1970s, Jarrett had two working bands: the "American" quartet, which included Dewey Redman on tenor sax (father of Young Lion Joshua Redman), Charlie Haden on bass, and Paul Motian on drums; and the European quartet, also known as **The Belonging Quartet**, which included saxophonist Jan Garbarek, bassist Palle Danielsson, and drummer Jon Christensen. After disbanding both groups, Jarrett put together a trio in 1983 that has to be ranked as one of the finest piano trios in jazz history. Working with bassist Gary Peacock and veteran drummer Jack DeJohnette, this trio has become well known for their various live and studio recordings of beautiful interpretations of jazz standards. The group has also recorded more exploratory ventures, such as the highly improvisational *Inside Out*, released in 2001.

Keith Jarrett is perhaps best known for his solo piano recordings. His first, *Facing You* from 1972, is an impressive album of eight original compositions. Later that year, he released the three-LP *Solo Concerts: Bremen and Lausanne*, a live recording of two solo piano concerts of totally unrehearsed, spontaneous improvisations. Although one of the pieces runs 64 minutes (three sides on LP as it was originally released), Jarrett was able to continuously invent new musical ideas from which to work. Other spontaneously improvised solo piano recordings followed, including *The Köln Concert* in 1975, *Paris Concert* in 1990, and *La Scala* in 1995. Jarrett's solo work is astonishingly beautiful and encompasses a wide variety of styles, from avant-garde to simple folk-like melodies to bluesy funk to romantic classicism. *Staircase*, a 1976 studio recording of reflective and repetitive solo piano is often credited with being the blueprint for the New Age piano movement.

Jarrett has also explored other diverse and often non-jazz projects. *In the Light*, from 1973 is an eclectic mix of modern classical music with string orchestra that drifts in and out of tonality. That same year, he released *Ruta and Daitya*, a duet with drummer DeJohnette that is one of the few recordings outside of his work with Davis in which he utilizes electric keyboards. His 1976 recording *Spheres* is best described as ethereal space music, while on 1985's *Spirits 1 & 2*, he plays all 18 instruments himself using multi-track recording technology. He has also recorded the works of classical composers J.S. Bach, Handel, Mozart, and Shostakovich. Despite suffering from chronic fatigue syndrome for the past several years, Jarrett continues to be a dynamic force in shaping the sound of contemporary jazz.

Freddie Hubbard (1938–2008) Trumpet/Composer/Bandleader

Like Wes Montgomery, **Freddie Hubbard** grew up in Indianapolis, and it was there he first studied trumpet at the Jordan Conservatory. As a teen, he began playing professionally, often with Montgomery and his brothers and later with his own group, the Jazz Contemporaries. In 1958 at age 20, Hubbard (April 7, 1938–December 29, 2008) moved to New York, where he quickly established himself among the city's elite trumpeters. During his first years in the city, he worked with Eric Dolphy, Sonny Rollins, and others and recorded as a sideman

on such notable LPs as Ornette Coleman's *Free Jazz: A Collective Improvisation*, Dolphy's *Out to Lunch*, and Oliver Nelson's *Blues and the Abstract Truth*. In 1960 Hubbard signed with Blue Note and released *Open Sesame*, his first of 60 albums as a leader. Then, in 1961 he joined Art Blakey's Jazz Messengers, where he worked in the front line alongside tenor saxophonist Wayne Shorter and trombonist Curtis Fuller. Hubbard stayed with the Messengers until 1966, and recorded eight albums with them, including the highly regarded *Buhaina's Delight* (from which "Backstage Sally," Track 13 in chapter 3, comes).

In 1961, Hubbard released what many consider to be his finest LP, *Ready for Freddie*, on which he assembled a stellar band that included Shorter on tenor sax, McCoy Tyner on piano, and Elvin Jones on drums. During this time he also continued to record as a sideman on LPs by John Coltrane, Herbie Hancock, Bill Evans, and Dexter Gordon, among others. By the end of the 1960s, Hubbard was one of the most recorded and sought-after musicians working in jazz and was recognized as a fiery virtuoso capable of playing exceptionally fast while maintaining a smooth lyricism and warm, rich tone.

As well regarded as he was in the jazz world, popular success eluded Hubbard until the 1970s when he signed with Creed Taylor's CTI Records. In all, he recorded eight albums for the label, mostly in more rock or pop-oriented settings, and often working with outstanding backup musicians such as pianist Hancock, tenor player Joe Henderson, bassist Ron Carter, and drummer Jack DeJohnette. His first CTI release was the highly regarded *Red Clay*; his third *First Light*, won a Grammy Award

Music Analysis

Track 46: "Suite Sioux"

(Hubbard) Freddie Hubbard from the album *Red Clay* recorded January 28, 1970 at Van Gelder Studios, Englewood Cliffs, New Jersey. Personnel: Freddie Hubbard: trumpet; Joe Henderson: tenor sax; Herbie Hancock: electric piano; Ron Carter: bass; Lenny White: drums

One of the most sought-after hard bop trumpeters of the 1960s, Freddie Hubbard achieved success as a leader in his own right in the 1970s with a dozen albums on CTI and Columbia. His first CTI release, *Red Clay*, from which "Suite Sioux" comes, has all the earmarks that would make the label famous: superb recording and production (by Rudy Van Gelder); studio groups assembled using the top musicians in jazz (including in this case, Joe Henderson, Herbie Hancock, Lenny White, and Ron Carter); and exquisite packaging. The music on *Red Clay* strikes a perfect balance between hard bop and contemporary jazz, and still sounds fresh today. Hubbard's solo on "Suite Sioux" shows why he was so highly thought of by his peers and is revered by young trumpeters today: it is hard-swinging, bluesy, and explosive from the very first note. *Red Clay* also offers a sampling of Hubbard's writing skills, with five of the albums six songs—including "Suite Sioux"—being originals (the sixth, "Cold Turkey," was written by John Lennon). Hubbard credits Art Blakey, with whom he played from 1961–64, as nurturing his compositional skills. "He gave us a chance to write. It was a good opportunity not just to play, but also to get your compositions together." (ref: *Hard Bop Academy: The (please capitalize) Sidemen of Art Blakey and the Jazz Messengers* by Alan Goldsher)

0:00	Intro by rhythm section
0:11	Horns enter with head "A" section, played twice
0:36	"B" section of head in double time
0:50	Last statement of "A" section in regular time
1:01	Trumpet solo by Freddie Hubbard
2:44	Tenor sax solo by Joe Henderson
4:21	Electric piano solo by Herbie Hancock
6:00	Drum solo by Lenny White
7:04	White re-establishes tempo; band enters to play head and finish song

in 1973 for Best Jazz Performance by a Group. He returned to straight-ahead jazz in 1977 as a member of the highly regarded V.S.O.P. Quintet, a reforming of the 1960s Miles Davis Quintet with Hubbard taking the trumpet chair for the then-retired Davis. Three albums and a well-received tour resulted from the group. During the 1980s, Hubbard once again led his own groups and continued to record prolifically and tour the world. In 1992, he ruptured his upper lip, a disastrous setback that led to a period of inactivity and the necessity to relearn the basics of playing the trumpet. "I had to go back, get some books and consult with classical trumpet teachers. I couldn't play a note for a while because it was so tender. It's so frustrating not being able to blow the way I blew." Hubbard did eventually return but recorded sporadically in the 2000s. He died of a heart attack in 2008.

Jazz/Rock Fusion

In the wake of Miles Davis' seminal *Bitches Brew* album, jazz musicians began to reevaluate their relationship with rock music. Incorporating elements of rock into jazz could potentially be a new creative outlet for them, as well as a way to reach out to a new and larger fan base. Rock and soul musicians were already moving in the direction of a fusion of the two styles, with rock bands Electric Flag, Blood Sweat & Tears, and Chicago Transit Authority (later simply Chicago), all founded in 1967, using jazz harmonies and jazz-influenced horn sections. Sly and the Family Stone, formed in 1966, and Jimi Hendrix, who burst onto the scene at the 1967 Monterey Pop Festival were especially influential to Davis and borrowed liberally from the jazz and blues traditions. Davis was influential in one other way to the creation of jazz/rock fusion: the founders of the first generation of fusion bands, Wayne Shorter, Joe Zawinul, Herbie Hancock, Chick Corea, Tony Williams, and John McLaughlin, were all alumni of his early 1970s bands.

By incorporating the straight rhythms of rock, fusion bands generally minimized the use of the swing rhythm found in most jazz played up to this point (Latin jazz also uses a straight rhythm, so most jazz musicians were familiar with it by then). Electronic instruments such as electric guitar, bass guitar, electric pianos, and synthesizers were used heavily, as were electronic effects such as wah-wah pedals and echo and reverb devices. Jazz musicians also started to employ rock performance techniques, such as the slap bass style that was developed by Larry Graham from Sly and the Family Stone.

Many fusion bands also adopted the simpler harmonies of rock, with songs often employing long, one-chord vamps. With their similarity to modal jazz harmonies, many jazz players were not unfamiliar with these simple harmonic structures. Although many of the early fusion bands had horn players, it was now the guitar players and keyboard players who occupied the primary lead roles. To further emphasize the strong rock beat, additional percussionists were often added. Most fusion bands maintained a large amount of improvisation, but at times it was overshadowed by meticulous ensemble passages. **Box 9-2** lists the characteristics of jazz/rock fusion.

Rock Performers/Bands Moving Toward Jazz/Rock Fusion
- Electric Flag
- Blood Sweat and Tears
- Chicago Transit Authority
- Sly and the Family Stone
- Jimi Hendrix

The **1967 Monterey Pop Festival** was the one-time-only event held in June 1967 that featured the debut of Janis Joplin and the Jimi Hendrix experience, as well as performances by the Who, the Grateful Dead, and others.

A **vamp** is a repeated phrase that is often used to connect two sections of a composition, to support extended solos, or to end songs.

BOX 9-2	Characteristics of Jazz/Rock Fusion

- Rock beat and straight rock rhythms replace jazz swing rhythm
- Simpler harmonic structures found in rock music
- Rock-performing techniques: slap bass, distortion, amplification
- Electronic instruments: guitar, bass, electric pianos, synthesizers
- Electronic effects used: wah-wah pedals, etc.
- Additional percussionists

First-Generation Fusion Bands

- Tony Williams Lifetime
- Herbie Hancock's Head Hunters
- Weather Report
- Mahavishnu Orchestra
- Return to Forever

A vamp is a repeated phrase that is often used to connect two sections of a composi-tion, to support extended solos, or to end songs.

Important First-Generation Fusion Bands/Performers

Tony Williams Lifetime

When **Tony Williams** left the Davis group in 1969, he formed the fusion trio Lifetime with British guitarist John McLaughlin and organist Larry Young. Many consider it to be the first true fusion band (other than Miles Davis, of course), as it was known for hard-driving rock-like energy while maintaining a high degree of jazz improvisation. Their first album, *Emergency!* included influences from Jimi Hendrix and gave listeners a glimpse of the future from the guitar work of the pre-Mahavishnu Orchestra McLaughlin. Before Lifetime broke up in 1971, it added British rocker Jack Bruce on bass, one of the members of the group Cream. Williams died of heart failure in 1997.

Herbie Hancock

Hancock became a star playing with Miles Davis from 1963 to 1968, but it was the funky 1962 hit song "Watermelon Man" from his debut album *Takin' Off* that first got him noticed. After leaving Davis, he formed an avant-garde sex-tet that exploited the use of electronic effects such as reverbs and echo units to create spacey and ethereal moods, first heard on the group's 1970 album *Mwandishi*. After marginal commercial success, in 1973, Hancock abandoned the avant-garde and rebuilt his band into a tight-funk unit modeled after Sly and the Family Stone and Stevie Wonder's early 1970s work. The first album release, *Head Hunters*, contained the hit single "Chameleon" as well as a funky rework-ing of his earlier hit "Watermelon Man." *Head Hunters* was a huge commercial success, and in 1986 became the first jazz album to go platinum (sales of one million units) and for the next 10 years, it was the largest selling jazz LP in his-tory. By the mid-1970s, Herbie Hancock was playing sold-out concerts across the country, with his former boss Miles Davis as his warm-up band.

> The **Fender Rhodes electric piano** was a popular brand of electric keyboard with a bell-like sound and whose keys simu-lated the feel of a real piano. Invented by Harold Rhodes in the late 1950s.

> The **clavinet** is an electric harpsichord-like keyboard instrument that was widely used by Stevie Wonder ("Superstition") and other funk artists in the 1970s.

On *Head Hunters*, Hancock concentrated on combining elements of jazz, funk, R&B, and soul, creating tight-knit grooves and funky counter-rhythms. He did this in part by using funk musicians who could play jazz (rather than jazz musicians who could play funk). He also created layers of electronic sounds, using keyboards such as the **Fender Rhodes electric piano**, the **clavinet**, and synthesizers. Jazz purists were alarmed at the commercial success of the album however and accused Hancock of selling out and becoming a sort of jazz traitor. Hancock did return to playing mainstream jazz in the late 1970s with a reunion of the Miles Davis 60s quintet known as V.S.O.P. (with all the original mem-bers except for Davis, who was replaced by Freddie Hubbard). Throughout the 1980s and 1990s, Hancock went on to explore other musical avenues, including techno-pop and hip-hop, producing young talent, and film scoring.

Weather Report

Founded in 1971 by Davis veterans **Wayne Shorter** and **Joe Zawinul**, **Weather Report** practically defined jazz/rock fusion in the 1970s. Although the group's nearly fifteen-year life span was marked by constant personnel changes, the two co-founders led the group until the end. Like Herbie Hancock, Zawinul had a taste of commercial success before joining Davis with his soulful composition "Mercy, Mercy, Mercy," which became a #11 hit for the Cannonball Adderley Quintet in 1967.

The initial version of Weather Report had an international cast, including Zawinul (Austria) on keyboards, Miroslav Vitous (Czechoslovakia) on electric

Weather Report, 1977

- Josef Zawinul— keyboards
- Wayne Shorter— saxophone
- Jaco Pastorius—bass
- Alex Acuña—drums
- Manolo Badrena— percussion

Music Analysis

Track 47: "Watermelon Man"

(Hancock) Herbie Hancock from the album *Head Hunters* recorded at Wally Heider Studio and Different Fur Trading Co., San Francisco in September 1973. Personnel: Herbie Hancock: Fender Rhodes electric piano, Hohner clavinet, ARP synthesizers; Bennie Maupin: soprano sax; Paul Jackson: bass guitar; Bill Summers: percussion, beer bottle; Harvey Mason: drums

Herbie Hancock's "Watermelon Man" is one of the most standard of jazz standards. It was first released in 1962 on Hancock's Blue Note debut album *Takin' Off*. In 1963 Cuban bandleader Mongo Santamaría had a #10 hit with his version of the song, providing Hancock with ample songwriting royalties throughout much of the 1960s. The song's popularity can be traced to its simple, gospel-like piano riff and shout-out melody, which Hancock said was inspired by actual watermelon street sellers of his youth. "I remember the cry of the watermelon man making the rounds through the back streets and alleys of Chicago. The wheels of his wagon beat out the rhythm on the cobblestones." The version found on *Head Hunters* is completely reworked from the original and is one of the delights of 1970s jazz/rock fusion. The song starts with the sound of percussionist Bill Summers blowing rhythmically into a glass bottle, which was inspired by the hindewhu music of the Pygmies of Central Africa. From there, Hancock and crew turn the song into a slow pressure cooker driven by Harvey Mason's sparse, syncopated drumming, Paul Jackson's lazy bass riff, and Hancock's funky clavinet stabs.

0:00	Introduction: percussionist Bill Summers creates rhythmic groove by blowing on a bottle and with vocalizations
0:45	Bassist Paul Jackson enters with bass riff
0:59	Drummer Harvey Mason enters
1:18	Herbie Hancock enters playing Hohner clavinet
2:04	Band kicks into a second groove with Hancock on electric piano
2:31	Return to first groove; Maupin plays head
3:16	Short interlude
3:24	Head is restated as Hancock returns to clavinet
4:08	Return to the second groove
4:35	Original groove re-established; Summers re-enters on bottle; band vamps out

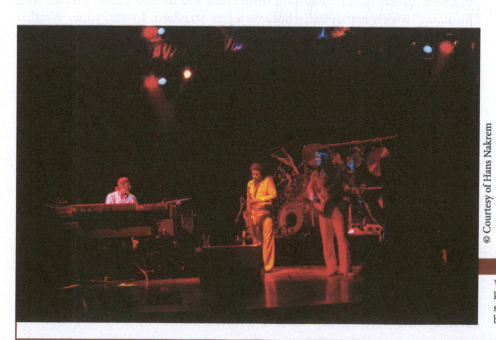

© Courtesy of Hans Nakrem

Weather Report, 1978. Left to right: keyboardist Josef Zawinul, tenor saxophonist Wayne Shorter, and bassist Jaco Pastorius.

Music Analysis

Track 48: "Birdland"

(Joe Zawinul), Weather Report, from the album *Heavy Weather*, recorded 1977 (5:01). Personnel: Zawinul, keyboards; Wayne Shorter, tenor and soprano sax; Jaco Pastorius, bass; Alex Acuna, drums; Manolo Badrena, percussion.

Joe Zawinul's composition "Birdland" is easily the most identifiable tune of the jazz/rock fusion era. Despite its catchy pop-sounding melodies and danceable rhythm that have made it so popular, it is actually quite complex in form, employing five different themes and several other countermelodies. Powered by a driving rhythm section that includes bass virtuoso Jaco Pastorius, "Birdland" is also a showcase for composer Joe Zawinul's creative use of synthesizer texturing.

0:00	First theme is played three times in low register on synthesizer
0:20	Bassist Jaco Pastorius (on harmonic overtones) and pianist Joe Zawinul add countermelody, played four times; Alex Acuna and Manolo Badrena enter on drums and percussion.
0:43	Second theme is added by saxophonist Wayne Shorter.
1:03	Third theme is played by piano and synthesizer.
1:31	Fourth theme is played by tenor sax and synthesizer.
1:59	Fifth and main theme is played six times
2:36	Transitional interlude with vocalizations and tenor sax solo.
3:34	Pastorius restates countermelody (from 0:20 above).
3:59	Second theme is restated.
4:12	Third theme is restated.
4:23	Fifth theme is restated, repeats, and fades as Zawinul improvises on synthesizer.

bass, Airto Moreira (Brazil) on percussion as well as Americans Shorter on saxophone, and Alphonse Mouzon on drums. Initially sounding like an offspring of the Miles Davis group, Weather Report's sound evolved into a more pop-oriented style that still maintained enough musical integrity to interest jazz musicians. In 1976, bass virtuoso Jaco Pastorius joined the band, becoming a third strong solo voice to compliment Shorter and Zawinul. Their 1977 album *Heavy Weather* became a "desert island" album for fusion fans and included Zawinul's hit song "Birdland," which immediately became a jazz standard. By this time, Weather Report skillfully intertwined improvised sections with catchy melodies, dance rhythms, and synthesizer layering. Later editions of the band included drummers Peter Erskine and Omar Hakim and bassist Victor Bailey. Before the band broke up in 1985, it increasingly relied on Third World rhythms and textures, and the keyboard wizardry of Zawinul.

Mahavishnu Orchestra

Mahavishnu Orchestra

- John McLaughlin—guitar
- Jan Hammer—keyboards
- Billy Cobham—drums
- Rick Laird—bass
- Jerry Goodman—electric violin

Founded in 1971 by guitar legend John McLaughlin, The Mahavishnu Orchestra, like Weather Report had an international flair: in addition to the British McLaughlin, the band included Czechoslovakian Jan Hammer on keyboards, Panamanian Billy Cobham on drums, Irish bass player Rick Laird, and American Jerry Goodman on electric violin. The Mahavishnu Orchestra sound was an electrifying combination of bombastic rock, overly complex compositions with European and Indian influences, blues vamps and country/folk riffs, and also music of great simplicity and beauty. In short, it was one of the most intense and explosive bands in jazz or rock history. Named after McLaughlin's spiritual name given by his guru, the group was an immediate success. Its first two albums, *The*

Inner Mounting Flame, and *Birds of Fire* hit the Billboard charts and the group played to sell-out audiences. Much of the appeal of the band was McLaughlin's stunning chops on his double-necked guitar, honed while playing with blues bands in London in the late 1960s, and with Miles Davis. McLaughlin, Hammer, and Goodman often traded high-speed solo improvisations or played difficult unison passages in tricky time signatures. Backing them up was Cobham, one of the most powerful drummers of his generation. The group broke up in 1975.

Return to Forever

Chick Corea (1941–2021) started **Return to Forever** in the fall of 1971 with Stanley Clarke on bass, Joe Farrell on tenor sax and flute, and the Brazilian husband and wife team of Airto Moreira on percussion and Flora Purim on vocal. The first edition of the band was more of a Latin/jazz fusion, with Corea playing the Fender Rhodes electric piano and Clarke on acoustic bass. Their second album *Light as a Feather* produced the jazz standard "Spain," which has become a kind of signature song for Corea. By 1973, the group had become a quartet while undergoing a wholesale personnel change, with new members Lenny White on drums and Bill Connors on electric guitar with Corea playing an array of synthesizers and Clarke playing electric bass. Their third album, *Hymn of the Seventh Galaxy* was firmly headed toward a progressive rock sound influenced by British art rock bands King Crimson and Yes.

In 1974, 19-year-old guitar wizard Al Di Meola replaced Connors, and from then until 1976, the band recorded three more albums, all of which made it to the Top 40 charts. One of these, *Romantic Warrior*, borrowed the concept album format utilized by the Beatles, Pink Floyd, and other art rock groups. Corea reassembled the group again in 1977, this time with a five-piece horn section and his wife Gayle Moran on keyboards. The band was permanently disbanded later that year. As a vehicle to showcase Corea's remarkable jazz technique and writing skills, Return to Forever was a success, spanning several stylistic changes. However, the band, especially in its middle period, was guilty of much of the excessiveness of rock that irritated jazz fans and ultimately turned many away from fusion.

> **Return to Forever, 1974**
> - Chick Corea—keyboards
> - Al DiMeola—guitar
> - Stanley Clarke—bass
> - Lenny White—drums

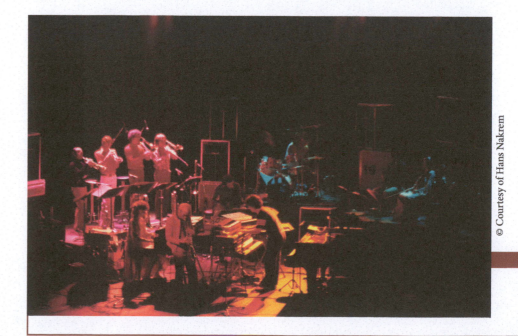

© Courtesy of Hans Nakrem

Chick Corea (keyboards, center) performing with Return to Forever in Châteauneuf, France, in 1978.

Name _____ Date _____

The 1960s, 1970s and Beyond

1. How did the civil rights movement affect the development of the free jazz movement?

2. Describe some of the reasons why the Miles Davis Quintet was so influential to jazz history.

3. Describe three phases of John Coltrane's career and the characteristics of each of them.

4. What elements of rock music and performance did jazz musicians adopt in the creating jazz/
 rock fusion?

5. Describe the characteristics of the album *Bitches Brew* and why it is so important.

6. What does "playing outside" mean, and how is it important to the free jazz movement and contemporary musicians?

7. Describe how Keith Jarrett's career in the 1970s was unique.

8. Describe why Miles Davis is so important to jazz/rock fusion in the 1970s.

9. Who were the earliest proponents of free jazz? Give specific examples of musicians and their works.

10. Describe some of the characteristics of Herbie Hancock's *Head Hunters*, and his means of achieving its success.

A NEW PARADIGM: JAZZ IN THE 1980S AND 1990S

Introduction

During the 1980s and 1990s, the convenient, canonic way of telling the history of jazz began to finally break down. The music's history could no longer be told in terms of one style emerging and becoming predominant until another one comes along to replace it. Instead, a state of pluralism began to take hold, where several styles and creative movements were able to coexist under the increasingly large jazz tent. These were uncharted waters for jazz, it seemed. But upon further scrutiny, one could say that the music had been branching out tributary style since the 1940s, first by the bebop revolution, then by a preponderance of styles in the 1950s, and further by the free jazz revolution of the 1960s. To most observers, however, it just seemed to become more obvious in the 1980s and 1990s. Saxophonist Joshua Redman summed it up in a 2003 interview by saying: "You can't tell the story of jazz in those neat, simple evolutionary terms now. But that doesn't mean that the music today is stagnant, or that it is not developing or any less creative. It may just mean that we have to view it through a different lens, and use a different paradigm to describe it."

Redman was right about the last years of the 20th century: jazz was not becoming stagnant or less creative. In fact, just the opposite was happening, as a wide variety of new approaches to the music began to emerge, and with it, an alluring roster of new jazz stars. The biggest of these, Wynton Marsalis, who burst onto the scene in the early 1980s, has fashioned a remarkable career that has earned him 10 Grammy awards for both jazz and classical recordings, a Peabody Award, and the Pulitzer Prize, while at the same time generated a considerable amount of controversy.

Wynton Marsalis (1961–) Trumpet/Composer/ Bandleader/Educator

Wynton Marsalis was born in New Orleans in 1961, one of five sons of respected jazz pianist and educator Ellis Marsalis is a respected jazz pianist and educator (Wynton's older brother Branford is a well-respected saxophonist). Wynton debuted with the New Orleans Philharmonic at age 14 playing the difficult Haydn trumpet concerto and first trumpet with the New Orleans Civic Orchestra throughout high school. At 17, he began studies at the Juilliard School of Music in New York, but soon quit to join Art Blakey's Jazz Messengers. In 1980, Marsalis

signed dual recording contracts with Columbia's jazz and classical divisions and made his jazz recording debut in 1981. In 1983, the year he turned 22, he became the first and only recording artist to win jazz and classical Grammy Awards in the same year for his albums *Think of One* and *Trumpet Concertos*. In 1984, he repeated the feat. So far in his career, he has recorded more than 40 jazz albums and 18 classical albums. Considering that by his estimate, he also plays an average of 120 gigs a year, his prolificacy in the studio is an achievement in and of itself.

But Marsalis' accomplishments go far beyond just being productive in the studio. He has won nine Grammy Awards, a Peabody Award, and the Pulitzer Prize has been awarded 30 honorary doctorates and has been given an honorary membership into England's Royal Academy of Music. He has written four ballets, two string quartets, two film soundtracks, and written and recorded a number of extended works on subjects as varied as slavery (*Blood on the Fields*, which won him his Pulitzer), 19th century Jim Crow laws (*Black Codes (From the Underground)*), and the tiny, medieval French town of Marciac (*The Marciac Suite*). Critics often compare his writing to that of Duke Ellington and Charles Mingus—not bad company to be in!

Of course, Marsalis first became known for his playing, and it has routinely been characterized with words like brilliant, flawless, or virtuosic. It has also been called derivative, unnecessarily showy, without meaning, and soulless. Welcome to the other side of the Wynton Marsalis story. In spite of all his accomplishments, Marsalis is also one of the most controversial jazz musicians in history. Much of it has resulted from his role as the torchbearer for the Neo-traditional movement— but that is just the beginning. Almost as soon as Marsalis made his entrance into public life, he began criticizing the respected elders of jazz in print, including and especially Miles Davis. The irony of this is that up until 1988 and the release of his transitional album *The Majesty of the Blues*, Marsalis' style and music seemed to be consciously patterned after Davis' 1960s quintet; in fact, on his first album, *Wynton Marsalis*, he used Miles' former quintet members as sidemen! Marsalis has also been attacked for showing off his abundant technical skills at the expense of coherent musical conception—in other words, according to critics, his solos are flashy but they do not say anything. Marsalis has also been criticized for Crow Jim tendencies by promoting the Young Lions and for his work as artistic director of New York's Jazz at Lincoln Center program, a position he was named to in 1987. And as the media and cultural darling of jazz for much of the last 20 years or more, Marsalis has been criticized for nothing more than for being everywhere, all the time. In the 1990s, it seemed that if there was a story in print or on TV or a documentary or film about jazz, Wynton was in it voicing his opinions.

As the jazz world moved into the 21st century, the Wynton Marsalis controversy began to dissipate to a large extent. But even today there are those who blame him for much of what ails jazz. One of the symptoms that is often pointed to, for which Wynton is supposedly responsible, is the emergence of the Neo-traditional (or Neo-conservative) movement.

Music Analysis

Track 49: "The Majesty of the Blues (The Puheeman Strut)"

(Marsalis) Wynton Marsalis Sextet from the album The Majesty of the Blues recorded at RCA Studio A in New York, October 27 and 28, 1988. Personnel: Marsalis: trumpet; Wes Anderson: alto sax; Todd Williams: tenor and soprano saxes; Marcus Roberts: piano; Reginald Veal: bass; Herlin Riley: drums

The Majesty of the Blues was a transitional album in the career of Wynton Marsalis. After signing with Columbia in 1981, Marsalis's first several albums were cut in the mold of Miles Davis's 1960s quintet. With *The Majesty of the Blues*, his career began to focus on the elements that are most essential to the Neo-traditional movement: swing rhythm and the blues. Future albums would include tributes to Duke Ellington, Jelly Roll Morton, and Thelonious Monk. Marsalis's new direction brought controversy: whereas his supporters called it a welcome return to the fundamentals of jazz, critics dismissed it as "ancestral worship." The sextet used on the album includes several Marsalis long-time associates, including the rhythm section of pianist Marcus Roberts, bassist Reginald Veal, and drummer Herlin Riley. The album also includes a spoken sermon written by Stanley Crouch, one of the leaders of the Neo-traditional movement, that warns of those who preach of "Premature Autopsies" on "The Death of Jazz" (two of the tracks on the album). The title track is a vehicle for Marsalis to display his mastery of the plunger mute.

0:00	Rhythm section sets up a swampy groove; tenor saxophonist Todd Williams solos
0:18	As groove and tenor solo continue, trumpeter Wynton Marsalis and alto saxophonist Wes Anderson play the head over 12-bar blues progression; Marsalis uses plunger mute
1:05	Marsalis solos using plunger mute
3:26	Marsalis and Anderson play arranged parts that signal the end of the trumpet solo
3:53	Pianist Marcus Roberts begins solo; track continues

The Neo-Traditional Movement

Ironically, the most controversial new movement of the last 40+ years is also the most conservative. Eschewing many of the stylistic and innovative advancements of the recent past, the Neo-traditional (or Neo-conservative) Movement stems in part from a vision that was first stated by writer Albert Murray in his 1976 book *Stomping the Blues*. Murray's book promotes the idea that the blues must be an essential ingredient in all jazz, and by inference, if there are no blues elements in the music, then it is not really jazz. Picking up Murray's cause was critic Stanley Crouch, a former free jazz drummer-turned-writer who together with Murray developed a narrow-minded ideology stating that jazz must have three essential elements: it must swing, it must have blues tonalities, and it must be played on acoustic instruments. Over time this notion blossomed into a movement that was picked up by jazz purists. Murray and especially the combative Crouch have also suggested in writing that white musicians cannot play jazz convincingly. Taken literally, these ground rules set by what amounted to modern-day jazz police mean that much of the music discussed in this chapter, Chapter 9, or even Chapter 8 is not jazz. Free jazz, jazz/rock fusion, even bossa nova does not meet the requirements set up by the Neo-traditionalists. The style that seems to most accurately fit the description of what they are looking for is hard bop, the style that originated in the 1950s. Hard bop swings, is very bluesy, acoustic, and, at least in its early years, was played almost exclusively by Black jazz musicians.

Aiding and abetting the emerging Neo-traditional movement was the return to the U.S. of Dexter Gordon. Gordon, who first gained fame as a first-generation bebop tenor saxophonist (see Chapter 7), moved to Europe in 1962 where he continued to play post-bop jazz, primarily with European musicians. When he finally returned to America in 1976 he was welcomed back as a stalwart

supporter of acoustic, mainstream jazz who eschewed the currently popular jazz/rock styles. His triumphant engagement at New York's Village Vanguard in December 1976 was recorded and released as the double album *Homecoming* on Columbia and revitalized his career.

Although mainstream acoustic jazz had never really gone away or out of style, and the fact that the ground rules set up by Crouch and Murray were very strict, the Neo-traditional movement nonetheless picked up steam and became the defining jazz story of the late 1970s, 1980s, and early 1990s. The explanation as to why can be easily described in two words: Wynton Marsalis. Marsalis burst into public view in 1980, when he joined Art Blakey's Jazz Messengers. He was 18 years old. His career path since then (described in more detail later in this chapter) has been nothing short of meteoric (in fact that may be understating it). Along the way, Marsalis has used the considerable corporate and institutional clout he had accumulated to promote the careers of other musicians that are cut in the same cloth as he and who fit neatly into the Neo-traditional canon. The Young Lions, as they became known, were young, Black, had a sense of style that was extremely marketable, and played music that was largely in the hard bop vein. The most prominent of the **Young Lions** were trumpeters Roy Hargrove, Terence Blanchard, and Nicholas Payton, tenor saxophonists Joshua Redman and James Carter, pianists Cyrus Chestnut and Jacky Terrasson, and bassist Christian McBride. With so much young, attractive, and impressive talent coming out of the woodwork playing music that had an aura of authenticity to it, it is easy to see why the Neo-traditional movement proved to be so popular.

But it was also controversial. Although the Young Lions were all technically more than proficient on their instruments, the case could be made that they had not matured to the degree that one might ordinarily need to earn a record contract. And when they did sign contracts, it was at the expense of other artists, especially older and more adventurous ones. (One story was told of an older, well-known musician that no longer had a contract but was giving lessons to two 20-something musicians who did.) Because in several instances these squeezed-out musicians happened to be white, the touchy issue of race, in this case, "Crow-Jim-ism" came into play. Controversy also arose over the fact that it seemed that writers were, perhaps for the first time in the history of any art form, calling the shots rather than the artists themselves. Furthermore, the Neo-traditionalists came under fire for essentially promoting an agenda of "ancestor worship," of moving backward rather than forward. Was it not an implicit truth that art must move forward? But in the end, all of these controversies were satellites revolving around the gravitational pull of Wynton Marsalis.

BOX 10-1	Characteristics of Neo-Traditional

- Focus on swing rhythms and blues tonalities
- Exclusion of avant-garde and other new jazz styles developed after the mid-1960s
- Use of acoustic instruments exclusively
- Virtuoso instrumental mastery of earlier jazz styles
- Usually bears some resemblance to the sound of hard bop

Fusion Evolves in the 1980s

As discussed in chapter 9, perhaps the most important development in jazz in the 1970s was the adoption by musicians of rock instruments, rhythms, and performance techniques into their music, resulting in a new hybrid style that became known as jazz/rock, or jazz/rock fusion. By the 1980s it was becoming

clear to many jazz musicians that combining rock and jazz elements was not only a way to open up new artistic avenues, but also a way to generate a new, and younger fan base. Musicians such as Herbie Hancock, Chick Corea, and Josef Zawinul, and Wayne Shorter of Weather Report did a remarkable job of maintaining a good accessibility/credibility balance of jazz and pop elements, which created increased record sales, and an expanded audience while still retaining their respectability and standing among jazz musicians and fans. Albums such as *Head Hunters, Heavy Weather*, and *Romantic Warrior* were benchmarks in this regard. While some jazz musicians continued to move even further into pop, creating a watered-down, but incredibly popular style known as **Smooth Jazz**, the case could be made that the mainstream sound of jazz in the 1980s was a post-1970s style that became known simply as fusion. **Fusion** can best be characterized by the equal triangulation of jazz, rock, and pop that places increased emphasis on studio production, memorable melodic riffs, and catchy rhythmic grooves without abandoning jazz integrity and credibility as the more pop-oriented smooth seemingly did. Using this definition, *Head Hunters, Heavy Weather*, and *Romantic Warrior* can be called early examples of fusion, and ultimately led to the emergence of the two most prominent fusionists of the 1980s, guitarist Pat Metheny and saxophonist Michael Brecker.

BOX 10-2	Characteristics of Smooth Jazz

- Danceable, rhythmic, melodic
- Commercial pop elements outweigh jazz elements
- Electronic instruments used: guitar, bass guitar, and especially synthesizers
- Saxophone typically used as main melodic voice

BOX 10-3	Characteristics of 1980s Fusion

- Equal triangulation of jazz, rock, and pop elements
- Increased emphasis on studio production
- Jazz credibility and integrity maintained
- Embrace of MIDI technology

Pat Metheny (1954–) Guitar/Guitar Synthesizer/Composer/Bandleader

Possibly the most uniquely original guitarist in jazz today, **Pat Metheny's** career has encompassed a variety of diverse projects that have won him a strong fan base while retaining a high degree of respect among jazz purists. Although he personally does not like to use the word fusion to categorize his music, he has kept the fire of creativity in the genre going long after the demise of Weather Report and Return to Forever. Born in Lee's Summit, Missouri, Metheny's youth was spent listening to such diverse music as the Beatles, Benny Goodman, the Beach Boys, Ornette Coleman, and Wes Montgomery, the latter heavily influencing his decision to play the guitar. Upon graduating from high school, he attended the University of Miami for a short time but quit his studies after receiving a teaching position at the school. In 1973, while still only 19 years old, he began teaching at the Berklee College of Music in Boston at the invitation of vibraphonist Gary Burton, who also taught at the school. In 1974, he joined Burton's group, with which he played until 1977.

In 1975, Metheny recorded his first solo album, *Bright Size Life*, with bassist Jaco Pastorius and drummer Bob Moses. Later that year, he met pianist Lyle Mays, with whom he formed the **Pat Metheny Group** in 1978, which also included bassist Mark

Music Analysis

Track 50: "Last Train Home"

(Metheny) Pat Metheny Group from the album *Still Life (Talking)* recorded March-April 1987. Personnel: Metheny: electric guitar, guitar synthesizer, acoustic guitar; Lyle Mays: piano, keyboards; Steve Rodby: bass; Paul Wertico: drums; Armando Marçal: percussion, background vocals; Mark Ledford, David Blamires: vocals.

Guitarist Pat Metheny burst onto the jazz scene in the early 1970s as the youngest instructor (at the time) at the prestigious Berklee College of Music and as a member of Gary Burton's highly regarded group—all while barely 20 years old. The forming of the Pat Metheny Group in 1978 would formalize a creative partnership with composer/pianist Lyle Mays that continues to this day. *Still Life (Talking)*, the group's sixth album, was the first released on the giant Geffen label. The album shot to #1 on the Billboard jazz chart and won a Grammy for Best Jazz Fusion Performance. "Last Train Home" is one of Metheny's most familiar pieces, having been used as background music for a number of TV commercials, a theme for various public radio programs, and as a regular feature on The Weather Channel. With a breezy, folk-like quality, the song somehow manages to sound new yet familiar and demonstrates Metheny's use of taste and restraint in his solo improvisation.

0:00	Introduction by rhythm section; drummer Paul Wertico sets up "train on tracks" groove using brushes on snare drum while bassist Steve Rodby, pianist Lye Mays and strings quietly support
0:10	Theme is played by guitarist Pat Metheny using sitar synth
0:48	Interlude, featuring train whistle sound effects
1:00	Theme played a second time
1:38	Interlude
1:48	Metheny solos
3:23	Bridge with wordless vocal by Mark Ledford and David Blamires
3:47	Metheny restates main theme
4:24	Interlude serves as a vamp out; Metheny solos, train sound effects as song fades

Egan and drummer Danny Gottlieb. The band's sophisticated and original mix of jazz and rock quickly gave them commercial success while maintaining the musical integrity that was absent from many fusion bands. Often collaborating with Mays (with whom he enjoys great musical rapport), Metheny's compositions from this period often conjured up images of Americana with his distinctive folk-like melodies. He often mixed such diverse elements as Brazilian music, guitar synthesizers, and wordless vocal lines to create a highly distinctive sound. Despite possessing prodigious technical skills on the guitar, Metheny has always been able to temper his playing to fit the musical context and not succumb to showmanship.

Although the Pat Metheny Group has remained a working ensemble since the late 1970s, Metheny has never been one to stay in one musical setting. His 1983 album *Rejoicing* is a trio setting with Ornette Coleman alumnus Charlie Haden and Billy Higgins that includes three Coleman compositions. His 1985 album *Song X* is a seemingly unworkable collaboration of free jazz with Coleman, Haden, and Jack DeJohnette that is excellent. Other collaborations include 1997s *Sign of 4* with avant-garde guitarist Derek Bailey, the peacefully beautiful *Beyond the Missouri Sky*, a duo album with bassist Haden; and 1994s *I Can See Your House from Here*, a showdown with guitar virtuoso John Scofield. His 1997 album *Imaginary Day* is a venture into world music, mixing Iranian, Balinese, African, and other influences with jazz, rock, and electronic instruments.

In the late 1990s, Metheny recorded and toured with bassist Larry Grenadier and drummer Bill Stewart, writing and performing some of the best small group material of his career. His latest projects include the 68-minute long *The Way Up*, which won Metheny his 16th Grammy Award, a collaboration with pianist

Brad Mehldau (*Metheny/Mehldau*), and the Orchestrion Project, in which he used solenoids and pneumatics to create an ensemble-based music for acoustic and acoustoelectric instruments. The results of this ambitious concept can be heard on the 2009 LP *Orchestrion*.

Michael Brecker (1949–2007) Tenor Saxophone/EWI/Composer

One of the most influential musicians of the last 30 years, **Michael Brecker** was the leading voice of the tenor saxophone in the post-Coltrane years until his death in early 2007. Although Brecker was a 13-time Grammy winner for his own albums, his busy schedule as a studio session player prevented him from recording his own until 1987, 17 years after his recording debut. Brecker was born in Philadelphia and attended the University of Indiana for a year before moving to New York in 1970. There he co-founded the innovative jazz/rock group Dreams with his trumpet-playing brother Randy. After two years, the Breckers moved on to play with Horace Silver for a year before starting the pioneering jazz/rock/funk group the Brecker Brothers. In the late 1970s, Michael formed a more jazz-oriented fusion group called Steps, which included vibraphonist Mike Mainieri, pianist Don Grolnick, bassist Eddie Gomez and drummer Steve Gadd. All were upper-call session players, and Steps (which later changed their name to Steps Ahead) was arguably the top fusion band of the early 1980s before disbanding in 1986. While with Steps Ahead, Brecker began playing the **EWI**, or electronic wind instrument, an expressive breath-controlled synthesizer controller that allowed him to convincingly play any sounds generated from synthesizers. He mastered the EWI and used it to great effect in his career; interestingly, no other major saxophonist has adopted it.

Music Analysis

Track 51: "Itsbynne Reel"

(Brecker/Grolnick) Michael Brecker from the album *Don't Try This at Home* recorded in 1988 at Master Sound Astoria Studios, Astoria, New York. Personnel: Michael Brecker: tenor sax, Akai EWI; Mike Stern: guitar; Don Grolnick: piano; Mark O'Connor: violin; Charlie Haden: acoustic bass; Jeff Andrews: fretless electric bass; Jack DeJohnette: drums

Michael Brecker's 1988 Grammy Award-winning *Don't Try This at Home* is the second of his eight album releases as a leader, and its opening track "Itsbynne Reel" serves notice that with the album he was going to push the boundaries of jazz/rock fusion and have a little fun while he was at it. Co-written by Brecker's long-time musical colleague, keyboardist Don Grolnick, "Itsbynne Reel" starts out with a high-energy Irish jig-cum-bluegrass hoe-down duet with Brecker on the Akai EWI (electronic wind instrument) and fiddle virtuoso Mark O'Connor. The duet goes on for more than four minutes before Brecker launches into one of his signature Coltrane-esque solos (which album liner note writer George Varga calls "arguably the best sax solo of Brecker's recording career"). For *Don't Try This at Home*, Brecker stated that, "We tried to stay away from obvious devices, and hoped to make a record that bears repeated listenings." "Itsbynne Reel" is certainly unlike anything else that was recorded in the late 1980s.

0:00	Michael Brecker, playing the Akai EWI, and violinist Mark O'Connor set up the tune
0:15	Pianist Don Grolnick enters with chords and bass line
0:54	Brecker and O'Connor start to improvise
2:12	Drummer Jack DeJohnette enters; bassists Charlie Haden and Jeff Andrews enter on pedal drone; band settles into a high-energy groove
3:16	New counter line is played by bass and piano
3:47	Return to pedal bass
4:18	Tenor sax solo by Brecker
6:30	O'Connor re-enters on new riff set up at end of saxophone solo; Brecker and O'Connor begin collective improvisation; track deconstructs, ends

In 1987, Brecker finally recorded his eponymous debut album, which won album of the year awards from both *DownBeat* and *Jazziz* magazines. His follow-up album, *Don't Try This at Home*, won him his first Grammy Award. Both albums display Brecker's remarkable technique, his Coltrane-esque tone, his inventiveness as a soloist, his use of the EWI, and his composing skills. Six more albums followed, all of which were well received by critics and fans. In 2004, Brecker was diagnosed with myelodysplastic syndrome (MDS), a blood disease that is often the precursor to leukemia. Therapy for the disease usually involves finding a donor with matching stem cells, which Brecker was unable to do despite a well-publicized search. Continuing on with his career as long as possible, Brecker made plans for one final album. Recorded in August 2006 and completed in January 2007 just two weeks before his death, *Pilgrimage* is a testament to the talent and courage of one of America's most important contemporary jazzmen. His memorial service was held at New York's Town Hall and included performances by Herbie Hancock and Paul Simon.

The New York Downtown Scene

While fusion could be called the mainstream sound of jazz in the 1980s, the music nonetheless continued to reinvent itself. One of the most important new developments in the late 1980s and early 1990s was the emergence of what became known as the Downtown scene in New York City. Downtown music, largely created in the lofts and performance spaces of the East Village and Lower East Side, was that which was too experimental or avant-garde to make it into the "uptown" world of Lincoln Center or Carnegie Hall. "The premise of downtown music is that music, like all other art, is a symbolic language of personal expression that each individual artist brings up from his or her soul," writes composer and critic Kyle Gann. "It is, of course, helpful and inspiring to know techniques and devices from the past used by other great musical minds. But even these potentially helpful techniques [can] become impediments to sincere personal expression…Very often it is conducive to a more sincere creativity to distance oneself from traditional forms—work with computers or weird instruments or hybrid genres—in order to escape of past and invariably foreign personalities." There had been a lively avant-garde scene in lower Manhattan since the 1960s free jazz movement, but by the mid-1980s it had atrophied, leaving the more adventurous and younger players hungry for an alternative space in which to perform. However, that all began to change in 1987 with the opening of The Knitting Factory, a club in the East Village that dedicated one night a week to avant-garde jazz. Soon other cutting-edge clubs followed, and the Downtown scene flourished. Among the most important of the downtown musicians were saxophonist John Zorn, trumpeter Dave Douglas, and guitarist Bill Frisell.

BOX 10-4	Characteristics of New York Downtown Music

- Too experimental for the establishment art scene of "uptown" New York
- Focus on personal expression
- Distances itself from traditional forms, conventions, etc.
- Centered around lower Manhattan: East Village, Lower East Side

Important Downtown Performers

John Zorn (1953–) Alto Sax/Composer/Producer

The career of John Zorn has been so chameleon-like and jam-packed that it is difficult to know where to begin. Zorn (1953–) was born and raised in New York City, where early on he was exposed to a wide variety of music including avant-garde classical,

jazz, world music, and doo-wop. By the time he was in his teens, he also became attracted to the music of composer Carl Stalling, who wrote the musical soundtracks to Bugs Bunny, Daffy Duck, and Road Runner cartoons. For Zorn, Stalling followed "the visual logic of screen action rather than the traditional rules of musical form," and by doing so, created "a radical compositional arc unprecedented in the history of music." Among Zorn's first works were a series of "game pieces" in which performers were free to play whatever they wanted, within a predetermined structure. "My first decision…was never to talk about language or sound at all. I left that completely up to the performers. What I was left with was *structure*. I can talk about *when* things happen and when they *stop*, but not *what* they are." By the mid-1980s, Zorn was bringing this approach to integrating composition and improvisation to a series of highly acclaimed concept albums that began with *The Big Gundown*, in which he reinterpreted the music of spaghetti Western composer Ennio Morricone.

In 1987 Zorn released the mind-boggling *Spillane*, which consisted of three compositions: the title cut, which evokes the imagery of the eponymous pulp novelist and includes 60 **jump-cuts** (moving quickly from one musical style to another) in its 25 minutes; "Two Lane Highway," a "concerto" for bluesman Albert Collins; and "Forbidden Fruit (Variations for Voice, String Quartet and Turntables)" featuring the Kronos Quartet. In 1989, Zorn released *Spy vs. Spy*, consisting of free jazz/speed metal versions of Ornette Coleman compositions, and *Naked City*, which, with 26 tracks was described by a critic from British music publication *Wire* as "jump-cutting microcollages of hardcore, country, sleazy jazz, covers of John Barry and Ornette Coleman, brief abstract tussles—a whole city crammed into two or three minute bursts."

Zorn also has led a number of groups that served as workshops for his music, including the jazz/rock Naked City, Masada, a four-piece classical/jazz hybrid band, and a sax-bass-drums trio called Painkiller that Zorn described as playing "the most annoying free-jazz heavy metal you can imagine." Zorn's other musical ventures include soundtracks for independent films, chamber music written for a variety of classical music ensembles ranging from solo cello to full orchestra, and a number of solo albums. To date, he has released nearly 100 albums. In 1995 Zorn founded **Tzadik**, a record label dedicated to avant-garde and experimental music that now has over 400 albums in its catalog. In 2005 he opened **The Stone**, a not-for-profit performance space at the corner of Avenue C and 2nd Street.

John Zorn is quite possibly the most prolific recording artist in history. In 2010 alone he has released at least ten albums, including the darkly beautiful *The Goddess—Music for the Ancient of Days*, a "collection of Odes in celebration of Women in Myth, Magick and Ritual throughout the Ages," and *Dictée/Liber Novus*, recorded with an 8-piece ensemble that includes a Japanese shakuhachi player, a sound effects person, three players whose duties include reciting narration in French, German, and Korean, and Kenny Wollesen on "wollesonics."

Bill Frisell (1951–) Guitar/Composer

Guitarist **Bill Frisell's** career has in many ways mirrored that of John Zorn in terms of its protean qualities, but unlike Zorn, Frisell is an in-demand session player who has played on well over 100 albums for artists as diverse as Zorn, Elvis Costello, and jazz vocalist Norah Jones. Frisell's own albums, as either leader or co-leader, number more than 30. He has honed a startlingly unique sound that is nearly impossible to categorize, but yet is instantly recognizable. In addition, he has developed into one of the foremost composers of progressive jazz. Frisell's (1951–) early years were not unlike many jazz musicians of his generation, with influences ranging from the Beatles, Beach Boys, and surf bands such as The Ventures. His interest in jazz intensified after moving to the New York City area from Denver with his parents in 1969, and eventually attended Berklee College

of Music. In 1979 he moved to New York and began to work his way into the local club scene. His break came in 1981 when he made his recording debut on ECM Records. In 1982, Frisell recorded his first album as a leader, *In Line*.

After spending the next several years touring and recording, Frisell became a fixture in the downtown Knitting Factory scene and was a member of John Zorn's band that debuted "Hu Die" there in early 1987. By the end of the decade, his numerous ventures both in the clubs and recordings were earning him recognition as one of the brightest new stars in jazz. Frisell's albums as a leader or co-leader have been consistently diverse in their conception and musical direction. Among his most notable albums are 1990's *Is That You?*, on which Frisell plays guitar, bass, banjo, ukulele, and clarinet on the nine original tunes; 1992's *Have a Little Faith in Me*, an album of very personal interpretations of tunes by Muddy Waters, Bob Dylan, Sonny Rollins, Stephen Foster, and others; two 1994 albums of music written for silent Buster Keaton films, *The High Sign, One Week* and *Go West*; and 1997's *Nashville*, recorded in Nashville with members of Allison Krauss's Union Station band. *Nashville* won the *DownBeat* critic's poll Album of the Year; Frisell won Guitarist of the Year in the poll in both 1998 and 1999. He has also written music for various film projects, including Gus Van Sant's films *Finding Forrester* and the remake of *Psycho*. His album *Unspeakable*, music written for a Gary Larsen animated TV show, won him the 2005 Grammy Award for Best Contemporary Jazz Album. One of Frisell's most recent albums is 2008's serenely beautiful *History Mystery*, recorded with an 8-piece ensemble that included trumpet, clarinet, and three string players. It was nominated for Best Instrumental Jazz Album.

Dave Douglas (1963–) Trumpet/Composer/Producer

Dave Douglas has been a major artistic force in New York's downtown scene since the mid-1980s. Douglas grew up in the greater New York City area and studied piano and trumpet in both the jazz and classical realms. After studying at Berklee College and the New England Conservatory in Boston, he returned to New York and began working his way into the city's club scene. By the early 1990s Douglas was writing music for the various groups he was performing and recording with, including the Horace Silver Quintet, citing his primary compositional influences as John Coltrane, Russian composer Igor Stravinsky and Stevie Wonder. In the mid-1990s Douglas also performed with John Zorn's Masada.

Around the early 1990s, Douglas began assembling a number of performing and recording groups, each designed to fulfill a different compositional or conceptual purpose. Parallel Worlds investigated the merging of improvised and contemporary classical music and recorded three albums between 1993 and 1997. The Tiny Bell Trio, a trumpet, drums, and guitar ensemble, was put together to meld jazz and Balkan music and recorded four albums over a ten-year period. Charms of the Night Sky was a four-piece ensemble featuring trumpet, accordion, violin, and bass. Witness was an experimental electric 7-piece group with trumpet, tenor sax, two keyboards, bass, drums, and electronic percussionist Ikue Mori, formed to play "music celebrating positive protest against the misuse of money and power." Sanctuary was an electric double quartet inspired by Ornette Coleman's *Free Jazz* that consisted of two trumpets, tenor sax, two basses, drums, and two digital sampler players. Douglas has also performed in more conventional quartet, quintet, and sextet settings, often using his sextet as a "legacy" band to play tributes to past jazz artists. Albums in this category include *In Our Lifetime*, a tribute to 1960s trumpeter Booker Little; *Stargazer*, a tribute to Wayne Shorter; and *Soul on Soul*, a tribute to pianist Mary Lou Williams.

Douglas has also been keenly interested in the possibilities presented by electronic instruments and sound processing, as evidenced by his 2003 album *Freak In*, in which tracks were electronically manipulated after the sessions were completed.

"The idea of *Freak In* was to create a sense of flow, of fluency that live bands get but with additional freedom of being able to really work the electronics in ways that their technology was created for. I think there is a big future for the use of this process in the music that's coming out of jazz." This line of thinking is leading him into further experimentation with electronics: "In one of my last sessions…I recorded about an hour of solo trumpet…I started transforming the tracks, turning raw trumpet sounds into grooves, textures, and melodies. Home-made miniatures started to take shape from the sounds of these raw tracks." One of his latest endeavors is the group Brass Ecstasy, a 5-piece group consisting of trumpet, French horn, trombone, tuba, and drums. Douglas has also taken control of the business end of his career with the founding of his own label in 2004, Greenleaf Music.

Urban Jazz Styles

In addition to the Downtown scene and its unique music, three new styles appeared in the 1980s from urban scenes that embraced recent jazz and funk developments. M-Base, short for "macro-basic array of structured extemporization" was developed by a collective based in New York led by alto saxophonist Steve Coleman that also included alto player Greg Osby, tenor saxophonist Gary Thomas, and vocalist Cassandra Wilson. It is more a way of conceptualizing creative expression and growth than a particular music style. The M-Base website puts it this way: "M-Base is a way of thinking about creating music, it is not the music itself. One of the main ideas in M-Base is growth through creativity. As we learn through our experiences then the music will change and grow to reflect that. The idea is not to develop some musical style and to play that forever." Although the music performed by the M-Base participants is unpredictable, much of it has a sort of free-jazz-mixed-with-funk sound to it.

> **M-Base**—(short for "macro-basic array of structured extemporization") is a concept of how to create modern music, which reached its peak in the mid-to-late-80s and early 90s.

Music Analysis

Track 52: "Shards"

(Douglas) Dave Douglas Tiny Bell Trio from the album Tiny Bell Trio recorded 1993 at Sear Sound in New York City. Personnel: Dave Douglas: trumpet; Brad Shepik: electric guitar; Jim Black: drums

One of trumpeter/composer Dave Douglas's many musical project bands is the Tiny Bell Trio, which he formed in 1991 with guitarist Brad Shepik and guitarist Jim Black. In the beginning, the group's material consisted of traditional East European folk music, but as the group evolved, they began composing their own material that blended the Euro folk ethos with their own improvisational skills. Adding to the development of the group was a steady gig on Friday nights at the Bell Café in the Soho district of New York, whose limited space and name became the inspiration for the group's own name. *Tiny Bell Trio*, from which "Shards" comes, was the first of four albums the group released in the 1990s. "Shards" is typical of much of the music of the New York downtown scene in the 1980s and 1990s, in that it is completely *untypical* in almost every way. For one thing, although there have been many trio formats used in jazz throughout the years, it is likely that this particular instrumental format was the first of its kind. Then there is the music itself: East European folk music, mixed with improvisational jazz, with a healthy dose of humor thrown in for good measure? Somehow it works—really well!

0:00	Head is played by trumpeter Dave Douglas
0:12	Repeat
0:24	New theme is stated four times
0:58	Guitar solo by Brad Shepik
1:17	Trumpeter Douglas and guitarist Shepik exchange short solos
2:19	Douglas and Shepik exchange short solos with drummer Jim Black
2:34	Theme and variations of the head
3:22	Second half of head is restated

Steve Coleman (no relation to Ornette) hitchhiked to New York from his native Chicago in 1978 while in his early 20s. For the first few years, he lived in the YMCA and played on the streets. Eventually, he worked his way into paying gigs with the big bands of Thad Jones/Mel Lewis, Cecil Taylor, and others; simultaneously he was putting together an experimental group called Five Elements, which became the workshop for the creation of M-Base. Although Coleman is looking for freedom of expression, he also wants an audience for his music. His big picture: music for "people who want to dance, something for people who are intellectual and want to find some abstract meaning, and something for people who just want to forget their troubles." Cassandra Wilson's career brought her to New York from her native Mississippi in 1982, where she made her recording debut in 1985 with Steve Coleman. Since that time, she has blossomed into arguably the most important singer in jazz. Her recorded output has been eclectic and includes everything from jazz standards (1988's *Blue Skies*) to covering tunes by Hank Williams, Son House, and U2 (1995's *New Moon Daughter*). Her low, throaty voice is reminiscent of avant-gardist Betty Carter.

Acid Jazz—a style originally created by London DJs from 1960s and '70s soul jazz and funk records.

Acid Jazz originally was created by DJs in the London club scene in the mid-1980s. It initially was built on the style known as rare groove, in which underground DJs introduced young club patrons to the soul jazz records from the 1950s and 1960s and the early fusion and funk work of Herbie Hancock's Head Hunters and others. The DJ most prominently associated with this movement and the man who supposedly coined the term acid jazz was **Gilles Peterson**, who operated his own pirate radio station out of his home in London. The records that Peterson and other DJs spun energized a group of musicians who started to create new music based on them.

Music Analysis

Track 53: "Entruption"

(Osby) Greg Osby from the album *Inner Circle* recorded April 22, 1999, at Systems Two Studio in Brooklyn, New York. Personnel: Greg Osby: alto sax; Jason Moran: piano; Stefon Harris: vibes; Tarus Mateen: bass; Eric Harland: drums

"Entruption," from Greg Osby's album *Inner Circle*, is exemplar of the M-Base style that emerged in New York City in the 1980s through the work of Osby, Steve Coleman, and others. M-Base draws on many influences, but generally the most pronounced are free jazz, bebop, and funk—which reflect the musical backgrounds of its architects. According to Osby, "M-Base is a collective that Steve Coleman and I started in 1985, out of the need for some kind of a musical situation that young musicians could write and create compositional and improvisational directives. There was no hangout scene in New York at the time when I got to town. There was no real dominating jam session situation where cats could talk shop and exchange information, informally get together once or twice a week amongst ourselves, the people that we pooled and talk about music, talk about music business, talk about production and music presentation, specifics. It was something that we felt was necessary because the music was in retrograde at that point. People were really looking to the past and more concerned with historical values as opposed to pushing the envelope and propelling themselves as a group into the future. Plus, we didn't want to discard any of our resource material that was fundamental in our musical make-up. We all come from R&B and soul music and funk, other types of jazz expression, other types of folk music, and we wanted to incorporate that in a contemporary offering, as opposed to a lot of our peers who just dismissed everything that was a part of their make-up, which we didn't think was honest." M-Base "worked out really well."

0:00	Track begins with alto saxophonist Greg Osby and vibraphonist Stefon Harris playing the head in unison
1:17	Pianist Moran solos
2:29	Osby solos
3:40	Head is restated, track ends

Acid jazz is very broad-based and hard to categorize. It can include everything from the soul jazz of the James Taylor Quartet (not the singer/songwriter); the Stevie Wonder-sounding pop music of Jamiroquai; to the disco-influenced Groove Collective. The band Us3 has a unique convergence of hip-hop and jazz, occasionally taking **digital samples** from 1950s and 1960s hard bop recordings and building grooves from them. Their 1993 hit single "Cantaloop (Flip Fantasia)" did exactly that, adding rap vocals and synthesized horns to sampled sections of Herbie Hancock's 1960s funk tune "Cantaloupe Island."

The question of whether acid jazz can legitimately be defined as jazz in the strictest sense is open for debate. The acid jazz and M-Base styles do point to the broadening influence of jazz into the contemporary pop world, as does a third category of urban style, the **jam band**. Although there have been rock bands that easily qualify as jam bands for many years (Cream, the Grateful Dead, etc), it was not until the 1990s that **Medeski, Martin and Wood (MM&W)** brought the concept into a jazz context. A variation of the 1950s organ trio using Hammond B3 (and other keyboards), bass, and drums, MM&W is a groove-based band that perhaps can best be described as the Grateful Dead meets soul jazz. MM&W songs often start on a simple riff set up by keyboardist John Medeski or drummer Billy Martin and evolve into long exploratory jams that are not set in the traditional one soloist at a time mold but instead a collective group effort. The effect is hypnotic and has made MM&W popular among jazz fans as well as young rock fans.

BOX 10-4	Characteristics of Urban Jazz Styles

- Emphasis on groove
- Experimental improvisational techniques, use of technology
- Electronic and acoustic instruments used
- Use of hip-hop elements, including rapping and digital samples

Continuing the Big Band Tradition

Even though the end of the swing era relegated big bands to near-dinosaur status for many years, they have managed to stave off extinction, and in many ways are flourishing today, at least creatively if not economically. For sure, traditional big band music has been kept alive by "ghost" bands such as those formerly led by Duke Ellington and Count Basie, and from high school, college, and repertory bands. But the genre has also maintained a strong tradition of innovation from new bands that have come along over the years, including those led by Buddy Rich, Maynard Ferguson, Gil Evans, Charlie Haden, and Roc McConnell. Two of the more interesting big bands from the 1960s formed on opposite coasts from each other. The band of Los Angeles-based trumpet player Don Ellis started out—like most post-swing era big bands—as a rehearsal band in 1965, but over time built up a strong following through local club appearances. By late 1967 they had signed with Columbia and released their debut album *Electric Bath*, which was nominated for a Grammy and was named the *DownBeat* Album of the Year in 1968. The Ellis orchestra was noted for combining influences from Indian music, odd time signatures, unusual instrumentation (such as two drummers or three bassists), and the use of electronic instruments such as electric pianos. Ellis also often processed his trumpet through devices such as echoplexes or ring modulators. The much more famous **Thad Jones/Mel Lewis Orchestra** debuted as a temporary filler for a few open Monday nights at New York's Village Vanguard on February 7, 1966. Led by trumpeter Jones, one of the finest big band arrangers in jazz

and brother of Coltrane drummer Elvin Jones, and drummer Lewis, the band from the beginning had an all-star cast of New York's finest jazz musicians, and quickly became known for its hard-swinging yet distinctively orchestral sound. Although Jones left in 1978 and Lewis died in 1990, the band is today known as the Vanguard Jazz Orchestra and continues to perform at its namesake club on Monday nights.

Other innovative contemporary big bands include the Toshiko Akiyoshi Jazz Orchestra, which was formed in Los Angeles in 1973 by Japanese pianist/composer Akiyoshi and her husband, tenor saxophonist Lew Tabackin. Inspired by Duke Ellington, who "was very conscious of his race," and the idea that "maybe that was [his] role, to portray [his] heritage within jazz," Akiyoshi released *Kogun* the following year, a suite portraying a Japanese army officer living in the Burmese jungle in the 1970s, unaware that WWII had ended. Over the next 10 years, Akiyoshi released a dozen more albums that often had tie-ins to her ethnic heritage, and she became a perennial winner in the Big Band, Arranger, and Composer categories of the *DownBeat* Critics Polls. Another inventive big band, the New York Composers Orchestra, was formed in 1986 by composer/keyboardist Wayne Horvitz and his wife Robin Holcomb as a workshop for experimental composers and arrangers. The NYCO's repertoire comes from Horvitz and other members including

Music Analysis

Track 54: "Central Park North"

(Jones) Vanguard Jazz Orchestra from the album *Thad Jones Legacy* recorded May 1 and 2, 1999 at Edison Recording Studios, New York City. Personnel: Earl Gardner, Joe Mosello, Glenn Drewes, Scott Wendholt: trumpets; John Mosca, Ed Neumeister, Jason Jackson: trombones; Douglas Purviance: bass trombone; Dick Oatts, Billy Drewes: alto and soprano saxophones; Rich Perry, Ralph LaLama: tenor saxophones; Gary Smulyan: baritone saxophone; Jim McNeely: piano; Dennis Irwin: bass; John Riley: drums

The Vanguard Jazz Orchestra is one of the jazz world's unique and most venerable institutions. Formed in 1966 as the Thad Jones/Mel Lewis Orchestra, the band was co-led by its two namesakes until Jones left in 1978 to become director of the Danish Radio Big Band in Copenhagen. Lewis stayed on until his death in 1990, at which time the band changed to its present name and appointed Jim McNeely as composer in residence. 1999's *Thad Jones Legacy* is a tribute to Jones, who not only played trumpet and flugelhorn with the band, but gave it its signature sound with his original compositions, all of which he also arranged. "Central Park North," written in 1969, is "Jones's attempt to come to grip with funk," stated Francis Davis in the album's liner notes. "Similar in heft and mobility to some of George Russell's pieces in the same vein, "Central Park North" is a wonderful blend of things—dissonance with swiveling hips. On balance, it's a near-masterpiece."

0:00	Tracks opens with guns a blazing, full-throttle introduction
0:55	Bassist Dennis Irwin sets up funk groove; piano and drums enter briefly before the horns enter with main melody
2:02	Scott Wendholt solos lyrically on flugelhorn as the funk groove comes to a complete stop
2:45	New, ballad tempo is established as Wendholt continues soloing
3:48	Dirtier funk groove is set up by drummer John Riley to support Glenn Drewes's plunger trumpet solo over a 12-bar blues
5:12	Funk groove continues as Dick Oatts solos on soprano saxophone
6:32	Shout chorus, with full scoring for horns
7:07	Drum solo by Riley
7:20	Riley, then Irwin re-establish same up-tempo funk groove from 0:55
7:33	Horns re-enter, song comes to dramatic conclusion

drummer Bobby Previte, as well as other notable composers such as Anthony Braxton and Elliot Sharp. To date, the band has released two albums, 1990s *The New York Composers Orchestra* and 1992s *First Program in Standard Time.* As for now, "We have not been active for a while, [but] we have the material for a new CD," according to Horvitz. New York is also the home base for other contemporary big bands, including the Millennial Territory Orchestra, which got its start with an extended engagement at the Greenwich Village nightclub Tonic and is led by slide trumpeter Steven Bernstein, and Jason Lindner and the Ensemble, which had a long residency at Smalls and is led by pianist/composer Lindner.

Undeniably the most important of the new big bands is the **Maria Schneider Orchestra**, led by one of the most charismatic and brilliant arranger/composers in jazz today. **Maria Schneider** (1960–) grew up in Minnesota, studied piano and music theory, and eventually attended the University of Minnesota. It was after hearing a collegiate performance of Leonard Bernstein's ballet *Fancy Free*, she realized her calling: "I was hoping to be a composer of some sort, but I wasn't sure if I had the talent," she recalled. "But that night…I remember thinking, 'Oh, my God. This is what I want to do.'" After earning her bachelor's degree from Minnesota and attending the University of Miami, Schneider earned a master's degree in jazz writing and contemporary media from the Eastman School of Music in 1985. That same year she moved to New York City, where she received a grant to study with composer/arranger Bob Brookmeyer, with whom she would continue to work until 1991. "He was the person who made my career happen. And he's still the man I go to when I get stuck or frustrated." With Brookmeyer's help, Schneider was able to get her foot in the door writing arrangements for the Vanguard Jazz Orchestra. In 1985 Schneider also began an apprenticeship with legendary composer/arranger Gil Evans, after an offhand remark to one of his friends about how much she admired his work resulted in an interview with Evans. Evans' ability to musically convey emotion was the most appealing thing about his compositions and arrangements, in Schneider's eyes. "When I first heard Gil's music, I heard the passion of music," she later told *DownBeat*. "I realized that this was the emotion I wanted to express in my own music." She worked with Evans on several projects including the film *The Color of Money* until his death in 1988.

After co-leading a rehearsal band with then–husband trombonist John Fedchock from 1989 to 1992, in 1993 she started the Maria Schneider Orchestra. Early on, the band was able to secure a regular Monday night residency at the now-defunct Greenwich Village club Visiones that lasted until the club closed in 1998. The first LP release of the MSO, *Evanescence*, a tribute to Schneider's mentor Gil Evans, displays her ability to write beautifully impressionistic compositions and arrangements and earned her two Grammy nominations. The MSO's second album *Coming About*, released in 1995, features a 30-minute, three-movement suite entitled "Scenes from Childhood" that starts with the sound of a Theremin and ends with "iridescent clouds of sound that shimmer into silence." *Coming About*, as well as its follow-up *Allégresse* (2000) were both nominated for Grammys; the latter LP was also named by both *Time* and *Billboard* as one of the top ten recordings of 2000. Schneider finally won a Grammy for her 2004 album *Concert in the Garden*, which was also named Album of the Year by the Jazz Journalists Awards and the *DownBeat* Critics Poll. Both groups also named her Arranger of the Year (her fourth such award from *DownBeat*) and Composer of the Year. Her latest recording *The Thompson Fields* was released in June 2015 and won the Grammy Award for Best Large Jazz Ensemble Album in 2017. It was her fifth Grammy.

Schneider has always been able to attract the cream of New York's jazz crop and has included saxophonists Steve Wilson and Rich Perry, trumpeters Ingrid Jensen and Laurie Frink, guitarist Ben Monder and pianist Kenny Werner. She has also taken complete control of her business affairs, and releases her music through **ArtistShare**, an innovative music collaborative in which artists release their music through Internet sales only; *Concert in the Garden* was the first ArtistShare album to win a Grammy. Schneider has also launched a "Live" project on ArtistShare, in which her fans are able to download pictures, interviews, outtakes, and videos that document the band as it goes out on tour. Her schedule is filled with constant touring as well as writing works commissioned by orchestras from around the world, including the Orchestre National de Jazz (Paris), the Norrbotten Big Band (Sweden) and the Metropole Orchestra (Netherlands), and a commissioned work for the Pilobolus Dance Theatre. She is also in great demand as an educator and clinician at institutions of higher learning.

Other Developments in Jazz From the 1980s and 1990s

Jazz Education

One of the most profound changes in jazz in the 1980s was the arrival of a new generation of young players with seemingly unlimited talent who were the products of the now well-established jazz educational system. "The institutionalization of jazz education made advanced technical skills commonplace," wrote Stuart Nicholson, "with colleges producing young musicians well versed in the craft of improvisation who might have stunned the jazz world just 20 years before with their technical prowess." Although the phenomena had really started in the 1970s, by the 1980s it seemed as if young jazz virtuosi were coming out of the woodwork. Formal jazz education programs had begun in the 1940s, and by the 1950s programs at North Texas State University (now the University of North Texas), the University of Miami, and **Berklee College of Music** in Boston had become leaders in the field. By the 1970s jazz education was ubiquitous in colleges and high schools across the country, and by 1981 there were by one estimate 400,000 student musicians playing in 20–25,000 junior high, high school, college, and university bands in America. Berklee's reputation as a bona fide jazz trade school (with graduates that included Quincy Jones, Gary Burton, and Josef Zawinul) would be further enhanced in the 1980s with its ever more impressive list of alumni and faculty that included many of the musicians discussed in this chapter. But there was a downside to the ascendancy of the college-educated jazz musician. "With so many musicians supporting the same sources of stylistic inspiration, similarity in concept and execution was inevitable…consequently individuality became less important than shared values of craftsmanship—technique, familiarity with the harmonic and rhythmic conventions of the music, an orthodox tone, and precise articulation." Guitarist Pat Metheny adds: "We're at a point now with so many great young players, it's a little like there's a thousand channels on cable but there's nothing to watch." If, he says, "it doesn't come embodied in a conception, it's 'just' good playing." In other words, was jazz in the 1980s becoming an era in which technical skills trumped individuality, and youth a bigger asset than experience?

Women in Jazz

Throughout the history of jazz, the role that women have played has generally been as vocalists: Billie Holiday, Ella Fitzgerald, Sarah Vaughan, Betty Carter, Anita O'Day, Carmen MacRae, and Dianne Reeves are just a few of the many names that come to mind. However, when it comes to instrumentalists, jazz has traditionally been a men's club. Many of the important women instrumentalists, including Lil' Hardin Armstrong, Mary Lou Williams, Marian McPartland, Alice Coltrane, and more recently Toshiko Akiyoshi and Carla Bley, have been pianists. Until recently, except for a few 'all-girl' novelty bands in the swing era and a few others (such as trombonist Melba Liston), women, because of the many factors that have traditionally suppressed them from achieving their rightful place in the workplace, have largely stayed away from careers as jazz musicians. Beginning in the 1980s, largely due to changing societal attitudes that have resulted in a large influx of women into the workforce and jazz education programs in high school and college, more and more women are making careers for themselves as jazz musicians. One sign of the progress women have made is the annual Mary Lou Williams Women in Jazz Festival held at the Kennedy Center, an event that is always enthusiastically received and sold out. Among the most prominent female jazz musicians in recent years (who are not already mentioned in this text) include soprano saxophonist Jane Ira Bloom, pianists Michele Rosewoman, Eliane Elias, Renee Rosnes, Hiromi Uhera, and Patrice Rushen, trumpeter Laurie Frink, guitarist Leni Stern, drummer Sherrie Maricle, trombonist Sarah Morrow, and tenor saxophonist Anat Cohen. Three that deserve our attention are trumpeter Ingrid Jensen, violinist Regina Carter, and drummer Terri Lyne Carrington.

Canadian **Ingrid Jensen** first came to the US to attend Berklee College, from which she graduated in 1989. After moving to New York and working her way up from playing in the subways, she has established a solid resume working with Maria Schneider and Dave Douglas among others and now teaches at the Peabody Conservatory in Baltimore. She has released six albums on Enja and ArtistShare, including *Vernal Fields*, which won a Canadian Juno Award. Detroit native **Regina Carter** made her recording debut as a leader in 1995 with Regina Carter on the Atlantic subsidiary Wea. Since then she has released five more albums including Motor City Moments, her homage to Detroit musicians, and *Paganini: After a Dream*, on which she used Niccoló Paganini's famous Guarneri violin. In 2006 she was awarded a $500,000 MacArthur Fellows "Genius" Award. One of Carter's latest releases is 2010's *Reverse Thread*, on which she explores the boundaries between jazz and African folk music. Former child prodigy **Terri Lyne Carrington** started playing the drums at 7, received a full scholarship to Berklee College at age 10, and moved to New York at 18, where she began playing with such artists as Stan Getz, James Moody, and Dave Sanborn. At 24 she moved to Los Angeles and became the drummer on the nationally syndicated Arsenio Hall Show. That same year (1989) she released her debut album, the Grammy-nominated *Real Life Story*, which featured Carlos Santana, John Scofield, and Grover Washington, Jr. She is most in demand as a session musician and has recorded for Wayne Shorter, Herbie Hancock, Cassandra Wilson, and Danilo Pérez, among others. Her latest LP is 2010's soulful *More to Say*, which features a stellar supporting cast that includes keyboardist George Duke, vocalist Nancy Wilson, and bassist Christian McBride, among others.

Music Analysis

Track 55: "Artistiya"

Doumbia) Regina Carter from the album *Reverse Thread* recorded at the Barber Shop Studios 2010. Personnel: Regina Carter: violin; Gary Versace: accordion; Chris Lightcap: bass; Alvester Garnett: drums, percussion

Since Regina Carter made her recording debut as a leader in 1995, she has earned a reputation as a fearless musical experimentalist. With her latest release *Reverse Thread*, Carter explores the boundaries where jazz and African folk melodies meet. Using an unconventional backup group of bass, accordion, drums, and percussion, occasionally augmented by the West African kora, Carter achieves her mission with satisfying results. "Artistiya" was written by Mariam Doumbia, one half of the Malian duo Amadou and Mariam; Carter stays faithful to the original recording by achieving a remarkably vocal-like quality to her violin playing. After stating the head, Carter launches into a jazz improvisation that at one point briefly quotes Copland's "Hoedown." Throughout the recording, accordionist Gary Versace, bassist Chris Lightcap, and drummer Alvester Garnett provide inspired support.

0:00	Drummer Alvester Garnett and bassist Chris Lightcap set up groove
0:11	Violinist Regina Carter enters with solo ad-libs; accordionist Gary Versace quietly enters in supporting role
0:32	Carter plays head
1:18	Violin solo by Carter
1:52	Violin breakdown; Carter quotes Aaron Copland's "Hoedown"
2:32	Carter restates head
3:16	Group returns to opening groove, song winds down and ends

Name _____ Date _____

Study Questions

A New Paradigm: Jazz in the 1980s and 1990s

1. Describe why there is so much controversy surrounding Wynton Marsalis.

2. In what ways are the Neo-traditional movement and the avant-garde movement different?

3. Describe why the Neo-traditional movement is controversial and the roles of Albert Murray and Stanley Crouch.

4. Describe some of the ways in which jazz/rock fusion evolved into fusion in the 1980s.

5. Describe the characteristics of Downtown music and list some major performers in the scene.

6. What are the differences between M-base, acid jazz, and jam bands?

7. Name some of the bands that kept the big band tradition alive since the swing era, and what role they played (especially the Thad Jones/Mel Lewis Orchestra).

8. Describe how jazz education has impacted jazz since 1980, and some of the positive and negative consequences of these changes.

9. Describe how the role of women in jazz has changed in recent years, and why those changes have taken place.

10. What is ArtistShare?

JAZZ IN THE NEW MILLENNIUM

At the Millennium: The Death of Jazz

Ken Burns to the Rescue

It was January 1, 2000—the beginning of the 21st century. The preceding months had been a time to reflect on the past 100 years and all of the advancements in technology, the arts, and civilization in general. Magazines and TV networks were busily gathering experts to make Top 100 lists of the most important this or the most influential that. Topping the various lists were such people and things as the Beatles, the personal computer, the first moon landing, and World War II. One end-of-the-century list that was not made was the Top 100 Jazz Records. Come to think of it, there weren't any jazz end-of-the-century lists. In fact, outside of the musicians who were trying to make a living by it, it seemed nobody was really thinking about jazz all that much. Jazz CD sales were at an all-time low of 2.9% of total CD sales and were destined to get worse (the most recent figures available from 2006 put the number at 2%). But almost before the oft-asked rhetorical question "Is jazz dead" could get asked once again, a knight in shining armor appeared on the horizon in the persona of filmmaker **Ken Burns**. Burns had already made a number of widely viewed public television documentaries that had renewed interest in their topics, most notably *The Civil War*, which was watched by approximately 40 million people in 1990. When it was announced that he would make a documentary about the history of jazz, many felt that Burns would work his magic once again and revive the struggling art form. In January 2001, the highly anticipated 19-hour *Jazz: A Film by Ken Burns* was shown over seven nights during prime time, accompanied by the publishing of a coffee table book and the release of nearly 30 compilation "best of" CDs of various artists. Rich in archival and never-before-seen film footage and bathed in a soundtrack of memorable jazz recordings, Burns made Jazz the final segment in his trilogy on the American experience: the strength of our constitution (*The Civil War*), the nature of our pastimes (*Baseball*), and the beauty of our art (*Jazz*). But critics began their attacks almost before the first episode was over. Among the complaints was Burns's "Crow-Jim" racism (Black musicians are portrayed as "innovators" while whites are "appropriators"), his decisions on whom to leave out (including Lennie Tristano, Keith Jarrett, Weather Report, and Michael Brecker), and the preachiness and overexposure of "talking head" Wynton Marsalis. Burns was also widely criticized for packing the last 40 years of jazz history into the final 2-hour episode and completely ignoring anything past *Bitches Brew*. Was it Burns' statement writ large that he too thought jazz was dead? In the end, none of it mattered, as the resurgence in the music's popularity that *Jazz* was supposed to bring just didn't happen.

KEY TERMS

Frederick P. Rose Hall
Glocalization
Jazz: A Film by Ken Burns
Jazz at Lincoln Center
Thirsty Ear Records Blue Series
Vocalese
Wordless Vocal

KEY FIGURES

Ambrose Akinmusire
Ben Monder
Brad Mehldau
Cécile McLorin Salvant
Chris Potter
Darcy James Argue
Dave Stryker/Stryker/ Slagle Band
esperanza spalding
Jan Garbarek
Jason Moran
Joe Lovano
Karrin Allyson
Ken Burns
Kenny Garrett
Kenny Werner
Kurt Elling
Kurt Rosenwinkel
Nicholas Payton
Roy Hargrove
Terance Blanchard
Vijay Iyer

IMPORTANT ALBUMS

Art of the Trio series—Brad Mehldau
Come Away with Me—Norah Jones

Future Shock—Herbie Hancock
Historicity—Vijay Iyer
Live in Chicago—Kurt Elling

Radio Music Society—esperanza spalding
Real Enemies—Darcy James Argue

Seven Days of Falling—Esbjörn Svensson Trio
TEN—Jason Moran

In reality, the 21st century began on January 1, 2001, a fact that nearly everyone chose to disregard in the excitement to get on with the business of millennium advancement.

City of Glass

As discussed in Chapter 10, Wynton Marsalis was named artistic director of **Jazz at Lincoln Center** in 1987, at the time, a somewhat controversial move. As it turned out, Marsalis eventually transcended his early image as jazz gadfly and became a much more valuable asset than his title would suggest. In 2003, as their new performance center was under construction with some $28 million yet to be raised, *Atlantic Monthly* writer David Hajdu asked JALC board chairperson Lisa Schiff the following question: "What strategy does the board of directors have for raising the necessary funds?" Her answer: "Wynton." Schiff's simple, straightforward—and ultimately highly successful—approach illustrates the position of power and influence that Marsalis holds in the cultural and corporate worlds today. On October 18, 2004, the $128 million **Frederick P. Rose Hall**, a spectacular complex of performance halls, educational center, and state-of-the-art recording studio opened in the Time Warner Center on New York's Columbus Circle. Included in the facility is the 1200 seat Rose Theater, designed so that no audience member is more than 90 feet from the stage; the 400+ seat Allen Room, which boasts a 50'x90' wall of glass behind the stage that dramatically overlooks Central Park and the New York skyline; and the intimate Dizzy's Club *Coca-Cola*, which is a bona fide jazz club featuring live jazz seven nights a week. Although the programming of Lincoln Center events drew extreme criticism in its early years, the rigid parameters of what and who could appear were eventually relaxed. One striking example: the July 2007 performance in the Allen Room by the four-piece ensemble So Percussion and the electronic laptop duo Matmos, accompanied by trumpeter Dave Douglas and experimental harpist Zeena Parkins—hardly the stuffy "uptown" type of repertory concert that critics were carping about in the late 1980s and early 1990s.

BOX 11-1	The Frederick P. Rose Hall/Jazz at Lincoln Center

Opened on October 18, 2004, the Frederick P. Rose Hall is located in the Time Warner Building at Columbus Circle (60th and Broadway) in New York City. It is the home of Jazz at Lincoln Center, which was established in 1987. Included in the facility are:

- The Rose Theatre, a 1200 seat auditorium
- The Allen Room, a 400 seat space with a dramatic glass wall behind the stage
- Dizzy's Club Coca-Cola, a small jazz club
- Irene Diamond Education Center
- A 96-track, 2,400 square foot state of the art digital recording studio
- Nesuhi Ertegun Jazz Hall of Fame, a multimedia installation that features an 18-foot video wall and interactive computer kiosks

Important Jazz Musicians in the 21st Century

As jazz moves into its second century, it is an appropriate time to take a look at some of the musicians that are currently bringing new vitality to the music. Here's a look at a few of them, grouped by instrument.

The Writers: spalding, Blanchard, and Argue

esperanza spalding is emblematic of the next generation of jazz musicians in that she combines a restless musical spirit with seemingly unbridled talent. Her music—nearly all of which consists of strikingly original compositions—combines elements of jazz, hip-hop, singer/songwriter, soul, Brazilian, and gospel music. She was born and raised in Portland by an African American father and a Welsh/Hispanic/Native American mother. After attending Portland State University for a short time, she applied to Berklee College of Music and won a full scholarship. By the time she was 20, she became a professor at the school—the youngest in its history. spalding released her first album *Junjo* in 2006 and her second, *Esperanza* (on which she sings in English, Spanish, and Portuguese) in 2008, both on small independent labels. By the time her third album *Chamber Music Society* was released in 2010, spalding was beginning to gain national attention. The album ultimately went to #1 on the Billboard jazz charts. The following year she won the Best New Artist Grammy, the first time a jazz musician had won the award. (Perhaps even more remarkable, she beat out Justin Bieber.) She also won the *DownBeat* Readers Poll for Jazz Artist of the Year. Her highly acclaimed fourth album *Radio Music Society* was released in 2012, which not only hit #1 on the jazz charts but went to #10 on the *Billboard* pop chart. spalding's vision for her music is to transcend category, much like Duke Ellington many years ago. "I guess you have to be in some genre because people have to have words to describe you," spalding said. spalding's latest work is the opera *Iphegenia*, which she co-authored with Wayne Shorter. *Iphigenia* received its world premiere at the Cutler Majestic Theatre

Music Analysis

Track 56: "Endangered Species"

(spalding/Shorter/Vitarelli) esperanza spalding from the album *Radio Music Society* recorded 2011. Personnel: esperanza spalding: vocals, electric bass; Leo Genovese: piano, keyboards, guembri; Teri Lyne Carrington: drums; Darren Barrett: trumpet; Daniel Blake: saxophone; Jef Lee Johnson: guitar; Lalah Hathaway: vocals

"Endangered Species" is a wonderful example of esperanza spalding's unique mix of soul, gospel, funk, jazz, and Brazilian music that is showcased on the album *Radio Music Society*. The song was co-written with jazz legend Wayne Shorter (Miles Davis 60s Quintet, Weather Report) and Joseph Vitarelli. The recording also features Lalah Hathaway, the daughter of the late soul singer Donny Hathaway. *Radio Music Society* received positive reviews from jazz critics and wide support from fans, both jazz and non-jazz alike, debuting at #10 on the Billboard pop chart. The music is almost indefinable, combining elements of big band jazz, funk, gospel, soul, and hip-hop. The album was also supported with a nationwide tour in which the band surrounded a giant radio dial. "Endangered Species" combines super-tight funk grooves with dense vocal harmonies and a number of tasteful improvised solos.

0:00	Keyboardist Leo Genovese begins the song improvising on the African guembri
0:20	Vocal harmonies introduce the song title
0:35	Drum fill brings in the band with a tight-knit funk groove
0:54	Vocal verse begins
2:00	Short synthesizer solo by Leo Genovese
3:34	Trumpeter Darren Barrett solos using a Harmon mute
4:37	Vocal re-enters
4:54	Synthesizer solo
5:11	Vocal re-enters
5:48	Final vamp begins, as track fades, horns engage in short collective improvisation, Genovese improvises on guembri

Music Analysis

Track 57: "Breathless"

(Blanchard) Terence Blanchard from the album *Breathless*, recorded in 2015 at Esplanade Recording Studios, New Orleans. Released May 26, 2015, on Blue Note Records. Personnel: Terence Blanchard: trumpet; Fabian Almazan: piano; Charles Altura: guitar; Donald Ramsey: bass; Oscar Seaton: drums

Breathless is Terence Blanchard's 21st album and the first with his group the E-Collective. The album's title and concept were inspired by the 2014 death of Eric Garner while in a police chokehold in New York City. As several police officers held Garner facedown on the pavement, he called out "I can't breathe" before falling unconscious. Although Garner's death was ruled a homicide, the officer who administered the chokehold was not indicted. The incident stirred nationwide protests and foreshadowed the similar death of George Floyd at the hands of police in 2020. "Breathless" is an almost formless composition that has intermittent vocal musings and trumpet solos by Blanchard. The words "we can't breathe" are repeated as the song fades out.

in Boston on November 12, 2021. spalding not only wrote the opera's libretto and helped found its independent production company (Real Magic, named after a remark made by Shorter) but also plays one of the production's six Iphigenias. At present, she has won four Grammy Awards.

New Orleans native **Terence Blanchard** has been a force to be reckoned with since emerging as the trumpeter for the Jazz Messengers in 1982 (replacing Wynton Marsalis). His early life included studying with Marsalis patriarch Ellis Marsalis and at Rutgers University. Blanchard is known today as one of the hottest new trumpeters in jazz, but he is most famous for his composing talents. To date, he has scored more than 40 films, written two operas, and released 23 albums containing primarily his own compositions. He is perhaps best known for his work scoring eight of Spike Lee's including *Jungle Fever*, *Summer of Sam*, and *BlacKkKlansman*. In 2006, Blanchard also composed the score for Lee's *When the Levees Broke: A Requiem in Four Acts*, a four-hour HBO documentary about Hurricane Katrina. In 2000 he was named artistic director of the Thelonious Monk Institute of Jazz at UCLA. Blanchard's jazz albums include 1993's *Malcolm X Jazz Suite*, featuring music he wrote for Lee's film *Malcolm X* arranged for 5-piece jazz group, and 2021's *Absence*, featuring his group the E-Collective and the Turtle Island String Quartet. To date, he has won five Grammys, including two for improvised solos. Blanchard's two operas, 2013's *Champion*, and 2019's *Fire Shut Up in My Bones* (based on the memoir of the same name by Charles Blow), have achieved widespread critical acclaim. *Fire* opened the Metropolitan Opera's 2021/2020 season on September 27, 2021, making it the first opera by a Black composer performed at the Met since its founding in 1883.

Vancouver, Canada native **Darcy James Argue** studied at McGill University in Montreal before moving to the US, where he studied with legendary jazz composer/arranger Bob Brookmeyer at Boston's New England Conservatory of Music. In 2005 he founded Secret Society, a group that has been referred to as a post-modern big band. The group has released three albums, 2008's *Infernal Machines*, 2012's *Brooklyn Babylon*, and 2016's *Real Enemies*, all three having garnered Grammy nominations. In 2015, he was awarded a Guggenheim Fellowship in Music Composition and a Doris Duke Artist Award. He has received commissions from the Fromm Music Foundation, the Jazz Gallery, the Manhattan New Music Project, the Jerome Foundation, and BAM, as well as ensembles including the Danish Radio Big Band, the Hard Rubber Orchestra, the West Point Jazz Knights, and the Orquestra Jazz de Matosinhos.

Real Enemies was commissioned and premiered by the Brooklyn Academy of Music's Next Wave Festival in 2016. It was inspired in part by Kathryn Olmsted's 2011 book "Real Enemies: Conspiracy Theories and American Democracy, World War I to 9/11," and includes 13 movements that are sometimes punctuated with snippets of famous speeches on the subject. Commenting on the work, Argue presciently warned "It can be maddening to deal with a political environment where it seems like the truth has no purchase anymore." (This was in 2015, years before the onset of the present fake news environment.) The work is overwhelming in its scope and ambition. Critic Nate Chinen wrote in the *New York Times* that it is "something close to a perfect collaboration" between music, text, and image—as well as "a work of furious ambition that feels deeply in tune with our present moment." In *The Nation*, critic David Hajdu began his review by saying, "I cannot imagine a work in any art form that could evoke the particular madness of our time with more potency."

The Pianists: Mehldau, Iyer, and Moran

Other contemporary jazz musicians that continue to reinvent and redefine the music in new and compelling ways include a number of young and strikingly original pianists. Connecticut native **Brad Mehldau** moved to New York City in 1988 to enroll at the New School and study with pianists Fred Hersch and Kenny Werner. Mehldau quickly became an active participant in the local club scene and made his recording debut in 1991 on an album by alto saxophonist Christopher Hollyday. Recording prolifically as a sideman with saxophonists Joshua Redman and Mark Turner and guitarist Peter Bernstein among others, Mehldau formed his own trio in 1994 with bassist Larry Grenadier and drummer Jorge Rossy. Since his 1995 major label debut *Introducing Brad Mehldau* on Warner, he has released 34 more LPs as a leader, including the five-album *Art of the Trio* series. He has also made a number of collaborative albums, including the highly acclaimed *Metheny—Mehldau* in 2006, *Mehliana: Taming the*

Music Analysis

Track 58: "Exit Music (For a Film)"

(Radiohead) Brad Mehldau from the album *Songs: Art of the Trio Volume Three* recorded May 27, 28, 1998 at Right Track Studio, New York City. Personnel: Brad Mehldau: piano; Larry Grenadier: bass; Jorge Rossy: drums

Brad Mehldau quickly made a name for himself in the jazz world after his major-label debut in 1995 with a stunning display of technique and creativity. Critic Nate Chinen has stated that "Mehldau is the most influential jazz pianist of the last 20 years." After his highly touted initial Warner Bros. release *Introducing Brad Mehldau*, he released the five-CD *Art of the Trio* series between 1996 and 2000. *Songs: Art of the Trio Volume Three* contains ten songs, five of which are originals, but also reaches into the great American songbook with standards such as "Bewitched, Bothered and Bewildered" and "For All We Know." Mehldau has also made somewhat of a name for himself with his very personal interpretations of songs from the rock and pop canon, and includes "River Man" by Nick Drake and "Exit Music (For a Film)" by Radiohead here. As of 2015, Mehldau has released 29 albums and has been nominated for five Grammy Awards.

0:00	Pianist Brad Mehldau introduces the song with simple chords
0:13	Melody is stated in the piano, drummer Jorge Rossy and bassist Larry Grenadier quietly enter
2:10	Mehldau begins first chorus of improvised solo
3:23	Head is restated, song winds down to a close

Dragon with percussionist Mark Guiliana in 2014, and 2016's *Chris Thile & Brad Mehldau* with virtuoso mandolinist Thile. Mehldau's influences come primarily from Bill Evans and Keith Jarrett, but his style is distinctively original. He is completely ambidextrous and often switches the traditional roles of the left and right hands. He also employs complex polyrhythms and is comfortable playing in odd meters. While Mehldau often reaches into the standard jazz repertoire and is a prolific composer, he has also drawn attention for his covers of songs written by rock bands, including Radiohead's "Exit Music (For a Film)" from *Songs: The Art of the Trio Volume Three*. Mehldau's most recent album is *Suite: 2020*, a solo piano reflection of the uncertainties of living in the midst of a pandemic.

Rochester, New York native **Vijay Iyer** has successfully fused jazz with musical influences from his Indian heritage into a highly original style. Iyer is one of the most highly educated musicians in jazz today, having received undergraduate degrees in math and physics from Yale and a Ph.D. in music and cognitive sciences from UC-Berkeley. While in the Bay area in the mid-1990s, Iyer began playing jazz gigs and making connections in the local scene. It was during this time that he met alto saxophonist Rudresh Mahanthappa, who shares Iyer's Indian ancestry and would become a regular collaborator in the future. Iyer's solo debut came in 1995 with *Memorphilia* on the independent Asian Improv label, an album that featured his three working groups, the Vijay Iyer Trio, the four-piece Poisonous Prophets, and the five-piece Spirit Complex.

Iyer's major break came in 2003 with the release of two imaginative albums, *Blood Sutra* and *Reimagining* using his quartet of Mahanthappa, Stephan Crump on bass, and Marcus Gilmore on drums. 2004 saw the release of the *In What Language?*, a collaboration with poet/hip-hop artist Mike Ladd. The album is a genre-defying commentary on post 9/11 America where ordinary citizens are subjected to wiretapping, illegal searches, and interrogations that include spoken word commentary throughout. Iyer's 2009 album *Historicity* features his trio of Stephan Crump on bass and Marcus Gilmore on drums playing original compositions mixed in with interpretations of music by Leonard Bernstein, Stevie Wonder, and hip-hop artist M.I.A. Among the many awards it has won are Album of the Year by the *DownBeat* Critics Poll and the *Village Voice* Critics Poll, and the Jazz Album of the Year by both *The New York Times* and National Public Radio. In 2013, he became a MacArthur Fellow. His most recent album is 2021's *Uneasy*, recorded with bassist Linda May Han Oh and percussionist/composer Tyshawn Sorey.

Jason Moran came to New York from Houston to attend the Manhattan School of Music, where he studied with such progressive pianists as Jaki Byard, Muhal Richard Abrams, and Andrew Hill. He joined Greg Osby's band in 1997 and made his recording debut on Osby's LP *Further Ado*. Moran's own debut, *Soundtrack to Human Motion* came in 1999 after signing with Blue Note. In quick succession, Moran has recorded six more diverse and interesting albums for Blue Note, including the solo *Modernistic*, which includes a cover of Afrika Bambaataa's "Planet Rock," and a complete reworking of the standard "Body and Soul;" *Same Mother*, an homage to the blues; and *The Bandwagon*, recorded live at the Village Vanguard. A recent release of Moran's is *Artist in Residence*, which employs a number of unusual concepts, including the mimicking of an artist's monologue on piano ("Artists Out to be Writing"); and a piano rendition of a Carl Maria von Weber tune ("Cradle Song") accompanied by pencil scribbling in memory of his mother, who used to take notes when he practiced as a child. The album also includes a rollicking version of the civil rights anthem "Lift Every Voice." One might say that Moran's star is rising: in 2010 he released his seventh album *TEN* was appointed to the faculty of the New England Conservatory and was awarded one of the year's $500,00 MacArthur Fellowship Grants. A recent

accomplishment was his score for *Between the World and Me* by Ta-Nehisi Coates, which premiered at the Apollo Theater in 2018.

The Guitarists: Monder, Rosenwinkel, and Stryker

Three guitarists who have followed divergent paths on the contemporary scene are also deserving of a closer look. Ben Monder is a native New Yorker who, after attending the University of Miami and Queens College returned to the city in 1984 and for the next two years "spent most of his time working with R&B and wedding bands and practicing jazz in his room," according to his website. (Monder offers three different bios on his website, so it's hard to tell where the truth lies...) His break came in 1986 with organist Brother Jack McDuff's band, after which Monder lived in Vienna for a while. On returning to New York, Monder became a sought-after sideman, working with (among others) Paul Motian, Lee Konitz, and Maria Schneider. His debut album as a leader came with 1995's *Flux*, a trio recording on the indie Songlines label; he has since released five more albums on his own and played on more than 90 for other artists. Monder has often worked with vocalist Theo Bleckmann, with whom he has recorded four albums. Bleckmann's role is often to sing wordless vocal lines, because as Monder says, "I don't hear other instruments playing those parts...I guess maybe the voice makes the complexity a little more accessible." One of Monder's more noteworthy albums is 2005's *Oceana*, a beautiful, atmospheric quartet recording with Bleckmann once again on vocals. According to Monder, 90% of *Oceana* is "through composed," rather than the usual head-solos-head format; the mood throughout can perhaps be described as Metheny with a European flavor. His latest release is *Day After Day*, recorded with bassist Matt Brewer and drummer Ted Poor.

> **Wordless Vocal**—
> a written vocal line sung without words, using instead simple monosyllabic "oohs" or "aahs."

Perhaps slightly more traditional in direction than Monder, Kurt Rosenwinkel is nonetheless not afraid to take chances musically. Rosenwinkel grew up in Philadelphia, became interested in jazz through the music of Pat Metheny, Bill Frisell, and John Scofield. He ultimately attended Berklee College for two years before leaving school to tour with Gary Burton. After moving to New York in the early 1990s, he went about putting together his own quartet, which included tenor player Mark Turner, bassist Ben Street, and drummer Jeff Ballard. After making his recording debut as a leader in 1996 (*East Coast Love Affair*), Rosenwinkel signed with Verve in 1999, with whom he released four albums. Like Monder, Rosenwinkel likes wordless vocals, but supplies them himself as a doubling to his guitar solos, and sees it as an integral part of his sound. "For a long time I felt that I never got my sound on records. Then I realized that the vocal is actually part of the sound. So I began...really exploring it as a possibility." Rosenwinkel also often employs alternate tunings, with purposely-unpredictable results, as on "A Shifting Design" from *The Next Step* (2001): "It's an alternate tuning, so when I play the guitar I have no idea what chords or notes I'm playing. The tune is all shapes to me." A recent Rosenwinkel release, *Star of Jupiter* (2012) contains 12 original compositions and features Aaron Parks on piano, Eric Revis on bass, and Justin Faulkner on drums.

For Omaha native Dave Stryker, the blues has always been a primary source of inspiration around which he has built a solid career as a jazz guitarist. Stryker got into music via the Beatles and Stones, but soon found himself gravitating towards blues-oriented groups such as the Allman Brothers, and from there to soulful jazz guitarists like Wes Montgomery, Grant Green, and the underappreciated Billy Rogers. Stryker moved to New York in 1980 and got his first big break in 1984 when organist Brother Jack McDuff asked him to join his band. "We played up at this place in Harlem called Dude's Lounge from 10–4 in the morning. He

Music Analysis

Track 59: "Echolalia"

(Monder) Ben Monder from the album *Oceana* recorded at Brooklyn Recording, Brooklyn, NY between January and October 2004. Personnel: Ben Monder: guitar; Theo Bleckmann: voice; Kermit Driscoll: bass; Ted Poor: drums

Ben Monder's *Oceana* is the third and most satisfying of his collaborative efforts with vocalist Theo Bleckmann. The album is a moody dreamscape that evokes images of other worlds, perhaps below the sea. "Echolalia" is a showcase for the talented Bleckmann, whose pure-toned voice adds a magical quality to the mix of instruments. Notes Nils Jacobson of allaboutjazz.com, "Bleckmann is a rare and notable exception in the jazz vocalist world because he has turned his voice into an effective instrument with its own characteristically clean, thin resonance." On "Echolalia" these qualities are brought to the foreground beautifully by Monder and band with their skillful, sensitive accompaniment. Monder's solo, starting at 3:20, is another highlight of the piece.

0.00	Guitarist Ben Monder sets up the brooding, mid-tempo groove with support from drummer Ted Poor and bassist Kermit Driscoll
0.08	Vocalist Theo Bleckmann enters with the melody, sung as a wordless vocal line
1.04	Melody repeats
1.56	New theme is introduced as Poor and Driscoll gradually evolve into a semi-samba groove
2.59	Main theme reintroduced
3.20	Monder begins guitar solo with staccato muted guitar
5.07	Bleckmann re-enters
6.04	Main theme reintroduced; track vamps out as Bleckmann sings variations of the theme

was the old school, and there's really not too much of that around anymore, which was really a great experience." While with McDuff, Stryker met his long-time musical collaborator, alto saxophonist Steve Slagle. After leaving McDuff in 1985, Stryker played in tenor saxophonist Stanley Turrentine's band from 1986 to 1995.

Stryker has several ongoing groups: the **Stryker/Slagle Band**, a hard-blowing post-bop quartet co-led by alto player Steve Slagle; the Blue to the Bone Band, an 8-piece four horn blues/funk band; The Shades Project, reminiscent of 1970s Miles Davis recordings that includes *Bitches Brew* drummer Lenny White; and Trio Mundo, which Stryker describes as "world music meets jazz trio" and includes former Weather Report drummer Manolo Badrena. One of Stryker's most recent recordings, *Big City*, was voted one of the top CDs of 2005 by *DownBeat* and includes fellow former Omahan Victor Lewis on drums. In recent years he has released to great critical and popular acclaim four albums in the *Eight Track* series, featuring jazz renditions of pop tunes from the 1960s and 1970s. His latest release, 2022's *As We Are*, features bassist John Patitucci, drummer Brian Blade, and String Quartet arranged by pianist Julian Shore.

The Saxophonists: Lovano, Garrett, Potter

Three saxophonists who emerged in the 1990s, Joe Lovano, Kenny Garrett, and Chris Potter, helped define the new mainstream direction of jazz. For **Joe Lovano**, playing jazz is all about being attentive to the music's history while creating your own history along the way. Lovano grew up in Cleveland, where his father, Anthony "Big T" Lovano was a professional tenor saxophonist and a central figure in the local jazz scene. Joe immersed himself in his dad's jazz records as a teen and was gigging

by age sixteen (often subbing for Big T), earning enough to put himself through college. He also developed what *DownBeat* has called a "broad-shouldered, hairy-chested, tenderhearted sound."34 After attending Berklee College in Boston in the early 1970s, Lovano began working the chitlin circuit with groups led by organists Dr. Lonnie Smith (with whom he made his recording debut) and Brother Jack McDuff. In 1976, Lovano moved to New York and worked with the big bands of Woody Herman and Mel Lewis before joining Bill Frisell in the Paul Motian Trio in 1981. During the 1980s, Lovano worked with a who's who list of musicians in New York (most notably the John Scofield Quartet) and recorded several albums for European independent labels, winning rave notices from critics and fans all along the way, including Blue Note head Bruce Lundvall: "The first time I heard Joe Lovano I felt that he was the most creative and hard-swinging tenor player I'd heard in years." In 1991, he made his major-label debut as a leader on Blue Note with the album Landmarks and has since recorded more than 25 albums for the Label. Among Lovano's more interesting album projects are *Universal Language* (1992), one of several album collaborations with his wife, vocalist Judi Silvano, and *Rush Hour* (1994), a collaboration with arranger Gunther Schuller.

The resume of Detroit native and alto saxophonist **Kenny Garrett** is one of the most stellar in contemporary jazz. After a three-year stint with the Mercer Ellington Orchestra (the son of Duke) right out of high school, Garrett went on to play in the bands of Freddie Hubbard, Woody Shaw, and Art Blakey before joining Miles Davis's band in 1986, where he stayed until the trumpeters death in 1991. "Miles always wanted his musicians to push the envelope," Garrett told *DownBeat*. "He wanted you to find your own way, but if you didn't...he'd push

Music Analysis

Track 60: "Shaw"

(Garrett) Kenny Garrett from the album *African Exchange Student* recorded 1990 at RCA Studios, New York (6:40). Personnel: Kenny Garrett: alto sax; Mulgrew Miller: piano; Ron Carter: bass; Elvin Jones: drums

"Shaw" is Kenny Garrett's tribute to Woody Shaw, one of the foremost post-hard bop jazz trumpeters in the 1960s, 1970s, and 1980s. Shaw was a bandleader as well as a sought-after sideman who played with such notable figures as Art Blakey, Horace Silver, Eric Dolphy, and Dexter Gordon. His 1978 album Rosewood was nominated for two Grammy Awards and was voted the Best Jazz Album in that year's *DownBeat* Readers Poll. He died in 1989, just weeks after a fall into the path of a subway train in Brooklyn, New York severed his left arm. On "Shaw," Kenny Garrett has assembled an amazing group consisting of John Coltrane Quartet drummer Elvin Jones, Miles Davis 1960s Quintet bassist Ron Carter, and one of the 1990s hottest new young pianists (and a relative newcomer compared to Jones and Carter), Mulgrew Miller. Together the four musicians have created an exciting and dynamic tribute to the great trumpet player on Garrett's fourth album as a leader.

0.00	Introduction: alto saxophonist Kenny Garrett briefly improvises while a modal groove is set up by drummer Elvin Jones, bassist Ron Carter, and pianist Mulgrew Miller
0.10	Head is stated by Garrett
0.46	Restatement of head
1.23	Piano solo by Miller
2.35	Alto saxophone solo by Garrett
4.08	Head is restated
4.44	As rhythm section returns to opening modal groove, Garrett solos; band slowly winds song down

me to think about another way to play the song." Garrett has taken Davis's advice to heart, developing a risk-taking approach to improvisation and an edgy sound that is unique among contemporary alto players. Garrett made his recording debut as a leader with 1984's Introducing Kenny Garrett and has since recorded thirteen more albums, primarily on Atlantic and Warner. One of Garrett's more interesting albums is 1996's *Pursuance: The Music of John Coltrane*, on which he interprets the music of Coltrane with a band that includes guitarist Pat Metheny. The album won the *DownBeat* Readers Poll Album of the Year Award. "I'm trying to tell a story in a different way with the same jazz language my heroes employed—express Kenny Garrett through my own voice in this music."

Chicago native **Chris Potter** played his first jazz gig at age thirteen in South Carolina where he grew up. During his high school years, while absorbing music on record from such diverse sources as J. S. Bach, Arnold Schoenberg, Miles Davis, and Dave Brubeck, Potter studied the soprano, alto, and tenor saxophones; the bass clarinet; and alto flute. In 1989, he moved to New York to study at the New School and the Manhattan School of Music, where he graduated in 1993. In New York, Potter quickly established himself as an inventive and versatile saxophonist and secured a four-year gig with veteran trumpet player Red Rodney. Subsequent sideman gigs were with such artists as Dave Douglas, Paul Motian, and the Mingus Big Band. In 1992, Potter released his first album as a leader, *Presenting Chris Potter*, which, with six original compositions, shows off his talents as a composer and player. Potter has since released 22 more albums as a leader, and nearly all of them contain Potter's original compositions. Noteworthy albums include the 1994 live duet with pianist (and his former New School professor) Kenny Werner, *Chris Potter, and Kenny Werner*; 2004's *Lift: Live at the Village Vanguard*; 2007's *Song for Anyone*, recorded with a 10-piece chamber jazz group; and his most recent, *Sunrise Reprise* with the Circuits Trio, consisting of Potter, James Francies on keyboards and Eric Harland on drums.

The Trumpeters: Hargrove, Payton, Akinmusire

During his 30-year career, trumpeter **Roy Hargrove** released 25 albums and won two Grammy Awards. His unfortunate death at age 49 cut short a remarkable career that saw him reach the highest levels of the jazz world. After an academic career that included studies at Berklee and the New School, Hargrove released his debut album *Diamond in the Rough* in 1990 and immediately won acclaim as one of the Young Lions of jazz. In 1993, Jazz at Lincoln Center commissioned him to write an original jazz suite, *The Love Suite: In Mahogany*, which he premiered in September of that year. In 1998 his album *Habana* won the Grammy Award for Best Latin Jazz Album, recorded with his group Crisol. He won the Grammy for Best Instrumental Jazz Album in 2002 for *Directions in Music: Live at Massey Hall*, an album recorded with an all-star cast of Herbie Hancock, Michael Brecker, John Patitucci on bass, and Brian Blade on drums. From 2003 to 2006, Hargrove released three albums as leader of the RH Factor, a group that brought in influences of soul, funk, and hip-hop. During his career, he was also a sought-after sideman, recording with such jazz artists as Sonny Rollins, Jimmy Smith, and Oscar Peterson. A long-time sufferer of kidney disease, Hargrove died of a cardiac arrest on November 2, 1028, at age 49. In 2020 his widow and daughter formed Roy Hargrove Legacy LLC to preserve his legacy.

Trumpeter **Nicholas Payton** grew up in New Orleans, where he often sat in with his father's Young Tuxedo Brass Band. After signing with Verve Records

in the early 1990s, he released his first album *From This Moment* in 1995. 1997 saw the release of his fourth album, *Doc Cheatham & Nicholas Payton*, which won him the Grammy for Best Jazz Instrumental Solo for his playing on the song "Stardust." In 2004, he was a founding member of the SFJAZZ Collective. To date he has released 21 albums as a leader, and is a much sought-after sideman, appearing on numerous albums by other artists, including fellow New Orleanians Dr. John and Allen Toussaint. In 2011 he made a controversial blog post entitled "Why Jazz Isn't Cool Anymore" in which he suggested that the word "jazz" should be replaced with "Black American Music." "I was talking about my disdain for the word jazz and that really created a firestorm of events that was far-reaching outside of the jazz world." From the ensuing debate emerged his *Black American Symphony*, a six-movement symphony for jazz quartet and symphony orchestra. The piece surveys the history of Black music from enslaved Africans to the present. *Black American Symphony* premiered in Europe in 2021 but did not receive its American premiere until 2019 with the Colorado Springs Philharmonic. Why did it take so long to get played in his home country? "I think there were some people who didn't want to touch me cause I got labeled as the angry Black guy. But you know, whereas I was talking about race 10 years ago, now everyone's talking about it every day and I don't seem so crazy anymore."

Oakland, California native **Ambrose Akinmusire** has taken a leading role in the contemporary avant-garde world of jazz trumpet, following in the tradition of Don Cherry, Bill Dixon, and Lester Bowie. After working briefly with Steve Coleman's Five Elements, he studied at the Manhattan School of Music and the University of Southern California and attended the Thelonious Monk Institute of Jazz. His breakout year came in 2007 when he won the Thelonious Monk International Jazz Competition, the Carmine Caruso International Jazz Trumpet Solo Competition, and released his debut album *Prelude...to Cora*. In

Music Analysis

Track 61: "Our Basement (Ed)"

(Stevens) Ambrose Akinmusire from the album *The Imagined Savior is Far Easier to Paint* recorded in 2013 at Brooklyn Recording, New York City, and Revolution Recording, Toronto. Produced by Ambrose Akinmusire. Personnel: Ambrose Akinmusire: trumpet; Becca Stevens: vocals; Sam Harris: piano; Justin Brown: drums; OSSO String Quartet

Ambrose Akinmusire's album *The Imagined Savior is Far Easier to Paint* was his second Blue Note release, and one of his most adventurous. It features musicians he has worked with frequently in the last ten years, including Walter Smith III on sax, Sam Harris on piano, and Justin Brown on drums. It also features three vocalists, Theo Bleckman, Cold Specks, and Becca Stevens, who is heard here on her composition "Our Basement (Ed)." *New York Times* critic Nate Chinen says the tune "suggests the interior monologue of a homeless man, its melody often tracing a dreamlike whole-tone scale." It also features imaginative trumpet playing by Akinmusire throughout.

0:00	Intro vamp is set up by pianist Harris, drummer Brown, and the OSSO String Quartet
0:21	Vocalist Becca Stevens enters
1:04	Chorus with vocal overdubs by Stevens
1:44	Akinmusire trumpet solo with string quartet accompaniment
2:26	Pianist Harris and drummer Brown re-enter
3:09	Vocalist Becca Stevens re-enters
5:39	Track slowly fades

2011 he signed with Blue Note and has released five albums for the venerable label. Like fellow trumpeters Hargrove and Payton, Akinmusire has extensive credits as a sideman, recording with such diverse artists as Vijay Iyer, esperanza spalding, Mary Halvorson, and Kendrick Lamar. He has also worked with free jazz legends, Roscoe Mitchell and Archie Shepp. He was named the Jazz Artist of the Year in 2011 by *DownBeat* and has won the trumpet category in the magazine's Critics Poll every year from 2013 to 2020.

The Singers: Elling, Allyson, and Salvant

Not to be outdone by the instrumentalists, jazz vocalists are carrying on the jazz tradition while expanding its horizons. One might call Kurt Elling old school, and not just because of his choice to stay true to his jazz calling and eschew pop stardom (which he surely could have attained had he chosen). An example of his retro-ness: a conversation with Elling is full of hepcat vernacular—"groovy," "dig it," "you cats," etc.—that comes across as genuine rather than contrived. He is a master at vocalese, the mostly forgotten art of adding lyrics to recorded instrumental solos. After a stint in divinity school in Chicago in the early 90s, Elling turned his attention to jazz singing and was soon after signed to Blue Note. His 1995 debut, *Close Your Eyes* was the first of 11 consecutive albums to receive Grammy nominations (with 2009's *Dedicated to You* winning). Two notable releases in his catalog are the adventurous *The Messenger* (1997), and *Live in Chicago* (2000). On the former, he dips into the pop catalog (the Zombies' "The Time of the Season"), incorporates hip, street-smart spoken word ("It's Just a Thing"), takes extreme improvisational risks ("Endless"), and employs his signature vocalese (Dexter Gordon's "Tanya Jean"). *Live in Chicago* and the accompanying *Live in Chicago Out Takes* were recorded at the famous Green Mill Restaurant. On them, Elling evokes his divinity school training with an extended version of the standard "My Foolish Heart" that includes a trance-like reading of a poem by St. John of the Cross, a 16th-century Christian mystic. Since 2000, Elling has topped the Readers Poll of *Jazz Times* and the Critics Poll of *DownBeat* nearly every year and recorded eight more solo albums. He has collaborated with a wide variety of artists, including Fred Hersch (*Leaves of Grass*), Liquid Soul (*Make Some Noise*), and the Yellowjackets (*Club Nocturne*).

Omaha native Karrin Allyson released her self-produced debut album *I Didn't Know About You* in 1992 from her adopted hometown of Kansas City, where she had relocated after briefly living in Minneapolis. By chance, a copy of the CD ended up in the hands of San Francisco DJ Stan Dunn of KJAZZ, who got such an overwhelming listener response to it that he forwarded it to Concord Records president Carl Jefferson, who personally signed Allyson to a contract. Since then her career has taken off like a rocket. To date, Allyson has released 16 albums that display her willingness to take risks and explore every corner of the musical universe. Firmly entrenched in the jazz tradition, she is an exceptional scat singer and swings as hard as any bebopper. Allyson has recorded compositions by Charlie Parker, Thelonious Monk, Charles Mingus, and Wayne Shorter. Her 2001 album *Ballads: Remembering John Coltrane* is a track-by-track recreation of Coltrane's 1962 album *Ballads* that garnered the singer a Grammy nomination. More recently, Allyson released *Footprints* in 2006, an album of jazz instrumental classics (such as Wayne Shorter's title cut, rechristened here as "Follow the Footprints") adapted for vocals. Allyson is also not afraid to cross over into the world of cabaret (Melissa Manchester's "I Got Eyes") or pop (Carole King's "It's Too Late"), and gives each a distinctive styling that is immediately recognizable. Her slight rasp and sassy attitude have put her albums high on

Vocalese—the technique of composing lyrics to fit existing recorded jazz improvised solos or instrumental arrangements.

Music Analysis

Track 62: "Downtown"

(Ferrante) Kurt Elling from the album *Live in Chicago* recorded July 14–16, 1999 at the Green Mill Jazz Club, Chicago. Personnel: Kurt Elling: vocal; Laurence Hobgood: piano; Rob Amster: bass; Michael Raynor: drums

"Downtown" is the exciting opening cut on Kurt Elling's fourth album *Live in Chicago*, recorded at the legendary Green Mill Jazz Club. The club, opened in 1907, has an illustrious past, including once being a watering hole for 1920s Chicago mobsters such as Al Capone, and also as the inspiration for the 1957 movie *The Joker is Wild* starring Frank Sinatra. Elling's performance on "Downtown" is absolutely scorching and displays the tremendous flexibility of his voice as well as his innovative scat singing technique. He also has a killer-tight band on the date, led by his longtime associate Laurence Hobgood. Other highlights from the album include the mesmerizing "My Foolish Heart," which includes the reading of a poem written by St. John of the Cross, and guest appearances from vocalese legend John Hendricks and Chicago tenor saxophonists Von Freeman, Eddie Johnson, and Ed Petersen. (ref: kurtelling.com; greenmilljazz.com)

0:05	Syncopated intro vamp is set up by pianist Laurence Hobgood, bassist Rob Amster, and drummer Michael Raynor; Kurt Elling adds introductory and welcoming remarks
0:33	Head is stated in unison by Elling and Hobgood
1:20	Return to intro vamp, including vocal and bass line at 1.34
1:48	Elling begins scat vocal
2:35	Intro vamp
2:49	Drum solo built around syncopated stabs by voice, bass, and piano
3:16	Return to head and coda ending

the jazz charts, in rotation on jazz radio stations, and has attracted notice from the critics. "Allyson coolly stakes her claim," writes *Village Voice* critic Gary Giddins. "She brings a timbre that is part ice and part grain … incisive, original, and emotionally convincing." Karrin's most recent release is 2019s *Shoulder to Shoulder: A Centennial Tribute to Women's Suffrage*, with guest appearances by Harry Belafonte, Rosanne Cash, and others.

Singer Cécile McLorin Salvant was born into a house "where we listened to all kinds of music. We listened to Haitian, hip hop, soul, classical jazz, gospel, and Cuban music, to name a few," she told *Essence* Magazine in 2020. "When you have access to that as a child, it just opens up your world." After studying piano at an early age, she switched to singing, and ultimately attended the Darius Milhaud Conservatory in Aix-en-Provence, France. In 2010 she released her debut album *Cécile & the Jean-François Bonnel Paris Quintet*, for which she garnered wide acclaim. That same year she won the Thelonious Monk International Jazz Competition, further establishing her as one of the brightest new stars in jazz. Many of the songs from her 2017 album *Dreams and Daggers* were recorded live at New York's Village Vanguard. Packaged as a two-CD set, it contains 23 tracks that include everything from Salvant originals to jazz standards. The album won a Grammy Award for Best Jazz Vocal Album in 2018. To date, she has recorded five albums under her own name.

Important Developments in Contemporary Jazz

In conclusion to this, the 7th edition of *The History and Tradition of Jazz*, we will take a look at three developments that have shaped contemporary jazz in profound ways: technology, globalization, and the worldwide pandemic. (For a look at the effects of the pandemic on New York City's jazz community, see the Epilog.)

Jazz+Technology

Incorporating new technologies into the creative process has been an essential part of jazz tradition throughout its history. After the Original Dixieland Jass Band made the first jazz recordings in 1917, jazz musicians quickly began to understand the importance of making records to document their work. Beginning in the 1950s they were also among the first musicians to take advantage of the freedoms that the 33-1/3 rpm LP allowed them in recording extended works. (Many people consider the Beatles *Sgt. Pepper's Lonely Hearts Club Band* to be the first 'concept' album; however, Charles Mingus did two concept albums in 1957 alone [*The Clown* and *Tijuana Moods*], a full 10 years *before* the Beatles' magnum opus.) By the early 1960s, many jazz musicians were taking advantage of the editing and overdubbing possibilities afforded by recording on magnetic tape, years before the well-documented experiments of the Beatles. By the 1960s, jazz musicians were routinely overdubbing solos (a practice Lennie Tristano was using as early as 1953) and incorporating electric organs, pianos, and bass guitars, and by 1969 Miles Davis was using wah-wah pedals and delay units to enhance the sound of his trumpet. In the early 1970s, Herbie Hancock added designated synthesist Dr. Patrick Gleason to add sound effects and ambiance to his band. Hancock also introduced the next quantum leap forward in the use of technology in 1983 with *Future Shock*, an album that incorporated industrial sounds and the turntable scratching of Grand Mixer D.ST on the opening track "Rockit." However, Hancock seemingly drew a line in the sand, as few other jazz musicians were willing to follow his lead (indeed, Hancock himself only occasionally used DJs after *Future Shock*, but perhaps this was more a result of his musical restlessness than anything else).

The last 20 years have seen a marked increase in the use of new instruments, computers, and software that are beginning to radically redefine not only the sound of jazz but also the creative process itself. And with the new technology came a new member of the jazz band. Since the late 1990s, "what began as a trickle had become, if not a flood, then a small but noticeable flow of ensembles that included a musician handling 'electronics' in their lineup," states Stuart Nicholson in his book *Is Jazz Dead? (Or Has It Moved to a New Address)*. "Albums began appearing with credits for mysterious tasks such as 'sequencing,' 'programming,' 'sampling,' 'DJ,' or 'electronics.'" According to Nicholson, the rapid advances in the use of technology in jazz have been due in part to the enormous advancements in computer science and its musical applications, which by the early 2000s was allowing musicians to be much more creative and sophisticated in sound design and manipulation. "Now the improviser's art could be played out against new sonic backdrops colored by fragments of electronic sounds, rhythms, and samples swimming through the music, while digital computer editing—also known as 'hard disc editing', where sounds are chopped up and rearranged inside the computer's virtual space—allowed for juxtapositions never dreamed of in Charlie Parker's day." The possibilities are endless. "There are no rules anymore," stated the late saxophonist/composer Bob Belden. "There is a sense of freedom one gets from dealing in the new world of artificial reality."

In the early 2000s, artists such as Craig Taborn (*Junk Magic*), Medeski, Martin and Wood (*Uninvisible*), Dave Douglas (*Freak In*), and **Kenny Werner** (*Lawn Chair Society*) have experimented with recording albums in which the DJ/producer acts as a co-composer of sorts by freely restructuring the music either while or after it was recorded. Norwegian saxophonist Jan Garbarek constructed the framework for his 2004 album *In Praise of Dreams* entirely on his laptop and added musicians later. One of the most innovative electronic experimenters is pianist Matthew Shipp, who was hired to lead **Thirsty Ear Records**' new subsidiary



Music Analysis



Track 63: "west_coast_variant"

(Pickett) Kenny Werner from the album *Lawn Chair Society* recorded at Charlestown Road Studios, Hampton, New Jersey 2007. Personnel: Kenny Werner: piano, keyboards, computer; Chris Potter: tenor sax; Dave Douglas: trumpet, cornet; Scott Colley: bass; Brian Blade: drums

Kenny Werner's 2007 album *Lawn Chair Society* has been hailed as a breakthrough for the pianist, who has been a fixture of the New York jazz scene since the late 1970s. In addition to having provided sensitive supporting roles for such luminaries as the Mel Lewis Orchestra, trumpeter Tom Harrell, saxophonist Joe Lovano, and harmonica virtuoso Toots Thielemans, Werner has made a name for himself with his acoustic piano trio as well as his exploratory solo piano albums. With *Lawn Chair Society*, Werner has combined traditional jazz elements with some far-reaching new ideas and technology that will surely provide a launching pad for further musical development. Supported by a strong cast that includes saxophonist Chris Potter and trumpeter Dave Douglas, Werner also brings on board former Tower of Power saxophonist Lenny Pickett as producer, songwriter, and occasional instrumentalist. Werner's use of "keyboards and computer" add a futuristic touch that makes the album "sit atop this year's best-of list for its innovation, its ties with tradition, and for the quintet's superb musicianship."

0:00	Rhythmic groove is created with occasional electronic effects that continues throughout song
0:16	Trumpeter Dave Douglas plays a single note
0:45	Tenor saxophonist Chris Potter begins noodling in lower register
3:11	Rhythm section drops out, Douglas and Potter briefly engage in collective improvisation, track ends

label **Blue Series** and responded with his albums *Nu-Bop* and *Equilibrium* in 2002 and 2003. For Shipp, jazz has always reflected the artist's environment, whether that artist was Louis Armstrong, Duke Ellington, Charlie Parker, or himself. "I live in an urban setting. There's lots of things I take in—sounds and the ambiance of the street—that I soak into my subconscious...There's things in the environment...that I'm trying to connect to, and I've been feeling that making jazz albums as we've known had not been adequate for me personally to connect to those things." New technology is not only a reflection of his contemporary environment, but offers Shipp a way to "connect to those things." With his own records and those of others he has produced, Shipp has propelled the Blue Series into the forefront of the use of new electronic technology.

Globalization: The World is Flat

In his book *The World is Flat: A Brief History of the Twenty-First Century*, *New York Times* columnist Thomas Friedman asserted that the world is increasingly no longer a place where innovation comes from a few at the top and eventually trickles down vertically to everyone else. It is instead a place where many people from all over the world can interconnect and collaborate 'horizontally'. In other words, the playing field is leveling and becoming less exclusive and more inclusive. To those immersed in the technological advances of the last 30 years, Friedman's viewpoint is nothing new or profound. In fact, *The World is Flat* was written in 2005—before much of our current technological world existed. But the flattening parallel can certainly be made with jazz in the 21st century. You no longer have to be in New York or even America to spark innovation in jazz. America's classical music has become a musical *lingua franca*—a common language—for musicians in countries all over the world. For jazz in the 21st century, the world is indeed flattening.

To musicians around the globe, jazz is a form that has, to make a computer science analogy, an open-source code, making it more like Linux than Windows. Stuart Nicholson states that today, one can "go to Africa or Brazil and you will hear music that takes American jazz as its starting point, but is shaped, both consciously and unconsciously, by elements from local culture." One of the most fertile areas for the growth of an independent, parallel jazz scene is Europe, which eagerly welcomed American jazz musicians as far back as the nineteen-teens and has enthusiastically supported touring and expatriate jazz musicians ever since. Today the European jazz scene encompasses many strains that range from those that are highly evocative of American jazz to those that are highly localized. One of the most vibrant European jazz scenes is in Scandinavia, where the majestic tranquility of open spaces and uninhabited natural beauty has produced an artistic culture of seeking a path of self-expression that seems well suited to jazz. "Nordic art is dangerous," states Danish artist Asger Jorn, describing the homeland of Norwegian painter Edvard Munch, Danish philosopher Soren Kierkegaard and Swedish filmmaker Ingmar Bergman. "It compresses all its power *inside* ourselves." Norwegian bassist Arild Andersen adds that in Nordic jazz, "The sound is very important, the space in the music is very important," but perhaps what sets it apart most from American jazz is that it is "not how clever you can play your instrument, how fast you can play or how impressive you could be but how expressive you are." One can certainly get a sense of this when listening to Andersen albums such as *Hyperborean* (2000) or *Karta* (2001) or the music of his fellow countrymen, pianists Tord Gustavsen and Bugge Wesseltoft.

Music Analysis

Track 64: "Elevation of Love"

(Svensson) Esbjörn Svensson Trio from the album *Seven Days of Falling* recorded June 2003. Personnel: Esbjörn Svensson: piano; Dan Berglund: bass; Magnus Öström: drums.

Seven Days of Falling was the seventh album released by the Swedish jazz piano trio Esbjörn Svensson Trio, often referred to as E.S.T. the group formed in 1993 and released three albums on Swedish labels before being picked up by the German label ACT, with which it released eight albums. The group became widely popular in Europe, primarily for their musical expressiveness and willingness to bring together elements of avant-garde jazz, classical music, and contemporary rock. Two major influences are 20th-century classical composer Béla Bartók and Radiohead. On the album bassist Dan Berglund is often found using pedals to distort or otherwise alter the sound of the bass. Although Svensson often plays with technical virtuosity, at heart, he is undeniably lyrical. The music of the group has, as allaboutjazz.com states, "unmistakable Nordic roots (elegiac, melancholy, and folkloric) underlying a jazz syncopation twisted around a rock esthetic." Tragically, Esbjörn Svensson died in a diving accident off Stockholm in 2008 at age 44.

0:00	Song starts with a simple riff played by Svensson on prepared piano with light drum accompaniment
0:16	Svensson and bassist Berglund play opening theme in unison
0:45	Opening riff is repeated
1:00	Piano restates theme, Berglund plays 'broken' walking bass
1:29	New theme introduced
1:52	Return to opening riff
2:07	Svensson solos on piano
4:20	Berglund increasingly takes the lead with a distorted, guitar-like solo
5:12	Opening riff, followed quickly by opening theme
5:49	New, quieter theme introduced on piano with sustained bass accompaniment, drums primarily play suspended cymbal, track ends

Scandinavian jazz was first introduced to many around the world in the 1970s through the ECM albums of Keith Jarrett's 'Belonging' quartet, which contained Norwegians Jan Garbarek and Jon Christiansen, and Swede Palle Danielsson. Saxophonist Jan Garbarek, Europe's most famous jazz musician, has a style that exhibits influences from Americans John Coltrane and Albert Ayler but also contains an element of calm and deep spirituality. "I can't say to what extent growing up in Norway would influence you, but I imagine deep down it must have some influence," he says. One of Garbarek's most famous (of perhaps at least 100) albums is 1976's *Dis*, in which his haunting tenor and soprano saxophones create atmospheric environments that evoke images of the fjords and tundra of his native country. Another noteworthy Nordic jazz musician is Finnish drummer Edward Vesala, who has collaborated with Arild Andersen, Garbarek, and Polish jazz trumpeter Tomasz Stanko. Vesala's 1990 album *Ode to the Death of Jazz* is a denouncement of the state of 1980s American Neo-traditional jazz; on the liner notes he asks, "This empty echoing of old styles—I think it's tragic. If that is what the jazz tradition has become then what about the tradition of creativity, innovation, individuality, and personality?"

Future Jazz and the Challenges Ahead

The previous edition of this book (the 6th, from 2018) discussed the challenges facing the 21st-century jazz ecosystem. Among them were the death of the record store, dwindling CD sales, the closing of jazz clubs, the economic difficulties of living in New York City, and the passing on of the old school bandleaders that provided apprenticeships for young players. Granted, these were, and still are challenges. But then the coronavirus pandemic hit, and suddenly, the jazz world (like the rest of the planet) was faced with an entirely new set of challenges that were existential in nature. Sadly, the Covid-19 disease took the lives of several well-loved jazz musicians, including Wallace Roney, Ellis Marsalis, Bucky Pizzarelli, and Lee Konitz. For those that survived, the pandemic was ruthless in how it exposed vulnerabilities in the way many in the music industry made their living. If you relied mostly or entirely on live performances for your income, you suddenly had a lot of time on your hands; on the other hand, if you had a tenured teaching job, life went on as usual. A new component to this edition, *Epilog: The Pandemic and the Jazz Community* at the conclusion of this chapter takes a look at how the pandemic has affected the jazz community in New York City, featuring interviews from several well-known musicians and club owners.

To talk about the current state of jazz, we don't need to get into record stores, which no longer exist, or even CD sales. CDs are *so yesterday*; in fact, industry analytics provider MRC Data shows that vinyl records outsold CDs in 2021. Let that sink in for a second. The music consumer now gets their music from streaming services. While traditional labels with jazz divisions, such as Warners, Sony, and Blue Note, and smaller, more progressive jazz/avant-garde labels such as John Zorn's Tzadik, Dave Douglas's Greenleaf, and Thirsty Ear's Blue Series still sell physical CDs, the money (or lack thereof) is now in streaming royalties. As far as jazz clubs go, it's never been an easy proposition to operate a jazz club, and it probably won't ever be. But somehow, they continue to survive. (See the Epilog for more information on the New York City club scene.)

So, from the perspective of early 2022, what lies ahead for jazz? Well, there certainly are challenges, but history tells us that the music is pretty darn resilient. Jazz supposedly died when it left New Orleans in the 1920s, when the swing era began in the 1930s, and with the birth of bebop in the 1940s. It was said to die again with the advent of free jazz in the 1960s, fusion in the 1970s, and with the

neo-traditional movement in the 1980s. And again, in the early 2000s when no one seemed to be listening. But it survived all those premature autopsies and was still around when the pandemic hit it for all it was worth in 2020. Somehow, it survived that, too. So, here we are, and here it is, still standing. As it has done in the past, jazz will adapt, it will take a punch, it will pick itself up and dust itself off. And not only that, it will continue to thrive, and in unpredictable ways. It is a free spirit and won't be pinned down or told where to go next. Jazz is constantly turning over a new leaf, shedding its skin, re-inventing itself. It reflects what is going on in the world around it, and in return gives us back new insights into who we are.

Jazz began as a novelty, evolved into dance music, then art music, then music that advocated for political change and promoting racial equality. It started its life in the Black ghetto of New Orleans and spread out to the entire world. Today it is studied in schools and played by younger and younger musicians in ever more far-reaching locales. It has worked its way into the DNA of musical cultures wherever people are playing and listening to music. Perhaps it is not the best comparison, considering the current state of affairs, but it is like a virus that invades musical immune systems and mutates freely. Because it speaks to the human condition and touches the soul, it is, and always has been, a social music. When jazz is played, people come together, whether to play or to listen, and are reminded that our differences are our strength, that our diversity is a good thing, and that we can unite for the common good.

But with all the newness, the bold steps into the future, the reinvention, and the reimagination, jazz always has and always will pay homage to its history and tradition. Even when we hear the newest new thing in jazz, there's always going to be something in there that connects to its glorious past. Because the music is still a draw to the most independent and adventurous of musicians, it will continue to embrace the new and experimental, too. As this text has attempted to illustrate, the umbrella of contemporary jazz is big and getting bigger. Jazz musicians young and old will continue to translate their experiences living in the contemporary world into improvised music that resonates with current and future generations. Jazz will survive, and it will prosper. Vive la jazz!

Name _____ Date _____

Jazz in the New Millennium

1. Describe the state of jazz at the turn of the century and why some observers were proclaiming that it was dead.

2. Explain why expectations about *Jazz: a Film by Ken Burns* were so high, and why it ultimately generated so much controversy.

3. What are some key characteristics that describe the music and talents of esperanza spalding?

4. Name one unique musical achievement or interesting aspect from each: Brad Mehldau, Vijay Iyer, and Jason Moran.

5. Kurt Rosenwinkel and Ben Monder make prominent use of the human voice in their recordings. Describe both.

6. Why are more and more women making major contributions to jazz today? Give some examples.

7. What is the "Norah effect," and what impact is it having on jazz?

8. Describe some of the characteristics of Kurt Elling's style. What is unusual about his background, and how has it manifested itself in his music?

9. What are some of the ways in which technology is changing the way jazz is conceived, performed, and recorded in the 21st century?

10. Explain the term "glocalization" and how it relates to jazz in the international scene today.

JAZZ IN NEW YORK CITY DURING THE PANDEMIC

When I began the process of updating *The History and Tradition of Jazz* to its 7th edition in late 2021, I knew that I would have to assess the current state of jazz. The book's 6th edition, from 2018, concluded with a laundry list of problems the music was facing that included the death of the CD, declining record sales, and the closing of record stores. The book ended up with some feel-good statements about how much young talent was out there and how passionate they were about the music. Reading that now, it looks kind of like I had to say something positive to counter all the negatives. "The test results are all bad, but I'm going to have a positive attitude!" said the terminal cancer patient. In 1973, Frank Zappa famously said, "Jazz isn't dead. It just smells funny." He wasn't the first person to speculate on the morbidity of jazz: proclaiming that jazz is dead has been such an enduring narrative that the statement itself has in fact become a part of jazz history.

The first installment of the 'jazz is dead' chronicle came in the late teens and early 1920s when jazz musicians began leaving New Orleans to move on to greener pastures. The story goes that once Storyville, the city's red-light district, was closed by the Secretary of the Navy in 1917 at the outset of WWI, clubs with live music were also shut down. Musicians left town to find work, first to Chicago and then to Kansas City and New York. In its new locales, the music began to change. While some viewed this as evolution, a shedding of skin, others cried that jazz in its truest form was gone. It was dead. Long live jazz.

There were, however, other factors that led to the demise of the New Orleans scene. One is the well-documented Great Migration, which brought millions of Southern Black Americans to the industrial north, seeking jobs and an escape from the racism and discrimination of the Jim Crow South. Another reason was the passing of the Volstead Act—Prohibition—in 1919. Almost immediately cribs, saloons, and brothels in New Orleans—the very places where jazz originated and was performed—began to be shut down by local authorities. While it's true that liquor continued to be easily attainable in New Orleans and other big cities (flaunting the law became de rigueur and even fashionable during the Roaring 20s) it is no coincidence that Chicago and Kansas City—the two cities most notorious for corrupt politicians and 'look the other way' policing—became jazz's new hotspots. While Chicago's speakeasy-gang-mobster scene has

been well documented, it is worth noting that there was not one single alcohol violation recorded in Kansas City during the Prohibition era.

But was there another reason that jazz musicians left New Orleans? Perhaps the Spanish flu pandemic of 1918 was also a contributing factor. According to the *Influenza Encyclopedia* from the University of Michigan Center for the History of Medicine, influenza was first brought to the city by an oil tanker on September 16, 1918. It quickly spread—by October 20, 2,000 cases *per day* were being reported. By April 1919, 54,089 cases of the flu had been reported along with 3,489 deaths. Those numbers reveal the staggering effects on the city: a case fatality rate of 6.5%, and an excess death rate of 734 per 100,000. At nearly one percent of the city's population—twice the national rate—New Orleans' death rate made it one of the worst-hit cities in the country.

Yet, my research has yielded very little documentation of the pandemic's effect on jazz in New Orleans. Perhaps this was because of its short life span, which ran from late 1918 to mid-1919. According to musicologist E. Douglas Bomberger, author of *Making Music American: 1917 and the Transformation of Culture*, the flu was seen "more as a temporary inconvenience than anything else." Louis Armstrong gave no more than a brief mention of the flu in his 1954 memoir *Satchmo: My Life in New Orleans*, saying in part, "Just when the government was about to let crowds of people congregate again so that we could play our horns once more the lid was clamped down tighter than ever. That forced me to take any odd jobs I could get. With everybody suffering from the flu, I had to work and play the doctor to everyone in my family as well as all my friends in the neighborhood. If I do say so, I did a good job curing them."

The pandemic hit less than a year after Storyville's November 12, 1917, closing and was undoubtedly one more hardship for the city's musicians to endure. On the bright side, the flu ironically created one grim, unexpected positive result: an increase in gigs for musicians playing at funerals. Nonetheless, "the combination of the dance-hall closings and the closing of Storyville created a significant drop in opportunities," writes Thomas Brothers in his informative book *Louis Armstrong's New Orleans*. Armstrong was 17 years old and a struggling young club and riverboat musician when the flu hit. Like many other first-generation New Orleans jazz musicians, he ultimately left the city for Chicago, although in his case it wasn't until 1922, a full three years after the pandemic was over. We can only speculate whether the flu played even a small part in his decision to leave, but it is clear that he was affected by it and had to temporarily resort to Plan B to make a living. While Louie apparently never got the flu himself, it seems that it may have knocked him down, but he picked himself up, brushed himself off, kept on keepin' on, and ultimately moved for reasons other than the flu.

Armstrong's resiliency is a metaphorical tale that can apply to jazz and its oft-repeated premature autopsies. It also brings us full circle to the present-day COVID-19 pandemic. With the lack of information on how the 1918 pandemic affected the then center of the jazz universe, it makes sense, at least to me, to document the effects of COVID on the current center of the jazz universe, New York City. As one of the few places left where a living can be made in whole or part related to the live performance of jazz, I felt that talking to New Yorkers involved in the scene might offer a compelling storyline of overcoming hardship for the sake of the art. Not knowing what to expect, I began reaching out to the city's club managers and musicians in January 2022 to find out if any would be willing to share their experiences dealing with the pandemic. To my surprise and delight, they were! Although I never heard back from a few that I contacted, I ultimately ended up doing live or email interviews with club operators Deborah

Gordon of the Village Vanguard, Spike Wilner of Smalls and Mezzrow, and Rio Sakairi of the Jazz Gallery, and musicians David Berkman, Wayne Tucker, John Ellis, Anthony Tidd, Kendra Shank, Mark Helias, Dan Tepfer, Walter Smith III, Dave Stryker, Fred Hersch, and Emmet Cohen.

While the pandemic is a still-developing story (as of February 2022), it has already largely impacted and restructured the jazz economy in New York. Of course, the city's jazz clubs have faced uncertainty for years, and many of the iconic venues, including Visiones, Bradley's, Sweet Basil's, and Tonic closed well before the pandemic. The first casualty of the Covid era was the Jazz Standard, one of New York's top clubs, which closed in early December 2020. Unfortunately, established clubs in other cities suffered similar fates, including L.A.'s Blue Whale, New Orleans's Prime Example, D.C.'s Twins Jazz, Black Dog in St. Paul, Minnesota, and Denver's El Chapultepec and Live @ Jack's. When cities began locking down in early 2020, the survival of restaurants, bars, and theatres suddenly became an iffy proposition. Jazz clubs took the hardest hit. "Keep in mind that jazz clubs are probably the most vulnerable, to begin with," said Audrey Fix Schaefer, the head of communications at the National Independent Venue Association. "They operate on really thin margins. These are houses of art. If you're going to open a blues club or a jazz club, it's because you are devoted to that art form and love it, it's not because you are an entrepreneur looking to make gobs of money," she told the *Washington Post*.

For some clubs, the first response to the lockdown was to first commit to keeping the music playing and then figure out how to do that. An obvious choice was live streaming, a technology that had been around for a few years and was just beginning to see widespread use on Facebook and other social media platforms. New York's Smalls and Mezzrow clubs were early adopters, having live streamed gigs since 2007. The pandemic put a new focus on the practice. "We were the very first club to do a live stream broadcast from New York City after the shutdown," Spike Wilner, partner/manager of both clubs told me in an email interview. "We and the entire city were shuttered on March 15th, 2020, and had been completely closed down. This live stream was on June 1st, and we were scared because we didn't know how people would react. It ended up becoming a daily live stream that reached out and inspired people worldwide to not be afraid and to embrace the importance of our music and the expression of art, even in oppressive environments."

New York's storied Village Vanguard also turned to live streaming, although not permanently, as Smalls and Mezzrow did. "The Vanguard did what every other club that presents live music did during the year and a half covid closure—jumped into the live stream," manager Deborah Gordon told me via email. For Gordon, the Vanguard is a family business: she is the daughter of Max Gordon, who opened the club in 1935, and his wife Lorraine Gordon, who took over running the club when Max died in 1989 until her death in 2018. "For us, streaming was a way of saying, 'Hey! we're still here—don't forget about us, we haven't forgotten about you!' And of course, to give musicians an opportunity to get together and play." The Vanguard started live streaming in June 2020 after installing high-quality video and audio equipment but stopped once the club reopened in September 2021. "It turns out it's not a way to keep one's head above water financially," says Gordon. "Upon reopening, it was immediately evident that the demands of streaming would not be compatible with presenting live music in the intimate Vanguard space."

Meanwhile, New York's Smoke Jazz Club shut down temporarily for renovations during the pandemic but inaugurated its Smoke Screen concert series. The

sessions consist of two live streamed sets played in the empty club each weekend that are also subsequently made available for purchase over the next 48 hours. Greenwich Village's 55 Bar, which has been in business since 1919, partnered with the Live from Our Living Room production company to offer recorded performances that were available on demand for 30 days after the performance.

After a bit of experimentation, The Jazz Gallery took a different route to present music online and avoided live streaming. I asked Artistic Director and Director of Programming Rio Sakairi if there was a reason she did not want to live stream. "Yeah. Where do I start?" Sakairi notes that live streaming takes away the experience of being in the room when an artist is making the magic happen. Speaking of Jazz Gallery co-founder Roy Hargrove, Sakairi told me in a Zoom interview, "I don't know if you saw him live, he was one of those performers that, when he's on, it feels like the room swells and the whole thing is just lifted. It's an unbelievable feeling. And when he passed away, I realized that he has a few good recordings, but none of them captures that feeling that he conveyed when you're in the same room." Add to that, "you don't know if they're watching the live stream on the phone or on the computer, what kind of quality they have as far as their output."

The Jazz Gallery's counter to live streaming came in the form of Lockdown Sessions. For each session, Sakairi selected four musicians who pre-record a 15-minute set from their respective lockdown stations. During the broadcast, which Sakairi hosts, the musicians present their sets, answer questions, and chat with fans. "The fun thing about the Lockdown Sessions was that I purposely put really young artists, older artists with people from left of the field to center so that there's a process of discovery for artists with each other," she says. "One session, I had Bill Frisell. And people tune in to see Bill Frisell, but there are three other people that they'd never heard of. And then, they would say, 'Oh, I thought that this person was not my cup of tea, but I actually like this.' And it created a lot of opportunity within the artist community, and then people who are kind of into jazz. So, it was a lot of fun." The first person to have a video played was vocalist Theo Bleckman. "He has such an amazing visual sense. I think that the way Theo sings is not immediately approachable if you just hear him. But with the video, it created the entry points." She added, "this is how artists should approach the Internet."

As Sakairi says, watching a live streamed gig cannot approximate the experience of going to see live jazz in a club, but it can be argued that there is value in it if there are no real alternatives, especially if you don't live in New York City. At the same time, it's easy to see why clubs can't depend on it as a business model. Smalls and Mezzrow streams are available for free; the Vanguard's and 55 Bar's are $10 and $15, respectively; the Lockdown Sessions are $10 for members, $20 for non-members. What other means were the clubs relying on to stay open? "Government grants and the donation button, which our generous customers made use of, were our lifelines," states Gordon. The Jazz Gallery also benefited from grants. "There was a silver lining with COVID, that as a non-profit, all of a sudden there are so many grants for general operating, which were never available before. So, financially, we are actually doing OK," according to Sakairi. Wilner, whose clubs were live streaming pre-pandemic, was also farsighted enough to start a foundation before the lockdown. "The SmallsLIVE Foundation was created in 2018 with the mission of supporting our live stream and archive," he says. "However, once the pandemic hit it became the primary fundraising tool to help both clubs (Smalls and Mezzrow) survive for the next two years. People could give directly through our site or sponsor a live show

directly. The response was incredible and thanks to the grassroots efforts of jazz fans worldwide we raised enough funds to not only pay for one band to perform each day (and get paid a good wage) but also all the club expenses (rent, insurance, power, etc) and a shoe-string staff."

To help it stay open, the 55 Bar launched a gofundme account in September 2021 in an attempt to raise $100,000 to cover operating expenses. The iconic Birdland Jazz Club started a gofundme in January 2021 to raise $250,000 and quickly surpassed that goal. New York's Iridium qualified for the Paycheck Protection Program, which helped it survive. "I'm cautiously optimistic, but it's definitely a stressful, anxious time," Iridium owner Ron Sturm told the *Washington Post*.

How did the musicians cope with the pandemic? Like the club owners, the first reaction for many was to find some way to perform and connect with others in spite of the lockdown and social distancing constraints. Out of necessity, these often resulted in new, creative, and previously unimagined endeavors. As you will read, the eleven musicians I interviewed for this article had eleven very different and interesting stories to tell. And there were so many more stories, as musicians in and outside of New York City overcame the odds to continue doing what they do. Notable examples include:

- Saxophonist Chris Potter released *There Is a Tide* in December 2000, an album in which he played all the instruments, including drums, bass, guitar, as well as sax.
- Pianist Larry Goldings joined the sponsorship platform Patreon and began releasing educational and behind-the-scenes videos once a week for a $25/month membership.
- Before his death in February 2021, pianist Chick Corea was live streaming solo practice sessions from his home.
- Trumpeter Nicholas Payton recorded *Quarantined with Nick* in his dining room with guitarist Cliff Hines and vocalist Sasha Masakowski and managed to get it done just before the lockdown hit. The album includes reflections on the current state with titles such as "Social Distance" and "Charmin Shortage Blues." (Remember when there was a shortage of TP?)

The jazz musicians I interviewed for this article are all directly connected in one way or another to the New York City jazz scene; with one exception, all of them live in the metropolitan area. Some had jobs in academia or grants that gave them a financial buffer through the lockdown, others didn't. But as you will see, all of them embarked on projects that perhaps wouldn't have happened without the pandemic. All of them came out of the dark days with a renewed sense of purpose. And all of them have picked up and got back at it. Compiling these stories has given me a lesson on the resiliency of the creative spirits that inhabit the jazz world. I hope they do the same for you.

For some the musicians, the pandemic was a time for self-reflection and a chance to reconnect with some personal growth on their instrument. "I just looked at it as kind of shed (practice) time, to be honest with you," veteran pianist/composer David Berkman told me in a phone interview. "And, you know, I practiced a lot. I stayed home. I worked on solo piano a lot, you know, 'cause I wasn't playing with other humans. I wrote a lot of music." Berkman, who is a Professor at Queens College in Queens, New York, does frequent Zoom playing sessions with long-time New York City pianist Bruce Barth. "He's one of my oldest friends in New York, so we'll just get together (remotely) and play tunes. Obviously, you can't play together. You can't play simultaneously, but you know,

he'll play on the changes, then I'll play on it. And actually, it's been very inspiring." Berkman also released the solo piano album *David Berkman Plays Music by John Coltrane and Pete Seeger* on Without Records in June 2020.

Trumpeter/composer Wayne Tucker found himself involved with two projects that came about only because of the pandemic. First, he recorded an album at home. "I wouldn't say I played all the instruments," he told me over a phone interview, "but I played a bunch of things, mostly trumpet, flugelhorn, violin, piano, and some keyboards. My roommate, pianist David Linard played on it, and I had a couple different drummers play on it, including Diego Ramirez from my band. The album's called *Encouragement*." Then, once the weather started getting nicer, drummer Ramirez "called me a few times and said, 'Man, we got to go outside and play. We got to go outside and play.' I was like, 'Man, I'm really happy inside just learning again, transcribing, and composing, and practicing.'" Once he agreed to give it a shot, Tucker, Ramirez, and bassist Tamir Shmerling went to Brooklyn's Prospect Park and played. "To be totally honest, I didn't think we sounded good at all. We even laughed about it. We hadn't really played with other people for a couple months. But people loved it. A crowd gathered around us, and we made decent money. So, we said, 'Okay, let's come back tomorrow with my brother,'" saxophonist Miles Tucker. The four musicians were eventually joined by pianist Linard, and, weather permitting, played at the park every day for about a year. The response? "Incredible. We got written up in the *New York Times* twice. We not only got to know the community but helped to make it grow. It gave me a different ideal for my musical experiences and for my purpose in the world." The experience changed Tucker's perspective on his career, from "wanting to play music to uplift people" to wanting to "uplift individuals and grow a community through music."

For saxophonist/composer John Ellis, gig cancellations had their pros and cons. "At first, there was actually a sense of relief. I had been grinding so hard, that it sort of felt nice to have a break. Of course, under the terrible circumstances, because there was so much grief, so much pain, so much fear. But a feeling of relief was there nonetheless, alongside those other feelings," he told me via email. "I did a lot of cooking. I tried to focus on playing the instruments I never have the chance to practice, so I spent a lot of time on the clarinet and bass clarinet at first." When his girlfriend started working from their apartment in the East Village, practicing there became impossible. "Luckily I have access to a rehearsal space in a basement about a 20-minute walk from my house, so I spent a lot of time down there." Ellis was able to keep busy, nonetheless. "There were quite a few grants that came in around that time that were very helpful, some of the gigs we lost still managed to pay us, there was still some live streaming from venues (The Jazz Gallery was particularly amazing at pivoting to a whole virtual model), and of course, I got the pandemic unemployment assistance. There was a surprising amount of studio recording that continued throughout, as well." He also released his album *The Ice Siren*. The release date, March 20, 2020, came just as things were starting to lockdown, an unfortunate coincidence that he describes as "rough timing."

Bassist/producer Anthony Tidd also saw his hectic touring schedule disappear. At the time, he was the Artistic Director for Jazz at the Kimmel Center in Philadelphia, which closed down. After isolating in his Harlem apartment, Tidd began conversations with his friend in Paris, Dimitri Louis, and the two began laying out the plans for what became the ACT4Music Festival. After speaking on the phone every day for about a month, Louis built the platform and the website. After launching on April 20th, 2020, the ACT4Music Festival continued for eight

weeks, six days a week, with four artists per day. Unlike what other artists were doing, it was not a live stream. Buying a ticket gave viewers a one-day access to four different acts, each giving a 30-minute video performance. They were also able to view any of the previous day's performers. After starting with performers from Philadelphia and Paris, as word about the festival got out, more artists became involved. Eventually around 250 artists from South Africa, Australia, Germany, the Netherlands, other parts of the U.S., and Nigeria became involved. And Tidd and Louis were able to monetize the festival, with a 'pay what you can' structure, and all of the proceeds going to the artists.

The lockdown was sudden and havoc-wreaking to vocalist Kendra Shank's professional life. "I had a primo two-night gig at Kitano Jazz that first weekend of the lockdown which was suddenly cancelled. And then, subsequently, a whole year of work went out the window," she told me via email. "Those first months of lockdown in NYC were rough—lonely and frightening with so little known about the virus and our city the hotspot with thousands of deaths." But like so many others, she found workarounds to keep performing. "My friend and bassist Dean Johnson and I played together via the Internet using the JamKazam program, which was a lifesaver in the early days of lockdown. The technology was inconsistent, but some days we were able to play with no latency. These were private sessions, not public performances, just to keep us in shape and enjoy playing." There were other online sessions as well. "I also met via Zoom with vocalist friends, including Jay Clayton, where we sang for each other and sometimes improvised together—it was a way of not only keeping connected with community but also an impetus to keep working on music and stay in shape in the absence of a gig deadline to push us. I also recorded some solo videos at home (accompanying myself on guitar and looper) which I posted on Facebook."

Playing over the Internet also provided a creative option for bassist Mark Helias, who with saxophonist Jane Ira Bloom released *Some Kind of Tomorrow* in January 2021. The album was recorded with each musician playing remotely from their home studios. "When I went into isolation on April 6 in upstate NY it was a time of extreme uncertainty," Helias told me in an email. "Nobody knew what was happening. Jane and I were desperate to play with someone else and we began trying with Zoom, just to connect. It was fantastic and awful. Great to play and connect and horrific sonically." Helias was in Cuddebackville, NY; Bloom was 90 miles away in New York City, a distance that was stretching the limits of the technology. After experimenting with several different remote recording applications, they learned how to work around the latency issues and improvise together. Helias, an experienced recording engineer, put together a system using Sonobus for the audio connection, while he and Bloom each recorded their parts on their local computers. Helias then took both audio feeds and mixed them in Pro Tools and mastered them in Logic. The results are such that you cannot tell the two weren't in the same room together. "To be clear, we were improvising with no directives, just being with each other musically and going for it. We have individually worked on open form improvisation for decades, so we're comfortable with that part of the process."

When the pandemic brought a halt to pianist Dan Tepfer's busy touring schedule, he was undeterred. "You know, I'm somebody who has always loved challenges, that's just who I am," he told me during a phone interview. "I'm unhappy when I'm not being challenged. I was concerned about the world just falling apart, but other than that, the challenges that presented themselves, both for me musically and to my career, there was something exciting about them, too." Like Helias, Tepfer was intrigued with the concept of playing remotely, but

using the technology for live performances rather than recordings. He began experimenting with JackTrip, an open-source research project app from Stanford University. "It's actually exceedingly hard to use, but I'm experienced with computers, so I was able to use it. I did a duo with my friend Jorge Roeder, a great bassist. And we were practically crying, because at that point it was just felt so amazing to actually play with another human." Attempting to make the app more user friendly led Tepfer to programmer Anton Runov, and together they completely rewrote JackTrip's code and came up with FarPlay. FarPlay is extremely easy to use, offers extremely low-latency, and is a free download. Between 2020 and early 2022, Tepfer did nearly 100 livestreams with other musicians in remote locations. "I just really like that basic human exchange, that ancestral relationship between two musicians playing together, between art and the listener. So, I started doing ticketed live streams." His live stream duo guests included Christian McBride, Cécile McLorin Salvant, Ben Wendel, Fred Hersch, Gilad Hekselman, French pianist Thomas Enhco, Antonio Sanchez, and Becca Stevens.

Although saxophonist/composer Walter Smith III lives in Boston as Chair of the Woodwind Department at Berklee College of Music, his performing career, which mostly took place internationally, but also occasionally in New York, took a hit. "I was playing at the Village Vanguard with Bill Stewart the first week of March (2020), and that was when we first started to hear that it (COVID-19) was in the US and things may be getting weird," he told me over a phone interview. Amid the fear and uncertainty of what the coronavirus would bring, attendance at the Vanguard began to taper off. "Usually Friday, Saturday night, no matter what, the Vanguard is full both sets. But by the time we got to Sunday night, man, there was nobody there. I think the second set there may have been eight people that came. Monday morning, I took the earliest flight to get back to Boston so I could get to school early, and I was the only person on the plane. It was literally just me flying to Boston from LaGuardia. It was very strange. I was sitting in the boarding area waiting, and no one else ever came, and they said, 'All right, we're going to board. Walter, come on up.' I was like, 'Wait, really? That's it?' And they're like, 'Yep, just you.'" Smith's biggest takeaway from the pandemic was not a musical one. "The biggest thing for me was that it hit at a point in my life where my goal was to try to be home a little more, or a lot more, and it put that into overdrive." In 2020, for the first time in a long time, "I was home for both my kid's birthdays, I was home for my anniversary. My wife and I were married July 23rd 17 years ago. I'd been in Europe 15 times in a row on that date." For now, "I'm prioritizing being home. I'm not doing gigs just for the sake of touring now. Being forced into that mode, along with everyone else, made me transition into feeling really comfortable with that shift. That was the biggest thing for me."

Guitarist Dave Stryker did some live streaming, albeit in a limited way, in part because he had other options on the table. "My trio did a couple of live streams from my basement that were pretty successful, but we didn't do it as much as some musicians," he told me via email. By a fortunate twist of fate, he had two records that were ready for release when the lockdown hit. "I had one record ready to go, *Blue Soul*, which I had recorded in Cologne Germany in 2019 with the WDR Big Band and was arranged by Bob Mintzer. So, I released that on my label Strikezone Records in April 2020. I figured since everyone was staying home, they would want to hear some new music and I was right. I think *Blue Soul* went to #1 on the JazzWeek radio chart for four weeks. I also had another record in the can called *Baker's Circle* with my working organ trio and (tenor saxophonist) Walter Smith III, so I released that a year later in 2021." And Stryker didn't stop there. "At the end of 2020, I decided to go ahead with a dream

project of recording with a string quartet arranged by former student and pianist Julian Shore. We basically collaborated throughout 2021 working back and forth and recorded *As We Are* in June of 2021."

Pianist/composer Fred Hersch left town for his second home in the woods of Pennsylvania when the lockdown began. Motivated by the death of a long-time friend, he set up an impromptu Facebook Live session in March 2020. "I played a couple of tunes in his memory that I know that he liked and then I just spontaneously decided I was going to do this every day," he told me in a phone interview. "So, every day for some six, seven weeks, at one o'clock, I would just get in front of the piano with the phone, and I would play what I called the 'Tune of the Day.'" Although initially planning to do this for the duration of the pandemic, "after a certain period of time, it began to feel like a bit of a chore, so I put it away sometime in mid-May."

"Even though I'm not a big tech guy, I had four very good microphones. So, I downloaded Logic and messed around with placing the microphones some-where reasonable and recorded a solo album called *Songs from Home*, which was basically an extension of the Tune of the Day. It wasn't designed to be heady or anything, just some nice tunes that might make people happy or feel some-thing. The idea was you're sitting in my living room and I'm playing a little set of tunes that I like." Then, ennui set in. "I think what happened is, from March until November, December, I really didn't want to accomplish anything. I didn't want to play music. I didn't particularly want to practice the piano. I thought, "Why practice? Nobody cares. I don't have any gigs. Why write something? I'm not going to hear it. I got very, what the *New York Times* called 'languishing.' I was playing a lot of computer games and crime novels and all that sort of stuff."

The pandemic also gave Hersch, who has lived with HIV since the 1980s and fell into a coma in 2008 that forced him to relearn how to play the piano, time to reflect on his life and career. "I had some dark thoughts. I really thought, 'Well, okay, if this it and the gigs don't come back, I think I can rest easy knowing that I had really a very nice career.' I can look back and say, 'Wow, I had some amazing experiences, and made some people happy, and had a lot of fun.' Obviously, I'm not walking away from it now, but I did have that thought, 'First of all, I shouldn't even be alive. Second of all, it's been a great ride.'" Hersch has returned to touring internationally, and in January 2022 released one of his most ambitious albums, *Breath by Breath*, recorded with his trio and the Crosby Street String Quartet.

When things started shutting down, an impromptu Facebook Live session provided pianist Emmet Cohen with an epiphany on how to move forward. Over a phone interview he told me, "I got a call from a promoter, Derek Kwan, who said, 'Hey, you're supposed to play in Lawrence, Kansas at the Lied Center on March 23rd (2020). I think everyone could use something positive—just do some kind of live stream and we'll pay you the full fee for the performance.' I asked Russell and Kyle, (bassist Hall and drummer Poole) 'do you want to do this gig?' They said, 'Of course. Nothing else going on.' So, we streamed, and it got over 40,000 views on Facebook, and more than that, we realized that people really needed a place to gather and listen to this music, communally, like we do in so many other settings. It's affirmed my belief that the music is meant to help people, it's meant to bring them together, it's meant to provide positivity and foster love and communication and teach people how to listen. A form of collec-tive therapy and healing

"And I think the most interesting part is the mythology. We're in the Roaring Twenties once again, this time in the 2000s. One hundred years ago, on this very street in Harlem (I live on Edgecombe Avenue) there were rent parties where

stride piano players like Mary Lou Williams, Monk, Fats Waller, Willie "The Lion" Smith, and James P. (Johnson) would play. They were in the very neighborhood that we're in, playing these rent parties, and here we are, a hundred years later, doing a virtual version of the same thing. There's something very spiritually aligned about the whole undertaking. It just felt like the right recipe and the right timing."

Cohen has turned "Live from Emmet's Place" into a business entity, with donations, sponsorships, and a membership group to pay the bills, which amount to "between $2,000 and $2,500" a week. "I don't think we've missed a week of sponsorship," which he describes as "another full-time job." But the response from fans worldwide and musicians in the New York area have convinced him that it's a worthwhile and much-needed endeavor. A mission. "I've gotten a ton of feedback; people have sent all kinds of gifts and cards. I have a foot-high stack of thank-you notes. People have been so generous with their donations and really found a way to create an ecosystem and support a lot of musicians and tech people throughout the last two years. It's been extremely hard and demanding work, but definitely rewarding, useful and necessary work."

Hearing these stories of self-reflection from those on the front lines of New York's jazz community makes me feel more optimistic about the music than I did just a few years ago, in spite of all that has transpired. The city's music scene suffered an existential threat unlike any that came before it in the "jazz is dead" narrative. Like Louis Armstrong over 100 years ago, the New York City scene, and jazz writ large, was knocked down by the pandemic, but it picked itself up, brushed itself off, and kept on keepin' on. "People still want to be in the same room with other people," says the Jazz Gallery's Rio Sakairi. "You go to a great show, whether it's a music or theater, whatever, and in the same space, that experience just cannot be replicated in any other way. And as human beings, we always crave that. So, I have faith in the power of music and the ability to bring people together and have that 'ah' feeling. So, I'm not worried." For bassist Anthony Tidd, whose mother passed away from COVID, the pandemic created a renewed sense of purpose which led him to completely reassess his life and his artistic purpose. A new realization of the impermanence of his time here. Kendra Shank commented on the sense of solidarity that the pandemic has brought to the city. "I don't know how I would've gotten through this without the support of my colleagues and musician friends. The community really pulled together with online gatherings, words of encouragement, sharing info about financial aid opportunities, navigating the complicated unemployment benefits application process, etc. And we supported our clubs' fundraisers and donated to their live streams. Most musicians I know are aware that we're all in this together and need to support the clubs and each other."

And the scene is back on its feet, at least for now. Said Dave Stryker, "Crowds seem happy to hear music again. People are happy to be out hearing music, and musicians are happy to be making music again." John Ellis: "Previously when the case numbers were low and the weather was nice, people were very enthusiastic, and the gigs felt extremely therapeutic. I'm sure we'll have more moments like that, and I'll be looking forward to the day when we do." Kendra Shank: "I'm looking forward to more gigging, including returning to the 55 Bar where I had a 20-year residency." As of this writing (February, 2022), the Village Vanguard, Jazz Gallery, Smalls, Mezzrow, Birdland, Iridium, and the 55 Bar are all open with full calendars. It's not yet spring, but there sure seems to be a sense of renewal in the air. There's a real vibe of resiliency and strength among all those that I talked to, and they are getting their creative energies recharged from playing music with

each other and for their fans. Rio Sakairi sums it up perfectly: "We just have to ride this out and the music is always going to be OK. One of my favorite things that (longtime *Village Voice* music critic) Greg Tate said was that 'The future needs jazz more than jazz needs the future.' And I think jazz, in particular, has a lot of ideas that we can really use as a society. And I don't know, I hate when people say, 'Oh, we have to revive jazz.' Jazz is OK. Jazz will always be OK."

Update: since this article was originally written, New York's iconic 55 Bar closed on May 23, 2022, primarily because it could not recover financially from its 14-month pandemic shutdown.

Name _____ Date _____

Jazz Performance

Review Sheet

Remember to:
1. Staple or stamp proof of attendance onto this sheet.
2. Turn it in within one week of the performance date.
3. Make sure that your name and Student ID Number are printed neatly.

Name:

Student ID #:

Section #:

Circle one: This is Jazz Review: 1 2 3 4 5

Date of Performance:

Location of Performance:

Name of Group/Performer:

Instruments used:

Name some of the songs/pieces that were performed:

Name some of the musical techniques that were used:

What was your overall impression of the performance? Write a brief summary or description.

Name _____ Date _____

Jazz Performance

Review Sheet

Remember to:
1. Staple or stamp proof of attendance onto this sheet.
2. Turn it in within one week of the performance date.
3. Make sure that your name and Student ID Number are printed neatly.

Name:

Student ID #:

Section #:

Circle one: This is Jazz Review: 1 2 3 4 5

Date of Performance:

Location of Performance:

Name of Group/Performer:

Instruments used:

Name some of the songs/pieces that were performed:

Name some of the musical techniques that were used:

What was your overall impression of the performance? Write a brief summary or description.

Name _____ Date _____

Jazz Performance

Review Sheet

Remember to:
 1. Staple or stamp proof of attendance onto this sheet.
 2. Turn it in within one week of the performance date.
 3. Make sure that your name and Student ID Number are printed neatly.

Name:

Student ID #:

Section #:

Circle one: This is Jazz Review: 1 2 3 4 5

Date of Performance:

Location of Performance:

Name of Group/Performer:

Instruments used:

Name some of the songs/pieces that were performed:

Name some of the musical techniques that were used:

What was your overall impression of the performance? Write a brief summary or description.

Name _____ Date _____

Review Sheet

Remember to:
1. Staple or stamp proof of attendance onto this sheet.
2. Turn it in within one week of the performance date.
3. Make sure that your name and Student ID Number are printed neatly.

Name:

Student ID #:

Section #:

Circle one: This is Jazz Review: 1 2 3 4 5

Date of Performance:

Location of Performance:

Name of Group/Performer:

Instruments used:

Name some of the songs/pieces that were performed:

Name some of the musical techniques that were used:

What was your overall impression of the performance? Write a brief summary or description.

Name _____ Date _____

Jazz Performance

Review Sheet

Remember to:
1. Staple or stamp proof of attendance onto this sheet.
2. Turn it in within one week of the performance date.
3. Make sure that your name and Student ID Number are printed neatly.

Name:

Student ID #:

Section #:

Circle one: This is Jazz Review: 1 2 3 4 5

Date of Performance:

Location of Performance:

Name of Group/Performer:

Instruments used:

Name some of the songs/pieces that were performed:

Name some of the musical techniques that were used:

What was your overall impression of the performance? Write a brief summary or description.

Name _____ Date _____

Jazz Performance

Review Sheet

Remember to:
1. Staple or stamp proof of attendance onto this sheet.
2. Turn it in within one week of the performance date.
3. Make sure that your name and Student ID Number are printed neatly.

Name:

Student ID #:

Section #:

Circle one: This is Jazz Review: 1 2 3 4 5

Date of Performance:

Location of Performance:

Name of Group/Performer:

Instruments used:

Name some of the songs/pieces that were performed:

Name some of the musical techniques that were used:

What was your overall impression of the performance? Write a brief summary or description.

REFERENCES

AMG All Music Guide.

Baraka, Amiri. *Blues People.* William Morrow & Company, 1963.

Bindas, Kenneth J. *Swing, That Modern Sound.* University Press of Mississippi, 2001.

Buerkle, Jack V., and Barker, Danny. *Bourbon Street Black: The New Orleans Black Jazzman.* Oxford University Press, 1973.

Carr, Roy. *A Century of Jazz.* Da Capo Press, 1997.

Charters, Samuel B. *Jazz New Orleans (1885–1963): An Index to the Negro Musicians of New Orleans.* Oak Publications, 1963.

Cole, Bill. *Miles Davis: A Musical Biography.* William Morrow & Company, 1974.

Collier, James Lincoln. *Benny Goodman and the Swing Era.* Oxford University Press, 1989.

Collier, James Lincoln. *Louis Armstrong: An American Genius.* Oxford University Press, 1983.

Collier, James Lincoln. *The Making of Jazz: A Comprehensive History.* Dell Publishing, 1978.

Condon, Eddie with Thomas Sugrue. *We Called It Music: A Generation of Jazz.* Da Capo Press, 1992.

Cooke, Mervyn. *The Chronicle of Jazz.* Abbeville Press, 1998.

Crow, Bill. *Jazz Anecdotes.* Oxford University Press, 1990.

Davis, Francis. *The History of the Blues.* Hyperion, 1995.

Davis, Miles with Quincy Troupe. *Miles: The Autobiography.* Touchstone (Simon & Schuster), 1989.

Delta Haze Corporation.

DeVeaux, Scott. *The Birth of Bebop: A Social and Musical History.* University of California Press, 1997.

Feather, Leonard. *The Encyclopedia of Jazz.* Bonanza Books, 1960.

Giddons, Gary. *Celebrating Bird: The Triumph of Charlie Parker.* Beech Tree Books/William Morrow, 1987.

Giddons, Gary. *Satchmo.* Dolphin/Doubleday, 1988.

Giddons, Gary. *Visions of Jazz: The First Century.* Oxford University Press, 1998.

Gioia, Ted. *The History of Jazz.* Oxford University Press, 1997.

Gioia, Ted. *West Coast Jazz: Modern Jazz in California 1945–1960.* Oxford University Press, 1992.

Gitler, Ira. *Swing to Bop.* Oxford University Press, 1985.

Gottlieb, Robert (editor). *Reading Jazz.* Vintage Books, 1999.

Guralnick, Peter. *Searching for Robert Johnson.* Penguin Putnam, Inc., 1989.

Halberstam, David. *The Fifties.* Villard Books, 1993.

Hennessey, Thomas J. *From Jazz to Swing.* Wayne State University Press, 1994.

Hesse, John Edward. *Beyond Category: The Life and Genius of Duke Ellington.* Simon & Schuster, 1993.

Huggins, Nathan Irvin. *Harlem Renaissance.* Oxford University Press, 1971.

jazzdisco.org; Jazz Discography Project.

Kahn, Ashley. *Kind of Blue: The Making of the Miles Davis Masterpiece.* Da Capo Press, 2000.

Kelly, Robin D.G.: *Thelonius Monk: The Life and Times of an American Original.* Free Press, 2009.

Kennedy, Rick. *Jelly Roll, Bix, and Hoagy: Gennett Studios and the Birth of Recorded Jazz.* Indiana University Press, 1994.

Lomax, Alan. *Mister Jelly Roll: The Fortunes of Jelly Roll Morton, New Orleans Creole and "Inventor of Jazz."* University of California Press, 1973.

The Macmillian Encyclopedia 2001. © Market House Books Ltd.

Murray, Albert. *Stomping the Blues.* Da Capo Press, 1976.

Nisenson, Eric. Blue: *The Murder of Jazz.* Da Capo Press, 1997.

Ostransky, Leroy. *Jazz City.* Prentice Hall, 1978.

Palmer, Robert. *Deep Blues.* Penguin Books, 1981.

pbs.org.

Pearson, Jr., Nathan W. *Goin' to Kansas City.* University of Illinois Press, 1987.

Roberts, John Storm. *Black Music of Two Worlds.* Praeger Publishers, 1972.

Rosenthal, David H. *Hard Bop: Jazz & Black Music 1955–1965.* Oxford University Press, 1992.

Russell, Ross. *Bird Lives!* Da Capo Press, 1973.

Russell, Ross. *Jazz Style in Kansas City and the Southwest.* University of California Press, 1971.

Scanlon, Tom. *The Joy of Jazz: Swing Era 1935–1947.* Fulcrum Publishing, 1996.

Schuller, Gunther. *Early Jazz: Its Roots and Musical Development.* Oxford University Press, 1968.

Shipton, Alyn. *Groovin' High: The Life of Dizzy Gillespie.* Da Capo Press, 1999.

Southern, Eileen. *The Music of Black Americans: A History.* W. W. Norton & Company, 1971.

Stearns, Marshall. *The Story of Jazz.* Oxford University Press, 1956.

Teachout, Terry. *Pops: A Life of Louis Armstrong.* Mariner Books, 2010.

Walser, Robert (editor). *Keeping Time: Readings in Jazz History.* Oxford University Press, 1999.

Ward, Geoffrey C. *Jazz: A History of America's Music.* Alfred A. Knopf, 2000.

Williams, Martin. *The Jazz Tradition.* Oxford University Press, 1983.

GLOSSARY

4/4 Rhythm—in jazz, 4/4 rhythm is achieved through the use of a walking bass pattern.

AAB Form—blues poetry or lyrics that follow an established AAB format. Over the 12-bar form, three phrases are sung, the first two being identical, the last phrase generally responding in some way to the first two.

Abolitionist Movement—the campaign to eliminate slavery in the United States that included the Underground Railroad.

Acid Jazz—a style originally created by London DJs from 1960s and 1970s soul jazz and funk records.

Acoustical Process—process of recording before 1925. An acoustical horn would capture the sound of the musicians huddled in front of it and transfer the vibrations to a cutting stylus that cut grooves onto a wax disc.

American Federation of Musicians Recording Ban—a prohibition of all recordings made by members of the AF of M that went into effect on August 1, 1942. The ban was rescinded in 1944.

Afro-Cuban—a jazz style that incorporates musical influences from Africa and Cuba, first made famous by Dizzy Gillespie's big band in 1947.

Arrangement—notated rendition of a song or composition.

Arranger—person who plans and notates the arrangement.

Atonal—refers to music without a tonal key center.

Avant-Garde—denoting artistic endeavors that are experimental, new and unusual, or cutting edge.

Backbeat—beats two and four of each measure.

Banjar—ancestor of the banjo.

Bar/Measure—repeated groupings that beats are organized into.

Battles of the Bands—competitions between two or more bands in which the winners were determined by the applause of the audience.

Bebop—the first modern jazz style; it emanated from jam sessions in Harlem in the late 1930s and early 1940s.

Berklee College of Music—an independent jazz and contemporary music college founded in 1945 in Boston.

Black, Brown, and Beige—an orchestral suite written by Duke Ellington that premiered at Carnegie Hall on January 23, 1943.

Black-and-Tan—a nightclub in the 1920s and 1930s where both Black and white patrons were welcome.

Block Chord Writing—a big band arranging technique in which melodies are harmonized to make them sound fuller.

Blue Notes—the altered scale steps (3, 5, and 7) of the blues scale

Blues—a form characterized by the use of a 12-bar chorus and an AAB lyrical verse that can be incorporated into jazz, rock, and other styles. The blues is also a separate style in and of itself that comes in many different forms.

Blues Scale—six-note scale that eliminates the second and sixth scale notes and lowers the third and seventh scale notes.

Bossa Nova—a Brazilian jazz style developed by Antonio Carlos Jobim and João Gilberto in the 1950s.

Cabaret—an eating and drinking establishment.

Cabaret Card—a card issued by the city of New York that allowed a performer to work in an establishment that sold liquor.

Cadenza—a short, unaccompanied instrumental solo, usually near the end of a performance.

Cakewalk—a dance contest popular in 19th-century America in which the winning couple won a cake.

Call and Response—a melodic phrase played or sung by one performer that is answered by the rest of the group.

Calypso—a style of Caribbean folk music.

"Cherokee"—a popular standard from the swing era; Charle Parker achieved a musical epiphany while playing this song in 1939.

Chicago Style—a style of jazz that emerged from white bands in Chicago in the 1920s.

Chord—three or four notes played simultaneously; the fundamental unit of harmony.

Chord Progression/Changes—the sequential order of the chords of a tune. In the jazz world, the chord progression is called the changes.

Chord Symbol—notational representations of chords, or a kind of shorthand used to quickly communicate the harmonic content of chord.

Chorus—each statement of the form.

Civil Rights Movement—the political struggle for racial equality that was led by Dr. Martin Luther King, Jr. and others.

Classic Blues—a style of blues that was popular in the 1920s; the most notable characteristic was the use of female vocalists.

Clavinet—an electric harpsichord-like keyboard instrument that was widely used by Stevie Wonder and other funk artists in the 1970s.

C-Melody Sax—a nontransposing saxophone popular in the 1920s and 1930s; its sound and range was similar to the alto saxophone.

Collective Improvisation—the distinctive characteristic of the New Orleans Style of jazz in which the front line instruments improvise simultaneously.

Commercial Band—a category of swing-era band that excelled at playing commercial music.

Comping—the interactive and syncopated way in which a pianist or guitarist plays in a jazz rhythm section; short for accompanying.

Concerto—musical composition for ensemble (traditionally an orchestra) that features a solo instrument.

Contrapuntal—of, relating to, or marked by counterpoint.

Cool—a term to describe a jazz soloist who plays in a more laid-back, lyrical fashion.

Cool Jazz—a jazz style from the 1950s that is characterized by restraint and European influences. Some-times known as West Coast Jazz.

Counterpoint—two or more melodic lines occurring simultaneously, sometimes referred to as polyphony.

Country Blues—the first blues style, characterized by male singers who accompanied themselves on the guitar.

Creoles of Color—people in New Orleans with a European (usually French) and African ancestry.

Cross-Sectional Voicing—written melody played in unison by two instruments from different sections, creating a new instrumental color.

Cutting Contest—an informal competitive duel where musicians try to outplay each other by showing more creativity and originality.

Digital Sample—a digital recording of a sound or musical phrase that is used in the performance or creation of a musical piece.

Dirge—somber song expressing grief and sorrow, performed during a New Orleans funeral procession.

Discriminatory Codes—regulatory laws that were enacted to legalize segregation and discrimination; also known as Jim Crow laws.

Dissonance—a musical term to describe nonharmonious notes or intervals

Djembe—an African drum with a bird bath shape.

Double Time—in an improvised solo, the technique of playing rhythmically twice as fast as the established tempo.

Doubling Instruments—instruments such as flutes or soprano saxophones that are occasionally used as a second instrument by a musician.

DownBeat—a jazz and contemporary music magazine first published in 1935.

Downbeat—beat one of each measure.

Dropping Bombs—spontaneous, syncopated accents played by a drummer on the bass drum.

ECM Records—(Edition of Contemporary Music) started in 1969 by German jazz and classical musician Manfred Eicher. ECM has been one of the leading labels for world and jazz fusions.

Electrical Process—a recording technology utilizing microphones to convert sound waves into electrical impulses.

Ellington Effect, The—the term coined by Billy Strayhorn to describe his emulation of Duke Ellington's composing and arranging style.

Embellishment/Ornamentation—simply the improvised decoration of "jazzing up" of a melody, whether in the head or in a solo.

Ensemble Swing—an arranging technique that allows a horn section to swing in a free and relaxed manner.

EWI—Electronic Wind Instrument.

Fake Book—a book made up of tunes in lead sheet form.

Famous Orchestra, The—the Duke Ellington Orchestra in the years 1940–1943 when it was at its peak.

Fender Rhodes Electric Piano—a popular brand of electric keyboard with a bell-like sound and whose keys simulated the feel of a real piano.

Field Holler—a solo (one performer) song-shout without form or steady rhythm that is highly spontaneous.

Fireside Chats—a series of radio talks given by President Franklin Roosevelt to inspire hope and inspiration during the Depression and World War II.

Flatted 5th—an interval commonly used by bebop musicians in their improvised solos and tune melodies.

Free Jazz—a jazz style from the 1960s that is characterized by a willingness to break conventional rules and norms.

French Impressionist Composers—a compositional school that attempted to infuse the ethos of impressionistic art into their compositions; famous adherents included Claude Debussy and Maurice Ravel.

Front Line—the wind instruments in a small jazz group.

Fronts—paneled cardboard structures designed to hide music stands and make the visual display of the saxophone section more attractive.

Fugue—a formal structure first used during the Baroque Era that makes extensive use of counterpoint based on an opening theme or subject.

Gig—a jazz performance.

Globalization—refers to increasing global connectivity, integration, and interdependence in the economic, social, technological, cultural, political, and ecological.

Griot—any of a class of musician-entertainers of western Africa whose performances include tribal histories and genealogies.

Hard Bop—a jazz style popular in the 1950s and 1960s that incorporates influences from R&B, gospel, and the blues.

Harlem Stride—see Stride piano.

Harlem Renaissance, The—an increased awareness and promoting of African-American artistic culture in Harlem in the 1920s that included theatre, literature, art, poetry, and music.

Harmolodics—Ornette Coleman's improvisational concept, a contraction of the words harmony, motion, and melodic.

Harmon Mute—a trumpet mute that gives the instrument a buzz-like whisper.

Head—the melody of a song.

Head Arrangement—an arrangement that is created in a spontaneous fashion without written music.

Hot—a term to describe a soloist who plays in a dramatic and virtuosic manner.

Hot Band—a category of swing-era band that played the most exciting and jazz-oriented music.

Improvisation—the act of simultaneously composing and performing.

Improvised Solo—the highest form of individual expression in a jazz performance.

"Intuition" and "Digression"—two spontaneously composed songs recorded by Lennie Tristano and his group on May 16, 1949, that are considered to be the first free jazz recordings.

Jam Band—a term that refers to bands, albums, festivals, etc., that relate directly or indirectly to the jam band culture.

Jam Session—an informal, improvisational playing session where musicians play for fun and often without pay.

Jazz at the Philharmonic—Norman Granz's concert and tour series that began in 1944 and continued into the 1960s.

Jazz Interpretation—unique way that jazz musicians produce sound.

Jazz Performance Form—the standard head-solos-head form of a jazz performance.

Jazz Standard—a jazz or pop tune that is widely known by jazz musicians and is played often.

Jazz/Rock Fusion—a jazz style from the 1970s that combined jazz elements with rock elements such as electric instruments and rock rhythms.

Jitney Dance—popular in the territories during the 1930s, where a 25-cent ticket bought a young man one dance with a girl.

Jug Bands—bands consisting of fiddles and banjos, washboards, and foot stomping.

Jump Band—R&B ensembles that were smaller descendents of the swing big band.

Jungle Style—the Duke Ellington composing style from the 1920s characterized mainly by the growling trumpet style of Bubber Miley.

Kalangu—talking drum.

Kalimba—thumb piano.

Kansas City Style—the jazz style that evolved in Kansas City in the 1920s and 1930s that is characterized by the use of 12-bar blues forms and head arrangements.

Ken Burns Jazz—the 10-episode, 19-hour long documentary first broadcast in January 2001.

Klezmer—originally the music of East European Jews from medieval times. Klezmer is up-tempo folk-dance music that is usually played by ensembles of violin, clarinet, accordion, drums, and other instruments.

Korro—large harp.

Lay Out—when a musician, such as a horn player, does not play during a performance.

Lead Sheet—a written-down notation of a tune using only the melody and chord symbols.

Legislative Code No. 111—a discriminatory code enacted in Louisiana in 1894 that formally legalized discrimination and segregation.

Let's Dance—a radio program broadcast on the NBC radio network from October 1934 to May 1935 that featured the Benny Goodman Orchestra.

Lindy Hop—a tribute to Charles Lindbergh's famous solo "hop" across the Atlantic, this dance was an exciting, athletic dance where dancers sometimes actually threw their partners up in the air.

Lyrical—a melody that is very singable or melodic. Cool soloists tend to play more lyrically than hot soloists.

M-Base—(short for "macro-basic array of structured extemporization") is a concept of how to create modern music that reached its peak in the mid-to-late-1980s and early 1990s.

Melodic Development—an improvisational technique where the soloist repeats a short phrase or riff with constant variation and modification.

Metronome—a magazine that reported on jazz and popular music.

MIDI (Musical Instrument Digital Interface)—a digital protocol that allows the transfer of musical information between digital instruments and computers, where it can be manipulated by sequencing software.

Minstrelsy—a traveling show that was popular during the 19th century featuring songs, skits, and dancing that usually portrayed African Americans in a derogatory fashion.

Missouri School, The—a group of ragtime composers and performers working in St. Louis and other Missouri cities in the 1890s that included Scott Joplin.

Modal Jazz—style in which the harmonic focus is on modes, or scales, rather than chord progressions.

Moldy Figs—purist advocates of early jazz.

Multiphonics—a technique in which a player produces more than one note at a time on a wind

instrument, often creating unusual intervals that sound dissonant.

Multi-Track Recording—tape recording technology that allows for multiple tracks to be recorded in sync all at once, or at different times.

Neo-Traditional—a jazz movement that became popular in the 1980s that advocates the use of swing rhythm, blues tonalities, and acoustic instruments exclusively.

New Orleans Revival—a short-lived nostalgic interest in the music of New Orleans that emerged in the late 1940s as a reaction to bebop.

New Orleans Style—the first style of jazz that emerged in New Orleans in the early years of the 20th century characterized by the use of collective improvisation.

New Thing, The—the term first applied to the style that became known as free jazz.

Octave—interval measuring eight diatonic steps.

Odd Meter—unusual groupings such as five, seven, or nine beats to the measure.

Ostinato—a short musical phrase, either melodic or rhythmic, that is repeated.

Overdub—a feature of multi-track tape recorders that allows musicians to record additional parts independently of each other while listening to already recorded tracks with headphones.

Pentatonic Scale—five-note scale (usually 1-2-3-5-6, or do-re-mi-sol-la), commonly used in folk music from different cultures, including Africa.

Phrasing—combining of melodies with silence, or rests.

Pianola—a player piano introduced in 1897 that played pre-cut piano rolls.

Pizzicato—snapping or plucking the strings of a stringed instrument instead of using a bow.

Playing Outside—a term describing a jazz musician's willingness to play in a fashion beyond the conventional rules.

Polyrhythm—using two or more rhythms simultaneously.

Postmodernism—at attitude about creating art that includes breaking down barriers between pop art and fine art, an eclectic blending of old and new styles, and ironic and cynical composition.

Professors—the solo pianists that played in the sporting houses (bordellos) of New Orleans's Storyville district.

Prohibition—legally known as the Volstead Act, Prohibition outlawed the manufacture, sale, and consumption of alcoholic beverages.

Publishing Royalties—payments collected from record companies that are distributed to publishing companies and song composers.

Pulse—fundamental beat driving the music that creates the tempo.

Race Records/Labels—the record companies and the records they released that featured Black performers and were sold to primarily Black consumers.

Ragging—the practice of adding the syncopated rhythms of ragtime to blues and popular songs that was utilized by early jazz musicians in New Orleans.

Ragtime—a notated and fully composed piano style that was popular in the 1890s and early 20th century.

Reconstruction—the period following the Civil War from 1986–77 when the Federal government controlled social legislation in the South that was introduced to grant new rights to freed Black citizens.

Reharmonization—the process of inserting new chords into the existing chord progression of an established tune, also known as chord substitution.

Rehearsal Band—an ensemble (usually a big band) that meets only in rehearsal to allow musicians to work on sight-reading skills and to try out new arrangements.

Rent Party—parties that charged an admission price that helped pay the next month's rent; popular in Harlem in the 1920s.

Repertory Band—bands dedicated to playing the music of a specific artist or jazz style.

Rhapsody in Blue—concerto by George Gershwin filled with jazz-inspired harmony and melodies that included blue notes and other jazz affectations.

Rhythm & Blues—a more commercial, dance-oriented version of the blues, often utilizing coordinated costumes and dance steps by performers.

Rhythm Changes—designates the chord progression used by the George Gershwin song "I Got Rhythm" that has also been used in many jazz compositions.

Riff—short melodic phrase or melody.

Ring Shout—an African ceremonial dance in which participants form a circle and shuffle in a counterclockwise direction in ever-increasing speed and intensity, eventually reaching a state of hysteria.

Sanko—zither-type instrument.

Scat Singing—an improvised solo sung by a vocalist using nonsense syllables.

Second Awakening—the second wave of a religious revival in the United States during the years 1800–1830 that was characterized by camp meetings attended by thousands that lasted for days at a time.

Second Line—the up-tempo and joyous music played on the return from a funeral in New Orleans; also denotes a rhythmic groove occasionally used in jazz performance.

Sectionalization—denotes a way to conceptualize a big band into trumpet, trombone, and reed sections and have them play riffs against each other in call-and-response fashion.

Session Musician—a musician used on a recording session; session musicians must be able to sight-read music and play fluently in a variety of styles.

Shakere—gourd that is covered with bead net.

Sheet Music—music that is notated and sold in a loose, unbound sheet format.

Sheets of Sound—an improvisation technique associated with John Coltrane in which notes are played in an extremely fast and rhythmical fashion.

Shouter—blues singers from the Kansas City jazz scene in the 1920s and 1930s.

Smearing—technique of sliding from one note to another used by vocalists or wind instrument players.

Smooth Jazz—a melodic and pop-oriented style of jazz that evolved from jazz/rock fusion in the 1980s and 1990s.

Song Plugger—musician who would perform a new song at music stores to encourage people to buy the sheet music.

Soul Jazz—a popular substyle of hard bop that drew heavily from R&B and soul music influences.

Spanish Tinge—Jelly Roll Morton's term for utilizing the rhythms of the tango and other Spanish dances in jazz compositions.

Speakeasy—gang-controlled establishment where liquor was sold illegally.

Spiritual—an American style of religious music originating in the 18th and 19th centuries that consisted of European hymns sung using African performance techniques.

St. Valentine's Day Massacre—the name given to the shooting of seven people (six of them gangsters) as part of a Prohibition era-conflict between two powerful criminal gangs in Chicago in the winter of 1929: the South Side Italian gang led by Al Capone and the North Side Irish/German gang led by Bugs Moran. Former members of the Egan's Rats gang were also suspected to play a large role in the St. Valentine's Day massacre, assisting Al Capone.

Standard Song Form—a 32-bar form comprised of four sections, either in an AABA or ABAC configuration, with each letter representing an eight-bar musical phrase.

Stock Arrangements—easy-to-play dance band arrangements of popular songs, sold by publishing companies.

"Strange Fruit"—antilynching song performed by Billie Holiday.

Stride Piano—a virtuosic piano style developed in Harlem in the 1910s and 1920s.

Sweet Bands—bands that played mild, syncopated dance music.

Swing—the name that was given to the music played by the dance bands of the 1930s and 1940s.

Swing Out—a magazine that reported on jazz and popular music.

Swing Rhythm—the loosening of the rigid adherence to the beat, accomplished by slightly delaying the notes played between the beats.

Symphonic Jazz—a style of jazz played by the Paul Whiteman Orchestra that incorporated heavy influences from European classical music.

Syncopation—rhythmically placing or accenting notes away from the beat and in unexpected places.

Tailgating—the manner of playing the trombone in the New Orleans Style that is characterized by dramatic slides and other effects; came into use as trombonists often sat on the tailgate of wagons while performing.

Taxi-Dance—dances where "taxi-dancers" charged their male partners a small fee for one dance.

Tempo—the speed of the music.

Theatre Owners Booking Agency (TOBA)—a booking agency for musicians, classic blues singers, and traveling shows in the 1920s and 1930s.

Third Stream—a term coined by Gunther Schuller in 1957 to describe the combining of jazz and classical music into a new style.

Thundering Herd—one of the incarnations of Woody Herman's big band.

Time Signature—the designation of the meter, or the number of beats in each measure in music.

Tin Pan Alley—describes the music publishing business in the first half of the 20th century and the songs and composing style that resulted from it.

Trad Jazz—a term sometimes used for traditional, or New Orleans Style jazz.

Trading 4s—the technique of exchanging four-bar solos, usually between a soloist and a drummer.

Treemonisha—an opera of early African-American folk life written and first staged by Scott Joplin in Harlem in 1915.

Trumpet Style—the piano style played by Earl "Fatha" Hines that incorporated the use of octaves in the right hand.

Two-Beat Rhythm—the rhythmic style of ragtime and much early jazz in which the bass plays on beats one and three, producing a boom-chuck feel.

Vamps—repeated phrase that is often used to connect two sections of a composition, to support extended solos, or to end songs.

Vaudeville—the type of live entertainment show popular in the late 19th and early 20th century that included short comedy skits and musical acts.

Vertical Style—an improvisational style based on using chord tones, which are stacked vertically in notated music; first associated with Coleman Hawkins.

Vibrato—technique of varying a pitch up and down slightly to produce a wavering sound.

Vocalese—technique of composing lyrics to fit existing recorded jazz improvised solos or instrumental arrangements.

Walking Bass—a technique of playing one note per beat to outline chords that is used in swing rhythm by bass players.

West Coast Jazz—a jazz style from the 1950s that is characterized by restraint and European influences. Sometimes known as Cool Jazz.

Wordless Vocal—a written vocal line sung without words, using instead simple monosyllabic "oohs" or "aahs."

Work Song—a song sung during the performance of a job, task, or work to make the work easier.

KEY TERMS, SONGS, AND MUSIC STYLES INDEX

For artists and places, please see the **Key Figures and Key Places Index.**
NOTE: Page numbers in italics represent photos or illustrations.

KEY FIGURES AND KEY PLACES INDEX

For terms, songs and music styles, please see the **Key Terms, Songs, and Music Styles Index**.
NOTE: Page numbers in italics represent photos or illustrations.